PENGUIN BOOKS

THE FIRST BOHEMIANS

'Vic Gatrell's evocation of a place "thick with coffee-houses, bordellos, bawds and privileged rakes on the razzle" takes you right back . . . [A] marvellous book . . . exhilarating, richly illustrated and witty' Orlando Bird, *Financial Times*

'Compelling . . . scholarly and bawdy'
Tristram Hunt, *Mail on Sunday*, Books of the Year

'Gatrell's love for this dangerous but brilliant age is matched by his expert knowledge of its culture, both high and low'
Dan Jones, *Daily Telegraph*, Books of the Year

'Gatrell does a fine job of tracing how the scurrilous behaviour of London's residents often inspired some of the finest works of art and literature . . . he evokes a Covent Garden of coffee houses, tenements, artist studios, taverns and brothels . . . the richness of detail makes *The First Bohemians* a pleasure to read . . . his enthusiasm feels infectious' *Economist*

'Gatrell is terrific company. He praises 18th-century writing for propelling us "niftily to the point" and his own prose performs the same trick . . . *The First Bohemians* is generously, often ingeniously, illustrated and Gatrell's pithy commentary on the prints and pictures can be scathing'
Frances Wilson, *New Statesman*

'Could be bought for its illustrations alone'
Frances Wilson, *The Times Literary Supplement*, Books of the Year

'Gatrell's richly documented (and wonderfully illustrated) study . . . [shows] how an unconventional way of looking at the world – vivid, unpretentious and often richly comic – eventually found its way to the heart of our culture, and we are richer for it . . . Gatrell deftly sketches the long-running conflict between two different approaches to painting in 18th-century England: the "high" school of the Royal Academicians, with its emphasis on noble history paintings, mythical scenes and grand Italianate landscapes, and the "low" school of Hogarth and his admirers [who] produced a transformation of taste, teaching the English to take pleasure in . . . the portrayal of simple human pleasures' Noel Malcolm, *Sunday Telegraph*

'Engrossing . . . a compelling, instructive read . . . masterful'
Hallie Rubenhold, *BBC History Magazine*

'Gatrell argues persuasively that it was their proximity to this
mayhem that made the artists and writers in 18th-century Covent
Garden so vivid and exciting . . . [He] proves a dab hand at recreating
the blazing furnace of 18th-century Covent Garden . . . a natural
iconoclast' Craig Brown, *Mail on Sunday*

'Gatrell's evocation of taverns, bagnios and alleys is compelling.
He has a lovely eye for shadows in paintings and how they
indicate time of day; he has a lively eye for sympathies in sketches.
Butchers, bawds, rakes, tradesmen, sailors, fruit-sellers, fruit-buyers,
tailors, cooks, pie-men, aristocrats, oilmen, coalmen, stay-makers,
bookbinders, button-sellers and dozens of others are particularised
fleetingly from crowds . . . For all its zest for sensual assault, [*The
First Bohemians*] engages with the unwashed great in illuminating
scholarship' Clare Brant, *Times Higher Education*

'The breadth of Gatrell's investigation is extraordinary and the
amount of detail that finds its way onto his pages is startling . . .
Meticulously researched and eloquently discussed, . . . the selection,
collection and reproduction of images is a triumph; they punctuate
and orient a narrative that is as frenetic, busy and rich as the world it
sets out to describe' Nell Stevens, *Review 31*

ABOUT THE AUTHOR

Vic Gatrell's last book, *City of Laughter*, won both the Wolfson Prize
for History and the PEN Hessell-Tiltman Prize; his *The Hanging Tree*
won the Whitfield Prize of the Royal Historical Society. He is a Life
Fellow of Caius College, Cambridge.

VIC GATRELL

The First Bohemians
Life and Art in London's Golden Age

PENGUIN BOOKS

PENGUIN BOOKS

Published by the Penguin Group
Penguin Books Ltd, 80 Strand, London WC2R ORL, England
Penguin Group (USA), Inc., 375 Hudson Street, New York, New York 10014, USA
Penguin Group (Canada), 90 Eglinton Avenue East, Suite 700, Toronto, Ontario, Canada M4P 2Y3
(a division of Pearson Penguin Canada Inc.)
Penguin Ireland, 25 St Stephen's Green, Dublin 2, Ireland
(a division of Penguin Books Ltd)
Penguin Group (Australia), 707 Collins Street, Melbourne, Victoria 3008, Australia
(a division of Pearson Australia Group Pty Ltd)
Penguin Books India Pvt Ltd, 11 Community Centre, Panchsheel Park,
New Delhi – 110 017, India
Penguin Group (NZ), 67 Apollo Drive, Rosedale, Auckland 0632, New Zealand
(a division of Pearson New Zealand Ltd)
Penguin Books (South Africa) (Pty) Ltd, Block D, Rosebank Office Park,
181 Jan Smuts Avenue, Parktown North, Gauteng, South Africa 2193

Penguin Books Ltd, Registered Offices: 80 Strand, London WC2R ORL, England

www.penguin.com
First published by Allen Lane 2013
Published in Penguin Books 2014
002

Copyright © Vic Gatrell, 2013

The moral right of the author has been asserted

Typeset by Palimpsest Book Production Limited, Falkirk, Stirlingshire
Printed in Great Britain by Clays Ltd, St Ives plc

A CIP catalogue record for this book is available from the British Library

978-0-718-19583-0

www.greenpenguin.co.uk

Contents

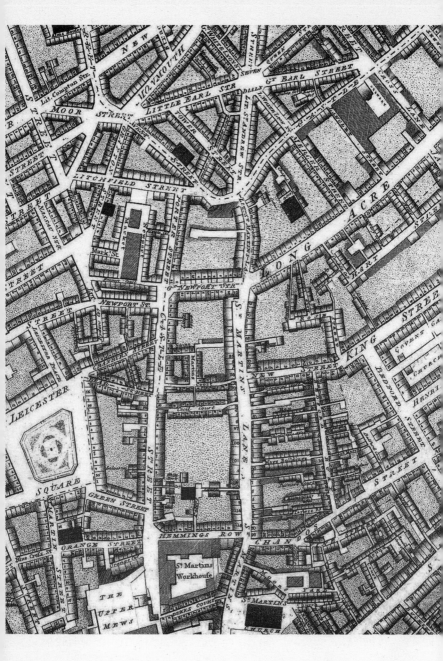

Covent Garden and the 'Town', from Richard Horwood's *Plan of the Cities of London and Westminster* (1792–9)

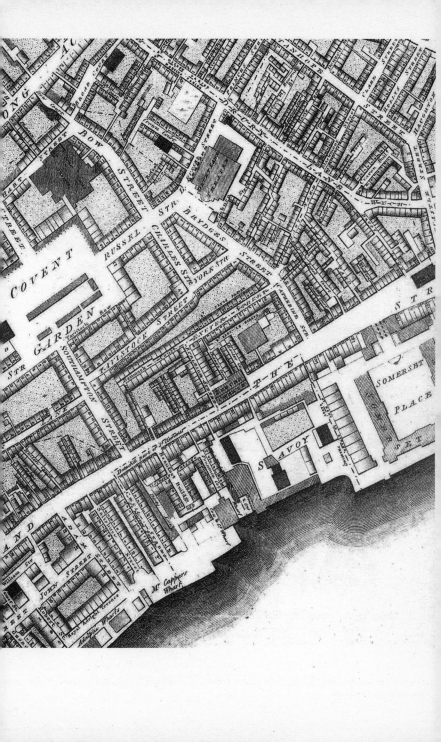

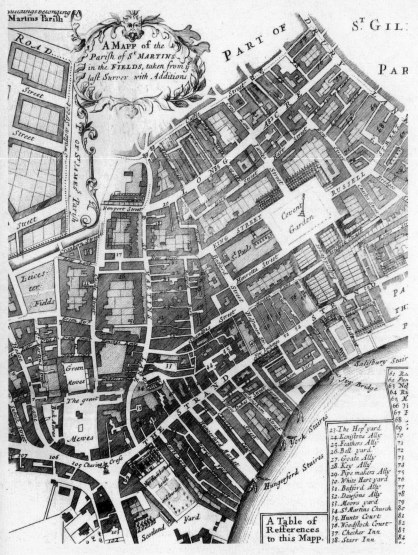

John Strype, St Paul's Parish, Covent Garden (surrounded by the Parish of St Martin-in-the-Fields) (1720)

Foreword

For reading and commenting on parts of what follows my thanks go to good friends: Bernard Barker, Vyvyen Brendon, Lizzie Collingham, Roger Court and Jerry White. I especially thank Jeremy Krikler, who argued hard and positively about my early drafts. To the support given over the years by Sheila O'Connell of the Prints and Drawings Department of the British Museum I have owed more than I can say. For encouragement, thanks too to Gill Coleridge, my agent, and Simon Winder, my editor. He and Marina Kemp have been unfailingly helpful to the book. Bela Cunha has been a copy-editor blessed with a superhuman tolerance of my inefficiencies: her patience and skill are marvellous. The cost of buying illustrations and permissions has been generously supported by the Paul Mellon Centre for the Study of British Art (London); my college, Gonville and Caius, has kindly helped too. As ever, Pam my wife has been guide, mentor and friend *sine qua non*. Our beautiful grandchildren, Freya, Harry and Jack, have entered the world while the book was in the writing. I dedicate it to them and their lovely parents, Alex, Anna, Emily and Matt.

Broad social histories of eighteenth-century art like the one that follows have been hugely helped by the wholesale digitization of historical images in the past dozen or so years. In the first stages of my earlier work on eighteenth-century caricature (*City of Laughter*), I had myself, inexpertly, to photograph several hundred satirical prints merely to get a preliminary measure of the subject. Today the British Museum offers a couple of million downloadable images that include the bulk of its eighteenth-century prints, drawings and watercolours. It allows their free reproduction in scholarly publications, while the Mellon Center for the Study of British Art at Yale allows the free

reproduction of its collection without restriction. Other libraries and museums have put their holdings on line too, though in the UK their charges can be extortionate. At any rate, one can now survey large artistic panoramas in ways hitherto unthinkable. It is possible to cut free from that well-bred connoisseurial interest in 'great' painting and its influences that stultified much of what passed as art history in the past century, and instead – as this book does – to attend to the material, social and topographical conditions under which artists worked, the richness of 'low' art forms, and the earthy rumbustious cultures that produced them.

Introduction

'What kind of a history this is;
what it is like, and what it is not like'

The chapter heading cited above comes from Henry Fielding's novel
Tom Jones, and the fact that it was written in his sister's house in Old
Boswell Court, a few minutes' walk from London's Covent Garden,
makes it both topical and apt in this book. It also propels us niftily to
the point, as no-nonsense eighteenth-century writing was so good at
doing. The kind of history that follows concerns the territory around
Covent Garden that in the eighteenth century accommodated what
may fairly be called the world's first creative 'bohemia'. It tackles the
flowering there of art forms that depicted or commented on 'real life',
and it explores what that art tells us about some of the more significant
expressions of Georgian culture, about its artists, and about London
itself.

To talk of London as if it were a unity is to forget the intense localism
of the lives lived there. Communities and localities have always mattered
in London's history, so that to understand its cultural energies in the
eighteenth century one must become intimate with its most creative
territory. It's an extraordinary fact that by far the majority of eighteenth-
century British painters and engravers, as well as most noted writers,
poets, actors and dramatists, lived in the square quarter-mile or so
around Covent Garden's Piazza. Victorians liked to say that more peo-
ple of genius were buried in the Piazza's church of St Paul's than in any
other church except Westminster Abbey. This list of Covent Garden's
eighteenth-century luminaries, artists, actors and actresses is typical of
those that Victorians remembered, and it is far from complete:

> Butler, Addison, Sir Richard Steele, Otway, Dryden, Pope, Warburton,
> Cibber, Fielding, Churchill, Bolingbroke and Dr Samuel Johnson; Rich,
> Woodward, Booth, Wilkes, Garrick and Macklin; Kitty Clive, Peg

Woffington, Mrs Pritchard, the Duchess of Bolton, Lady Derby, Lady Thurlow and the Duchess of St Albans; Sir Peter Lely, Sir Godfrey Kneller and Sir James Thornhill; Vandervelde, Zincke, Lambert, Hogarth, Hayman, Wilson, Dance, Meyer and Samuel Foote.[1]

What contemporaries called 'the Town' had developed between the City of London and the City of Westmister in the seventeenth century. With the Piazza at its centre (fig. 1), it stretched from Soho and Leicester Fields (now Square) to Drury Lane in the east, and from St Giles's and Long Acre in the north to Charing Cross and the Strand in the south. It had important outreaches eastwards along Fleet Street and into the booksellers' quarter of St Paul's Churchyard, but you could walk across its core in ten or fifteen minutes. Why did so many creative people flock there, and what might that have meant for the making of English art and letters? To find the answer, Part I of the book explores the district closely – both its finer streets and its grimmer back alleys and the poor people who lived in them. The district

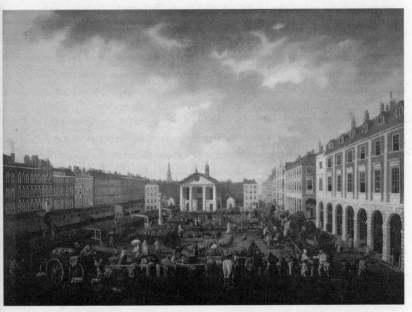

1. John Collet, *Covent Garden Piazza and Market* (oil, 1771–80)

could be as polished a place as any in England, but also as rough. Both qualities influenced the subject-matter of the pictures, books and plays that were produced there.

Part II turns to the 'bohemian' lives of Covent Garden's painters and engravers (and in some degree writers as well), and to their responses to the vivid life around them. Many of course were in thrall to a profitable and fashionable neo-classicism and wouldn't touch low life with a barge-pole. But the men we're interested in (hardly any women) wouldn't have claimed the least responsibility for their era's supposed 'elegance'. They avoided or parodied the neo-classical fantasies and idealized portraiture that today shape our politer notions of what eighteenth-century art and letters were about. Instead, in a range of forms, novelists such as Defoe and Henry Fielding and artists like William Hogarth, Paul Sandby and Thomas Rowlandson depicted people in their homes, streets, taverns and shops, in order to explore how they made or didn't make their livings, and how they behaved themselves or didn't. That's why the book reproduces some 200 pictures, mostly seldom seen. Some are fine and others are simple; but together they say much about what the artists' London was like, and what it was like to be them.

The significance of place in artistic creation won't surprise readers familiar with the art histories of Florence, Venice or Amsterdam. In such cities, as in London later, locality and community determined what was known and talked about and provided the patronage, market and service networks upon which creative people depended. By the same token, few early- to mid-eighteenth-century English artists, writers or dramatists could flourish if they kept their distance from Covent Garden's vigorous provocations and opportunities. London's main theatres were located there, and the district was thick with coffee-houses, bordellos, bawds and privileged rakes on the razzle. Theft, seduction and violence were daily facts of life, and some bleak lives were lived around its edges. But it was also a vital part of workaday London. If pimps, whores, courtesans and rakes abounded, so did craftsmen, traders, market people, shopkeepers, musicians and actors. Many artists and writers were little more than craftsmen themselves.

'Formerly,' wrote George Vertue, the chronicler of the early eighteenth-century art world, 'many skillful Painters lived in Black Fryers,

before Covent Garden was built.'² But the Great Fire that destroyed much of the ancient City in 1666 drove its artistic enclaves westwards into the expanding 'Town'. The City became all but dead to artistic enterprise, while at the western end of London the squares and streets of St James's developed as aristocratic and courtier territories, in craft terms less productive even than the City. London's East End was mercantile or maritime and poor, while Southwark, south of the Thames, was a cultural desert. A French visitor in 1772 found it 'but two streets in its breadth, and almost entirely occupied by tanners and weavers'; the aesthete Horace Walpole sniffily boasted that he had never once had cause to cross the river to visit it.³ In Covent Garden, by contrast, artists, writers, actors and dramatists knitted themselves into a creative community without equal in history.

Their energy had many sources, but the vibrancy of life at the heart of the world's greatest city was the most important. London was the world's first metropolis: by 1801 it held near-on a million people; Paris was half its size. Lubricated by the wealth that accrued from empire, slavery, commerce and invention, it was becoming the greatest trading and financial centre ever known. Although Paris beat London in its aristocratic luxury consumption, it couldn't match the social *breadth* of London's market for artefacts, books, pictures and life's multiplying conveniences.

By the end of the eighteenth century, about 3,000 to 4,500 aristocratic and gentry families lived in London during the parliamentary season. The mercantile and financial elites – some 1,000 families – joined them as the chief motor forces behind the building of fine houses and the buying of Old Masters, fine art and luxuries. By 1800, these families made up about 2 or 3 per cent of the London population, retinues included. If we add to them the loosely defined 'middle classes' (a term that was unused in most of the eighteenth century, but which we can understand as embracing the higher professional people and the more successful merchants, traders, manufacturers, and literary and artistic figures), we swell the proportion of London adults who could afford significant cultural consumption to some 10 per cent by the century's end. The capacity to buy books and engraved pictures also increased among the so-called 'middling' sorts of craftsmen and tradesmen beneath them. There were probably about 30,000

such families in 1801, making one in seven of the total.[4] Poverty and low literacy prevented most of them from spending on culture. Yet, for some, life was improving, and with it the confidence and where-withal to express their tastes. The more educated among them were opinionated as well as aspiring people.

Aristocratic patronage always mattered, but its relative importance diminished as middle people joined high people in buying art, litera-ture and tickets to the theatre. This accelerated the flows of artistic and literary ideas, as well as the aspiration and emulation that were fostered by living in London's heartland. To this we should add the neighbourhood's forgotten intimacy. Great men became friends or else met each other accidentally. In the 1740s, for instance, William Hogarth was on visiting terms with the novelist Samuel Richardson. One day in Richardson's house he saw a person standing at a window, 'shaking his head, and rolling himself about in a strange ridiculous manner'. He assumed that the man must be an idiot under Richardson's care; but then 'the figure stalked forwards to where he and Mr Richardson were sitting' and joined in their argument with 'such a power of eloquence, that Hogarth looked at him with astonishment'. It was Samuel Johnson, of course (his famous convulsions nowadays sometimes diagnosed as Tourette's syndrome).[5] Add again the promis-cuous social mix of Covent Garden's population. Even its very poorest people weren't relegated to the edges of the artist's and writer's vision; they were unavoidably at its centre. Even as irritants, they were more central to the creative men's lived sense of London than the affluent patrons were off whom both whores and artists lived parasitically (fig. 2).

For reasons like these, this extraordinary quarter of a square mile – in which stellar talent and workaday street life and criminal life were closely compacted, where everyone knew each other and lived within minutes of each others' lodgings, tenements, workshops, stu-dios, coffee-houses and taverns – this was nothing less than the space in which the primary expressions of Georgian art and literature were hatched.

*

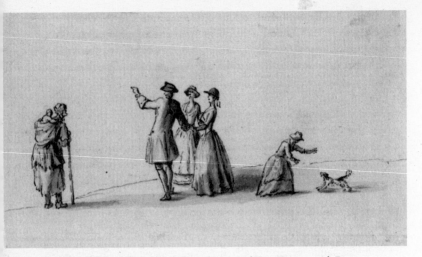

2. Thomas Rosse, *Beggar-woman and Man and Two Women with Dog* (ink, 1730–57)

How 'bohemian' was this Covent Garden? Part II of the book opens with that question. Formally speaking, the word is an anachronism in our context. In the eighteenth and early nineteenth centuries, the French word *bohémien* referred to a gypsy. Only in 1845 did Henri Murger's stories for what became his *Scènes de la vie de Bohème* (1851) apply the word to the creative *demi-monde* of Paris. In the following year in England W. M. Thackeray adopted it in his novel *Vanity Fair* to describe the people of irregular and unconventional habits whom his anti-heroine Becky Sharp liked too much for her own good. In his *Adventures of Philip* a dozen years later Thackeray defined a 'bohemia' as 'a pleasant land, not fenced with drab stucco, like [fashionable] Tyburnia or Belgravia', but 'a land of song; ... where men call each other by their Christian names; where most are poor, where almost all are young'.

There's much to be said for applying the notion of a cultural bohemia to eighteenth-century Covent Garden. For a start, its definition is pleasantly loose. The editors of a major modern anthology on bohemianism reviewed the vast literature on the subject and found that there were 'only two characteristics of bohemianism which appear to hold constant over the century-and-a-half of its recognized existence:

(1) an attitude of dissent from the prevailing values of middle-class society – artistic, political, utilitarian, sexual – usually expressed in life-style and through a medium of the arts; and (2) a café.[6]

Discard as unnecessarily restrictive the chronological limit and the nineteenth-century notion of a 'middle-class society', and the term allows room for the louche tavern- and coffee-house-saturated Covent Garden of the eighteenth century, for the easy informality of its manners, and for the often impoverished and tortured geniuses who populated it.

Not all of Covent Garden's creative or would-be creative inhabitants were the rough diamonds that bohemians are supposed to be; but that was equally true of the later Left Bank or Soho. They also lacked the conspicuous affectations of later bohemians, because they had less need of them. Common eighteenth-century manners were already intrinsically eccentric and libertine by later standards, and bawdry was a common language. So nobody felt it particularly necessary to scandalize the bourgeoisie, because the bourgeoisie was as yet neither fully aware of itself nor as prudish as it became. No need, therefore, to take lobsters for walks on leashes, as the poet de Nerval did in the gardens of the Paris Tuileries, or to wear outrageous red waistcoats or Spanish capes as Gautier did to the Paris theatre, or to affect a cult of free love. If Covent Garden artists and writers loved, drank and gambled more freely than respectable people later thought seemly – well, eighteenth-century practice pointed that way. If they were lax in religion – who, other than church or dissenting people, wasn't? In most male circles, moreover, libertine values were widespread.

That said, 'bohemian' eccentricity and fecklessness were common among Covent Garden artists, and we shall see that even by the standards of the time they generated some wonderfully exotic and profligate behaviours. Moreover, if dissent from prevailing values is a measure of bohemian culture, there was plenty of that too. This, after all, was an art world in which neo-classicists and 'Dutchified' realists were increasingly at loggerheads, and in which plenty of artists defied 'academic' values when they could afford to – or when they had to (after failure). Experimentation flourished – and would always offend someone, like the old-fashioned landscapist Thomas Hearne who thought J. M. W. Turner's skies must have been painted by a madman.

Covent Garden was also politically dissident, as bohemias should be. The point shouldn't be overdone, because most artists were either loyalists or else suppressed their views in order to woo well-heeled customers. For obvious reasons, it was the satirists whose heads most often appeared above the political parapets. Even so, it was by and large whig-radical and anti-court territory, and it was suffused by some distinctly free-thinking and even egalitarian understandings. Deists met in Slaughter's coffee-house in St Martin's Lane; and the likes of Voltaire and Benjamin Franklin, when in London, along with coteries of unitarians and Huguenot intellectuals, all chose to reside near Covent Garden. Moreover, triggered early in the century by the political dominance and corruption of Sir Robert Walpole, the nation's first prime minister, a subversive folk-realization prevailed. As John Gay's *Beggar's Opera* put it, there was 'such a similitude of manners in high and low life, that it is difficult to determine whether (in the fashionable vices) the fine gentlemen imitate the gentlemen of the road, or the gentlemen of the road the fine gentlemen'. Or as Henry Fielding wrote,

> Great whores in coaches gang,
> Smaller misses,
> For their kisses,
> Are in Bridewell bang'd;
> Whilst in vogue
> Lives the great rogue,
> Small rogues are by dozens hang'd.

Or again as Defoe asked, 'How many honest gentlemen have we in England, of good estates and noble circumstances, that would be highway men, and come to the gallows, if they were poor?' Among Europeans, the German pastor Wendeborn wrote in 1791, it was only the English who knew that 'those, who, on account of their station, or employment in life, wear a rich, or a singular dress, are and remain but men'.[7] So it causes no surprise that this egalitarian vein informed Hogarth's mockery of the people *a-la-mode*, or that graphic satirists throughout the century delineated the ironic equivalences between great people on the one hand, and beggars, thieves and whores on the other. In Isaac Cruikshank's satire (fig. 3), the St Giles's whores dividing the spoils of pocket-picking are equated with the *grandes dames* of St

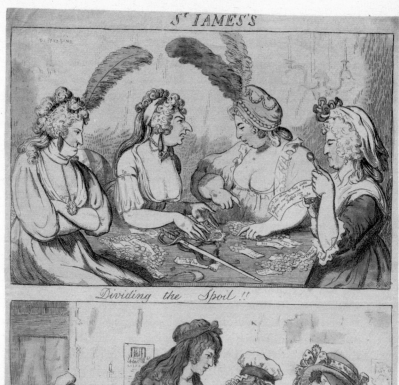

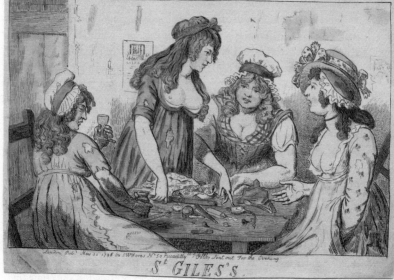

3. Isaac Cruikshank, *Dividing the Spoil!! St James's. St Giles's* (etching, 1796)

James's dividing the ill-gotten gains of the gambling table; both kinds of women even share a relaxed attitude to cleavages. The mockery of privilege and its duplicities had a central place in printshop satires; and nobody failed to defend free expression against extending controls. The radical MPs John Wilkes and Charles James Fox were strongly supported in Covent Garden, and Covent Garden artisans were to found the London Corresponding Society, which nurtured the advanced English radicalism that was triggered by Revolution in France.

Local intimacy was another condition of 'bohemian' living. As Murger was to write of the denizens of the Parisian Latin Quarter, 'they cannot take ten steps on the Boulevard without meeting a friend, and thirty, no matter where, without encountering a creditor'.[8] Eighteenth-century Covent Garden offered exactly the same experience. Furthermore, if sexual freedom is a condition of bohemian life, Covent Garden was especially blessed with it. Apart from vegetables, flowers and fruit, the most intense of its miasmas was the sex that well-attuned nostrils might breathe in its very air. If the neighbourhood buzzed with market people and tradespeople, it also delivered very high quotas of courtesans and whores. Ringed by dank courtyards, alleys and brothels, it was the 'Grand Seraglio to the nation' and 'the great square of Venus'. St Paul's church in the Piazza was a trysting ground for both sexes, while the Piazza and Lincoln's Inn Fields were London's homosexual cruising grounds. Under the Piazza's arcades, according to the *London Journal* in 1726, 'they make their Bargains, and then withdraw into some dark Corners to indorse, as they call it, but in plain English to commit Sodomy'.[9]

What mattered most about Covent Garden, however, was that it was the magnet for every man of talent newly come to London. It was full of artists, engravers, writers, dramatists, actors and advanced designers (Wedgwood the potter and Chippendale the furniture-maker both sold from St Martin's Lane). Each of these regarded it 'as the school of manners, and an epitome of the world'. This was what Samuel Johnson's biographer, Hawkins, said of the painters Hogarth, Hayman, Lambeth and their friends; but these artists weren't alone in believing that a whole and a rich life might be lived there. Literary men as diverse as Johnson, Fielding and Sheridan would have agreed. Of Dryden the playwright it was said that he 'presided in the chair [in Wills's coffee-house] at Russell Street; his plays came out in the theatre

at the other end of it [Drury Lane]; he lived in Gerrard Street, which is not far off; and, alas! For the anticlimax! He was beaten by hired bravos in Rose Street, now called Rose Alley' (next to the Lamb and Flag tavern, which still stands).[10]

In 1726, George Vertue counted eleven artists' studios in the Piazza alone – all 'inhabbited by Painters (a Credit to live there)'. But that gives no measure of the total. This book's Appendix lists 146 artists who at some point in their careers lived in that square quarter- to half-mile or so, and whose addresses can be traced. The list includes the majority of noted artists and engravers in London – and thus in Britain. Birthplaces and fathers' occupations are included where known. These show that most came from humble or middling craft or shopkeeper backgrounds, and that most were born outside London – in the English provinces or Scotland, or in France, the Low Countries, Germany or Switzerland. The foreign influx made Covent Garden the most cosmopolitan of all bohemias. It explains why to discuss the 'Englishness' of English art is often ill advised.

Artists did live elsewhere in London, of course. Soho was particularly favoured, enriched as it was by its French Huguenot and Italian exiles, and so, increasingly, was Newman Street north of Oxford Street. By the end of the century, painters with addresses in Soho or Newman Street probably outnumbered those immediately around Covent Garden.* All the same, few of these addresses were more than half a mile from the Piazza – so in discussing 'Covent Garden' in this book, the part will sometimes refer to the whole, with an inclusion of Soho implied. In any case, by the late eighteenth century, when the most fashionable artists had drifted northwards to Marylebone, Covent Garden remained artists' favoured pleasure ground, as well as the place to go for engravers, framers, paint-shops and auctioneers. Reynolds, the Royal Academy's president, lived in Leicester Fields until his death in 1792. And everyone who was anyone still gravitated towards

* At one or another point in their lives, William Blake and Bartolozzi lived in Broad Street; Blake again, Paul Sandby, Thomas Malton, and Thomas Rowlandson in Poland Street; Canaletto, 1746–56, at 16 Silver Street (now 41 Beak Street), Soho. Benjamin West, Valentine Green, George Dawe, James Ward, John Raphael Smith, J. T. Smith, J. H. Ramberg, and Thomas Stothard lived in Newman Street, and James Barry's squalid house was round the corner in Castle Street.

Covent Garden for good company. In 1793, the Academician Joseph Farington could tell his diary that 'the meeting of the Academy did not break up till past twelve o'clock, when Hamilton, Smirke, and myself went to the Bedford Coffee House [in the Piazza] where we found Tyler, Rooker, Dance, Lawrence, Westall [all of them Royal Academicians]. We staid till four in the morning.'[11]

<p style="text-align:center">*</p>

To claim that eighteenth-century Covent Garden was the first of the world's bohemias is not to deny the congregations of creative genius of earlier times. In the seventeenth century, for instance, the Dutch Republic had been far richer than contemporary England, both economically and artistically. It has been estimated that in the mid-seventeenth century some 650 to 750 painters in the Netherlands each produced on average ninety-four paintings a year, or 63,000 to 70,000 altogether. Probate inventories show that in Delft in the 1670s the average household represented in those sources owned twenty paintings, and in Amsterdam forty. One weaver in Leiden possessed sixty-four paintings in 1643, and another two weavers in the 1670s owned ninety-six and 103 paintings. Even if many of these works were of low quality, very few commoners in London would match that scale of ownership in the eighteenth or nineteenth centuries.[12]

That said, it's no easier to think of a bohemian Amsterdam than it is to think of a bohemian Florence or Venice. In London, the invigorating effects of size and dynamic population growth and the diffusion of new wealth generated an infinitely greater diversity of creative forms than was apparent in any of those earlier places. Speaking quantitatively, neither the Italian city-states nor Amsterdam had the theatrical, literary and scientific amplitude of London in our period. Their literature and theatre had a weaker purchase, too; and in no culture had satire flourished as it now did in London.

In 1600, London's population was about 187,000 as against Amsterdam's 48,000, Florence's 65,000, Venice's 151,000 and Paris's 245,000. Big though it was, it had arguably been the weakest cultural entity at that date. By 1700, however, London had grown by

194 per cent to 550,000 or so people; Amsterdam increased to 220,000 and Paris to 530,000, while Florence stagnated (68,000) and Venice contracted (144,000).[13] Then, across the eighteenth century, London grew to nearly a million, as against Paris's very modest expansion to 546,000. The sheer scale of London's half-million doubling was probably unprecedented in history. So was London's central role in national life. A steady 10 per cent of the English and Welsh population lived in London across the eighteenth century; only one in forty or fifty French people lived in Paris. Around mid-century, moreover, about one in six of all English men and women either lived or had lived in London. It was this energy and the mercantile, naval and imperial wealth that fuelled it that now gave eighteenth-century London the edge.

The outcome was that Amsterdam, Venice, Florence, the Parisian Left Bank or New York's Greenwich Village never, on such a scale, generated such culturally engaged lifestyles or such opportunities for talent and innovation as Georgian London did in general, and Covent Garden did in particular. Indeed, Covent Garden was the only unrivalled 'bohemia' the English can really boast of, and what it achieved in art, literature and theatre transformed prevailing notions of what these things should be. In the density of its talent, in the louche, boozy and sexy convivialities its creative inhabitants lived by, in the dangerous promises and threats of its back alleys, and in the absence of serious cultural competition from other British cities, Covent Garden's bohemian credentials knock the later bohemian credentials of Chelsea, Hampstead and even Soho sideways, while they make those of the Left Bank, Montmartre, or Greenwich Village look pallid.

*

A powerful tradition of realistic or quasi-realistic representation threads its way through the pictures reproduced in this book, and, as Part II explains, Covent Garden's pressing human, social and sometimes comic realities did most to sustain it. The tradition had its literary equivalents. Poets and dramatists from Dryden, Congreve, Pope and Gay through to Sheridan and Goldsmith also fed off the

town's vitality, as did the world's first 'novelists'. Defoe, Cleland, Richardson, Smollett and Fielding all declared that 'real life' was their subject. Among the artists, the works of Hogarth, Paul Sandby, Scott, Collet and Rowlandson were saturated in local references and responded directly to people and streets. They were joined by increasing numbers of topographical or satirical artists and engravers who were also moved to seize the moment before them, sometimes just for the pleasure of the thing. Louis-Philippe Boitard's watercolour sketch of *Holbein's Gateway and Inigo Jones's Banqueting House, Whitehall* (*c.* 1740) would be unmemorable had he not included the bearded beggar leaning on the railing: we believe that he really did see him (fig. 4). (The Tudor gateway was demolished in 1759.) And though the more fashionable artists found it profitable to woo elite buyers by pretending that they lived in classical Greece or Rome, even their

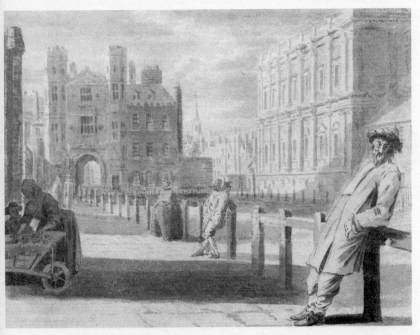

4. Louis-Philippe Boitard, *Holbein's Gateway and Inigo Jones's Banqueting House, Whitehall* (pen, ink, watercolour, *c.* 1740)

images in effect reacted against Covent Garden's loucheness. People who evade or deny the old Adam's vulgar presence and vulgar impulses are still likely to be conscious of them. They merely defend themselves against their contaminations. What sustains the 'civilizing process' if not that systematic negation of what, unpleasantly, *is*?

The snobberies expressed in that weasel word 'taste' were ineradicable in the eighteenth century, so much so that hardly anyone noticed them. The classical tradition offered comforting identifications with an idealized past, and the educated and well-travelled understood it better than the common people. Italian renaissance masters had shared this vision, which is why eighteenth-century taste-makers recommended their emulation in a market that was dominated by privileged or aspirant patrons who knew that cultural consumption was the best way of affirming their standing. The 'high' taste was institutionalized in the formation of the Royal Academy in 1768. Successor to a sequence of informal academies, it differed from them by excluding engravers and similarly 'mechanical' vulgarians, and by organizing itself hierarchically on the model of the French Academy. Joshua Reynolds served as its first president from 1768 to 1792, and he long inveighed against the vulgarity of the 'Dutch' tradition of real-life representation, insisting instead on the moral and aesthetic virtues of 'history painting' – in effect of a myth-peddling and monumentalized classicism.

It would be too much to say that the art world was divided by the dispute between the Academicians and the artists who attended to 'real life'. Few artists who consulted their own interests and had skill enough would detach themselves from the more lucrative tradition, and most of them internalized its justifications too. By the time of his death, Reynolds would have felt that he had won such argument as there had been. All the same, Hogarth's alternate legacy was never obliterated, so that not all art in that era was about nymphs and shepherds in classical landscapes, or about cherubs on clouds, or about the vast history tableaux of which the Academy approved; nor did all its portraits depict only the sanitized high people. Great swathes of imagery were rooted in the here-and-now, and were of the kind that Academicians dismissed as 'low'. For the historian, this is for the better. J. H. Plumb once noted of the portraits commissioned

by the eighteenth-century elites that the world in which their subjects moved

> seems incompatible with violence and aggression, with coarse language and gross manners, with dirt, disease and lust. It is hard to believe that Gainsborough's diaphanous creatures, gliding with such grace in the freshness of the morning, were of an earthiness both in speech and in action that would shock what we like to think of as [our] franker age. Alongside Gainsborough, Reynolds, Zoffany or Stubbs must be placed the savage pictures of Hogarth and the brutal squibs of Rowlandson and Gillray ... The world which they depict is closer to the historical records of Georgian society; far closer than the pictures of the fashionable world.[14]

The artists responsible for this earthier representation were responding to the deepening pockets of people who wanted an imagery that mirrored rather than moralized about their lives and surroundings. Their loyalty to the *actual* explains the increase in informative or humorous imagery and the deepening pleasure in the real and the secular over the mythic and heroic. The burgeoning of scientific and topographical illustration was one expression of this, and of genre art works and satirical and humorous prints another. In all these cases, in drawings, paintings and engravings, the artists in question depicted unnamed individuals engaged in common and sometimes reprehensible pursuits. Not all of their works were distinguished and some were awful – but in whatever form, 'real life' was the subject. They represented what may be called a *people's* art that stood apart from the sanitized art of the high people.

The relationship between images and reality is unreliable. Artists' techniques, assumptions and purposes, viewers' projections and misinterpretations, and the distances of time, all guarantee that images have to be read knowingly. Even so, it's as silly to dismiss what pictures can tell us about past lives as it is to trust them mindlessly. Anything one can say against the reliability of visual evidence one can just as well say against the reliability of texts. It helps that in pre-photographic and image-hungry eras many images were designed to inform about rather than to reimagine or idealize the world. William Hogarth once wrote that 'ocular demonstration will carry more con-

viction to the mind of a sensible man, than all he would find in a thousand volumes.'[15] Despite its difficulties, this thought informs the book that follows.

As is usually the way with panoramic surveys, this is not a book to turn to for a one-directional narrative. The Royal Academy's foundation and strengthening control of the art world is only a subsidiary theme here, just as 'Academic art' and its portrait tradition feature only as a foil to the art of the 'real'. Since the book focuses on artists, much else is omitted – the history of literary and theatrical feuds particularly. A full history would need to be many times the length of this one.

Even so, Covent Garden reveals its own history of change in what follows, as it evolved from an aristocratic and genteel enclave in the seventeenth century into the raucous district it became in the eighteenth. The growth of the market, the swelling presence of poor people, and their eruption in the lootings and burnings of the 1780 Gordon Riots, all hastened an end (or one end) to the story. This last disaster drove ever more artists and writers towards Marylebone and Fitzrovia or to what were then London's outer villages – so that by the 1790s Covent Garden's creative dynamism was all but scattered and spent. By the time the boy Charles Dickens walked bleakly from his humiliating labours in the blacking factory in Chandos Street to gaze and wonder at the pineapples in the market, Covent Garden's great days were over.

PART I

Covent Garden

I

A Sense of Place

Here's bullies, gamblers, bawds, and whores,
Who daily do ensnare men;
Thief-takers, vintners, pimps by scores,
With Welsh and Irish chairmen.

And trav'lers who the world go through,
Have given attestation;
So strange a place, you cannot trace
In any other nation.

> 'The Humours of Covent Garden' –
> G. A. Stevens, *The Choice Spirit's Chaplet* (1771)

The *Bird Eye View of Covent Garden Market* in fig. 5 overleaf confronts us with Covent Garden's vitality at the end of our period. Published by Ackermann of the Strand in 1811, the buildings by August Charles Pugin and the figures by Thomas Rowlandson, it shows how the market's sheds, stalls and shacks have by now taken over the whole of the Piazza; and Inigo Jones's original architecture is already being degraded at the James Street corner on the right. The market is full of women shopping, bartering and selling, of vendors and hustlers, and of horses, donkeys, carts and baskets. Pugin was a conscientious architectural draughtsman who got his perspectives and buildings right, so details are sharply observed, from St Paul's church at the centre down to the recently bow-windowed shops of Tavistock Row on the left. Trust – though not enjoyment – weakens with Rowlandson's contribution. No other artist could capture the bustle of street

3

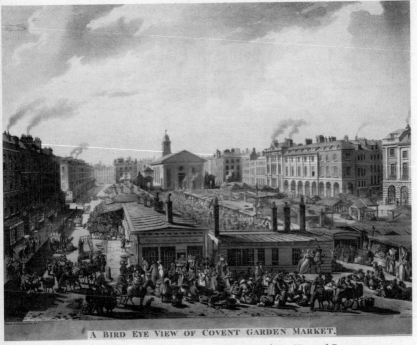

5. Rowlandson and Augustus Charles Pugin, *A Bird Eye View of Covent Garden Market* (detail) (etching, aquatint, 1811)

life as he does; but he could be indifferent to its real dispositions, and many of his figures come from stock. Still, what results is an image of infinite zest and plausible disorder, a sense of the place's crowded humanity.

The mix of rich people, poor people and creative people in and around eighteenth-century Covent Garden made it an uncomfortable territory, however. The timid believed with some reason that thieves and prostitutes lurked round every corner, while in their turn the thieves and prostitutes were upset by the constables and press-gangs who periodically swept through the Piazza in search of loose men and women or cannon-fodder for the navy or army. And crowd violence had always been possible. In 1710 High Church supporters of the Tory Anglican Dr Sacheverell smashed up Presbyterian meeting-

4

houses in Lincoln's Inn Fields and Bow Street and burned their contents in the street. Sailors destroyed bawdy houses in the Strand in 1749. Butchers, sedan chairmen and market people rampaged in the Piazza at election times. And theatre audiences at Drury Lane and Covent Garden turned violent whenever prices rose or performances were disliked. In November 1760 one of the greatest theatrical riots in London history broke out in Drury Lane simply because its manager, Garrick, had hired Swiss dancers and a French troupe who were assumed to be Catholic. There were free fights on the stage, the auditorium was ruined, and the windows of Garrick's house in Southampton Street were broken.[1] Worst of all, in one week of 1780 anti-papist rioters sacked and burned houses in Leicester Fields, St Martin's Street, Bow Street, Great Queen Street and Clare Market, and destroyed Newgate prison a mile away.

Still, like writers and theatre folk, artists found that because of the neighbourhood's dangers, rather than despite them, there was in Covent Garden 'too much of the *outré*, too much of oddity and humour ... in every square, street, alley, and lane' for anyone to be bored.[2] With its central 'Piazza' laid out in the 1630s and ringed on its northern and eastern sides by porticoed terraced housing, Covent Garden had originally been aristocratic and grand. But a century later its theatres, coffee-houses and bordellos made it indispensable to men who thrived on sensation. All was 'life and joy', James Boswell wrote when he first came to London in 1763, anticipating cheerful sexual conquest there. 'What a picture of *life* was there! It was *all life*!' – the caricaturist George Cruikshank erupted later.[3] Covent Garden and the Strand, Charles Dickens wrote of his younger days, 'perfectly entranced him with pleasure'.[4] Later, in *Little Dorrit*, he described Covent Garden as a complex of *ideas*, which is also how it will soon strike us:

courtly ideas of Covent Garden, as a place with famous coffee-houses, where gentlemen wearing gold-laced coats and swords had quarrelled and fought duels; costly ideas of Covent Garden, as a place where there were flowers in winter at guineas a-piece, pine-apples at guineas a pound, and peas at guineas a pint; picturesque ideas of Covent Garden, as a place where there was a mighty theatre, showing wonderful and

beautiful sights to richly-dressed ladies and gentlemen, and which was for ever far beyond the reach of poor Fanny or poor uncle; desolate ideas of Covent Garden, as having all those arches in it, where the miserable children in rags among whom she had just now passed, like young rats, slunk and hid, fed on offal, huddled together for warmth, and were hunted about . . .; teeming ideas of Covent Garden, as a place of past and present mystery, romance, abundance, want, beauty, ugliness, fair country gardens, and foul street-gutters, all confused together.

COVENT GARDEN NOW

Today the best way to engage with Covent Garden's past is to walk its streets. You can still recognize the footprint of the Bedford family's estate and of the streets and alleys that encircled it, even though only patches of the original architecture have survived fires, demolitions and modernizations. In the nineteenth century Trafalgar Square, Charing Cross Road, Garrick Street, William IV Street and Shaftesbury Avenue were pushed through the tighter labyrinths, and a little further afield the Aldwych and Kingsway completed the job in the early twentieth century. But you can still cross the district's core in ten minutes. It's a half-mile walk from Seven Dials in St Giles's down St Martin's Lane to Charing Cross. It's half a mile, too, both from Hogarth's house in Leicester Fields to Drury Lane, and from Joshua Reynolds's Leicester Fields home to Somerset House in the Strand, where Reynolds presided over the Royal Academy. It's seven-tenths of a mile to the Piazza from Poland Street on the western edge of Soho, where William Blake and Thomas Rowlandson lived in the 1780s.

What remains of the Piazza is now a charmless tourist trap with no pre-Victorian architecture left in it whatsoever. Even Inigo Jones's St Paul's church was repeatedly tinkered with and then rebuilt after plumbers set it on fire in 1795. The church has been altered since, though its access passages and churchyard replicate those of the seventeenth century. Inigo Jones's porticoed houses were altered too. In 1716–17 their four north-western bays were replaced by the baroque frontage of 43 King Street. (This still stands; in the 1960s it concealed an underground carpark.)[5] The arcaded houses to the south of Russell

Street (the so-called Little Piazza), were destroyed by fire in 1769 and rebuilt without arcades. A Doric pillar bearing a four-faced sundial topped by a gilded sphere, erected in the square in 1668-9, was removed in 1790, displacing the women who had long sat on its steps selling hot rice milk and barley broth. Later some of Jones's stone pilasters and red-brick frontages were stuccoed over and white-washed. Then came the demolitions in the nineteenth century and after. In 1830, the old market sheds in the Piazza's centre, with their 'careless picturesque look, as if a bit of an old suburban garden had survived from ancient times',[6] were replaced by the neo-classical building that stands there now. In 1858 the four portico bays at the east end of the north side of the Great Piazza were replaced by the market's Floral Hall, and ten years later the remainder of this range was rebuilt as a hotel. In 1974 the fruit, vegetable and flower markets were removed after three and a quarter centuries of trading, and only public outcry saved the site from wholesale demolition. In 1980 the central buildings reopened as the brash emporium it is today. What was left of the north-eastern range was then obliterated by the recon-struction of the Royal Opera House in the 1990s. Not a single building remains of the original development. Only the pastiche of Bedford Chambers, built in the 1870s, pays the very faintest tribute to Inigo Jones's porticos.

Much has changed locally, too. Drury Lane's once labyrinthine back alleys and courtyards, the so-called 'Hundreds of Drury', thick with poor people, thieves, harlots, and actors and actresses down on their luck, have been rebuilt and sanitized. The Strand itself is now unrecognizably wider and busier than the bottlenecked lane that had been the smartest shopping street in eighteenth-century London. At that time had you walked a few hundred yards south of the Strand you would have sloshed into the mud of the Thames, since the mod-ern Embankment didn't exist then. Newspapers often reported people who sank in the mud to their doom.

All the same, you'll find the actor-manager Garrick's house still standing in Southampton Street, and Thomas Davis's bookshop in Russell Street, now a coffee-bar, where Dr Johnson and James Boswell first met in 1763. Queen Anne and Georgian houses survive in Russell Street, King Street, and Southampton Street, though most are now

covered in time-effacing stucco. And you'd obviously see the two great theatres of Drury Lane and Covent Garden. Drury Lane was founded in 1663 and has since been rebuilt four times; Covent Garden opened in 1732 as a more modest playhouse. In both venues the common audiences as well as the high people once used to contemplate each other in mutual distaste, the first from the pit, riotous and opinionated, the second from the boxes, aloofly gossiping behind fans.

You could further imagine streets full of sedan-chairs, carts, carriages and horses, the clatter increased by the harsh accents of underwashed people, by market women straw-hatted and in the capacious skirts of those days, and by grimy children shouting. If you were sententiously inclined, you might recall the historian G. M. Trevelyan's unembarrassed reminder about the now lost past – that 'on this earth, on this familiar spot of ground, walked other men and women, as actual as we are today, thinking their own thoughts, swayed by their own passions, but now all gone, one generation vanishing into another, gone as utterly as we ourselves shall shortly be gone, like ghosts at cockcrow'[7] – real people, in other words, who underneath their odd clothes were as fleshy, lustful, anxious or happy as we are (though probably more agued and crippled), pursuing their businesses, pleasures and crimes at the very street corners upon which we stand now. We might, if fancifully gifted, sense their presence there, or, as some would say, their auras.

COVENT GARDEN THEN

'Covent Garden' originally referred to the gardens and pastures that had served medieval Westminster Abbey. They had extended from the Strand northwards to Long Acre and from St Martin's Lane eastwards to Drury Lane. 'Covent' was Anglo-French for 'convent' or monastery: that was the word Chaucer used. The latinized 'convent' was introduced in English *c.* 1550, and within a century it had superseded the early word, except in reference to Covent Garden. This always caused confusion. Samuel Pepys in the 1660s referred to 'Common Garden', and local people still called it that well into the nineteenth century.[8]

After the dissolution of the monasteries, the estate passed to the

Duke of Somerset; but Somerset's head was chopped off in 1552, so the estate was picked up by the aristocratic Bedford family, to their enduring profit. On the Strand they built their huge timber-and-plaster mansion, Bedford House, and pushed its gardens back into the pasture behind. By the beginning of the seventeenth century an aristocratic and gentry overspill from this and other Strand mansions was leaking up rural Drury Lane. The Spanish ambassador Gondomar used Drury Lane to travel to court from Ely House in rural Holborn. His anal piles made for an uncomfortable journey:

> The ladies as he went, knowing his times, would not be wanting to appear in their balconies or windows to present him their civilities, and he would watch for it; and as he was carried in his litter or bottomless chair (the easiest seat for his fistula), he would strain himself as much as an old man could to the humblest posture of respect.[9]

By 1630 'thatched Houses, Stables, and such like' had been built around the estate's fringes, but the central twenty acres remained as pasture. It was here that the fourth Earl of Bedford and Inigo Jones proceeded to build on an Italianate model for 'people of quality' in 1631. Every square built subsequently in London was built with its success in mind, including London's largest square, Lincoln's Inn Fields, in the 1640s, though its planning lacked Inigo Jones's efforts at uniformity.[10]

For an overview of this territory in its early days we can't do better than look at a bird's-eye plan made in the 1660s by the Czech-born cartographer Wenceslaus Hollar. Hollar was planning a complete map of London, and since many of his potential subscribers lived in the newly built central 'town', he advertised it by engraving this unfinished sample plate to cover the area from St Martin's Lane across the Piazza to Lincoln's Inn Fields, and from Holborn in the north down to the Strand and the Thames. Reproduced here is the central section of the sole surviving impression from that plate (held by the British Museum) (fig. 6). In the event the Great Fire put paid to his ambition to map the whole of London in this way.

Hollar's bird's-eye view is a spectacularly informative work of art. The houses are standardized and their elevations exaggerated, but the surveying accurately reveals tantalizing gateways, courtyards and

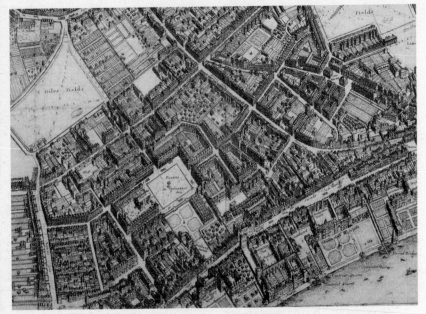

6. Wenceslaus Hollar, *Bird's-Eye Plan of the West Central District of London* (etching, 1660–66)

gardens which invite our entry; it shows how the 'bow' of Bow Street to the east of the Piazza was at that point closed off from Long Acre; and the longer curve of Drury Lane bisects the whole. You can see St Giles's Fields upon which the streets converging on Seven Dials were built later, and the Strand's unregulated narrowings and widenings, as well as its aristocratic Tudor palaces, soon mostly to be demolished. There, too, are the enormous gardens of Bedford House stretching up to the Piazza's southern edge, and Somerset House on the Strand at the bottom-right. There are the cramped courtyards between St Martin's Lane and Bedfordbury to the west of the Piazza, and off Drury Lane to the east. Under big magnification one might just make out one of the Piazza's innovations, the balconies on a couple of houses on its north side.[11] Several of these 'purgulas' were being built in the more fashionable streets, causing sensation enough to invite this bawdy interchange in Thomas Nabbes's play *Covent Garden* (1633–8):

ARTLOVE: Mistress Tongall, you are delighting yourselfe with these new erections.

TONGALL: Faire erections are pleasing things.

ARTLOVE: Indeed they are faire ones, and their uniformity addes much to their beauty.

TONGALL: How like you the Balconee's? They set off a Ladyes person well, when she presents herselfe to the view of gazing passengers. Artificiall sucations [cosmetics] are not discerned at a distance.

The map also shows how the Piazza of the 1630s was enclosed in the north and east by three uniform terraces of houses and in the west by Jones's church of St Paul's. As London's chronicler John Strype put it in 1720, the Piazza was built 'for the dwelling of Persons of Repute and Quality, their Fronts standing on Pillars and Arches of Brick and Stone Rustick Work, with Piazzas, or Walks, like those in the Royal Exchange in London, and imitating the Rialto in Venice'. It was, he added, 'the only View, in Imitation of the Italians, we have in or about London'.[12] In the event the Piazza was never completed. Only seventeen porticoed houses were erected on its northern and eastern ranges. The equivalent Parisian piazzas, the Place Royale of 1605–12 (now Place des Vosges), 'a fair quadrangle of stately palaces, arched underneath', as John Evelyn described it in 1644,[13] and the Palais Royal of 1639, were by comparison harmonious and complete. The range to the north in Covent Garden came to be called the 'Great' Piazza, while the eastern range south of Russell Street (with smaller gardens) was called the 'Little' Piazza.

The porticoed houses first filled with aristocrats, gentry and rich merchant families, many of them driven from the City by the Fire of 1666. What they bought into was commodious and stylish. Each arcaded house had a basement below the portico walk and four main storeys above it. Each back garden had a water-pump and two 'houses of office', one for the servants. These were connected to a sewer that, to the vexation of Strand inhabitants, ran downhill to the Strand and across it into the Thames (perhaps via Dirty Lane). By 1720 Strype described the Piazza's centre as 'well gravelled for the Accommodation of the People to walk there, and so raised with an easy Ascent to the Middle, that the Rain soon draineth off, and the gravelly Bottom

becomes dry, fit to walk on'. The walkways under the porticoes were twenty-one feet wide, paved in freestone, and finely proportioned and stately. To the south the Piazza was closed off by the back garden wall of Bedford House, until that was demolished and the whole garden site developed in 1705.

On the face of it, all was well regulated. The parish's 'fine, streight, and broad Streets' and 'good Buildings, so well inhabited', wrote Strype, together with its 'scarce admitting of any Poor, not being pestered with mean Courts and Alleys', made it 'one of the best Parishes in the Cities of London and Westminster'. Daniel Defoe said much the same a few years later: the Covent Garden shops 'intercepted the Quality so much, the Streets also being large and commodious for Coaches, that the Court came no more into the City to buy Clothes', he reported. Bedford Street, King Street and Henrietta Street as well as the Piazza were filled with 'eminent Tradesmen, as Mercers, Lacemen, Drapers, &c.'. Ladies of note came in their carriages to spend afternoons 'going from one mercer's shop to another, to look upon their fine silks, and to rattle and banter the journeymen and shopkeepers, and have not so much as the least occasion, much less intention, to buy anything'.[14] The gentlemen, meanwhile, were capable of vacuous self-display. Henry Fielding described one in *Joseph Andrews* (1742):

'In the morning I arose, took my great stick, and walked out in my green frock, with my hair in papers (a groan from Adams), and sauntered about till ten. Went to the auction; told Lady – she had a dirty face; laughed heartily at something Captain – said, I can't remember what, for I did not very well hear it; whispered Lord – ; bowed to the Duke of – ; and was going to bid for a snuff-box, but did not, for fear I should have had it. From 2 to 4, drest myself. A groan. 4 to 6, dined. A groan. 6 to 8, coffee-house. 8 to 9, Drury-lane playhouse. 9 to 10, Lincoln's Inn Fields. 10 to 12, Drawing-room. A great groan. At all which places nothing happened worth remark.' At which Adams said, with some vehemence, 'Sir, this is below the life of an animal, hardly above vegetation.'

None of these accounts, however, mentioned that the Piazza's tone was even then being lowered by the noise and dirt of the expanding

market, and by the impact of theatre, bagnios and brothels. Just out-side the parish, poor courts and alleys encircled the estate like a necklace, providing it with its miserably paid labour and its pickpock-ets and whores. The 'Quality' were already beginning their long retreat to the developing West End.

PAINTING THE PIAZZA

What do artists tell us about Covent Garden's Piazza in its heyday? Oddly, Inigo Jones's architectural wonder of the 1630s received little attention from seventeenth-century artists: the market for topographical views expanded only at the beginning of the next century. Nor was it English artists who catered to that taste. The first paintings to depict the Piazza were by Low Countries immigrants well trained in depicting incident-filled landscape. The Amsterdam-born Jan Griffier the Elder (c. 1645–1718) produced the first of them in the 1710s or early 1720s. A moody and lowering painting of inexact perspective, its conversing people, children and prancing dogs come straight out of a Netherlandish townscape of the previous century. **Plate 3** shows a detail. It was followed in the 1720s by works by the Flemish Pieter Angellis and Joseph van Aken and c. 1737 by one from the virtually unknown, allegedly Spanish-born, Balthasar Nebot. Angellis's painting (detail fig. 7) reflects something of Antoine Watteau's rococo delicacy: the Frenchman had lately visited London and was known to Angellis in the artists' Rose and Crown Club.[15] It pivots on the elegant gentleman and ladies at the centre. The figure arrangement is uncomfortably elongated, and one group's actions (outside this detail) are unclear. Yet it takes pleasure in the market's humanity – in the pancake-seller with her brazier and the drunken or idle husband asleep behind her, in the boy and girl buying from her, in the bustle of market-women, and in the trader showing off by balancing vegetable baskets on his head (a bravura display that one could witness in the market all the way down to the 1960s).

For a painting of the Piazza by an Englishman we have to wait until the mid-1750s for Samuel Scott's (**plate 4**). Scott lived first in the Piazza and then in Henrietta Street between 1718 and 1758. Here he

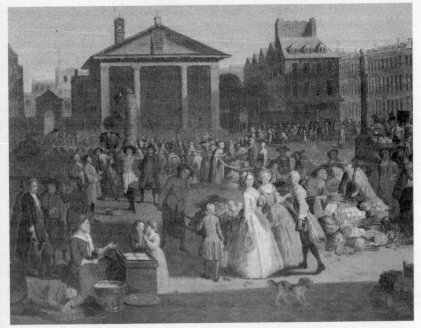

7. Pieter Angellis, *Covent Garden* (detail) (oil on copper, *c.* 1726)

paints the view from his first-floor studio in the Piazza.[16] This picture strives for the compositional breadth and realism that he was currently learning from Canaletto. While the earlier paintings showed a fairly well-contained market with a modest line or two of sheds, this one shows how the market had spread over the whole Piazza and become uncommonly busy. The shadows suggest that it is a morning view, and the stress is less on the buildings than on the life between them. With its stalls and sheds on the southern side, its milling traders, horses and wagons, and its accurate shadowing, Scott's painting is the first to invite full trust in the artist's observation. In that locality, where everyone knew everyone else, a painting of this kind was almost certainly seen by other interested artists, not least because again Scott painted more than one version.[17] So it probably set the model for John Collet's careful vista a dozen or so years later (fig. 1, Introduction) as well as for

Rowlandson's and Pugin's later *A Bird Eye View of Covent Garden Market* (fig. 5).

The final example is a finely understated watercolour drawing by the brothers Thomas and Paul Sandby from about 1770, in which Paul did the figures and Thomas the architecture (**plate 1**). Thomas, the elder, had just become professor of architecture at the newly formed Royal Academy. His drawings were always precisely proportioned, shadowed and detailed. Both brothers' experience as military topographers in Scotland had trained them in perspective. Here they rejected the bird's-eye vista and focused on the particular instead. The panoramic view is large (520 by 675 millimetres), and it's in grey ink washed with now faded watercolour. It looks eastwards from under the Piazza's northern arcade. The effect, to modern taste, is virtually photographic. The arcade is populated by a couple of well-dressed women and children, some conversing men and a prancing dog. Outside the arcade, a market man walks away carrying hat-boxes on a staff (one is triangular, for a man's tricorn hat), and there are market women in the distance. The drawing conveys an unexpected stillness and quietness. The fall of the sun shows that it was drawn on a sunny mid-afternoon when the market had wound down after the morning's trading. The springtime sun reflects brightly off the Piazza's eastern façade, and the mothers and children seek shade. The sedan chairs wait unused in a frozen moment that anticipates their night-time business. (When Garrick was acting, the chairs queued round the Piazza, down Southampton Street and along Maiden Lane.)[18] There's a credible reminder here that the Piazza wasn't permanently awash with prostitutes, as some imagine. It shows, too, that London's streets and spaces were often uncrowded.

These several images take us as near as we'll get to a sense of what Georgian Covent Garden looked like at different times of day and at dates nearly a century apart. Despite their distortions it would be a witless historian who ignored their evidence. Their producers were indifferent to the classicized fantasies of polite or academic art. Instead, they testified to a deepening fascination with the city around them, and committed themselves to the celebration of Londoners' energy and zest for life.

'THE TOWN'

Covent Garden's distinction had been affirmed in 1645 when the small parish of St Paul's, Covent Garden, was carved out of the heart of the much larger and henceforth encircling parish of St Martin-in-the-Fields. St Paul's was always lightly inhabited, relatively. At the first national census of 1801, the parish had just under 5,000 people (61 per cent of them female) in 620 houses. St Martin-in-the-Fields, by contrast, extending northwards from Whitehall via Charing Cross and the Haymarket and eastwards along the Strand to the Savoy, had five times as many people in 2,803 houses; it made up 17 per cent of Westminster's population as against St Paul's 3 per cent.

If we could return to those spaces before their sundry demolitions and improvements, we'd recognize their footprints and some of their landmarks, but they would otherwise seem as distant and otherly as the streets of Shakespeare's London a couple of centuries earlier. Although they stank and were muddy, they were made for human convenience, and were highly walkable and by later standards traffic-free. London's size alarmed contemporaries, but we'd find it intimate. From Hampstead Heath you could see the whole metropolis at one viewing, smoke and fog permitting. Building heights were low. Only churches stood out, far more than they do now, along with the huge bulk of Drury Lane theatre after it was rebuilt in 1794: until it burned down in 1809 it was among the largest buildings in London. Some manoeuvring for sight-lines would let you see fair distances. An octogenarian in 1825 claimed that, when he was a boy, a man with a telescope on the slight elevation of Leicester Fields charged a half-penny for a view of the desiccated Jacobite heads that were impaled over Temple Bar before they were blown down in 1772. Temple Bar, which divided the Strand and Fleet Street, is only three-quarters of a mile from Leicester Square as the crow flies. In such a town it was no hardship for people to walk a mile or two to do business with each other. Neighbours, employers and fellow workers were accessible and known.

The Strand has much to tell us. It was hardly 'bohemian' territory, but artists lived here and important printshops were located here. It

has timelessly linked the Cities of London and Westminster, and used to be the spinal route which once organized most understandings of London's topography. Running east to west only two blocks south of the Piazza, it is part of the ancient riverside ('strand'-side) highway that follows the course of the Roman Akeman Street from Cornhill and Cheapside, down Ludgate Hill into Fleet Street and the Strand, before swinging south at Charing Cross down Whitehall to Westminster and eventually Chiswick. It served as a processional route for royal, public and civic masques and displays, whose symbolic and carnivalesque forms were ancient. It was along the Strand that a mocking procession was organized in 1680 to execrate Catholics after the Popish Plot; and along the Strand, too, the ending of the War of the Spanish Succession was celebrated in 1713 when 4,000 charity children sat in tiers of benches to sing hymns as both Houses of Parliament processed past them to give thanks in St Paul's Cathedral.[19]

The last procession along the Strand on this scale occurred in 1742. It parodied the mumbo-jumbo of the 'Free and Accepted Masons' on the day of their annual feast. In a carnivalesque parade of mock-freemasons, carts were drawn by donkeys, and men on donkeys blew cowhorns and banged drums – all to comment on a now forgotten masonic feud. This was virtually the last remnant of mocking public spectacles and massed 'rough music' in the capital. Its ambition is commemorated in one of the largest of all eighteenth-century topographical engravings: *A Geometrical View of the Grand Procession of Scald Miserable Masons, designed as they were drawn up over against Somerset-House, in the Strand on the 27th of April, 1742* (fig. 8). This was made and sold by the French-born Antoine Benoist from 'his Lodgings at Mr Jordan's a Grocer ye North East Corner of Compton Street So-ho'. In two joined sections, it presents a panorama which measures 47 inches wide by 9 inches high (1,195 by 231 mm). That Benoist produced this while lodging with a grocer says much about conditions of production.[20]

There is a courtly French datedness in its draughtsmanship. The street is unrealistically wide, and the onlookers are stylized and well clothed. Yet its depiction of the procession makes an impressive statement about one of London's public rituals, and also about the architecture on the Strand's southern side. The old Somerset House,

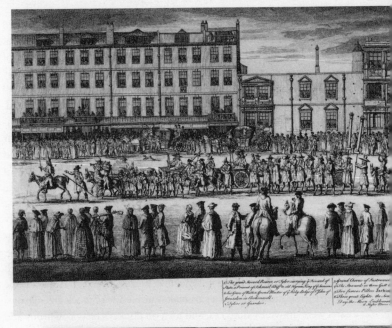

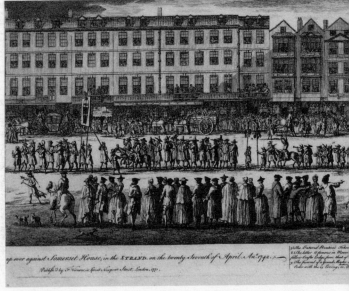

8. Antoine Benoist, *A Geometrical View of the Grand Procession of the Scald Miserable Masons, designed as they were drawn up over against Somerset-House, in the Strand on the 27th of April,* 1742 (etching, 1742)

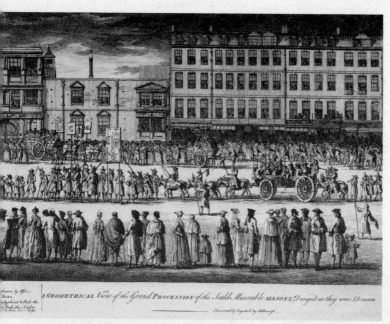

drawn by Officer.

Beau.

isphabited to Ride the

Rode the Night

I Rode his Deputy

A GEOMETRICAL *View of the Grand* PROCESSION *of the Scald Miserable* MASONS, *Design'd as they were Drawn*

Invented & Engrav'd by A. Benoist.

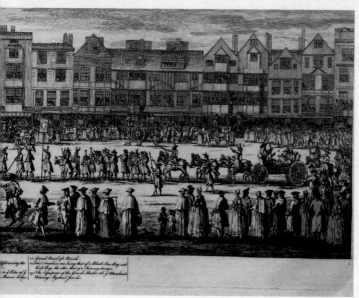

ifferencing the

11. *Grand Band of Musick.*

12. *Two Chaplains one being that of a Black Stov-Bay, and

Each Boy, the other that of a Chimney-Sweeper.*

13. *The Equipage of the Grand Master all of Attendance

Wearing Mystical Jewels.*

England's first renaissance palace, is accurately shown in the middle of the first sheet. Built in 1547–50 for Lord Protector Somerset, it was finished two years before his head came off. After a complex royal history, it was demolished in 1775 and replaced by Sir William Chambers's Somerset House, which, with additions, still stands. As striking as the palace in the print are the new and uniform Georgian houses that are creeping eastwards from Temple Bar (to the left, outside the plate), until they are abruptly checked by the uneven plaster-and-lathe Tudor and seventeenth-century buildings shown in the second plate.

Behind the façades shown here lay dangerous warrens of poor alleys and yards that led to the Thames. In *Industry and Idleness* Hogarth set Tom Idle's capture in the aptly named Blood Bowl, one of the drinking dens there. But by the 1770s there were also fine developments such as the Adelphi, which the Adam brothers designed

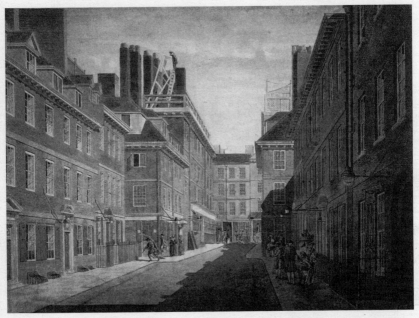

9. Thomas and Paul Sandby, *View of Beaufort Buildings* (pen, ink, watercolour, c. 1765)

in neo-classical style to pull in wealthy tenants, bits of which survive: Thomas Rowlandson was to live there. There, too, stood Beaufort Buildings, built between the Strand and the river in the 1680s, full of 'very fair and good houses . . . , well inhabited, generally by Gentry'.[21] Here the novelist Tobias Smollett lived in the 1750s while practising as a surgeon and writing *Peregrine Pickle*; and William Shipley ran his drawing school, attended by Richard Cosway, John Hamilton Mortimer and Joseph Nollekens among others. The Sandby brothers made a meticulous watercolour drawing of the Buildings looking north to the Strand (fig. 9). It shows on the roof an observatory built by the scientific instrument-maker Jonathan Sissons, who kept shop on the Strand corner. Ackermann briefly ran his printshop on the opposite corner in 1795–6. In the drawing a woman sells vegetables from her baskets and a chair-mender carries his rushes and a chair – figures lifted from Paul Sandby's *Cries of London*. That there was a pavement at all indicated the street's status.

TRAFFIC

Nearly all streets then were ill paved or unpaved; until the 1760s maintaining their condition was left to householders. Strype in 1720 saw it as a rare distinction that St Martin's Lane had 'a fine freestone pavement, secured from carts and coaches by handsome posts set up', and tradesmen there advertised their location 'on the paved stones' as a mark of their distinction.[22] Westminster and the City set about paving their main thoroughfares only in the 1760s. A decade later, the French visitor P. J. Grosley reported that freestone paving had been laid along Parliament Street to Charing Cross and down part of Pall Mall, and that a start had been made on the Strand. Even so, the surfaces still meant that the richest coaches were no more comfortable than carts. 'The streets some time ago were paved with stones, / Which, aided by a hackney coach, half broke your bones.'[23]

Freestone paving was one of London's scarcest and dearest commodities because it had to be brought from the kingdom's extremities. Since the setts were cut square without tail or foot, they could easily become unstable and throw up the rich soups of horse

dung, urine and mud trapped beneath them. Even where paving had been completed, there were muddiness and splashy swills that had to be carefully negotiated. Along the Strand raised causeways were laid at intervals to allow people to cross the street without becoming filthy. In bad weather big streets were so 'foul with a dirty puddle to the height of three or four inches' that shopfronts and coaches were caked with muck. Coach windows had to be closed to keep passengers clean, and apprentices washed down the façades of their masters' premises every morning. But there was improvement. By the 1780s, a German visitor could claim that London streets were cleaner, better paved and better lit than those of Paris – and safer.[24]

There were bottlenecks everywhere. Access to the Piazza from the Strand was choked by narrowings at Half Moon Street and South-ampton Street. Chandos Street and New Street entered the estate just as narrowly from St Martin's Lane. Bow Street was a residential cul-de-sac until it was opened to Long Acre in 1793. The Haymarket was blocked by haycarts three days a week, because it was indeed a hay-market. If you entered the Strand from the east, you would have to negotiate three narrowings: at Temple Bar, between the churches of St Clement Dane's and St Mary-le-Strand, and at Exeter Change. Until it was demolished in 1829 Exeter Change narrowed the street to the breadth of a country lane.

If conversely you entered the Strand from Charing Cross to the west, you'd find access narrowed by the looming façade of Northumberland House. Along with Somerset House, this was the last of the Strand's dozen or so great aristocratic palaces. In 1748 the seventh Duke of Somerset inherited it in a shoddy condition. 'We have a vast old house in London not only to furnish from top to bottom,' his Duchess wrote, 'but to lay new Floors, put up new Ceilings, Chimney-pieces, Sashes and Doors, for everything is gone into ruin.' Somerset also paid £30,000 to replace nine houses on the northern Strand with stables, the Strand 'there to be widened'.[25] Yet the widening he achieved was minimal. When in 1752 the first Duke of Northumberland (Somerset's successor) employed Canaletto to paint the mansion's remodelled façade, his pic-ture showed how meanly the Strand's narrowing still contrasted with Charing Cross's spaciousness (**plate 2**). Le Sueur's equestrian statue of Charles I (1633) to this day stands where it was in Canaletto's day, at

the top of Whitehall. On the painting's left stands the Golden Cross Inn (where David Copperfield stayed). It was demolished in 1830 when John Nash's Improvement Scheme cleared the north-western Strand up to St Martin-in-the-Fields to prepare for what became Trafalgar Square. The mansion itself was demolished to make way for Northumberland Avenue in 1874. Until then, it was the greatest Jacobean mansion in London. Its courtyards and gardens extended hundreds of yards towards the river, though you had to enter its gateway to see how it could accommodate what Defoe said was 'a retinue of One hundred in Family'.[26]

Canaletto lived in Soho between 1746 and 1756. He had come from Venice to add fine riverscapes and cityscapes of London to the vast stock of his Venetian views that were already imported into England. Just as his Thames panoramas created a fashion which Samuel Scott and his pupil William Marlow particularly exploited, so his *Northumberland House* set a new standard for urban topographical painting.[27] It shows the house in the morning sun. The new sash windows are in place, and the proud Percy Lion has lately been placed on the central plinth at the top, its tail sticking out behind it. Six feet high, eleven-and-a-half feet long, and cast in lead, the Lion became one of the sights of London, though he now lives out his retirement at Syon House in Isleworth.

How little traffic Canaletto gives his Charing Cross, however! Charles I in the middle of it causes not the least problem, and there are discarded planks, cart wheels and barrels in the roadway, and a market-woman or two and a child, and people talking or walking, and one of Canaletto's little dogs. Only two coaches stand outside the Golden Cross inn to the left, while another disappears into the Strand. There is a pedestrian pavement behind the bollards in the foreground; the road is awaiting its freestone. You'd hardly realize that this was the antique junction from which Whitehall forked south to Westminster and Cockburn Street forked westward to Piccadilly, or upon which St Martin's Lane and the Haymarket debouched from the north. There's no evidence that this is the place at which what Dr Johnson called the 'full tide of human existence' passed by.

But the observation was accurate, all the same. A few decades later, Francis Place the tailor looked from his window across Charing Cross

10. William Marlow, *Whitehall looking Northeast* (oil, *c.* 1775)

and down Whitehall at eleven o'clock one morning, and carefully counted 102 horses and thirty-seven carriages, including five stage coaches each with four horses, a turnip wagon with six horses, and a cart bearing a block of stone pulled by seven horses. That sounds a lot until one realizes that most of those horses plodded along at walking pace, and only two stage-coaches were 'running' when Place looked out, and this down a Whitehall vista some half-mile long and thirty yards wide, with Charing Cross added to it.[28] In about 1775 William Marlow painted a Canalettesque view of *Whitehall* (fig. 10), looking north-east beyond the Horse Guards on the left and Inigo Jones's Banqueting House on the right, with the spire of St Martin-in-the-Fields in the distance (Whitehall's paving, incidentally, only then being laid). Its emptiness matched the emptiness of Charing Cross. Likewise, in the topographical artist Thomas Hosmer Shepherd's drawings of *St Mary*

11. Thomas Hosmer Shepherd, *View of Somerset House* (etching, 1819)

le Strand and Somerset House (1810, etched 1819), the broadened roadway outside Somerset House is occupied by two carriages and a stage-coach, a group of cavalrymen, some relaxed pedestrians, and a boy and his dog herding *sheep* in the street (fig. 11). His brother George Shepherd in 1815 showed the Strand where it narrowed at Exeter Exchange. This was just as relaxed: three dogs socialize in the street, the people are pedestrians, a cab waits idly (fig. 12).

London was getting noisier, however. When in 1552 Protector Somerset's death sentence was announced in Westminster Hall, people there 'made such a shryke and castinge up of caps, that it was heard into the Long Acre beyonde Charinge Crosse' – a mile away. It would have been unthinkable for sound to carry this far a couple of centuries later.[29] In the eighteenth century you could hear London from a distance as you approached it, 'as if all the noises of all the wheels of all the carriages in creation were mingled and ground together in one

12. George Shepherd, *Exeter Change, Strand* (etching, watercolour, 1815)

subdued, hoarse, moaning hum'.[30] The traffic was light by our standards, but iron-shod wheels trundling over cobbles would irritate or deafen you, and the clatter of hooves was incessant.

Then there were the street cries. Nothing 'more astonishes a Foreigner,

26

and frights a Country Squire' than these, Joseph Addison reported. Milk-sellers sung their wares 'in sounds so exceeding shrill, that it often sets our teeth on edge'; worse was 'the idle accomplishment which they all of them aim at, of crying so as not to be understood', so that people learned the tunes but never the words.[31] Hogarth's *Enraged Musician* (1741), set in St Martin's Lane, is a reminder of the din of ballad-singers, paviors, dustmen, knife-grinders, hautboy players, bell-ringers, courting rooftop cats, barking dogs, chimney-sweeps and children (fig. 13).[32] And, though Hogarth never bothered himself with hygienic matters, it's worth knowing what that milk-girl was selling. In Smollett's novel *Humphry Clinker* (1771), Matt Bramble gives a peevish description – of milk

13. Hogarth, *The Enraged Musician* (etching, engraving, 1741)

frothed with bruised snails, carried through the streets in open pails, exposed to foul rinsings, discharged from doors and windows, spittle, snot, and tobacco-quids from foot passengers, overflowings from mud carts, spatterings from coach wheels, dirt and trash chucked into it by roguish boys for the joke's sake, the spewings of infants, who have slabbered in the tin-measure, which is thrown back in that condition among the milk, for the benefit of the next customer; and, finally, the vermin that drops from the rags of the nasty drab that vends this precious mixture, under the respectable denomination of milk-maid.

The little boy urinating in front of the astonished little girl reminds one, too, of the smells. For again, as you approached London from the country, your nostrils would be assailed by the strengthening odours of smoke, horses, humans, dead fish and offal – all the more powerfully when trapped by the smog. Edward Jenner the doctor said that while he was in London he never noticed a taint on his handkerchief when he sniffed it; but after he had travelled several miles out of London into purer air he easily smelled on it the results of being there. 'The little leisure I have,' Robert Southey wrote, 'is employed in blowing my nose, with interludes of coughing.'[33] It didn't help that every day each of London's many thousands of horses deposited an estimated twenty-two pounds of dung. That amounted to a total per horse of three and a half tons a year.[34] Not to forget the humans. Giacomo Casanova, fresh in London in 1763, was shocked to see a line of four or five people openly defecating in the street, and others urinating. At least the Venetians relieved themselves in doorways, he wrote, which was a more sanitary way of doing it.[35] Cesspits were everywhere. The lane next west of Beaufort Buildings was called Dirty Lane, and there was another Dirty Lane off Long Acre. Dunghill Mews stood behind the Royal Mews where the National Gallery is now. If you entered Denmark Court or Marygold Court off the Strand, or the danker courts off Drury Lane and Bedfordbury, you'd splash through sewage and be sickened by stink. The poor people who lived there went barefoot or wore pattens or clogs.

2

A Low and Turbulent People

> To the Hundreds of Drury I write,
> And to all my Filching Companions,
> The Buttocks* who pad it all Night,
> The Whores, the Thieves, and the Stallions

THE HUNDREDS OF DRURY

Thomas Rowlandson's wonderfully expressive stipple engraving from the 1780s (fig. 14) draws us into the darker spaces of Covent Garden, and the poorest ones too. For where the writ of the Bedford family ceased at St Paul's parish boundaries, the old unplanned London took over. The courtyards and alleys that encircled the Bedfords' Covent Garden estate were densely occupied and labyrinthine. They help explain the intimate social juxtapositions and encounters that were so peculiar to the district – peculiar, indeed, to all of that London that had been built in or before the seventeenth century. Courtyards had long provided jobbing builders and speculators with ways of in-filling to maximum densities, so the pre-modern metropolis was in effect built on these patterns. Their inhabitants weren't carriage-using people, so through traffic didn't have to be provided for. As like as not they were poor newcomers to the metropolis.

Eighteenth-century death rates in London exceeded birth rates, so it was largely thanks to in-migration that the eighteenth-century capital expanded from some 550,000 people to nearly a million by

* prostitutes

14. Rowlandson, *Tavern Scene* (stipple engraving, 1786?)

1801. Net immigration at mid-century (after deducting departures) probably reached some 8,000 a year, and the average age of newcomers was around twenty. In the country at large, London's magnetism rested on the impossibility of *not* hearing stories about its wonders and opportunities – about Dick Whittington, say, arriving on foot with his resolute cat and becoming mayor of London. People travelled large and difficult distances on foot, or on horses, carts and coaches across unsignposted and battered roads to have a chance of following his example. Some came by boat, for the Irish influx was substantial, and the French, German and Dutch influxes were substantial too.[1] Among all country-born newcomers, we must imagine much disorientation. At eight o'clock one evening, Richard Steele visited a country friend newly come to town and discovered that he had gone to bed: 'my old-fashioned friend religiously adhered to the example of his forefathers, and observed the same hours that had been observed in his family ever since the Conquest.'[2] He found this comic.

Much of the new labour, when it arrived, was cheap labour, if employed at all. Domestic service was a chief magnet, which is why 54

per cent of London's population by the end of the century was female.[3] Most poorer immigrants found their niches in Southwark south of the Thames, or in the east from the Tower through to Whitechapel and Wapping, but a significant part of this inflow was of young adults into the central town. Here mortality rates increased with residential densities. Around mid-century the pauper burials associated with the courts off Long Acre, Drury Lane, Maiden Lane and Exeter Street explain why eighteenth-century London was 'one of the great killing grounds of Europe': death rates were higher there than they were even in the northern cotton towns.[4] In the parish of St Martin-in-the-Fields 1,000 or so in the population of 30,000 died each year, with the highest mortality among children and young men. The same fates befell those in the courts and streets between Clare Market and St Clement Danes in the Strand. Those who didn't die knew dire poverty. Immiseration explains the vast size of the St Giles's workhouse. Built in 1727 at Short Gardens off upper Drury Lane, it housed up to 900 paupers by the early nineteenth century. The St Martin's parish workhouse, in Hemmings Row at the foot of St Martin's Lane, was similarly extended in 1772 into a complex of buildings so big that it covered almost as much ground as Leicester Square. Six years later, Covent Garden's St Paul's parish had to replace a small workhouse in Denmark Court, Exeter Street, with another monster. With its accompanying graveyard, it had to be built on Bedford land in Cleveland Street, St Pancras. This was the institution in which Oliver Twist one distant day was to ask for more.[5]

None of this makes Covent Garden's back alleys sound like bearable living quarters; and it would be perverse to downplay the plights of those who lived in some of them. Nor, shortly, will the prostitution and the lawlessness that ruled them be denied. But at this point, so far as it goes, one mitigation is needed to give our sense of these places some balance. For if filth, tears and death were all there was to say about them, Covent Garden's cultures would have been infinitely more desolate and defeated than they were. Our well-meaning present-mindedness can obscure the natives' more positive experience of such places. It can blind us to William Hazlitt's point when he wrote in another context that Hogarth's art would have lost much of its humanity had Hogarth not recognized 'wit or enjoyment in a night cellar', or the 'cripple's ability to dance and sing'.

We know next to *nothing* about how poor people in the past inwardly experienced their lives. 'We are very silent, so silent that no one to this hour knows what we think on any subject, or how we think it': the social investigator Charles Masterman imagined poor people saying this in 1902.[6] Today assumptions on the question of what it was like to be deeply poor certainly speak for the powers of a learned sympathy, but they may also entail the projections of assumptions from above and outside. In human experience squalor was, is, normal; and odorous and bug-plagued accommodations had characterized London housing for a millennium or two past. The word 'slum' is a recent invention. First recorded in 1812 as a slang word meaning 'room', it began thereafter to be applied to dwellings allegedly ripe for removal and so was transformed into the ideological device it remains to this day. By justifying demolition it no doubt added to the sum of healthy living; but moral and material improvements weren't always forthcoming, and the words 'slum' and 'reform' also served the interests of segregative labelling and control.[7] Modern 'well-being' studies tell us that unspeakably poor people can express a greater contentment with their lives than some affluent westerners admit to, thanks to communal supports and low expectations that have nothing to do with the power to consume. If so, given a modicum of health, people with a zest for life must have been legion in London's poorest quarters. Polite people would see roistering, jolly or mocking people wherever they looked. As Fanny Burney's favourite cousin Edward showed in an unfinished drawing, the harassments of bare-footed chimney-sweeps during their May Day rituals around Charing Cross would irritate passing ladies (are these two Fanny and her sister Susan?), but they spoke for a cheery plebeian vitality all the same (fig. 15).

Not all the mazy courts and dark abodes around Covent Garden were benighted. The worst that Strype in 1720 would say of some Drury Lane courts was that they were 'narrow and ordinary', or that their buildings and inhabitants were 'of no great account'. Angel Court and Earl's Court he found 'very handsome, well built and [well] inhabited . . . with a good freestone pavement cleanly kept', and with 'very good new built houses well inhabited'. Photographs of some of these places at the end of their lives show that they weren't beyond restoration by modern conservationist standards.[8]

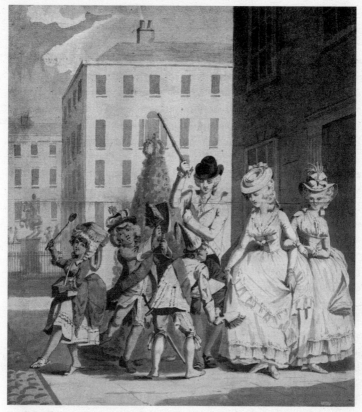

15. Edward Francis Burney, *May Day 'Jack in the Green'* (ink, pencil, watercolour, 1783)

Moreover, many courts that were later notorious were respectable in the early eighteenth century, and some stayed respectable throughout it. Even the grimier ones accommodated craftsmen, bookshops and engravers: many artists lived there. John Hamilton Mortimer the painter lived in Church Court, next to Church Lane behind St Martin-in-the-Fields, well known for its whores. The engravers George Bickham the Younger and J. T. Smith lived and worked in May's Buildings in the alleys between Bedfordbury and St Martin's Lane. In Old Round Court between Chandos Street and the Strand, the engraver

and printseller Charles Mosley traded in the 1740s, and James Caulfield opened his printshop there in 1780; Dr Johnson was a customer. The print partnership of Matthew and Mary Darly traded from Duke's Court, St Martin's Lane, and from Seymour Court, Chandos Street, in the early 1750s. James Aitken, publisher and printer, worked in Little Russell Court, and John Raphael Smith in Exeter Court, Strand, in the 1770s. And so on. Countless well-heeled men felt safe enough routinely to enter the courtyards and alleys in search of women; we usually hear only about the few who as a result had a bad time. The young rake William Hickey lost his virginity to 'a very pretty little girl' who accosted him under the arches of the Piazza. For five shillings she took him to a 'dark narrow court out of Drury Lane', and 'in this den of wretchedness I passed three truly happy hours'.[9]

The painter George Scharf lodged above a grocer's shop at 3 St Martin's Lane between 1817 and 1830, and in 1828 he drew Church Lane, a corner or two away (**plate 5**). It was one of the alleys and courts leading to the Strand south of Chandos Street and east of St Martin's Church. Ben Jonson had known these as the 'Bermudas' or the 'Caribbee Islands' because of the difficulties of navigating their 'countless straits and intricate thieves' passages'. By the eighteenth century they were known as 'Porridge Island' after an alley leading from St Martin's churchyard to Round Court that was full of cookshops.[10] Reformers (as we call them) claimed that one house in every five or six in that patch sold gin or was a brothel. By 1828 Church Lane's dereliction must have been as well advanced as it had ever been, because Scharf painted it just before it was demolished to make way for Trafalgar Square, the lower Strand and the old Charing Cross hospital, whose buildings occupy the site today.

His drawing, however, conveys neither vice nor dereliction. There the lane is, narrow, quaint, antique, with St Martin's spire overlooking it, and with its open gutter, hanging washing and bookshop, and with the wigshop on the left advertising hair in its window; a toy mannequin hangs from another doorway, a coffee-shop perhaps. The drawing shows no mud, litter or of course smells, and the paving is clean; it might have been summer. Now, all representations of past living are filtered through others' perception, and we know that prostitution and thieving were common around here. And Scharf

might have prettified the scene, for he lamented its demolition. Yet he was a meticulous and honest reporter, and his eye for detail is apparent in scores of drawings. The lightness here is accentuated by his use of watercolour. Colour unfailingly adds a pleasantness that is excluded from the depressing black-and-white Victorian social-problem photography that bedizens most retrospective views of London's poverty. Put *colour* into the depiction of such a place, indicate that people actually worked or read books or bought toys there (as distinct from receiving stolen goods or selling their own or other people's bodies), and add a touch of sunshine, and its meanings shift spectacularly. Church Lane had to be pulled down, and up Charing Cross hospital had to go. Yet the picture suggests that the many areas of London that were ancient, dirt-poor and ramshackle were acceptably habitable.

In a much later article on 'Gin Shops' in *Sketches by Boz* (1836), Charles Dickens discussed the Drury Lane courts without once referring to prostitution or crime. His reticence reflected the prudishness of his age, yet he also conveyed sympathetically the workaday realities of the back alleys that prevailed in all pre-modern cities. The courts he described were impoverished and they hid much misery, but they weren't full of stereotyped 'thieves' and 'whores'. He saw that there was effort in these lives as well as iniquity. So he reported

> wretched houses with broken windows patched with rags and paper: every room let out to a different family, and in many instances to two or even three – fruit and 'sweet stuff' manufacturing in the cellars, barbers and red-herring vendors in the front parlours, cobblers in the back; a bird fancier in the first floor, three families on the second, starvation in the attics, Irishman in the passage, a 'musician' in the front kitchen, and a charwoman and five hungry children in the back one – filth everywhere – a gutter before the houses and a drain behind – clothes drying, and slops emptying, from the windows; girls of fourteen or fifteen with matted hair, walking about barefoot, and in white greatcoats, almost their only covering; boys of all ages, in coats of all sizes and no coats at all; men and women, in every variety of scanty and dirty apparel, lounging, scolding, drinking, smoking, squabbling, fighting, and swearing.

By the time Dickens wrote, it's unlikely that much had changed since the early eighteenth century – other than the arrival of more intrusive policing and (in his case) more sympathetic reporting.

*

A wonderful map gives a sense of the alleys and yards around Covent Garden. It is Richard Horwood's huge *Plan of the Cities of London and Westminster, the Borough of Southwark, and Parts Adjoining Shewing every House*, which was published in thirty-two sheets between 1792 and 1799. Its predecessor was John Rocque's twenty-four-sheet, 26-inches-to-the-mile map of 1746. Rocque's was also a beautifully engraved production; but he hadn't indicated individual houses and his charting of courtyards and alleys was cursory. In any case, London grew so rapidly that it was out of date a quarter-century later. Horwood's new map beat Rocque's in size. Also at 26-inches-to-the-mile, it was the largest map so far printed in Britain, and, with the exception of the 25-inches-to-the-mile Ordnance Survey maps of 1862–72, it is also the largest map of London ever published. Put together, its thirty-two sheets measure over 13 by 7 feet.[11]

Its title – 'shewing every house' – indicates its ambition. Horwood and his assistants spent several footsore years tramping with theodolite and measuring-chains through 5,500 London streets, courts and alleys, not only to get angles and distances right, but also to record the street numbers (introduced in the 1760s) and the relative sizes of some 110,000 inhabited houses. No other map was to show numbered houses until the 1930s. The depths and rear spaces of buildings usually had to be guessed at, and some courtyards couldn't be measured because inhabitants threw stones at strangers. And house-numbering was still absent or incomplete in poorer areas. Still, Horwood achieved a cartographic masterpiece and a work of beauty, and his charting of courtyards and alleys was unrivalled.

His map shows clearly the ring of antique courts and alleys that laid siege to the Piazza – to the north between Long Acre and Castle Street, to the east off Drury Lane, across to Clare Market and down to the Strand, to the south between Chandos Street, Maiden Lane, and Exeter Street and the Strand, and to the west between Bedford-

bury and St Martin's Lane. St Giles's parish to the north, similarly, was soon to contain the poorest and most crowded territories of central London. Laid out on drained marshland in the 1690s, its seven streets radiating from the Seven Dials sundial obelisk at their hub occupied St Giles's Fields in Hollar's plan above (fig. 6). Their first occupants had been comfortable tradesmen, professionals and Huguenot immigrants, but in the 1730s the freehold was sold off, restrictive covenants were discarded, and many houses were subdivided into lodgings and workshops. Its small shops and printworks survived into the nineteenth century, but, as doss-houses multiplied, the area became one of the most benighted territories in London. The phrase 'St Giles's Breed, Better to hang than feed' was proverbial, and the transportation of felons from the parish was said to furnish the plantations in America with more souls than the rest of the Kingdom put together.[12] Even so, despite the cautions and reservations made above, in the eighteenth century, for poverty, congestion and crime, Covent Garden's courtyards beat St Giles's hollow.

In the courts between Bedfordbury and St Martin's Lane to the west, for instance (fig. 16), the Bedford family by 1700 was permitting occupants to pay small perpetual ground rents. The result was that grantees became their own freeholders, their plots of land under their own control, and Bedfordbury commenced its life 'by every man doing what was right in his own eyes in the way of building'. As the Victorian report that paved the way for demolitions continued: 'A number of alleys came into existence, and instead of a single house being put upon a single plot . . . a man would put two or three or four on it, maybe half-a-dozen houses, or cottages, or anything he pleased upon it, and that went on in perpetuity; and from the time those grants were made until a few years ago . . . Bedfordbury gradually became one of the worst dens in London.' Many of its passages and courts, like those in the other strips of fee-farm land, were barely two feet wide, and were 'so dark that even when the morning sun was shining brightly outside it was necessary carefully to feel every step taken'.[13] The Victorian writer George Augustus Sala found Bedfordbury 'a devious, slimy little reptile of a place, whose tumble-down tenements and reeking courts spume forth plumps of animated rags, such as can be equalled in no London thoroughfare save Church

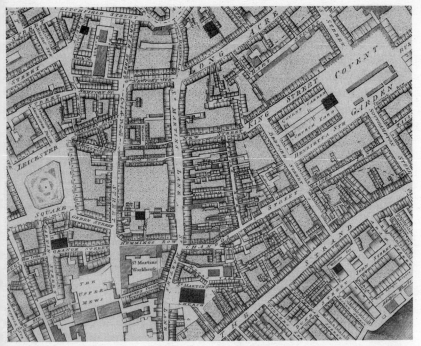

16. Bedfordbury and St Martin's Lane, detail from Horwood's *Plan of the Cities of London and Westminster* (etching, 1792–9)

Lane, St Giles's. I don't think there are five windows in Bedfordbury with a whole pane of glass in them.'[14]

The Drury Lane courts had the worst reputation (fig. 17). Drury Lane itself had remained semi-genteel throughout the seventeenth century – 'with good Houses that are well inhabited by Tradesmen, as being so great a Through-fare both for Man and Horse' (Strype); and it long remained a shopping and craft as well as a theatrical street. But at the time of Hollar's map in the 1660s tenements and alleys were already thickening behind it, and everyone knew what that meant. Very early in the seventeenth century, justice records were filled with complaints about this or that victim's being 'enticed and persuaded' into Drury Lane to enjoy the 'pretty wenches': 'He had the company of women several times in the chamber, and there was common resort

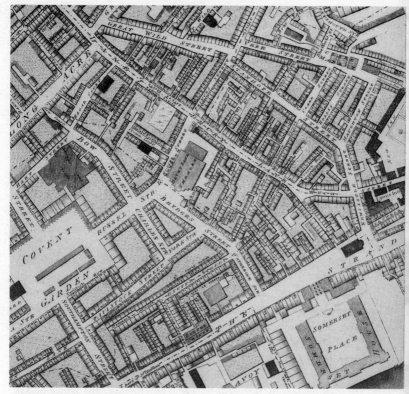

17. Drury Lane, detail from Horwood's *Plan of the Cities of London and Westminster* (etching, 1792–9)

of men and women unto the said house and they lay together and kept very evil rule and many of them that frequented and lodged there were Irish men and women.' [15] In 1642 'Covent-Garden, Long-Acre, and Drury-Lane' were where the 'doves of Venus . . . build their nests'. The parodic reference to the pretend-administrative unit, the 'Hundreds of Drury', became a shorthand for its whoring and thieving dens, while Drury Lane itself became a place of myth and fantasy. In 1709 Richard Steele launched an erotic fiction set in a Drury Lane 'kingdom' that was 'the only part of Great-Britain where the tenure of vassalage is still in being':

> All that long course of buildings is under particular districts or lady-
> ships, after the manner of lordships in other parts, over which matrons
> of known abilities preside, and have, for the support of their age and
> infirmities, certain taxes paid out of the rewards of the amorous labours
> of the young. This seraglio of Great-Britain is disposed into convenient
> alleys and apartments, and every house, from the cellar to the garret,
> inhabited by nymphs of different orders, that persons of every rank
> may be accommodated with an immediate consort, to allay their
> flames, and partake of their cares.[16]

The Lane was named after the Drury family that first built there, but
that didn't check the belief well into the nineteenth century that the
word came from the Chaucerian word for fornication, 'druerie'.

The women were attracted by the availability of lodgings at two-
pence a night or a garret for a shilling or a shilling and sixpence a
week. The rents were low because Drury Lane, Wych Street (connect-
ing Drury Lane to the Strand), and the streets and courtyards between
Clare Market and St Clement Dane's were full of wood-framed lathe-
and-plaster buildings from the sixteenth or seventeenth centuries.
Photographs taken in 1867 show some in Drury Lane and Wych
Street with rare brilliance on the eve of demolition (fig. 18).

As they aged, houses like these had a habit of 'falling down' or
catching fire. 'Two old houses fell down in Henrietta Street . . . The
people being alarm'd some minutes before by their cracking got out'
(though passers-by were killed). Or: 'On Thursday the house of Mr
[Grinling] Gibbons, the famous carver, in Bow Street Covent Garden
fell down; but by a special providence none of the family were killed;
but 'tis said a young girl, which was playing in the court, being miss-
ing, is supposed to be buried in the rubbish.'[17] Hogarth's mother died
of 'fright' at a fire that destroyed Cecil Court off St Martin's Lane in
1735. A fire that broke out in 1772 at a linen draper's on the corner
of Round Court and Chandos Street obliterated a row of houses in
neighbouring Castle Court in less than an hour because there was no
water to put it out.[18] Marygold Court was burned down in 1707–8.
Rebuilt for small tradesmen, it became famous for its brothels.

If houses escaped fire or collapse, they didn't escape rats or worse.
The radical tailor Francis Place was born in 1771 in Vinegar Yard

18. A. and J. Bool, *Old Houses in Drury Lane* (photograph, 1867)

next to Drury Lane theatre; his violent father kept a private debtors' prison there. He recalled his boyhood house 'filled with rats, mice and bugs'. 'Circulation of air was out of the question, the putrid effluvia was a great inconvenience and a horrid nuisance, there was always a reservoir of putrid matter in the lower part of the house.'[19] The reason for the reservoir was that Russell Court, next to Vinegar Yard, was built around a parish graveyard into which the dead were 'shovelled in as the filth of the streets is into scavengers' carts'. By the 1770s, deep open graves were covered only with boards until they were full. They raised the ground by several feet and by the 1830s emanated 'the mephitical effluvia of death'. The site is still there, now a small and innocent park.[20]

Dwellings like these inevitably filled with the very poor. By 1725 Drury Lane was reckoned to accommodate 107 'pleasure-houses' whose ladies 'ply the Passengers at Noon-day, as publickly as the Proctors do their Clients at Doctors Commons'.[21] In 1716 John Gay's *Trivia* described the nocturnal appearance and propositioning of the Drury Lane prostitute precisely:

> Beneath the Lamp her tawdry Ribbons glare,
> The new-scower'd Manteau, and the slattern Air;
> High-draggled Petticoats her Travels show,
> And hollow Cheeks with artful Blushes glow;
> With flatt'ring Sounds she sooths the cred'lous Ear,
> 'My noble Captain! Charmer! Love! my Dear!'
> In Riding-hood near Tavern-Doors she plies,
> Or muffled Pinners hide her livid Eyes.
> With empty Bandbox she delights to range,
> And feigns a distant Errand from the Change;
> Nay, she will oft' the Quaker's Hood prophane,
> And trudge demure the Rounds of Drury-Lane.
> She darts from Sarsnet Ambush wily Leers,
> Twitches thy Sleeve, or with familiar Airs
> Her Fan will pat thy Cheek; these Snares disdain,
> Nor gaze behind thee, when she turns again.

A little later, Drury Lane's reputation was confirmed by the fame of the people's hero-criminal, the miraculous Jack Sheppard. He was

aged twenty-two. Apprenticed to a Drury Lane carpenter, he had turned burglar, and his several spectacular escapes after arrest in 1724 became the stuff of legend. Imprisoned in the St Giles's roundhouse, he escaped through the roof; recaptured, he broke out of the Clerkenwell New Prison; rearrested by the corrupt thief-taker Jonathan Wild and condemned to death at the Old Bailey, he twice escaped from Newgate. Relishing his own daring and freedom, he committed his last burglary at a Drury Lane pawnbroker's. From this last he supplied himself with a black suit, silver sword, diamonds and watches before hiring a coach in which he triumphantly toured town with his sweethearts, and then swaggering around the Clare Market ginshops. He was arrested in a Drury Lane brandy shop, very drunk. This time the shackles and chains held him.

Such was his fame that Hogarth's father-in-law James Thornhill paid a shilling and sixpence to visit and draw him in his condemned cell; a profitable mezzotint was taken from his sketch. And an inspired hack composed *John Sheppard's Last Epistle*, a sardonic ballad in canting slang that purported to come from the great boy himself before his final quietus. It begins with the wry salutation to the Hundreds of Drury that opens this chapter – 'To the Hundreds of Drury I write, / And to all my Filching Companions' – and it ends chillingly with Sheppard's hanging at Tyburn:

> By the gullet we're ty'd very tight;
> We beg all spectators, pray for us.
> Our peepers are hid from the light,
> The tumbril shoves off, and we morrice*.[22]

Terrifying though such an outcome was, the wages of sin could for a while be quite pleasurable; and again on such a question the natives' views of their own world should weigh more than those of their enemies. 'Prostitutes swarm in the streets of this metropolis to such a degree, and bawdy houses are kept in such open and public manner, that a stranger would think that . . . the whole town was one general stew': so wrote the magistrate Saunders Welch.[23] But such a man was hardly going to note that in the poorest courts communal jollity and

* Dance (on the end of the rope)

pleasure also prevailed, as they had for centuries, and that in any case to such an observer the identity 'whore' was more meaningful than it had to be to her companions.

For there were taverns and ginshops everywhere in these streets and courtyards, full of raucous men and women whose late-night singing and bawdry would disconcert the most hardened of today's clubbers. As Rowlandson showed in his brilliant stipple engraving (fig. 14), they there took such pleasures as their hard lives afforded, and who was Saunders Welch to gainsay them? Aptly named cock-and-hen clubs catered to apprentices and their girls down a dozen off-Strand alleys. The participants had good times, Francis Place recalled, 'drinking – smoaking – swearing – and singing flash songs', until the sexes paired off and 'by 12 o clock none remained'. He remembered fifteen or so such clubs between the Strand and the Thames in the 1780s, and in his youthful apprentice days he seems to have enjoyed them. Importantly, he was at pains to stress that the girls weren't whores, for among many poor and middling people the borders between whoring, casual promiscuity and respectability were hazy. The girls were 'under comparatively little restraint', he wrote, and 'want of chastity' was 'not by any means considered so disreputable in master tradesmens families as it is now [1820s] in journeymen mechanics families'.[24] Most would pair off and settle down in their twenties or thirties.

'THE ENEMY'

In 1752, Henry Fielding chillingly described how 'the People of Fascination' were being driven from Covent Garden by the incursions of 'the enemy' – i.e. the vulgar. Once, he wrote, the high people had occupied all Covent Garden and much of St Giles-in-the-Fields. But then 'the enemy broke in and the [fashionable people's] circle was . . . contracted to Leicester Fields and Golden Square' in Soho. After that, the continuing pressure of the humble meant that the fashionables had to retreat further west to Hanover Square, and further still to Grosvenor Square and beyond.[25]

This was smart analysis. The aristocratic enclave was certainly collapsing fast in our period, even if it was a long way short of dissolv-

ing wholly. Large houses were subdivided, lodgings multiplied, and rents fell. In came craftsmen, shopkeepers, artists, actors, writers, musicians, printers, courtesans, pornographers, tavern-keepers, and rakes with unpleasant tastes. The last titled ratepayer to leave the Piazza was Lord Archer in 1757; his house (the one with its baroque façade at 43 King Street) became a hotel in 1774.

Among the incomers the aristocratic evacuation was unlamented. The neighbourhood's thickening sleaze was more invigorating than its earlier gentility. And since in any case the genteel still came to Covent Garden to buy theatrical and other pleasures, artists had no need to follow them westward, even if they could afford to. There was much to enjoy here. Taverns, clubs, gambling dives and brothels encouraged indulgences that cut against all that was thought polite in that age, even as the more salubrious of its coffee-houses encouraged serious conversations by way of balance. The poverty of the surrounding courtyards guaranteed ready supplies of cheap labour and cheap women. Girls of easy virtue were as numerous as the raucous market women, and artists found that nude models were easily come by. Well-heeled sparks came slumming it, spending youthful nights worrying how high or how low to go. In chandeliered bordellos and bagnios (bath-houses) the smarter girls waited for grandees to pay for their nights in guineas, while men of simpler taste picked up girls like the one that James Boswell knew, who, in her white thread stockings, 'tramps along the Strand and will resign her engaging person . . . for a pint of wine and a shilling'.[26]

Rude books and pictures were plentiful too. The bookseller Edmund Curll was magnetically drawn towards Covent Garden. He moved from his first shop in Fleet Street, via shops in Catherine Street off the Strand and in Bow Street next to Wills's coffee-house, to Rose Street (between King Street and Long Acre), where he traded from 1735 until he died in 1747. This was the 'Unspeakable Curll' whom Pope poisonously attacked for plagiarizing his writings. In 1725 he had been the first person to be convicted of obscene libel under common law for republishing the French *Venus in the Cloister, or The Nun in her Smock* and the eloquently illustrated *Treatise of the Use of Flogging in Venereal Affairs*. He was sent to the pillory. Much good this did the morals of Covent Garden, however. The tailor

Francis Place reported of his Drury Lane boyhood in the 1770s and 80s that

> obscene Prints were sold at all the principal print shops and at most others. At Roach's in Russell Court . . . Mrs Roach used to open a portfolio to any boy and to any maid servant, who came to buy a penny or other book or a sheet of paper, the portfolio contained a multitude of obscene prints – some coloured, some not, and asked them if they wanted some pretty pictures, and she encouraged them to look at them. And this was done by many others.[27]

Roach's and several other shops were prosecuted in 1794 for selling *Harris's List of Covent Garden Ladies*. Between 1782 and 1786, similarly, the satirical printseller William Holland seems to have traded in Drury Lane alongside a publisher of flagellation literature, George Peacock, possibly a partner. Holland ran his own erotic and flagellatory sidelines, and might have been the unnamed Drury Lane dealer who first employed the young George Morland on his erotica. He certainly employed James Gillray, and in several of his early prints for Holland Gillray also catered to those tastes by developing flagellatory motifs. References to flagellation recur so often at this time, in text and in image – here a print or book illustration whose context is unknown; it is thought to be by the French engraver and book illustrator H.-F. Gravelot in the mid-1740s – that it must have been a Covent Garden speciality (fig. 19). Later gossip had it that the Prince Regent bared his bottom to the disciplines of the young ladies at Mrs Collet's establishment in Tavistock Court.[28]

*

Yet, when all is said and done, Fielding shamelessly exaggerated the malignity of 'the enemy'. Most incomers to the neighbourhood were innocent and hardworking, and some were just quixotic. A shop was opened at 27 Russell Street by two elderly Frenchwomen who had 'come over' and now passed their lives chewing paper for the papier mâché makers.[29] Marionette theatres opened in St Martin's Lane and the Little Piazza. (Punch and Judy were first recorded when Pepys saw a performance in the Piazza in 1662 and was delighted enough to

19. H.-F. Gravelot (attrib.), *Molly's First Correction* (pencilled title)
(etching, *c.* 1740–45)

bring his wife to watch a little later.) Otherwise, local skills multiplied.
Long Acre and Great Queen Street filled with workshops for coachbuild-
ers, goldsmiths, goldbeaters, barrow-makers, colour-makers, artists'
tool-makers, modellers and fan-mounters. Chippendale's furniture work-
shop and salesroom occupied three houses at 60–62 St Martin's Lane in

20. Paul Sandby, *Woman and Child Holding
a Doll* (pencil, ink, wash, *c.* 1758–60)

1754–1813, and in 1768 Wedgwood and Bentley opened their porcelain
showrooms in Great Newport Street. Countless shopkeepers also traded
in obvious or unexpected places. They dwelt above their workplaces,
next door to rich houses or down alleys and in courtyards, in juxtaposi-
tions that accentuated the levelling proximities that were common
throughout London but were especially marked here.

Thus, while nearly every street in town had 'gentlemen' and 'esquires'
listed in its ratebooks, these lived alongside chandlers, victuallers, coffee-
men, tailors, ostlers, tavern-keepers, mercers, glaziers, cheese-mongers,
pastry-cooks, cutlers, button-sellers, butchers, oilmen, stay-makers and
carpenters. They entered fiction, too. 'The man's name is Smith, a dealer
in gloves, snuff, and such petty merchandise: his wife the shopkeeper: he
a maker of the gloves they sell. Honest people, it seems' – this the couple
with whom Samuel Richardson's *Clarissa* (1748) lodged in King Street,
off the Piazza, as she waited to die; they sold 'tapes, ribbands, silk-laces,

21. Elias Martin, *Scene inside a Shop* (etching, 1773)

pins and needles ... powder, patches, wash-balls, stockings garters, snuffs and pin cushions'. It was the everyday reality of working people of this kind that caught the artist's notice – as in Paul Sandby's pleasantly incidental sketch of a mother and daughter (fig. 20); or as in this etching of the dim interior clutter of a general dealer's (fig. 21); or as in the countless trade cards and engravings that show busy endeavour. One reveals the bare wooden flooring of a Drury Lane printer ('George Beacher Copper-Plate-Printer at the Bible and Crown in Drury Lane facing Long Acre London Carefully Prints all manner of Copper Plates For Printsellers Booksellers Stationers &c Tickets for Balls, Plays, Funerals') (fig. 22). Another is the card that Hogarth designed in 1730 for his sisters' drapery shop, which comfortably prospered behind St Bartholomew's Hospital, near the Hogarth family's first home (fig. 23).

22. Trade card, *George Beacher Copper-Plate-Printer at the Bible and Crown in Drury Lane facing Long Acre* (etching, 1740s)

In short, countless productive lives like these were being lived that are now forgotten because they entered the records neither of the courts nor of the Poor Law. Something of their quality is conveyed in a German gentleman's account of a Soho shopkeeper's family whom he visited in 1725:

23. Hogarth, trade card, *Mary and Ann Hogarth, Little Britain Gate* (etching, 1730)

the Man's Income, I believe, might amount to about seventy Pounds per Annum, and his Family consisted of one Wife and a Daughter of about eighteen; they were extraordinary Oeconomists, brew'd their own Beer, wash'd at home, made a Joint hold out two Days, and a Shift three; let three Parts of their House ready furnish'd, and kept paying one Quarter's Rent under another. In such like Circumstances had they gone on for some Years, and the worst the World could say of them was, That they liv'd above what they had, that their Daughter was as proud a Slut as ever clapt Clog on Shoe Leather, and that they entertained Lodgers as were no better than they should be.[30]

Meanwhile, the functioning of the artistic community and the development of a sense of artistic identity depended on the auction rooms, picture-framers, printshops and colour-shops whose multiplication testified to an increasingly commercialized and professionalized art

world. The centre of gravity of the satirical and humorous print trade, upon whose patronage many jobbing artists depended, began to move westwards in the later 1780s in order to catch the aristocratic and political markets there. In that decade Fores of Piccadilly published 214 satirical titles, followed by Hannah Humphrey of Bond Street with 109. But that output had earlier been beaten by Matthew and Mary Darly of the Strand and Leicester Fields, by Carington Bowles of St Paul's Churchyard, and by Robert Sayer of Fleet Street; and it was matched by the combined output of William Humphrey of Gerrard Street and the Strand and William Holland of Drury Lane and Oxford Street.[31]

In an era when the public visibility of artworks was limited, auction rooms provided invaluable opportunities for viewing them, and auctioneers became household names. The Piazza became London's leading auction centre; the first English salesroom was opened there in 1692. Christopher Cock and Abraham Langford ran auctions from Sir Peter Lely's old address in the north-eastern corner of the Piazza, Langford continuing there after Cock's death in 1748. James Christie (1730–1803) began his career in a Covent Garden auction room before following the elite market westwards down Pall Mall. Hutchins's and Paterson's auction houses in King Street aerated the upper art market.

Picture-framers and paintshops were just as important in the artistic economy, and some were highly profitable. Gainsborough's portrait of David Garrick in 1769 had a frame and burnished gold cresting that cost £68.14s in all; this exceeded the £63 that Gainsborough charged for the portrait. In the 1780s, the carver and wax modeller William Flaxman (the artist's brother), from addresses in Covent Garden, St Martin's Lane and Soho, made frames for Gainsborough at a much cheaper fourteen or so guineas.[32] St Martin's Lane also boasted the leading colour-shops. Between 1778 and 1830 John Middleton's stood at 80–81, next door to Slaughter's coffee-house. It advertised colours that in 1785 ranged in price from threepence a bladder for Blue Black and Ivory Black to three guineas for an ounce of Ultramarine or ten guineas for the best quality. Middleton's customers included Reynolds, Gainsborough, Ramsay, Lawrence, West, Constable and Turner. The very model of the prospering tradesman, he affirmed his status by having himself, his housekeeper and his four children painted in a family group c. 1797. His drawing-room is shown with its Chippendale chairs (made

a few doors away) and what may be a spinet, though it was otherwise simply furnished and the painter was uninspired and is now unknown.[33] Another leading colour-shop, Edward Powell's, was also in St Martin's Lane. His family had supplied artists' colours since at least the 1760s and perhaps the 1730s, and he did business there between 1774 and 1814. The ornate doorcase depicted in Scharf's 1829 drawing of the shop (fig. 24) probably dated from when the house was inhabited by the quack Dr Misaubin, whom Hogarth had satirized.[34] You could find lesser colour-shops in many local streets. 'Pictures carefully cleand, lin'd & framed in the neatest manner', announced the trade card of Martin Foxhall, carver and gilder of Seven Dials, adding: 'NB all sorts of hosiery and haberdashery goods, with checks and Irish cloth, at the lowest prices'.[35] While a boy in his father's wig-making shop in Maiden Lane, J. M. W. Turner must often have visited William Ward's shop at 66 Chandos Street, barely a dozen yards away. There he would have gazed on

> all Sorts of primed Cloths, & fine Colours, in Oil, and in Water, Likewise Tools, Fitches, Pencils, Box, Ebony, Cedar & Deal Sticks, Palett Boards, Knives, Chalks, Port-Crayons, Mahogany Colour Boxes, Easels &c. All sorts of House Colours & Oils, Wholesale Retail and for Exportation,

24. George Scharf, *Allen's Colour Shop, St Martin's Lane* (ink, watercolour, 1829)

at the Lowest Prices, & Curious Poppy Oil./ NB Pictures Lin'd in the Neatest Manner.[36]

Watercolour pigments were more easily come by when William Reeves and his brother, in Little Britain off Smithfield from 1766 to 1781 and then in the Strand until the end of the century, invented the 'Moist Watercolour Paint-Cake'. This saved watercolourists from having to grind and wash their own pigments and mix them with gum arabic (though many, like Blake, still preferred to do so).[37] This invention helps explain the multiplication of amateur watercolourists in the later eighteenth century – and why nearly all satirical prints then began to be watercoloured. It also encouraged the spread of Turner's and Girtin's new technique of painting directly onto paper in translucent washes.

*

Alongside all this, there was the market too. In 1705, the garden wall of Bedford House that had closed off the Piazza to the south was demolished, as was Bedford House in the Strand. Fourteen plain houses went up along Tavistock Row and Henrietta Street. Southampton Street was built to link the Piazza to the Strand, and other streets like Maiden Lane were laid out around it. The informal market for fruits, herbs, roots and flowers that had been trading against the wall since 1656 now had to move into the Piazza's centre. What ensued delivered a fatal blow to the Piazza as a high-status residential area.

Some welcomed the market's expansion. It brought to town refreshing whiffs of countryside. Early one morning in 1712 Joseph Addison travelled by boat down the Thames from Richmond, and fell in with a fleet of ten boats full of 'apricocks', melons and cheerful gardeners. He could tell that they were heading for Covent Garden from 'the Countenances of the Ruddy Virgins, who were Supercargoes'. They were friskier and more forward than the girls of other markets, and, as it turned out, they weren't at all virginal because they were so familiar with the Piazza's 'Morning Rakes':

> We arrived at Strand-bridge at Six of the Clock, and were unloading, when the Hackney-Coachmen of the foregoing Night took their leave of each other at the Dark-House, to go to Bed before the Day was too

far spent. Chimney-Sweepers pass'd by us as we made up to the Market, and some Rallery [*sic*] happened between one of the Fruit Wenches and those black Men, about the Devil and Eve, with Allusion to their several Professions. I could not believe any Place more entertaining than Covent Garden; where I strolled from one Fruit-Shop to another, with Crowds of agreeable young Women around me, who were purchasing Fruit for their respective Families.

Well over a century later Leigh Hunt also delighted in the market's robust female essences: 'The country girls who bring the things to market at early dawn, are a sight themselves worthy of the apples and the roses.'[38] Hogarth's painting of *The Shrimp Girl* is discussed later (**plate 16**), but that work makes it clear that he thought the same.

Not everyone agreed on the market women's charms, however. Paul Sandby's *Cries of London* in 1760 represented some of them as vulgar termagants, while Matt Bramble in Smollett's *Humphry Clinker* described

a dirty barrow-bunter in the street, cleaning her dusty fruit with her own spittle; and, who knows but some fine lady of St James's parish might admit into her delicate mouth those very cherries, which had been rolled and moistened between the filthy, and, perhaps, ulcerated chops of a St Giles's huckster – I need not dwell upon the pallid, contaminated mash, which they call strawberries; soiled and tossed by greasy paws through twenty baskets crusted with dirt.

It took a rare artist like Louis-Philippe Boitard to notice the hardness of these lives, his sketch of an exhausted washerwoman poignant still (fig. 25). One market specialism entailed gathering from rural ditches, springs and hedges at earliest dawn the herbs and medicines for which there was a constant demand in town: 'water-cresses, dandelions, scurvy-grass, nettles, bitter-sweet, cough-grass, feverfew, hedge mustard, Jack by the hedge, and sauce-alone', as well as snails, leeches and vipers. With packs full, the vendors often trudged fifteen miles to get to the market as early as they could; and then in the afternoon they would trudge back again, to sleep in barns for the night. The women were fond of brass rings on every finger, someone recalled; 'their faces and arms are sunburnt and freckled, and they live to a

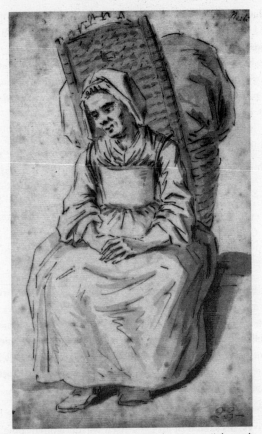

25. Louis-Philippe Boitard, *A Washerwoman* (ink, wash, no date)

great age, notwithstanding their constant wet and heavy burthens, which are always earned on the loins'.[39]

Trouble with the market was unavoidable. By mid-century, traders had erected 106 permanent single-storey shops and 229 stalls across the Piazza's southern half, and itinerant dealers invaded the open area also. 'Fruit women screamed, carters fought, cabbage stalks and rotten apples accumulated in heaps at the thresholds of the Countess of Berkshire and of the Bishop of Durham.'[40] Shady brandy- and coffee-shops multiplied,

and, until they were checked in the 1770s, shops infiltrated the portico walks and a picture-stall at the Russell Street corner displayed rude prints. Residents petitioned in vain against 'the stench and filth of the Markett, the Offensive Smoke of the Chimneys of the said several Sheds and the Disturbances which frequently happen, by the great Number of profligate and Disorderly people, who frequent the Square, and particularly that part of it called Irish Row'.[41]

It didn't help that the swill of poor people made the Piazza a favoured hunting-ground for press gangs. 'Yesterday four Coaches full of loose disorderly Persons, who had been taken the Night before, were carried from Covent-Garden Round-house, guarded by Soldiers to the Rendezvous, in order to be sent on board some of his Majesty's Ships of War.'[42] Add to these disturbances the recurrent clean-ups initiated by zealous magistrates such as Thomas de Veil. One night in 1742, 'a parcel of drunken constables' – Horace Walpole's words – invaded a bagnio in the Piazza and made the mistake of arresting three high people who were having a boisterous time there: John Spencer (grandson of the Duke of Marlborough), Lord George Graham (son of the Duke of Montrose) and a Mr Stewart. They locked them up in the Covent Garden roundhouse ('the constables' prison' for disorderly persons), but let them go when they realized that they were 'worth more than eighteen pence' (Walpole). Their mistake spurred them on to arrest 'every Woman they met', including some who were perfectly peaceable. Twenty-four of them they corralled in St Martin's roundhouse at the foot of St Martin's Lane, a hard and pitiless place. Outside stood stocks whose post was carved into the figure of one man flogging another with the cat o' nine-tails – 'most admirably well executed'.[43] Inside, the keeper William Bird forced the women to spend a hot sultry night in

a Hole, which is not above 6 Foot Square, and the Ceiling scarcely five Foot ten Inches high, with the Window close shut. Nor had he the least Regard to their Outcries of Murder, so that four Women were suffocated; one of them a Chairwoman, who was big with Child, had been late at Work, and was going home to her Husband, and another was just come from Gravesend to see her Sister.

Walpole added that

the poor creatures . . . screamed as long as they had any breath left, begging at least for water. One poor wretch said she was worth eighteen pence and would gladly give it for a draught of water, but in vain. So well did they keep them there that in the morning four were found stifled to death, two died soon after, and a dozen more are in a shocking way.

Bird allegedly shouted 'Let the bitches die and be damned'. As news spread, local people attacked and pulled down the roundhouse and prevented its rebuilding. 'The greatest criminals in this town are the officers of justice,' Walpole wrote; 'there is no tyranny they do not exercise, no villainy of which they do not partake.' Bird was transported to the Plantations. To universal satisfaction, he died on the journey 'for want of water'.[44]

RAKES

The girls of easy virtue got most of the blame for local disorders. In truth, privileged males were the worst offenders. Covent Garden had long been their playground. As early as 1663, Pepys noted how the drunken Sir Charles Sedley caused a near-riot by exposing himself naked at a balcony of the Cock tavern in Bow Street – there

acting all the postures of lust and buggery that could be imagined, and abusing of scripture and, as it were, from thence preaching a Mountebanke sermon from that pulpitt, saying that there he hath to sell such a pouder as should make all the cunts in town run after him, – a thousand people standing underneath to see and hear him. And that being done, he took a glass of wine and washed his prick in it and then drank it off; and then took another and drank the King's health.[45]

In the same year, Aubrey de Vere, twentieth Earl of Oxford, after a sham marriage with the actress Hester Davenport, lived riotously in number 8 in the Great Piazza; a brawl among his guests was checked only by the arrival of soldiers. Pepys visited Oxford's house two years later and found that 'his lordship was in bed at past ten o'clock: and Lord help us, so rude and dirty family I never saw in my life'. None of this stopped the great man getting himself portrayed a few years later in earl-flattering satins, silks and sword by his neighbour Godfrey Kneller.[46]

Then there were the 'mohocks'. Nicknamed after Iroquois chiefs who visited London in 1710, these were members of the long succession of aristocratic hoodlums who in the name of manliness, fun and frolic have rampaged, broken windows and furniture, and assaulted women and passers-by from the days of the Elizabethan roaring boys down to Oxford's Bullingdon Club mobsters of recent fame. In 1712 Sir Mark Cole and three of his friends were tried at the Old Bailey for riot and assault, each then to be fined the laughable sum of 3s. 4d. In a single night, they had rampaged across town from Golden Square, via Newport Street, the Piazza, Essex Street, Clare Market, Snow Hill and one of London's several Pissing Alleys, to Devereux Court south of the Strand, in the course of which, wielding short clubs loaded with lead at both ends, they had beaten up thirteen men in a Piazza gaming house, abused a watchman, slit two people's noses, cut a woman in the arm so that 'she lost all use of it', rolled another woman down Snow Hill in a barrel, sat on other women's heads, and overturned several coaches and sedan chairs – declaring in their own defence that they had merely gone out to 'scour' the streets for malefactors, and were really on the side of law and order.[47] Whence John Gay in his *Trivia*:

> Who has not heard the Scourers' midnight fame?
> Who has not trembled at the Mohocks' name?
> Was there a watchman took his hourly rounds,
> Safe from their blows or new-invented wounds?
> I pass their desperate deeds, and mischief done,
> Where from Snow-hill black steepy torrents run;
> How matrons, hoop'd within the hogshead's womb,
> Are tumbled furious thence: the rolling tomb
> O'er the stones thunders, bounds from side to side . . .

Pope, Defoe and Swift as well as Gay all described the mohocks with varying degrees of conviction. According to Richard Steele in the *Spectator*,

> they take care to drink themselves to a pitch, that is, beyond the possibility of attending to any notions of reason or humanity; they then make a general sally, and attack all that are so unfortunate as to walk the streets through which they patrol . . . Some are celebrated for a happy dexterity in tipping the lion upon them; which is performed by

26. Anon., *He and his Drunken Companions raise a Riot in Covent Garden* (etching, 1735)

squeezing the nose flat to the face and boring out the eyes with their fingers.

Everyone was soon quoting the playwright Shadwell's character in his *Scourers* (1691) who complained that 'a man could not go from the Rose Tavern to the Piazza once, but he must venture his life twice'.

The depredations of these privileged thugs were probably exaggerated in order to make political capital out of London's disorders.[48] But they sounded real enough to Jonathan Swift, who gave up his evening walks because he thought that the bullies (or pimps) were after him personally. And the moral panic of 1712 gave the mohocks an enduringly mythic stature. One night a dozen years later in the Piazza a Strand perfumier had a window of his sedan chair broken. He described his evening as follows: 'From ten to twelve at Tom's, Covent Garden, talking of the

quarrel between Mrs Oldfield and Mrs Rogers. Had one of my chair glasses broke by a mohock in my return home. Went to bed and wak'd in a sad fright having dream'd the mohocks had fashioned my nose like a lion and cut with a penknife cross the back of my whitest hand.'[49] And in 1735 an anonymous print, *He and his Drunken Companions raise a Riot in Covent Garden* (fig. 26), capitalized on the success of Hogarth's *Rake's Progress* by inventing an episode in the rake's career that drew on Mohock memory. Thus its subtext:

> See Ramble, tho' he Risks his life
> Will from the Husband force the Wife.
> As rudely his Companions treat
> All that in Petticoats they meet.
> The Women Struggle, Scream and Scratch
> Loud swear the men – In comes the Watch
> Alarm'd by the outrageous Noise
> And fall upon the Roaring Boys . . .

Aristocratic hooliganism made other people's lives difficult throughout the century. One day in the early 1790s George Morland the painter

27. Rowlandson, *Six Stages of Marring a Face* (etching, 1792)

28. Rowlandson and Augustus Charles Pugin, *Covent Garden Market, Westminster Election* (etching, aquatint, 1808)

was drinking in the Rummer tavern in Charing Cross when the Duke of Hamilton entered and for no obvious reason challenged Morland to a pugilistic spar. 'The first blow knocked him [Morland] across the room, and he afterward declared, he was so awed by the mere name of a nobleman, that, had he possessed the utmost skill, he could not have employed it' against him. The Duke made some amends by driving Morland back to Morland's house, but he peremptorily ordered the artist out of the coach before they got there, angering Morland mightily. A year or so later Rowlandson dedicated his *Six Stages of Marring a Face* (1792) 'with Respect to his Grace the Duke of Hamilton' (fig. 27). Morland and Rowlandson were sharing lodgings at this point, so the print was a graphic revenge delivered by the low, who had few weapons to wield, upon the high, who had too many.[50]

ELECTIONS

The common people's theatre needed neither auditorium nor actors. It took the form of a carnival that was conducted at electoral contests for the parliamentary constituency of Westminster. On these occasions shed-like hustings were erected outside St Paul's church in the Piazza, and grandees abased themselves to woo the votes of the humble. All Westminster's voters had to come here (from the rest of the town and from the West End alike), and it was here that candidates addressed the people as the latter heckled and threw dead or living cats. Drink and bribes flowed, violence was licensed, old scores were settled. Momentarily the world was turned upside-down. Rowlandson and Pugin's aquatint in 1808 owes its rumbustious energy to Rowlandson's comic eye; but it credibly conveys the plebeians' electoral presence (fig. 28), just as several dozen other satirical prints show their violence. Westminster saw twenty-one general elections and twelve by-elections across the eighteenth century. Most were unopposed, but over a dozen were hard-fought, corrupt and vicious.

The constituency of Westminster was the second largest and by far the most democratic in the nation's unreformed electoral system. By historical accident, virtually all adult male rate-paying householders had the Westminster vote. There were 10,000 of these in 1802, making some one in fifteen of the total population, one in seven of the total male population, and one in four of the adult male workforce as recorded at the 1801 census. Voters in St Paul's Covent Garden and St Martin-in-the-Fields were less easily influenced by powerful patrons than voters were in the constituency's affluent western and court-dominated parishes. Not all were radical by any means. But substantial numbers of middling men, including the meaner among them (smiths, carters, butchers), had been so galvanized by John Wilkes's radicalism in the 1760s that they had in effect evolved into an 'informal political nation' which was sure of its power. Committed to voter independence and electoral reform, these voters knew they could swing elections, so their excitement was contagious. Each voter could cast two votes. In 1784 the Westminster turnout was 84 per cent, with middling voters in the overwhelming majority.

At issue in this most inflammatory of elections was the king's dismissal of the Fox–North coalition and his appointment of the younger Pitt as prime minister, despite Pitt's lack of majority support in the Commons. Charles James Fox's no confidence motions and the Whigs' refusal to vote the supplies now forced Pitt to call an election. In the event Pitt won across the nation overall, but Fox and his friends could plausibly present themselves as the 'People's Party', and they narrowly won in Westminster. In Covent Garden ministerial bribery and intimidation assured the tightness of the contest. To take a random example, fourteen of the electors of Maiden Lane (coffee-man, tailor, picture-dealer, greengrocer, glass-maker, bookbinder, mercer, hairdresser, two painters, two glaziers, two gentlemen) 'plumped' both of their votes for Fox, but nine (cook, smith, stay-maker, tailor, coal merchant, cabinet-maker, pawnbroker, dyer, gentleman) split their votes between the ministerialist candidates Hood and Wray, and eleven (cheese-monger, cutler, pastrycook, button-seller, butcher, painter, oilman, tailor, victualler, embroiderer, cider merchant) split between Fox and Hood; a victualler plumped for Hood.[51] So it wasn't a walk-over for Fox; but enough to ensure that Westminster was represented by Fox's radical Whiggism from 1780 until his death in 1806, and by the Foxite radical, Sir Francis Burdett, thereafter.

*

Innocent bystanders at the Piazza's rowdier elections might have been forgiven their alarm at the outbreak at critical moments of the most peculiar and sinister sound. It came from the clacking and ringing tones made when bevies of butchers clashed meat-cleavers against marrow-bones. This produced more or less musical notes:

TITANIA: What, wilt thou hear some musicke, my sweet love?
BOTTOM: I have a reasonable good eare in musicke. Let us have the tongs and the bones.

'Musicke Tongs, Rurall Musicke', Shakespeare's stage direction then reads sweetly. Music of this kind was played at the shaming rituals that mocked adulterous couples or henpecked husbands or it was played celebratorily at weddings (where refusal to pay for the music invited

harassment or worse), and it was increasingly heard at elections and mock-elections to show approval or otherwise.[52] A 'reasonable good ear' it didn't invite. At its most ominous it sounded like the music of insurrection.

Meat-cleavers seem to have displaced Bottom's fire-tongs in the mid-seventeenth century. In 1659 Pepys reported that butchers celebrated the end of the Rump Parliament by burning rump steaks and ringing 'a peal with their knifes' at the Strand Maypole at the foot of Drury Lane.[53] We next hear of them in the 'melodious clank of marrow-bone and cleaver and a chorus of bells' that celebrated George I's coronation in 1714. Two years later, marrow-bones and cleavers were clashed by the butchers among Jacobite rioters on the rampage. Soon cleavers and bones could feature without explanation in satirical prints. Hogarth includes them in the street-band that inflicts rough music on the industrious apprentice at his marriage in *Industry and Idleness* (1747). He also puts them in the background of *Chairing the Member* in his *Election* series (1754); and in his print *The Times I* (1762), butchers clack cleavers beneath the figure of William Pitt. Again, on Admiral Vernon's birthday in 1742, Horace Walpole reported that 'the shops are full of favours, the streets of marrow-bones and cleavers, and the night will be full of mobbing, bonfires, and lights' – Vernon being the popular opponent of Walpole's father, Sir Robert. When they disturbed his concentration, Horace Walpole required his porter to dismiss 'those marrowbones and cleavers' in the street. 'Sir, they are not at *our* door,' the porter replied, 'but over the way at my Lord Carteret's.' 'Oh,' Walpole replied, 'then let them alone.' Some people were beginning to find the music antique and quaint. When Bonnell Thornton in 1749 composed a burlesque *Ode on St Cecilia's Day, Adapted to the Ancient British Musick*, it included music from 'the salt-box, the jew's-harp, the marrow-bones and cleavers, the hum-strum or hurdy-gurdy &c.'. It was later performed at Ranelagh pleasure gardens, and Boswell reported that Samuel Johnson, otherwise wholly indifferent to music, enjoyed it. Marrow-bone music lived on into the next century; both Shelley and Dickens referred to it.[54]

Butchers had been trading in the stalls of Clare Market ever since it was founded in the 1650s in the side streets off Vere Street, two blocks west of Drury Lane (which is when Pepys first heard them). A rude lot,

they enjoyed settling their feuds with the butchers of Newgate and Leadenhall Markets by staging brutal dog fights at Hockley-in-the-Hole in Clerkenwell – and joining the dogs in the ring when the spirit (or spirits) moved them.[55] By the 1780s their most visible field of enterprise was at the Covent Garden hustings. Their past Jacobitism forgotten, they joined forces with brewers and Irish sedan-chairmen to lend muscle to the Whig interest. The connection seems to have been first acknowledged when Charles James Fox arrived at the hustings at the head of this carnivalesque procession for the most turbulent of all Westminster elections, in 1784. The chief contemporary history of the election described the procession's arrangement as follows:

> Porters, with cockades, two and two.
>
> Marrow-bones and cleavers.
>
> Mr Keys, the messenger to the Friends of Liberty.
>
> Standard, '*Fox and LIBERTY*'
>
> Electors, four and four, with cockades.
>
> Standard, '*FREEDOM OF ELECTION*',
>
> On the one side, on the other,
>
> '*FOX AND THE CONSTITUTION*'.
>
> Electors, four and four.
>
> Grand Band of Wind Instruments.
>
> Standard, '*MAY CHELSEA HOSPITAL FOR EVER STAND*' on one side,
>
> On the other,
>
> '*NO TAX ON MAID SERVANTS*'.
>
> Electors, four and four.
>
> Mr FOX.
>
> Carriages of his Friends and Supporters, amongst which were those of the first
>
> Whig Families in the Kingdom.

At least three satirical prints on the 1788 by-election show that the butchers' association with Fox was by then secure.[56]

The clamour that greeted Fox's arrival at the 1784 hustings wasn't all friendly. In an election energized by the Pittite ministry's determination to get Fox out of Parliament for his personal immorality and his support of the coalition and the India Bill, confrontations were

bound to turn nasty; even the king followed events closely. Passions were inflamed by the Tory Wray's treacherous defection from Fox's camp and by his intention to demolish Chelsea Hospital and to tax maidservants. (The largest occupational group in later eighteenth-century Westminster was its 27,000 domestic servants: Wray's policy didn't go down well with their employers.) The other side was inflamed not only by Fox's claim to be the 'People's Friend', but also by the unseemly female canvassing on his behalf by his grand Whig friends the Duchess of Devonshire and her sister Lady Duncannon. A story that Devonshire solicited a butcher's vote by kissing him exploded into a dozen scurrilously crude satirical images. 'I'll leave no Stone unturned to serve the Cause,' the duchess says meaningfully in Dent's *The Dutchess Canvassing for her Favourite Member*, as, in 'Cockspur Street', she gives a friendly squeeze to a butcher's favourite member, or perhaps one of his stones. 'Sweep, sweep,' says a chimney-boy on the ground, as he and his dog peer up her dress into darkness (fig. 29).

The shock delivered by the great ladies' engagement in elections is conveyed in Robert Dighton's fine drawing from the Westminster

29. William Dent, *The Dutchess Canvassing her Favourite Member* (etching, 1784)

by-election four years later (**plate 6**). Here, in 1788, the Duchess Georgiana looks out at us as she stands centre-stage in virginal white alongside her sister Duncannon and the latest Foxite candidate, Fox's old Etonian chum Lord John Townshend. In the right background, the Prince of Wales and his mistress Mrs Fitzherbert scatter the plebeians by spearing their phaeton straight through them. The squint-eyed and yellow-clad John Wilkes has his pocket picked to the left, while the bespectacled and behatted Edmund Burke talks to the Duke of Norfolk, right. There's a parody here of Hogarth's *Idle 'Prentice Executed at Tyburn* and also of Thomas Rowlandson's *Vaux-Hall*, exhibited at the Academy three years earlier and engraved shortly after, in which Georgiana and Lady Duncannon again hold centre-stage with the Prince of Wales in the offing, though surrounded by highly fashionable people. Dighton's style and palette are very like Rowlandson's. Needless to say, his picture is artfully composed; yet it fairly illustrates the social mixing of rich and poor on such occasions. The election is in full swing, and the great are surrounded by a mêlée of pestering and tattered men, women and energetic boys, and panniered donkeys and salesmen. A Hogarthian ballad-singer sings on the right; Fox's emblem is held up on a stick, an unfortunate cat is thrown through the air, and in the background there is an ominous waving of sticks and staves. Stylized though it is, this image comes second only to Hogarth's election paintings in conveying the hustings' energy.

The sticks and staves? Given the fact that Covent Garden had been devastatingly invaded by Gordon rioters in 1780, it is strange how tolerated, even licensed, these threatening implements were – or, in that unpoliced society, how tolerated they had to be. Little was done to curb them. During the six weeks of polling in 1784 (Westminster elections were prolonged affairs), gangs of sailors regularly arrived from Wapping waving banners and banging drums in support of the two ministerialist candidates, not least because one of them was the nation's naval hero, Admiral Hood, and some claimed he had bribed them to attend. The bludgeon-wielding sailors intimidated the Foxites gathered in the Shakespeare Tavern; they intercepted Fox in Charing Cross and forced him to take refuge in a private house; and they waged pitched battles with Covent Garden's Irish chairmen in James's Street, where most chairs were parked. Within days the Irish had broken

'scores' of sailors' ribs, arms and legs and fractured 'several' skulls – the kinds of common injury that in those days were never properly counted and only perfunctorily mentioned in newspapers.

These reprisals might have calmed the crowds had not a much hated Shoreditch magistrate named David Wilmot at this point summoned a body of Tower Hamlets constables to the ministerialists' aid. The Foxites published one of his letters: 'Sir, I expects soon to be call'd out on a Mergensey, so send me all the ax of parlyment re Latin [relating] to a Gustis of Piece. I am, yours to Command &c, Justis Wilmot.'[57] What ensued was witnessed by Sheridan, himself a Whig MP, owner-manager of the Theatre Royal, Drury Lane, and by now famed as the author of *The School for Scandal*. He thought Wilmot's men 'a very extraordinary sort of people' who looked not at all like peace officers. They proved his suspicion by abusing Foxite voters and disrupting the poll with shouts of 'No Fox!' This drew the attention of the marrow-bones and cleavers and the chairmen. In the great punch-up that ensued a constable was killed, though it was never clear by whom. At the murder trial in the Old Bailey a month later, a porter testified that the riot was begun by 'chairmen, and butchers with cleavers':

> I saw the butchers begin with the marrow-bones, and then the cleavers, and they went marching on, and the chairmen followed the butchers, and were marching from Henrietta-street to King-street . . . The constables came, part of them were in Henrietta-street and part in King-street; the butchers . . . let the Irish chairmen in till . . . they got right facing the constables: . . . the Irish chairmen began to play with their staves . . .; one of the chairmen called out to his companions, Go it, my boys, go it. Then the chairmen began playing with their bludgeons; I did not see the butchers strike any person, the chairmen began cutting and knocking down every person they met, knocking away with their sticks.

The accused were acquitted, however, when Sheridan testified to the court that the constables got what they had asked for, that 'there was not one marrow-bone and cleaver came up while I was there', and that the dead man had been knocked on the head by his colleagues. When Sheridan stood as Whig candidate for Westminster in 1806, his defence of truth those twenty-odd years ago didn't stop a butcher armed with marrow-bone and cleaver knocking him on the head too.[58]

3

Harlots

O may thy virtue guard thee through the roads
Of Drury's mazy courts and dark abodes!
The harlots' guileful paths, who nightly stand
Where Catherine-street descends into the Strand.

John Gay – *Trivia, or The Art of Walking the*
Streets of London (1716)

ON PROSTITUTES

Covent Garden's street girls were unavoidable presences in the eighteenth-century artistic and literary imagination. They populated not only Hogarth's moral narratives but also the work of artistic commentators on London life subsequently, from Paul Sandby and John Collet on to Thomas Rowlandson (fig. 30), and countless lesser print-makers and satirists besides. In theatre and novel, Polly Peachum, Mother Cole, Moll Flanders and Fanny Hill were all Covent Garden archetypes. 'Baudy Covent Garden,' the writer D'Urfey hailed it in 1707, 'that filthy place, where ne'er a Wench was ever worth a Farthing.' 'This town two bargains has not worth one farthing, /– A Smithfield horse, and wife of Covent Garden,' wrote Dryden. 'Paltry and proud as drabs in Drury Lane,' said Pope. According to Ned Ward, the Covent Garden whore hung her clothes on herself 'according to the Drury-Lane Mode, as if she could shake 'em off and leap into Bed, in the Twinkling of a Bed-Staff'.[1]

In view of her ubiquity and her prominence in moral discourses, novels and plays, artists' preoccupation with the prostitute is unsurprising.

30. Rowlandson, *Angry Scene in a Street* (pencil, ink, watercolour, 1805–10)

They doubtless found her presence as intrusive as others did, but this dangerous 'other' also provoked a gutsy curiosity. To Hogarth's prostitute images we turn in chapter 8. Suffice to note here that he makes most of his whores come to sticky ends – in *A Harlot's Progress*, *A Rake's Progress*, *Gin Lane* and *Industry and Idleness*. His interest in moralizing at the prostitute's expense was significantly diluted in the artists who followed him, however. Images of prostitutes that noted their pathos, or deplored their very existence or endorsed their 'reform' became extremely rare. Countless satires in the second half of the century aimed less at the whore than at the punter's gullibility, establishing kinship in this with guidebooks that warned of the tricks of the town. Rowlandson, similarly, simply celebrated the prostitute's vitality. In fig. 30 he depicts a street fight, supplementing it with his usual caricatured embellishments – a larceny here, a snatched cuddle there, breasts bared everywhere – but he doesn't moralize. Again, the fine stipple engraving taken from his *Sketch from Nature* (1784) (fig. 31) paid its respects to Hogarth's orgy scene in *A Rake's Progress* over a half-century before (fig. 47 below). But his print subverts Hogarth's

31. William Paulet Carey, after Rowlandson, *A Sketch from Nature* (stipple engraving, 1784)

moralism by allowing the young their erotic energy. The girls are merry, pretty and unabashed. While the drunken old bawd sleeps and the old man is teased, there is none of the thieving and pocket-picking that Hogarth had depicted. Uniquely, Rowlandson allowed the wretched some happiness. He was never one to insist that a cheerful Bacchanal must lead to a grim denouement.

Other prostitute images simply observed the moment, or implied a narrative whose origins and outcomes are withheld. They could achieve a startling candour without being titillatory or judgemental. John Collet's *The Guards of the Night Defeated* (1774), for example, took sides with the whore against the law's intrusiveness (fig. 32). In a vigorous engraving he allows the girls power enough to vanquish the raiding constables. Better still is the superbly atmospheric mezzotint that Carington Bowles published from Collet's *Fielding's Myrmidons Spoiling Bob Booty's Morning Draught* (1781) (fig. 33).

32. James Caldwell, after John Collet, *The Guards of the Night Defeated* (etching, 1774)

Sir John Fielding's Bow Street Runners – the 'myrmidons' of the title (Fielding had died a few months before this was published) – disturb the highwayman at his nocturnal pleasures. He and his girlfriends have come from a masquerade. One girl reaches for his pistols; a banknote lies on his coat at the foot of the bed, and a framed picture of Jack Sheppard is on the wall. Collet's image fuses one of the narrative scenes in Hogarth's *Industry and Idleness* with an allusion to *The Beggar's Opera*. (Mrs Peachum's favourite thief in the *Opera* was 'Robin of Bagshot, alias Gordon, alias Bluff Bob, alias Carbuncle, alias Bob Booty'.) But Collet's work differs from Hogarth's by leaving us unsure whose side we're meant to be on – the threesome in bed or the Bow Street men in the doorway. This ambivalence gave an edge to many examinations of low-life in the last decades of the century. It put them at a fair distance from the merely voyeuristic.

*

33. John Collet (after), *Fielding's Myrmidons Spoiling Bob Booty's Morning Draught* (mezzotint, 1781)

For better or worse, the sexual vices of eighteenth-century Covent Garden have fascinated popular historians for some 200 years. This book must attend to them too, for its own reason. They were central to the realities that our 'bohemians' experienced and noticed.

Publicly, no doubt, people of standing either pretended not to notice the prostitute's existence, or else they shared the repugnance of Fielding's Joseph Andrews: 'their persons appeared to me as painted palaces, inhabited by Disease and Death: nor could their beauty make them more desirable objects in my eyes than gilding could make me covet a pill, or golden plates a coffin'. Yet there's no knowing how sincere or widespread views of this kind were, for throughout the century other opinions were more audible, some of them brutal, others generous. The most unpleasant were the coldly instrumental or the mindlessly jocular. 'I went to the Park,' James Boswell wrote in 1763, 'picked up a low brimstone, called myself [pretended I was] a barber,

74

and agreed with her for sixpence, went to the bottom of the Park arm in arm, and dipped my machine in the canal and performed most manfully'. After such encounters Boswell was often disgusted with himself, but not invariably. Here he is at work in the Shakespeare's Head tavern, in the north-eastern corner of the Piazza:

> I then sallied forth to the Piazzas in rich flow of animal spirits and burning with fierce desire. I met two very pretty little girls who asked me to take them with me. 'My dear girls,' said I, 'I am a poor fellow. I can give you no money. But if you choose to have a glass of wine and my company and let us be gay and obliging to each other without money, I am your man.' They agreed with great good humour. So back to the Shakespeare we went . . . We were shown into a good room and had a bottle of sherry before us in a minute. I surveyed my seraglio and found them both good subjects for amorous play. I toyed with them and drank about and sung 'Youth's the Season' and thought myself Captain Macheath; and then I solaced my existence with them, one after the other, according to their seniority. I was quite raised, as the phrase is: thought I was in a London tavern, the Shakespeare's Head, enjoying high debauchery after my sober winter. I parted with my ladies politely and came home in a glow of spirits.[2]

Harris's List of Covent Garden Ladies; or, The Man of Pleasure's Kalendar catered for men exactly like Boswell. In its several editions it sold thousands of expensive copies at two shillings and sixpence each by listing girls' talents in facetious by punning terms: 'Miss M[on]tague is a well-shaped girl, about twenty-three, good-natured and said to be thoroughly experienced in the whole art and mysterie of Venus's tactics and [will] as soon reduce a perpendicular to less than the curve of a parabola. She is rather generous and you may sometimes find your way in there free of expence [*sic*].'[3] Sex was a joke which both sexes shared. 'Pray, Mr Quin, do you ever make love?' the Duchess of Queensberry asked the portly actor James Quin. 'No, Madam,' he replied, 'I always buy it ready made.'[4] Isaac Bickerstaffe's farce *The Modern Poetasters . . . as Acted in the Hundreds of Drury* (1721) has this:

> GOOSE: . . . we'll quit this Conversation, and retire to a House of Diversion in the Hundreds of Drury; we'll drink 'till we rival the Sun with our

ruddy Complexions; set up all Night with the Moon; lye with half a Dozen Virgins; break all the Windows of the Mansion; and then, like true Sons of Parnassus, make a hasty Escape, and pay no Reckoning.

Countless men either took for granted their entitlement to use women or found it convenient to assume that women were equal or more lustful partners in their transgressions. Beneath these postures lay fear also. Late in the century the philanthropist Jonas Hanway calculated that 3,000 Londoners died annually of venereal disease.[5] Sexual adventures were dangerous in that era. Women feared pregnancy, and both sexes feared infection. Men who got too close to Drury Lane women risked the 'Covent-Garden gout' (1697) or 'Covent-Garden ague' (1778). The warning literature was brutal: 'But three Days past – Oh! Needles, poynts of Pins, My Back – My Head – My xxxx Oh! My Shinns, Lets see my Shirt Oh! Spots of Green and Yellow What will my Father say – A Pretty Fellow' – this the subtext to the engraving of a young rake in his bedroom in a volume of 'rake' verses in 1732 (fig. 34).[6] Or, as other verses put it some years later:

> But O fond Youth! Forebear! take sage Advice!
> Gaze not with Wonder on the Cockatrice:
> Trust not the Adder for her spotted Skin!
> Least when's too late you'll feel the poisonous Sting.[7]

The cure was more than offputting. Boswell, advising a friend in 1763 to 'take care of falling under the Displeasure of Dame VENUS', told him that if ever he were 'sous'd again' he would find 'a Pewter Syringe is the best. Eheu!' His sigh was heartfelt, for he was experienced in the matter. To cure gonorrhea, mercurial remedies were injected by syringe directly into the inflamed urethra. He was to endure this many times in his life. Not surprisingly, he put his fullest trust in those 'fine Machines called cundums' that Mrs Philips of Half-Moon Street had been selling for forty years, and which she so poetically advertised:

> To guard yourself from shame or fear,
> Votaries to Venus, hasten here,
> None in our wares e'er found a flaw,
> Self-preservation's nature's law.
> 　　Letters (post paid) duly answered.[8]

But three Days past — Oh! Needles, poynts of Pins,
My Back — My Head — My XXXX *Oh! my Shinns,*
Lets see my Shirt Oh! Spots of Green and Yellow
What will my Father say — A Pretty Fellow.

34. Anon., 'Oh! Needles, poynts of Pins, My Back –
My Head – My XXXX...' (etching, 1732)

Made of washable animal membrane, usually catgut, the 'Machines'
had dainty pink ribbons to tie them on with (fig. 35).[9]

Despite the exploitation, jocularity and fear, more humane voices
were beginning to acknowledge the pathos of the prostitute's plight,

35. Condom (*c.* 1790–1810)

so that nobody, not even Boswell, not even the compiler of *Harris's List*, could be unaware of the sad realities they so casually exploited. As early as 1712, Richard Steele of the *Spectator* had offered this poignant vignette. It sounded the first notes in the sympathetic chorus that was gradually amplified as the decades passed:

> The other evening, passing alone near Covent-Garden, I was jogged on the elbow as I turned into the Piazza, on the right hand coming out of James-street, by a slim young girl of about seventeen, who with a pert air asked me if I was for a pint of wine ... We stood under one of the arches by twilight; and there I could observe as exact features as I had ever seen, the most agreeable shape, the finest neck and bosom, in a

word, the whole person of a woman exquisitely beautiful. She affected
to allure me with a forced wantonness in her look and air; but I saw it
checked with hunger and cold: her eyes were wan and eager, her dress
thin and tawdry, her mien genteel and childish. This strange figure gave
me much anguish of heart, and, to avoid being seen with her, I went
away, but could not forbear giving her a crown. The poor thing sighed,
courtesied [curtsied], and, with a blessing, expressed with the utmost
vehemence, turned from me.

Steele assumed that the girl was newly come to town and had already
been debauched, because he very well knew how that process worked.
A week earlier in a City inn he had witnessed 'the most artful pro-
curess in town' quizzing a country girl newly arrived in the carrier's
waggon: the girl's 'innocent *forsooths, yes's, an't please you's, and she
would do her endeavor*, moved the good old lady to take her out of
the hands of a country bumpkin her brother, and hire her for her own
maid'. Steele predicted that 'after she has been long enough a prey to
lust, she will be delivered over to famine'. This was the scene that
Hogarth exactly replicated in the first plate of *A Harlot's Progress*
twenty years later.[10]

By mid-century compassion was more widespread. 'As we walked
along the Strand tonight, arm in arm,' Boswell reported of a walk
with Johnson, 'a woman of the town accosted us, in the usual enticing
manner. "No, no, my girl (said Johnson,) it won't do".' He and Boswell
proceeded to discuss 'the wretched life of such women', agreeing that
'much more misery than happiness, upon the whole, is produced by
illicit commerce between the sexes'.[11] This was a bit rich coming from
the sexually incontinent Boswell; but Johnson lacked Boswell's preda-
tory compulsions. After his wife's death he found consolation in
company and conversation, and when that failed he would wander
the streets at night and converse with the street girls he met. 'Of these
he was very inquisitive as to their course of life, the history of their
seduction, and the chances of reclaiming them. The first question he
generally asked was if they could read.'[12] One girl's account he turned
into his fiction, *Misella*, in 1751:

If those who pass their days in plenty and security could visit for an
hour the dismal receptacles to which the prostitute retires from her

nocturnal excursions, and see the wretches that lie crowded together, mad with intemperance, ghastly with famine, nauseous with filth, and noisome with disease; it would not be easy for any degree of abhorrence to harden them against compassion, or to repress the desire which they immediately feel to rescue such numbers of human beings from a state so dreadful.

The replies he got from talking to street women could be heart-stopping. 'Of one who was very handsome, he asked, for what she thought God had given her so much beauty: she answered – "To please gentlemen".'[13]

In 1758 the blind magistrate John Fielding (the novelist Henry's half-brother) described how 'on a search night, when the Constables have taken up near forty Prostitutes, it has appeared on their Examination, that the major Part of them have been . . . under the Age of Eighteen, many not more than Twelve, and those, though so young, half eat up with the foul Distemper'.[14] He, Jonas Hanway and others established the Magdalen House for Penitent Prostitutes in Whitechapel a few months later.

STREET GIRLS

Even if most of the courtyards that ringed Covent Garden weren't as benighted as moralists made out, some were frightening enough. The low women got the blame as ever, but the bad men were worse. In some courtyards the contrast with the open streets would hit you at once – and literally. These were the 'lanes, alleys, courts and by places' that Henry Fielding had in mind when he described London as 'a vast wood or forest, in which a thief may harbour with as great security as wild beasts do in the deserts of Africa or Arabia'.[15] And, though more or less honest labourers lived in all these places, here also lived the poor men and women who pimped, stole, begged or sold themselves as need or chance dictated. In the Piazza in the 1740s pickpockets were said to emerge from the courtyards 'in large bodies, armed with couteaus [knives], and [to] attack whole parties' after the theatres closed'.[16] If you entered their quarters as a moderately well-dressed male (well-dressed women daren't go there), you would be proposi-

tioned, and if you didn't accept the offer, you'd be taunted, and if you went with a girl overnight, and were drunk, you had a chance of losing your watch or being beaten up. Even in the main streets a finely dressed man would be mocked, especially if he was foreign. Giacomo Casanova reported that 'a porter, a loafer, a scapegrace from the dregs of the people would throw mud, laugh in his face, push him to make him say something'.[17]

Then as now, people who read too many trial reports could pass their lives in mild panic. Here's a random example of the tales they would encounter. At ten one evening in October 1799, Henry Scoen of Leicester Square, an auctioneer's son, went looking for a whore down Vine Street (a cul-de-sac off Chandos Street). Mary Box (alias Ward) 'took hold of me, and asked me if I would go with her':

> Accordingly I went with her, up one pair of stairs to her chamber, at No. 1, Newton's-court;[18] when I went up with her, she told me there was a very good looking young woman below stairs; that she would call her up; then she called up ... Frances Smith, [who] began to squeeze pretty close to me; I told her there was no necessity for her coming-up [so close]; after a little while she asked me to give her a shilling, which I did after a minute or two; she left the room, and then I was alone with Mary Box.

Scoen couldn't or wouldn't recall whether Frances joined him and Mary in bed, but he did remember that at one point both women left the room and that he then missed his gold watch. When he challenged Box on her return, she told him that Frances Smith must have taken it, so they got dressed and together plunged into 'several passages that were unknown to me before' (very dimly illuminated by occasional candle-lit windows). At the end of a courtyard

> were several women standing up; I believe the court led into the Strand; then Mary Box came between me and the others; the women asked me what the matter was, I told them I had lost a watch; in the meanwhile Mary Box ran away, and not knowing the different windings, I lost sight of her.

Scoen had to be rescued from the labyrinth by a watchman who returned him to Vine Street.

Next morning Scoen had the constable take Mary and Frances before the Bow Street Justice. The fairness of his doing so was challenged. 'Question. You do not know how many other girls there might be in that house? – Answer [Scoen]. No. Q. Do not you know it is a house full of girls? – A. Yes.' Thanks to these admissions the girls were discharged for want of evidence. Later the case was resumed when one Sarah Williams (another 'unfortunate woman', she called herself) came forward to testify that she lived in Vine Street with several women in her own 'way of life', and that she knew Mary and Frances because she 'walked up and down the streets with them'. On the night of the theft, Mary Box had joined her in her room, along with Frances Smith. Frances had pulled a watch from her bosom. This they had then buried in '*mud*' in Taylor's Passage off Bedfordbury before looking for someone to sell it to. Asked why she hadn't given evidence earlier, Williams said she had been frightened of Frances Smith's 'man'. Then she admitted that she had visited the accused women in their Newgate cell and had tea with them. The court decided that her account was unreliable. Mary and Frances were acquitted.[19]

They were lucky, since both had form, it seems. Mary's alias was known at the Old Bailey, while a Frances Smith appeared before the Westminster justices as a disorderly person in 1794 and again at the Old Bailey in 1796. Since the name was common, this might mean nothing; but the prosecutor's complaint against her sounds familiar: 'LUKE VERNEYsworn. – I drive a post-chaise; I met with the prisoner in Long-Acre about eleven o'clock at night, we went and had something to drink together, and then I went home with her to her lodgings, in Parker's Lane [off Drury Lane's eastern side]; she was a stranger to me.' When he woke at 4.30 in the morning she was nowhere to be seen. Nor were three guineas and a silk handkerchief. Frances leaves her trace in the Prison Registers: 'aged 29 years, sallow complexion, brown hair, hazle eyes, single'.[20]

*

The most poignant summary of the street girl's decline as time or disease took its toll was written in the female voice in Polly Peachum's song in Gay's *Beggar's Opera*:

Virgins are like the fair flower in its lustre,
Which in the garden enamels the ground;
Near it the bees in play flutter and cluster,
And gaudy butterflies frolic around;
But, when once pluck'd, 'tis no longer alluring,
To Covent-garden 'tis sent, (as yet sweet).
There fades and shrinks, and grows past all enduring,
Rots, stinks, and dies, and is trod under feet.

The harlot's most likely progress was here gently stated. Others, like the Grub Street journalist Ned Ward, put the point with more brutality:

She may riggle her Breech into such taudry Silks as the Tally-man will trust her with; become a celebrated Punk [prostitute] in Drury-Lane Pit, for the first Year or two; after that a Tatter'd Furbulo Customer for the Eighteen-Penny Gallery; from thence turn Fleet-street Stroler, in a Sarsnet-Hood and White Apron, only a fit Mistress for a Water-Lane Pick-pocket; in which miserable Station she is likely to continue, till Pox and Poverty recommend her to an Hospital, where a thorough Salivation [mercury treatment for pox produced excessive saliva] either sends her to the Devil, or patches up her rotten Carcase for some foreign Plantation.[21]

The image of the ageing street woman disordered by pox and drink was to feed into Rowlandson's frighteningly uncompromising depiction, many decades later, of a *Bawd on her Last Legs* (**plate 7**), one of his many darker images that mix disgust with a determination to confront the real.

Drink helped none of these women. By the 1740s the average annual gin consumption in Britain exceeded six gallons per person; nearly a half of all wheat harvests went to gin, and some one in four houses in St Giles's were said to be selling it. The way things were going, Henry Fielding wrote, there would soon be 'few of the common people left to drink it'. It might have been the gin craze, primarily, that produced the exceptional peakings in London's mortality rates and the substantial drop in its baptisms that marked the second quarter of the century.[22] Hogarth's *Gin Lane* (1751) was one well-known effort to alert London to the crisis (fig. 36). He set his gin-sodden mother

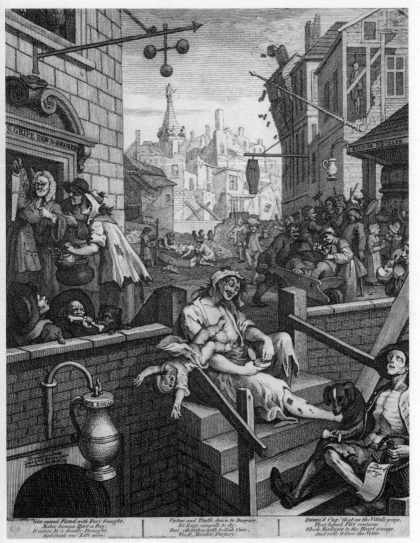

36. Hogarth, *Gin Lane* (etching, engraving, 1751)

with her baby tumbling unregarded in St Giles's (the tower of St George's, Bloomsbury, visible in the distance) in a print fearsomely packed with multiple emblems of depravity, suicide and death.

Gin Lane's point about the drunken mother's shortcomings was fair enough. Accidental and unwanted offspring were only too easily disposed of elsewhere if necessary, or deserted and left to their fates if mothers were gaoled, transported or hanged. Feral children haunted London's byways. The Black Boy Alley gang, based in the alley of that name off Chick Lane, Smithfield, was described as a 'brother- and sisterhood of rogues, thieves, and raggimuffins [*sic*], [who] usually past [*sic*] their miserable days on the dunghills and laystalls; their nights like wild beasts hunting after prey'. 'There is a hill near that place,' the thief-taker who caught them explained at their trial, where 'sometimes forty or fifty of them will sit together in the day time, smoaking their pipes and drinking'.[23] These were the forebears of those 'miserable children in rags' under the Covent Garden arches that Dickens described in *Little Dorrit*, who 'like young rats, slunk and hid, fed on offal, huddled together for warmth, and were hunted about'.

Living off their bodies and wits, their records and identities usually known to the constables however often they changed lodgings, the street girls spent much of their lives in and out of lock-up, court and prison. When free, they spilled into the Strand routinely. 'At night-fall they range themselves in a file in the foot-paths of all the great streets, in companies of five or six, most of them drest very genteely. The low-taverns serve them as a retreat, to receive their gallants in: in those houses there is always a room set apart for this purpose. Whole rows of them accost passengers in the broad daylight; and above all, foreigners.'[24] Rowlandson, a compulsive rapporteur on such matters, caught their brazenness in an on-the-spot sketch which he took home to redraw and lightly colour (fig. 37) – a good illustration here of his street observation at work.

People got upset by this nuisance. The Strand was infested with 'nothing but strumpets and pickpockets', *The Times* declared in 1787: 'They assemble in such crowds, and behave with such indecency and audacity, as makes it dangerous and shocking for any female of character to pass

37. Rowlandson, *Women on Steps* (on-the-spot ink sketch, and watercoloured drawing, no date)

that way.' Complaint extended well into the next century about the damage they did to shopkeepers' custom and about their night-time screaming and cries of murder. Exeter Street ratepayers were still complaining about one Mrs Crutchley's house in which the screams of 'women of the lowest description ... throughout the greater part of the night keep the neighbourhood in a constant state of annoyance ... Women in a state of almost perfect nudity and drunkenness are constantly exposing themselves in the yard of the said premises over which the windows of our houses look to the constant annoyance of ourselves, our wives and families.'[25] Or as the Westminster justices were told in 1803, Marygold Court off the Strand was

in a continued riot from the constant contention kept up among the wretched inmates, who were frequently seen half naked exerting their martial spirits upon each other ... In the evening they began to dress, and to assemble by dozens at the end of the court next the Strand, so

that the shopkeepers were deprived of custom, and the attention of the passenger wholly directed to their lewd orgies.[26]

It was the 'nudity' that upset most of these complainants. Street girls' exposed breasts were commonly depicted in satirical prints or in Rowlandson's drawings. Many were doubtless fantasies. Yet the radical misogynist Francis Place remembered from his Drury Lane youth gowns that were open 'to expose their breasts this was a fashion', and breasts that 'hung down in a most disgusting manner'. 'Fighting among themselves as well as with the men was common and black eyes might be seen on a great many,' he added. John Collet depicted several street fights between women; Rowlandson did the same (fig. 30). In mid-century, young William Hickey visited a dive called Wetherby's in Russell Street in which two women fought in a scratching and boxing match, 'their faces entirely covered with blood, bosoms bare, and the clothes nearly torn from their bodies'. He then escaped to Murphy's in the same street, and found it full of pickpockets and prostitutes. Next, he and his friends visited three bawdy houses in Bow Street 'in rotation'. One was 'under the very nose' of the magistrate Sir John Fielding, and it puzzled Hickey that Fielding was not only literally blind but also apparently deaf to the riotous mayhem next door.[27]

Usually excluded from respectable complaints about these places were references to their profiting landlords. In 1803, however, the parish officers of St Martin-in-the-Fields brought a prosecution against the owner of the Marygold Court houses. He was a shopkeeper-*rentier* named Jesse Horwood (no relation to the map-maker), and in Marygold Court he both ran a victualler's shop and, according to the ratebooks, owned six houses. Two were rated at £14, the others at £12, £7, £8 and £6 – humble places, in other words, 'let out in tenements, from the ground floors to the attics, the price varying according to the elegance of the accommodation'. Horwood had a respectable front. He had served on coroners' juries in the 1760s. For some forty years he was the 'collector' for a decayed musicians' benevolent fund. In 1782 he had prosecuted one of his lodgers, a soldier, for stealing scrap iron from his attic, and got the man transported for seven years. By 1802 he was living fashionably on King (today

Kingly) Street between Oxford Street and Golden Square; and the electoral pollbook for that year described him at that address as a 'gentleman'. He got away with his misdemeanours in 1803 by explaining that his leases were so high that he had to let to 'girls of the town' out of necessity, even though he disliked doing so. Luckily for him, the girls who lived there testified that they had always paid their rents to *Mrs* Horwood, and that she had been 'particularly anxious that Mr Horwood should have nothing to do with her fair tenants', and that she had recently died. On this account, helped also by his acceptable dress and address and advanced years, Horwood was acquitted.[28]

DOING WELL

Not all street girls met dreadful fates. There were hierarchies in whoring, and it was with good reason that innumerable prints depicted girls on the town who were much more elaborately dressed than Boswell's sixpennies (fig. 38). These middle-rankers were allowed names and identities. They had risen just as artists and actors had risen; and one could *know* them. Stories such as Cleland's *Woman of Pleasure* cut against the messages that moralists like Hogarth felt obliged to tell, for in the long run Fanny Hill married well. They took their cues from Defoe's great fiction of 1721:

> THE FORTUNES AND MISFORTUNES of the FAMOUS *Moll Flanders*, &c. Who was BORN in NEWGATE, and during a Life of continu'd Variety of Threescore Years, besides her Childhood, was Twelve Year a *Whore*, five times a *Wife* (whereof once to her own *Brother*), Twelve Year a *Thief*, Eight Year a Transported *Felon* in *Virginia*, at last grew *Rich*, liv'd *Honest*, and died a *Penitent*. Written from her own MEMO-RANDUMS.

Moll Flanders was a composite of several female thief-whores whom Defoe had interviewed in Newgate or read about in criminal reports. Defoe himself had stood three days in the Temple Bar pillory and then spent four months in Newgate after he was convicted of seditious libel in 1702. Its picaresque structure, its plausible narratives of failed as well as successful thefts, and its close attention to circumstantial

MISS LOVEJOY.
Pub accor to the Feb.ᵉ 9.ᵗ 1772 by Marly Strand

38. *Miss Lovejoy*, from *Caricatures, Macaronies &
Characters* (etching, M. Darly, 1772)

and neighbourhood detail, all spoke for first-hand knowledge as well
as conscientious research and reporting, and strengthened Defoe's
claim that he wrote from 'fact'. Invented here in this first of all novels
was both a new subject and a new literary form that rooted itself in
real lives as Hogarth's pictures would.*

A century later, William Hazlitt condemned Moll's character as vile

* Defoe lived in the City but had two of *Moll Flanders*'s first three editions (1722)
'Printed for, and Sold by W CHETWOOD, at *Cato's-Head*, in Russel-street, Covent-
Garden; and T. EDLIN, at the *Prince's-Arms*, over-against Exeter-Change in the Strand
. . .' [etc.]. A Covent Garden gambling den was the scene of one of Moll's adventures.

and detestable, while Charles Lamb wrote that so amoral a novel would never now appeal to people higher than servant-girls. All the same, the novel is free of cant. Its main purpose is to expose the deceit and opportunism that ruled the marriage market and the underworld alike. It is also one long meditation on the right way to conduct oneself in adverse conditions, and, predator though she is, Moll's moral debate with herself is incessant. Not only does she think that promiscuous sex is acceptable if it advances a woman's interests; she also shows that if a woman of the town plays her hand intelligently, finds wealthy protectors, and picks pockets or shoplifts skilfully, the wages of sin might be generous. She never ceases to fear 'the terrible prospect of poverty and starving, which lay on me as a frightful spectre', but she knows that she is far above the 'imprudent brazen wench of Drury Lane breeding'. And after many vicissitudes, narrowly missed arrests, and nearly respectable marriages (one, mistakenly, to her hitherto unknown Newgate-born brother), Moll can boast in middle age that she has '£700 by me in money, besides clothes, rings, some plate, and two gold watches, and all of them stolen'. A botched theft lands her in Newgate (where she had been born). She narrowly escapes the noose, transports herself to the colonies, and there finds a good husband and lives happily ever after.

This was a model that many real-life courtesans lived up to, some indeed who did better even than Moll. The beautiful Fanny Murray (1729–1778) may stand for many. She started young, though without much choice in the matter. She was seduced by the Duke of Marlborough's grandson, Jack Spencer, when she was a twelve year-old flowergirl in Bath. Discarded, she became Beau Nash's mistress. When he discarded her in turn in the 1740s, she got herself to London and lived hand-to-mouth in Covent Garden, her money soon exhausted in debts to her landlady and in 'chirurgical fees' to treat the pox. According to her semi-fictionalized biography, her solution was to lay on her rouge, dress up in 'dabs', and embark on a week's intensive patrolling in the Strand and Fleet Street. By the end of a week she had earned £5. 10s. 6d. Against this she had to pay her landlady £1. 15s. 0d. for board and lodging (the board mainly 'small beer and sprats') and an extortionate £3. 1s. 0d. for the loan of a brocade gown, stays, silk stockings, silk shoes, stone buckles, smocks,

H. Morland Pinx. J. McArdell fec.

Miss. Fanny Murrey.

Here sportive Loves inviting seem to say,
Behold this Face, and gaze your Heart away.

Sold by J.M.Ardell at the Golden Head Covent Garden.

39. James McArdell, after Henry Morland, *Miss Fanny
Murrey* [sic] (mezzotint, 1740–56)

ruffles, petticoats ('all of the lower sort, except one water tabby
petticoat piss-burnt': i.e. yellowish or urine-stained taffeta), a hat and
ribbons, a capuchin (cloak), a gauze apron, and a gauze handkerchief
– mostly 'worthless'. To this she had to add 6d. for 'pins', 3s. for brushes,

carmine and tooth-powder – both made of brick-dust, and 10s. 6d. for 'seeing the constable of the night, for preventing her going to Bridewell'. This put her week's profit at sixpence.[29]

Her luck turned when her implausibly virginal demeanour and beauty were advertised in *Harris's List* as those of 'a fine brown girl, rising nineteen next season, perfectly sound in wind and limb'. She was then allegedly picked up and kept by John Montagu, fourth Earl of Sandwich, and it was a mark of her new-found distinction that George Morland's father, Henry, painted one of her two portraits, here engraved by James McArdell of Henrietta Street: 'Here sportive Loves inviting seem to say, / Behold this Face, and gaze your Heart away', the sub-text reads (fig. 39). Lord Chancellor Hardwicke claimed to have seen a portrait of her and another courtesan, Kitty Fisher, both naked, in the collection of Sandwich's brother, William Montagu. (The Montagu clan had a reputation for this kind of thing. The Earl of Sandwich was already in love with Martha Ray – whose mother he had paid £400 for 'the purchase of his daughter's honour'. He lived with her for some eighteen years until she was shot dead by a jealous lover outside Covent Garden Theatre in 1779. His love for her didn't stop his dalliances on the side.) Fanny, however, made good. In the 1750s she married the actor David Ross and lived more or less respectably until her death in her forty-ninth year.[30]

*

Few humbly born women achieved outcomes as satisfying as Fanny Murray. But many found that the next best thing to marriage, common-law or otherwise, was the running of a coffee-house or bagnio – even if a rumbustiously comic low-life vignette by the Grub Street journalist Ned Ward shows that these careers didn't necessarily amount to much.

One day Ward and a companion paid a visit to a widow's coffee-house in the City. It was a dreadful den. They had to 'blunder thro' the long dark Entry of an Ancient Fabrick' and then up stairs 'which were rais'd as Perpindicular as a Tilers Ladder'. Inside, the widow advertised her virtue on their arrival by composing herself before a Bible on the table. She was surrounded by bottles, a green earthernware chamber-pot

stood in the corner, and on the mantelpiece lay a patch-box and a syringe for the pox, flanked by advertisements for a 'rare White-Wash for the Face' and for 'the speedy cure of a violent Gonorrhea, without loss of time, or hindrance of Business'. Otherwise there were just 'a broken Floor like an old Stable, Windows mended with Brown paper; and bare Walls full of Dust and Cobwebs'. Ward was about to seat himself when the whole house began to shake wondrously:

> Of a sudden [I] felt such a trembling in the Fabrick, that the Windows jarr'd, the Fire-Irons jingled, in short all things in the Room seem'd to be in motion, and kept time, with a tinkling noise, like the Bells in a Morris Dance; that had I not some reasons to suspect the contrary, I should have been under the frightful Apprehension of an Earthquake. But in a little time the violent Pulsation, that had given an Ague to the whole House was over, and all things were again reconcil'd to their former rest.
>
> Presently after came down Stairs, from a loftier Apartment, reserv'd for Private Uses, a couple of Airy Youths, who, by their Crop'd Hair, Stone Buckles in their Shoes, broad Gold Hatbands, and no Swords, I took to be Merchants Sons, or the Apprentices of topping Traders. They stay'd not above a Minute in the Coffee Room, but, Magpye like, ask'd what's a Clock? Then made their Honours after the newest Fashion, and so departed.

A little later, the men were followed downstairs by 'a couple of Mortal Angels as nimble as Squirrels, with Looks as sharp, and Eyes as piercing as a Tygers, who I suppose, after rumpling their Feathers in a hot Engagement, had staid to rectifie their disorder'd Plumes, and make ready for a fresh Encounter'. When Ward's companion asked one of them to repay a debt she owed him, she feistily dismissed him as a 'Twat-Scouring Pimp'. The argument was dropped when a sober citizen ascended the outer stairs. The girls assembled their rods and birches (freshly purchased) and without more ado retired with him to 'their Secret Work-Room of Iniquity' to earn their next few pennies.[31]

Of course many coffee-houses were high-minded, or politically minded or, in the City, business-minded – and we'll see later how important they were to Covent Garden artists. But perhaps historians get a little too solemn about these venues, because they are supposed to have

been central to the so-called 'public sphere' of early-modern sociability. Yet few have realized that, as Ward's story suggests, probably only a minority of coffee-houses were like these favoured places.[32] 'Bawds,' *The Country Gentleman's Vade Mecum* affirmed in 1699, 'generally keep Seraglio's . . . with the Superscription of Chocolate or Coffee over their Doors, which are constantly guarded with three or four painted Harlots.' Another writer noted that there was 'scarce a Coffee-Hut but affords a Tawdry Woman, a wanton Daughter, or a Buxome Maide, to accommodate Customers'. The early coffee-house sign of a 'Turkish Woman stradling' [*sic*] was an 'Emblem of what is to be done within'.* The writer Thomas Brown stated that

> Bawdy-houses are fain to go in Disguise; *Coffee, and Tea to be sold*, or *fine Spanish Chocolate* invite you in, when in reality they sell only . . . Liquor, fit to enflame the Reckoning and fire the Blood; while the *Secret Commodities* of the Place [i.e. the girls], are ready in the Warehouses, to cool one Inflamation [*sic*] and give a greater.

Coffee-house signboards, Brown added, carried coded messages:

> Where the Sign is painted with a Woman's Hand in't, 'tis a Bawdy-house; where a Man's, it has another Qualification; but where it has a Star in the Sign, 'tis calculated for every lewd Purpose . . . At the Bar the good Man always places a charming *Phillis* or two, who invite you by their Amorous Glances into their Smoaky Territories, to the loss of your Sight.[33]

Moreover, coffee had long been regarded as an aphrodisiac that made 'the Erection more vigorous, the Ejaculation more full'. Well into the eighteenth century it was assumed that when coffee was 'foppishly fum'd into [men's] Noses, Eyes and Ears, [it] has the Virtue to make them talk and prattle together of everything but what they should do' (thus again Thomas Brown). Furthermore, by the late seventeenth century Covent Garden's 'coffee-house dames' were undermining the profits of their counterparts in the City. One ballad bore this informative title: *The Complaint of All the She-Traders in Rosemary-lane, Black-Mary's*

* That was reported in 1672, yet over a century later James Gillray's satirical print *The Thunderer* (1782) shows the Prince of Wales and Colonel Tarleton outside a house advertising 'Alamode Beef, hot every Night'; the notice is topped by a pole on which is impaled a bare-breasted courtesan-puppet with legs open to receive the supporting pole.

Hole, Ratcliff, Dog-and-Bitch Yard, Moor-fields and Petticoat-lane, against the City Cheats, or new Coffee-houses, about Charing-Cross, Westminster, Covent-garden, Fleet-street, and those Parts of the Town:

A Curse on your shams, ye Coffee-house Dames
Who instead of extinguishing, cherish men's Flames;
How finely you draw the poor gentlemen in,
With your devil's commander, wine, to the Sin
 Fornication.
Sobriety cloaks your lust, with a Pox,
While we deal more plainly, like honester Fokes
Altho' we can hardly keep open our Dores,
For all we maintain the perfectest Whores
 In the Nation.[34]

The downmarket coffee-house offered one way for ageing bawds to make a living. Running a bagnio or bath-house offered another. Again, some of these places were legitimate. Newspaper advertisements would stress that this or that bagnio was conducted with 'perfect decency'. And, in an era when people washed their bodies less often than their clothes, those who could afford them went to them innocently enough. There they bathed, shampooed, sweated and got cupped, or simply enjoyed the rare pleasure of swishing about in lots of hot water. Lord Chesterfield chastised his son in 1750 for failing to wash at the bagnio more often.

The smarter bagnios of the seventeenth century were well enough known to serve as referents to local businesses: 'Sold by P. Bouche in long aecre in Condet Court near the kings bagnio, London' – thus the imprint on a Pierce Tempest print in the late seventeenth century.[35] In them the sexes were meant to be segregated. A silver and brass admission token from the late 1660s is inscribed, 'THE DVKES BAGNIO IN LONG ACRE: TVESDAY FRYDAY. WOMEN' (fig. 40). Men were admitted on the other days. This bagnio was so named when the future James II granted it to 'Sir William Jennings, the onely undertaker of this new building'. It was erected in Long Acre, and the water was perfumed. It was sometimes confused with 'Queen Anne's Bath' at 3 Old Belton (now Endell) Street, off Long Acre. This had its own architectural pretensions. 'The exterior had pilasters,' a frequenter later recalled,

40. Admission medal, *The Dukes Bagnio in Long Acre: Tvesday Fryday. Women.* (*c.* 1667)

and a handsome cornice in the style of Inigo Jones, – all being built in dark red brick. Within there was a large plunging bath, paved and lined with marble, the walls being covered by small tiles of blue and white, in the Dutch fashion. The supply of water was from a well on the premises. There were several apartments for warm-bathing, having the baths and pavements of marble, and to several of these were attached dressing rooms.

By the date of this Victorian reminiscence the bath was dilapidated and occupied by a carpenter, but a drawing of it in this late condition confirmed the description (fig. 41).[36]

The first bagnio to open in the Little Piazza was the initially respectable Hummum's in 1683 (after the Turkish 'hamam'). The second was Haddock's, at number 8: it operated from 1742 to 1798, and had a branch in Charing Cross. By one account, Haddock was a noted extortioner of 'unhappy women' whom he set up in coffee-houses under impossible rents, sending them to the Marshalsea prison when they defaulted.[37] A third bagnio was Lovejoy's (1769), next to Hummum's. By 1750 ratebooks were identifying further bagnios in Bedford Street, Maiden Lane, King Street, York Street, Bow Street and Charles Street. Ratebooks show that the one in Bedford Street was rated at ten

41. John Wykeham Archer, *Queen Anne's Bath, the old St Giles's Spring* (pencil, watercolour, 1844)

shillings, so it was virtually a hovel. The one in Charles Street was run by the bawd Mother Haywood. It was known to Henry Fielding. There he set his Drury Lane farce, *Miss Lucy in Town* (1742), for this supervising a stage set that was said by a knowing spectator 'exactly' to duplicate Haywood's.[38] Other bagnios were in Chancery Lane, Leicester Fields, Charing Cross and (the oldest of them all) Bagnio Court off Newgate Street. In 1722, at the Three Tuns bagnio in Chandos Street, Sally Pridden (known as Sally Salisbury, her portrait

once painted by Kneller) stabbed in jealousy the Hon. John Finch; she died in Newgate prison as a result.

Increasing numbers of these places were no more than bordellos equipped with some kind of bath and with bedrooms upstairs, well equipped for 'a white-leggd Chicken' to 'coaxk [*sic*] an old Dotard' – though the classier of these, like this one in a Sayer and Bennet mezzotint of 1778 (fig. 42), were rather grand. Some provided the girls themselves, requiring them to offer 'a necessary outward decency, with unbounded secret liberty' in 'a little family of love', as Cleland put it in describing Fanny Hill's employment in Covent Garden:

> As soon then as the evening began, and the shew of a shop was shut, the academy opened; the mask of mock-modesty was completely taken off, and all the girls delivered over to their respective calls of pleasure or interest with their men: and none of that sex was promiscuously admitted, but only such as Mrs Cole was previously satisfied with their character and discretion.[39]

Other bagnios were open to outsiders of both sexes. In 1746 Hogarth's friend Jean André Rouquet told his French readers that an English bagnio received any couple seeking a room or bed for an hour or for a night 'in pursuit of libertinism'. It would charge between five shillings and half a guinea a night, for which considerable price it would offer discretion and cleanliness.[40]

So it was that the bagnio entered rakes' vocabulary. 'Two Buxom girls we jointly met, . . . So to the Bagnio strait we went; to Bed they shew'd us neat and clean' (1732); the 'jade . . . would not come to, till I promised to take her into keeping, and then we made a night at the Key Bagnio, and a luscious hussey she is' (1766).[41] Even the King's bagnio became 'a house of ill fame, and gave its name as a generic to similar places'. 'Ladies and Gentlemen who object to bathing in public company may contract for the private use of the same bath,' a bagnio in Charles Street coyly advertised.[42] The nation's premier duke, Norfolk, who never washed if he could help it, got clean only when he took a girl or girls to a bagnio or when his servants hosed him down when he was drunk, which luckily was often.

At Hummum's there must have been some improvement, since Boswell's respectable and long-suffering wife visited it in 1778 to

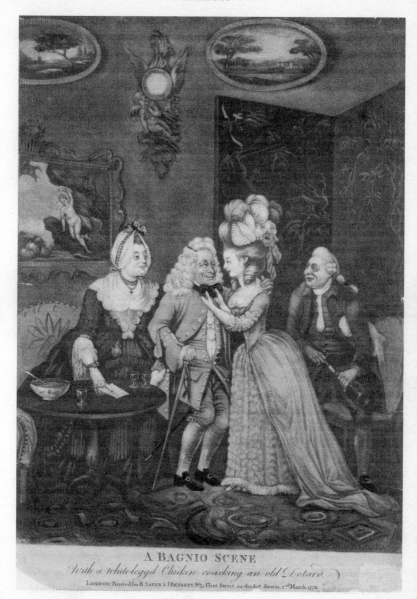

A BAGNIO SCENE

With a whitelegg'd Chicken coaxing an old Dotard.

LONDON: Printed for R. SAYER & I. BENNETT, N°53 Fleet Street, as the Act directs, 2ᵈ March 1778.

42. Anon., *A Bagnio Scene* (mezzotint, Sayer and Bennett, 1778)

check on the story that the ghost of Dr Johnson's relative parson Cornelius Ford had haunted the place after the parson died in one of the bagnio's bedchambers. On that occasion Boswell carefully explained to her that a bagnio was 'a place where people get themselves cupped'. He knew better, of course. Two years earlier, with the 'whoring rage' upon him, he had decided to 'devote a night to it': so 'I went to Charing Cross bagnio with a wholesome-looking, bouncing wench, stripped, and went to bed with her. But after my desires were satiated by repeated indulgence, I could not rest . . . and went home cold and disturbed and dreary and vexed, with remorse rising like a black cloud without any distinct form.' Likewise the energetic young rake William Hickey. The son of an affluent lawyer who was Burke's and Reynolds's attorney (Reynolds painted both the father and his daughter), Hickey didn't live up to his father's standing. His memoirs described how in the 1760s he would take 'the most hackneyed and common woman' to the lowest bagnios, preferring them to politer company. Outside the Charing Cross bagnio his brother was once involved in a killing affray.[43]

Bagnios changed ownership often. The drink-smitten Betty Careless ran a 'coffee-house' and then a bagnio in Tavistock Row in the Piazza. In the late 1720s and early 1730s she had been an actress in the lesser theatres and fairgrounds, and Hogarth commemorated her (marginally) in plate 8 of *A Rake's Progress*: one of his Bedlam lunatics has chalked the phrase 'charming Betty Careless' on a banister. Henry Fielding once saw her in her prime in a Drury Lane audience. He found it 'impossible to conceive a greater Appearance of Modesty, Innocence and Simplicity, than what Nature had displayed in the Countenance of that Girl', then apologized for his further knowledge of her:

> and yet, all Appearances notwithstanding, I myself (remember Critic it was in my Youth) had a few Mornings before seen that very identical Picture of all those ingaging Qualities in Bed with a Rake at a Bagnio, smoaking Tobacco, drinking Punch, talking Obscenity, and swearing and cursing with all the Impudence and Impiety of the lowest and most abandoned Trull of a Soldier.[44]

She was later famous for her reply to 'Lord D – n' who one day told her that her legs were so alike that they must be twins: 'but indeed,' she replied, 'you are mistaken, for I have had more than two or three

between them'.[45] Thanks to drink, she had a sorry end. Unrelieved by benefit performances, she ran a bagnio as a last resort. She died in the Covent Garden poorhouse in 1752, well remembered 'by the gay Gentlemen of the Town, of whose Money she had been the Occasion (as it is said) of spending upward of fifty thousand Pounds'.[46]

Betty's most lasting commemoration may be Louis-Philippe Boitard's *Covent Garden Morning Frolick* (1747) (fig. 43). The print is said to show Betty in very early morning, drunkenly lolling her way home in a sedan chair after a night's business. Her way is lit by Little Cazey the barefooted link-boy on the left: 'A Lad tho' Young yet wicked, fly, and arch; / Much of the World this pretty Youth has seen / And fifteen Times in Tothill Bridewell been'.[47] And she is allegedly accompanied by the artist Marcellus Laroon III (the Younger) (with the artichoke spiked on his stick) and, precariously balanced on the chair's top, by 'mad Captain Montagu', another of that egregious

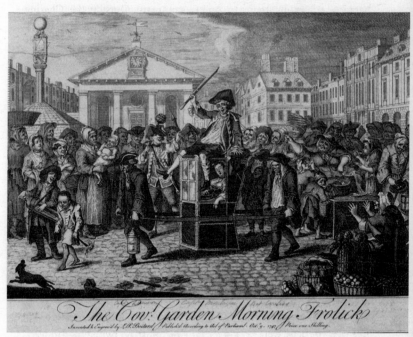

43. Louis-Philippe Boitard, *The Covt. Garden Morning Frolick* (etching, 1747)

clan, this one the wayward son of Lady Mary Wortley Montagu and a rake notorious for being friendly with highwaymen. These identifications are far from watertight, however.[48]

MOLL AND TOM KING

A final instance of the higher harlotry brings us closer to the artists we'll be meeting in Part II. It concerns the careers of Tom and Moll King and their market-shed 'coffee-house' in the Piazza. Hogarth, George Bickham and Marcellus Laroon III all found material there. According to J. T. Smith, a 'large and spirited drawing in red chalk by Captain Laroon exhibiting the inside of Moll King's' hung in Horace Walpole's house at Strawberry Hill (now lost). Smith also reported that he had been told by Benjamin West, Reynolds's successor as the Academy's president, who in turn had it from Hogarth's friend Francis Hayman, that one night while Hogarth and Hayman were drinking at the Kings', Hogarth noticed

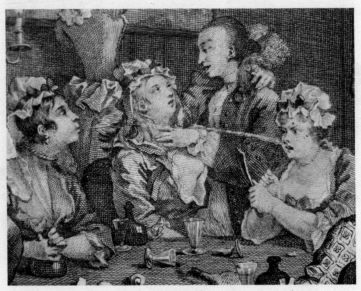

44. Hogarth, detail from *Orgy at the Rose Tavern, Drury Lane*, plate 3, *A Rake's Progress* (etching, engraving, 1735)

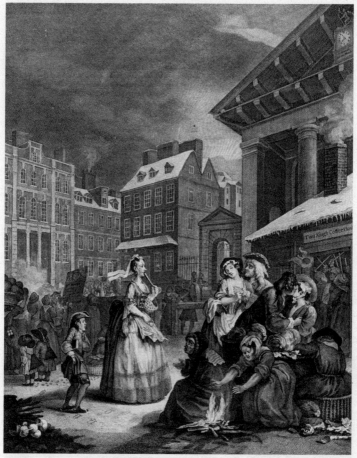

45. Hogarth, *Morning* (etching, engraving, 1738)

'two ladies, whose dispute bespake a warm contest' – women of the town, of course; 'and, at last, one of them, who had taken a mouthful of wine or gin, squirted it in the other's face, which so delighted the artist, that he exclaimed, "Frank, mind the b---'s [bitch's] mouth!"'. Hogarth at once sketched the disagreement in his notebook and in 1735 resurrected it as an element in the *Rake*'s orgy in the Rose tavern (detail, fig. 44).[49] Hogarth also featured the Kings' dive in *Morning* (1738) (fig. 45). On a

On a freezing morning, an elderly spinster, with an attendant link-boy to light her way, walks to St Paul's Church in the Piazza and raises her fan in distaste as she passes two couples who have emerged from the Kings' shed. They have made a night of it – or perhaps haven't yet quite. One man's hand fondles his partner's breast, the other couple kiss enthusiastically, all four anticipating pleasures or profits ahead. Through the door one glimpses rowdy customers. Above it are painted the words 'Tom King's Coffee-House'.

In its time, the Kings' was the best known of all dives in Covent Garden, a pick-up place though not technically a brothel. The only bed available was Tom and Moll's own bed in the loft, and when they went to sleep they pulled up the ladder. Couples who met there went to bagnios to conclude their business. Yet it was the Kings' enterprise that by the 1740s helped shift the location of upmarket sexual commerce from Drury Lane to the Piazza:

> Now stands the Garden, where the jolly Train
> Fly from the Strand, or late-fam'd Drury-Lane.
> (Drury, no more Resort of well-drest Nymphs,
> But Cinder Nan, or Moll who deals in Shrimps).
> ... [to] TOM KING's, a Shrine of Love, familiar known
> To ev'ry Rake and *Fille de joye* in Town.[50]

The main source on the King's is the anonymous *Life and Character of Moll King*, a twenty-five-page pamphlet sold after her death in 1747 for threepence. It tells us, extraordinarily, that Tom went to school at Eton, a fact confirmed in the school's registers.[51] He left or was expelled for unexplained reasons to become a waiter in a Covent Garden bawdy-house. Moll (Mary) was the daughter of a St Giles's cobbler; her mother peddled fruit and greens in the market. Moll became a barrow-girl, and had 'several sweethearts before she was 14 Years old'. Then she was 'drawn away' by 'a young Gentleman nam'd Murray' – allegedly the future judge Lord Mansfield, though there's no confirmation of this. 'Several others shar'd her favours', and she did some street-walking with the noted Sally Salisbury. She and Tom contracted an irregular Fleet marriage (without banns) in the 1720s, and then opened their market-shed to sell coffee, tea and chocolate at a penny a dish. They added brandy, arrack and punch to

their offerings and kept open all night to catch the early morning trade.

Thus 'Tom's' became a nocturnal meeting place of rakes and whores.[52] Soon, as the *Life* put it, 'Every Swain, even from the Star and Garter [the Prince of Wales] to the Coffee-House Boy, might be sure of finding a Nymph in waiting at Moll's Fair Reception House.' Ladies of the town, dressed as 'Persons of Quality', went there with their bullies (or pimps) dressed as footmen 'to deceive the unwary Youths, who were so unhappy as to cast their Eyes upon these deceitful Water-Wag-Tails'.[53] Artists went there, as we've seen. Courtiers also turned up in 'full dress, with swords and bags, and in rich brocaded silk coats', even as Moll served 'chimney-sweepers, gardeners, and the market people in common with her lords of the highest rank'.[54] 'The House became so very famous for nightly Revels, and for Company of all Sorts, that it got the Name of a College, and it was frequent among the Players, and witty Beaux to accost each other, with, Are you for King's College to Night, to have a Dish of Flash with Moll?' Everyone spoke 'flash' slang, as one Old Bailey trial showed:

> Fluellin and his Man W – conducted him to Tom King's in Covent Garden, where they sent for Mrs Brown, and told her they had brought her a Daucy Cock, (a sleeping Cull) [i.e., dupe] who had 50 or 60 Ridges (Guineas) about him.[55]

The anonymous pamphlet *Rake's Progress* listed customers that included Bet Careless (than whom 'none knows more to command / The heaving A – se, the quick'ning Hand'), Sally King (whose 'Skin most white the Contrast shews, / Near where Love's sacred Arbour grows'), Betsy Cox (whose 'taper leg, a clean white Foot, / Makes one almost in Fancy do't'), a Moll (whose 'Finger neat, / Made to perform the am'rous Feat. / Now briskly up and down they move, / Now please below, and now above') – and so on to Mrs Stewart, Mrs Howell, Peggy Yates, Sally King and Nanny Hall.[56]

Tom died in 1737, having 'greatly impaired his Health from drinking, and other Vices'; and Moll died in 1747. But their fame lived on in several volumes of verse and Moll's posthumous biography. Fielding in 1736 set part of his dramatic entertainment *Tumble-Down Dick* in Tom's, and Smollett briefly featured the dive in *Roderick Ran-*

dom in 1748. On Tom's death a sixpenny etching illustrated a mock *Monument for Tom K–g* (unsigned, but the style is George Bickham's or L.-P. Boitard's) (fig. 46). 'For thee all Bawds all Pimps lament, / From every Bagnio Sigh's are sent,' it heartily declares. A plinth bears the figure of the dead Tom reclining on an inverted punchbowl; next to him is the lamenting barmaid, Black Betty. A tablet announces that the monument has been erected by his 'loving Daughters', their abbreviated names referring to Mother Douglas, Molly Stewart and Bet Careless. The base bears a tableau of a nocturnal street fight, and the whole is flanked by a rake on the left and a weeping girl to the right standing on barrels of arrack and brandy. Their heads support artichokes (the market) and steaming coffee and chocolate pots. At the top, the coat of arms bears three cats *passant regardant*. Its motto is 'To Kiss and Scratch'. Flanked by figures of Bacchus and Venus, it is topped by a cock treading a hen.

According to her *Life*, Moll appeared a score of times before the Westminster Grand Jury for keeping a disorderly house, and for a while the zealous magistrate Gonson harassed her establishment almost nightly. But she usually got away with it until she was prosecuted at the King's Bench in 1739 for beating up a client.[57] Sentenced to a £200 fine or three months' imprisonment, she chose prison as the cheaper option. Then she retired with considerable savings, built three houses on Haverstock Hill, Hampstead (you can see them, incidentally, on the distant horizon of Hogarth's *March to Finchley*), and married a Mr Hoff. Mr Hoff had 'hopes of having the Fingering of her Cash', but she had made a widow's will to her son and allegedly sent him to Eton like his dad (though there's no trace of him in the registers). She died in 1747, earning not only her prose biography, but also a mock heroic sixpenny poem: *Covent Garden in Mourning . . . Containing some Memoirs of the Late Celebrated Moll King, and Anecdotes of Some of her Sisters, particularly Mrs D--gl--s, Mrs L--w--s, Mrs C--mpb--ll, Mrs C--r--y, Mrs P--ge, &c. With the Distresses and Lamentations of the Rakes and Ladies for the Loss of so good a Mother*:

> Thro' the Piazza hollow Winds return,
> That MOLL is gone, and all the Watchmen mourn.
> O! waft it round yet Watchmen, as ye cry

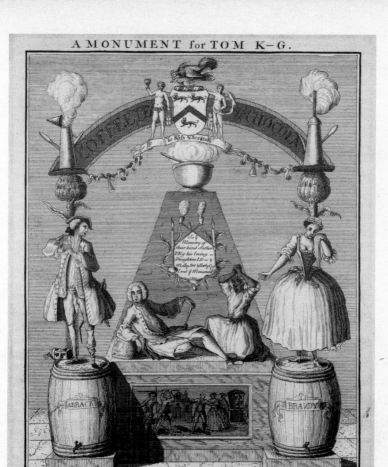

46. George Bickham (the Younger) or L.-P. Boitard, *A Monument for Tom K–[in]g* (etching, engraving, 1737)

The Hours of Night, and MOLL is gone reply.
In Deluges of Tears ye painted Whores,
Napp'd for Desertion, and for double Scores;
Weep all the Bowls full, and the Kennels* swell,
Who most shall weep shall best her Passion tell.

Many would have given their eye-teeth for the fame Moll achieved.

*

In 1732–3 Hogarth painted the century's iconic orgy scene in the third tableau of *A Rake's Progress*; it was engraved in 1735 (fig. 47). The other tableaux in the series were just as masterly as they told their tale of mounting dissipation and final madness in Bedlam, but this one is saturated in the sexual references and symbols that came as easily to Covent Garden denizens as it had to Low Countries artists like Jan Steen in the preceding century. Hogarth sets his scene in the clubroom of the Rose tavern (the trysting joint on the corner of Russell and Brydges Street in which Pepys once tried to meet Doll Lane).

The rake lolls in his chair, his sword meaningfully out of its scabbard, while the strumpets sport with and steal from him. In the background, the angry girl Hogarth supposedly sketched in the Kings' coffee-house spits her mouthful of wine or gin into her colleague's face. Another girl sets light to the wall map of the world with her candle; the mirror is broken, pictures defaced. A posture girl or stripper removes her clothes in the foreground in order to dance on the pewter dish the waiter is bringing to the table: the candle he carries will be her chief prop. The pregnant ballad-singer, right, is about to sing *The Black Joke*. The song's title is legible on her sheet. Hogarth expected his purchasers to recognize its reference to the female pudenda and to the naturalness of sex:

> No mortal sure can blame the man,
> Who prompted by Nature will act as he can,
> With a black joke, and belly so white:
> For he the Platonist must gainsay,
> That will not human Nature obey,

* drains

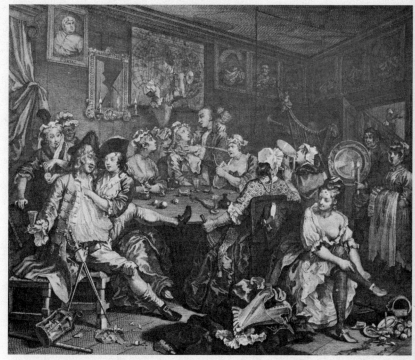

47. Hogarth, *Orgy at the Rose Tavern, Drury Lane*, plate 3, *A Rake's Progress* (etching, engraving, 1735)

> [chorus]
> *in working a joke, as will lather like soap,*
> *and the hair of her joke,*
> *will draw more than a rope,*
> *with a black joke, and belly so white.*[58]

A Rake's Progress was a great success for Hogarth. Three years earlier he had been vexed by direct plagiaries or 'plagiaries-by-memory' of *A Harlot's Progress* (based on hearsay or recalled from visits to his studio). This time he meant to profit from the new work to the full. For this purpose he and his friends in Slaughter's coffee-house in St Martin's Lane famously petitioned parliament for an engravers' Copyright Bill that was duly passed on 25 June 1735. It was a critical achievement. It

protected engravers' copyright in their works for fourteen years after publication (extended to twenty-eight years in 1767). Henceforth every print had to carry its publication date and publisher's name and address (a boon to historians).

Hogarth released the prints of *A Rake's Progress* on the day the Act became law. Initially, however, his hopes of curbing anonymous piracies of the *Rake* from memory were thwarted, since he had invited potential subscribers to view the *Rake* paintings in the preceding November. Copyists seized their chance; travesties were published in book form.[59] The most interesting of these derivatives returns us to the Kings' dive in the Piazza – for it suggests the location of Hogarth's inspiration for the story as strongly as does the story of the spitting girls' feud. The print in question was by George Bickham the Younger (c. 1704–1771).

Bickham has been called one of the most energetic and enigmatic figures in the London print trade and the most talented political satirist of his period.[60] Prolific and risk-taking, he produced hard-hitting anti-Walpolian satires, informed comments on international affairs, a fair amount of now lost erotica, and (with his father) illustrated song-sheets and calligraphic manuals. In 1745 government agents reported not only that Bickham kept a printing press in his house (which was itself suspicious), but also that they had recovered 'about 150 Obscene books with all sorts of Obscene Postures Seized out of Mr Bickhams Escrutore'. In 1745 he was advertising in the newspapers 'a Set of Cuts to the *School of Venus*, new. Price 2s plain, 6s colour'd'. He seems to have escaped prosecution.[61]

Bickham published his Hogarth-derived print in 1735. It was entitled *The Rake's Rendez-Vous, or the Midnight Revels, Wherein are Delineated the Various Humours of Tom King's Coffee-house in Covent Garden*; it cost sixpence and was uncoloured, as nearly all prints were before the last quarter of the century (fig. 48). It carries Bickham's name in the bottom right corner, but it omits its publication date, so it was probably published just before the Copyright Act and the publication of Hogarth's *Rake*.

But it wasn't a piracy. Hogarth's orgy is more masterful in its tight composition, and more theatrical, but Bickham's representation has a ring of truth to it, and it is clear that Bickham knew Tom King's well.

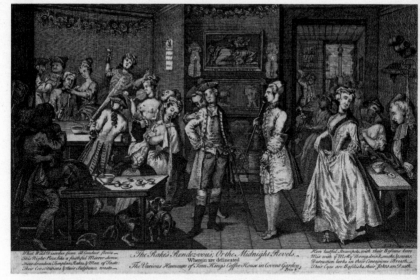

48. George Bickham (the Younger), *The Rake's Rendez-Vous, or the Midnight Revels, Wherein are Delineated the Various Humours of Tom King's Coffee-house in Covent Garden* (etching, *c.* 1735)

He lived and worked around a corner or two; and his print also makes the spatial sense that suggests familiarity with the place.* Perhaps he thought the Kings' dive was a more credible location for sexual adventuring than the Rose, or else he recalled Hogarth's own presence there. He didn't know the story of the wine-spitting girls, however – or else he displaced it by having a man throw a glassful of wine at one of the women.†

The scene looks through from the crowded inner saloon of the Kings' to the entrance bar beyond, and then to the Piazza's obelisk outside. On the saloon wall, a picture over the fireplace shows a harlequin figure

* One of his prints was issued in 1733 from May's Buildings between Bedfordbury and St Martin's Lane, a block or so away. In 1737, he had an address in Bedfordbury, then one in the Strand, and again in May's Buildings throughout the 1740s.
† The scrap of paper pinned to the wall above the vomiting woman reads 'dump, dump, dump. H[ouse of]. C[orrection].' beneath the image of a hemp-beating woman in Bridewell. This quotes from plate 4 of *A Harlot's Progress*. The drunken parson (?), far right, recalls a figure in *A Midnight Modern Conversation* (1732).

labelled 'The Curious Docter' kissing a crouching woman's bared back-side. This was the quack Doctor Rock, infamous for his venereal remedies. (Hogarth included a glimpse of that doctor in *Morning* as well.) Bickham spots his protagonists' faces and bosoms with disease (as Hogarth did), and in his subtext he bangs home the coffee-house's perils:

> What Wild Disorder from ill Conduct flows –
> This Night-Piece, like a faithful Mirror shows.
> Here drunken Templars, Rakes, & Men of Taste :
> Their Constitutions & their Substance waste –
> Here lustful Strumpets, with their Bosoms bare
> Mix with ye Motly Throng, drink, smoke, & swear.
> Destruction lurks in their Contagious Breath –
> Their eyes are Basilisks,* their Jokes are Death.

As always in these productions, wild disorder and lustful strumpets with bosoms bare were subjects too arresting for purchasers to extract from them messages exclusively of destruction and death. Among men accustomed to such scenes in life, the noise, danger and energy of Bickham's dive invited no moral reflection. Even the two dogs under the table were merely 'acting in the mode of the place'.[62] The women fondle, flirt, expose themselves, smoke and vomit, while little Black Betty serves. The men swagger or preen centre-stage, or quarrel, caress or sit drunkenly under that leaking barrel of gin. To contemporaries, some of the protagonists were easily identifiable (though as usual posterity got most of them wrong).† The paper being read by the man

* 'Cockatrice' or 'basilisk': a mythical reptile hatched by a serpent from a cock's egg: its look and breath were fatal (*OED*).
† The fop in the centre of *Rake's Rendez-Vous* was 'Cadwallader' Apreece, later mocked in Samuel Foote's farce, *The Author*. One of the BM's two impressions has Victorian pencilled identifications that claim that the bare-breasted smoking woman was the courtesan 'Sally Salisbury', but she had died in 1724 after catching gaol fever in Newgate. The central young man is described as a famous highwayman, either Maclean or Turpin. Turpin was being hunted by the law when the print was made, but he operated on the furthest outskirts of London, and later in Yorkshire, and there is no record of him in Covent Garden. The highwayman James Maclean was aged ten when the print was made.

back left is addressed to 'Mrs Yates'. In the anonymous *The Rake's Progress; or, The Humours of Drury Lane*, 'Y--es' is identified as the 'darling' of the Rake's 'heart',

> Whose secret Charms such Bliss impart.
> So sweetly move her B----cks, Thighs,
> Her Legs, her Arms, her Breast, her Eyes,
> Her Lover in a Rapture dies

– a difficult reputation to live up to.

PART II
Artists

4

The First Bohemians

DISTRESSED POETS

Poverty and struggle have always been the first characteristics of the kinds of creative people who come to be regarded as 'bohemian', and in Covent Garden there were struggling Rodolfos and Mimis of this kind (à la Puccini, that is) in plenty. Spartan lives they led, even if liquor, women and friendship alleviated them. The archetype was a literary one, though it embraced artists and actors as well. Its iconic representation was Hogarth's *Distressed Poet* of 1737 (fig. 49). In his impoverished attic, the poet tears at the hair under his wig as he labours at a poem on 'Poverty', while his wife is confronted by the milkmaid demanding her payment and the dog eats the family chop. Hogarth's subtext cited Pope's *Dunciad*: 'Studious he sate, with all his books around, / Sinking from thought to thought, a vast prof[o]und; / Plung'd for his sense, but found no bottom there, / Then writ, and flounder'd on, in mere despair'; but his idea was most likely fired by a poet's fictitious complaint in the *Grub Street Journal* three years before. In that, too, the wife tries to mend his ragged breeches, the milk-woman bawls for her money, the cat sits on his threadbare coat, while the poet scratches his head to 'draw a few fustian verses from my hard-bound brains'.[1]

Hogarth's print bears some responsibility for the enduring image of the penurious and garret-bound writer, but it had real-life counterparts. Samuel Johnson's observation, in his biography of the derelict poet Richard Savage, that most heroes of literature were more remarkable for what they had suffered than for what they had achieved was fair comment on his own generation of writers. In Pope's era before him writers had enjoyed a great age of patronage, especially thanks to

Studious he sate, with all his books around,
Sinking from thought to thought, a vast profound :

Plung'd for his sense, but found no bottom there :
Then writ, and flounder'd on, in mere despair.

DUNCIAD Book I. line 111

49. Hogarth, *The Distressed Poet* (etching, engraving, 1737)

the munificence of Edward Harley, second Earl of Oxford (1689–1741). But Robert Walpole, Britain's premier from 1721 to 1742, cared little for books or authors, so writers came to be 'exiled from decent society' (in Dickens's words later), since their profession 'had hardly acquired a recognised standing in the world, or found for itself a definite and indisputable sphere of usefulness'.[2] It was well over a century before the steam-driven printing press and a widened reading public enabled aspirant writers to feel they had fair chances of escaping the Distressed Poet's fate.

Of course there were writers with private incomes, like Horace Walpole, Robert's son; and as time passed the successful were fêted in

50. John Wykeham Archer, *Milton Street, formerly Grub Street* (pencil, watercolour, 1848)

West End salons, or ran them, and towards the end of the century increasing numbers were women. Both Henry Fielding and Tobias Smollett came from well-connected families. Fielding was the son of a lieutenant-general, Smollett of a Dunbartonshire landowner, and they trained as a lawyer and as a doctor respectively. All the same, few well-heeled men would write for money, and it was only when his too fecund and four-times-marrying father promised Fielding an allowance of a mere £200 a year that he had to choose, he said, between being 'a Hackney Writer or a Hackney Coachman'. He needn't have worried. Coming to London from Somerset in 1730, within six years he established himself as the most prominent playwright since Dryden, and was soon living in big houses in Essex Street off the Strand and then in Spring Garden off Charing Cross – though this didn't save him from an involuntary

fortnight's sojourn for debt in a bailiff's sponging-house (i.e. debtors' lock-up) in 1741. He stayed in the Covent Garden neighbourhood for most of his working life (in Old Boswell Court; Panton Street off the Haymarket; Brownlow Street off Drury Lane; and Wardour Street, Soho), before his last six years as Bow Street magistrate from 1748 to 1754.

Eighteenth-century writers 'had very little existence except in London', Dickens noted. He might as well have said that jobbing writers had little existence outside an extraordinarily narrow stretch of town. This extended from Soho and Covent Garden along the Strand and Fleet Street and their cheaper side streets to St Paul's (Cathedral) Churchyard and up north to Grub Street. Grub Street's antiquity was indicatively if too prettily captured by John Wykeham Archer in 1848 (fig. 50); it had never been a hopeful place. (Bombed in war, its site is now covered by the Barbican complex.) Johnson defined it in his *Dictionary* as 'much inhabited by writers of small histories, dictionaries, and temporary poems; whence any mean production is called *Grub-street*'.

For most of the century it was to these streets and their low rents that would-be writers were drawn. Here, Dickens wrote, they 'starved and broke their hearts in wretched garrets, or earned a despicable living by flattering the great'. He cited Richard Savage, 'compelled by his vices and his needs to herd in cellars with the scum of the town'. He also cited Oliver Goldsmith, saved from the debtors' prison only by Samuel Johnson's intervention; and the boy Chatterton, who killed himself 'in hunger, heart-sickness, and despair'; and young Johnson himself, 'dining behind a screen at Cave the bookseller's, because he was too shabby to appear, and pacing the streets of London all night with Savage, because neither had money to procure even the meanest lodging'.[3]

Savage and Johnson were crucial in this representation. It was Johnson's *Life of Richard Savage* (1744) that first gave what was later called the 'bohemian' his feckless identity. As Johnson explained, 'It was the constant practice of Mr Savage to enter a tavern with any company that proposed it, drink the most expensive wines with great profusion, and when the reckoning was demanded, to be without money.' He would then pass his nights

> in mean houses, which are set open at night to any casual wanderers, sometimes in cellars among the riot and filth of the meanest and most

profligate of the rabble; and sometimes, when he had not money to support even the expences of these receptacles, walked about the streets till he was weary, and lay down in the summer upon a bulk [vendor's stall], or in the winter with his associates in poverty, among the ashes of a glass-house.

Here, Johnson wrote, among thieves and beggars, 'was to be found the Author of *The Wanderer*, the man of exalted sentiments, extensive views, and curious observations; the man whose remarks on life might have assisted the statesman, whose ideas of virtue might have enlightened the moralist, and whose delicacy might have polished courts'.[4]

Johnson's representation was elaborated by T. B. Macaulay when he reviewed Croker's edition of Boswell's *Life of Johnson* in 1831. While Johnson had described one writer's dereliction, Macaulay generalized Savage's condition into that of a class. In effect he thus defined the bohemian archetype long before Murger's *Scènes de la vie de Bohème* of 1845, and before Thackeray appropriated it in English in the following year to describe loose and unconventional people (above, p. xvi). Here in 1831, self-evidently influenced by Johnson's account, Macaulay offered the 'bohemian's' aboriginal description:

All that is squalid and miserable might now be summed up in the one word – Poet. That word denoted a creature dressed like a scarecrow, familiar with compters and spunging houses . . . Even the poorest pitied him; and they might well pity him . . . To lodge in a garret up four pair of stairs, to dine in a cellar among footmen out of place, to translate ten hours a day for the wages of a ditcher, to be hunted by bailiffs from one haunt of beggary and pestilence to another, from Grub Street to St George's Fields, and from St George's Fields to the alleys behind St Martin's Church, to sleep on a bulk in June and amidst the ashes of a glass-house in December, to die in an hospital and to be buried in a parish vault, was the fate of more than one writer, who, . . . if he had lived in our time, would have received from the booksellers several hundred pounds a year.

. . . Such was the life of Savage, of Boyse, and of a crowd of others. Sometimes blazing in gold-laced hats and waistcoats; sometimes lying in bed because their coats had gone to pieces, or wearing paper cravats because their linen was in pawn; sometimes drinking Champagne and

Tokay with Betty Careless; sometimes standing at the window of an eating-house in Porridge Island, to snuff up the scent of what they could not afford to taste; they knew luxury – they knew beggary – but they never knew comfort. These men were irreclaimable. They looked on a regular and frugal life with the same aversion which an old *gipsy* or a Mohawk hunter feels for a stationary abode, and for the restraints and securities of civilised communities. They were as untameable, as much wedded to their desolate freedom, as the wild ass ... To assist them was impossible; and the most benevolent of mankind at length became weary of giving relief, which was dissipated with the wildest profusion as soon as it had been received.[5]

In truth, few lived such unrelentingly desperate lives as this; yet, among poets and artists alike, poverty and debt were common; and the eccentricity was too. When the 27-year-old Samuel Johnson first went to London in 1737 with his pupil David Garrick (the latter hoping for a theatrical career), they travelled the 150 miles from Lichfield in Staffordshire by sharing a horse. One walked as the other rode ahead; the latter then tethered the horse and walked on until the other reached and mounted the horse and caught up – and so on in turns. By the time they hit London, Johnson had twopence-ha'fpenny left in his pocket (Garrick had less). They headed straight for Covent Garden. It was cheap to live in, great names had preceded them there, and Johnson's uncouthness would go unnoticed. Johnson took the cheapest lodgings he could find, with a staymaker in Exeter Street.

He had arrived 'precisely at the time when the condition of a man of letters was most miserable and degraded' (Macaulay). In his first decade it was a sign of his difficulties that he changed lodgings ten times. Apart from a couple of sojourns in west London and Greenwich, and after he had emerged 'from cocklofts and sixpenny ordinaries [dining rooms] into the society of the polished and the opulent' (Macaulay again, reviewing Boswell's *Life*), he lived in much the same neighbourhood or off Fleet Street for the rest of his life. His friendship with Savage induced in him 'some indulgencies which occasioned much distress to his virtuous mind', as Boswell put it demurely in the *Life*. But of their likely sexual exploits Boswell says nothing; we only know that with Savage he roamed the streets 'in high spirits and brimful of patri-

otism'. As Macaulay further observed, Johnson never quite sloughed off the boorish manners of his background and of these struggling years. 'He ate as it was natural that a man should eat who, during a great part of his life, had passed the morning in doubt whether he should have food for the afternoon . . . He tore his dinner like a famished wolf' and 'when he drank [wine], he drank it greedily, and in large tumblers.' Johnson's verbal rotundities and mannerisms, his pointless antitheses and 'big words wasted on little things', Macaulay regarded as defences against a repeat of the humiliations he had known in his younger days. Johnson himself later commented on how he had to struggle earnestly to be accepted as a gentleman, finding it difficult, among other things, to laugh not out of merriment, but as 'one of the arts of adulation'. When amused, he would usually 'burst out suddenly into an awkward noise which was not always favourably interpreted'. Someone said he laughed like a rhinoceros.[6]

The market for literature strengthened after mid-century. The likes of Edmund Burke, Thomas Gray, Edward Gibbon and Charles Churchill found life easier than Johnson's generation had, and not merely because of their better connections. Johnson himself was rescued in middle age by a pension from Lord Bute. By the 1760s, successful writers were at last enjoying newly urbane forms of conviviality in which talents were celebrated – Johnson's not least. In 1764 Joshua Reynolds formed a 'Literary Club' that met weekly at the Turk's Head at 9 Gerrard Street, two blocks north of Leicester Fields. Established in Johnson's honour, it aimed to 'consist of Such men, as that if only Two of them chanced to meet, they should be able to entertain each other without wanting the addition of more Company to pass the Evening agreeably'. Burke and Goldsmith were among the nine original members; Sheridan the playwright, Joseph Banks the scientist, Emma's cuckolded husband Sir William Hamilton and the musicologist Charles Burney joined later.

Even so, the literary career remained chancy for most. Half-a-dozen years before Goldsmith joined the Literary Club, he told his brother that he was worn down by 'eight years of disappointment, anguish, and study', and invited him to 'imagine to yourself a pale melancholy visage, with two great wrinkles between the eyebrows, with an eye disgustingly severe, and a big wig; and you may have a perfect picture

of my present appearance'. He had been living in 12 Green Arbour Court between the Old Bailey and the Fleet Market, a battered place which one reached up the aptly named Breakneck Stairs. 'Every night,' Goldsmith's early biographer recorded, 'he would risk his neck at those steep stone stairs; every day – for his clothes had become too ragged to submit to daylight scrutiny – he would keep within his dirty, naked, unfurnished room, with its single wooden chair and window bench.' (A half-century later, two of the houses 'fell down' from age and dilapidation.) In self-mocking doggerel Goldsmith described his condition when he moved to lodge in the Red Lion in Drury Lane:

> There, in a lonely room, from bailiffs snug,
> The Muse found Scroggen stretch'd beneath a rug:
> A window, patched with paper, lent a ray,

51. Rowlandson *A Grub Street Poet*
(ink, pencil, wash, no date)

That dimly shew'd the state in which he lay;
The sanded floor, that grits beneath the tread,
The humid wall with paltry pictures spread . . .
A night-cap deck'd his brows instead of bay,
A cap by night, a stocking all the day![7]

Many decades would pass before Rowlandson's comments on the author's plight would lose their point – his caricature of *A Grub Street Poet* in advancing decay, for example (fig. 51).[8]

ACTORS

Covent Garden afforded provincial immigrants like Johnson all manner of social camouflages. It was full of people who were as rough-hewn and as unschooled in the polite courtesies as he was, and nobody thought the worse of them. For, in its loucher quarters, Johnson and others entered an oddly fluid and equalizing world. Under certain conditions well-born and humbly born people could associate more or less relaxedly, and manners were less tautly regulated or stultifying than they were in the West End.

Gambling dens offered innumerable opportunities for this mixing, but the theatres offered better. After the Restoration, Covent Garden came to accommodate London's leading theatres, and they affected its character and sociability profoundly. They were the point at which the works of artists, actors and literary men fused, and they also gave ample employment to scenery painters, such as Michael Angelo Rooker, who elegantly depicts himself at work in the scenery loft of the Haymarket theatre (fig. 52).

Lincoln's Inn Fields Theatre opened in 1661, the Theatre Royal Drury Lane in 1663, the small Theatre Royal in the Haymarket in 1720 and Covent Garden Theatre in 1732. Drury Lane and Covent Garden were 'patent' theatres that were licensed to present spoken drama; the Haymarket was granted its licence in 1766. The first Theatre Royal, between Drury Lane and Brydges Street on the site of an earlier Cockpit Theatre, was built of wood, and its pit was open to the sky; hemmed in by housing and approached down alleyways, it held 700

52. Michael Angelo Rooker, *The Scene-Painter's Loft at the Theatre Royal, Haymarket* (pencil, watercolour, c. 1785)

people. It was rebuilt to designs by Christopher Wren, and rebuilt again in 1775–6 when its manager David Garrick employed the Adam brothers to redesign the interior and push a new pedimented façade through to Bridges Street. Garrick's successor, the playwright Richard Brinsley Sheridan, rebuilt it once more in 1791–4. This vast building, designed by Henry Holland, accommodated 3,600 people, and it was impossible to hear the stage from the back. Churches apart, it was the tallest building in London until it burned down in 1809. The rebuilt theatre opened in 1812; its exterior survives today.

The Lincoln's Inn Fields Theatre achieved its greatest triumph in 1728 when John Gay and John Rich, its manager, staged Gay's *Beggar's Opera* – making 'Gay rich and Rich gay', the quip went. This most wonderful of plays, sardonic, knowing, and commercially the

most successful of the century, ran for a then record of sixty-two nights and was staged many times thereafter. On its profits Rich built the Covent Garden Theatre. Its size was modest at first. One entrance was tucked away in the north-eastern corner of the Piazza and another was driven through to Bow Street to emerge between the Shakespeare tavern and an oyster shop. Only after its destruction by fire in 1808 was an imposing façade erected in Bow Street, where its successor still stands.

The theatres became indispensable to London's sociability and Covent Garden's enlivening social connectedness. The likes of the young James Boswell, for example, went to Drury Lane for the first time in 1763 and enjoyed the ensuing social encounters more than the performance, one feels:

> At three I swallowed an apple tart, then wrapped myself up in two pairs of stockings, two shirts and a greatcoat, and thus fortified against the weather [it was February], I got into a snug [sedan] chair and was carried to Drury Lane. I took up my associates at the Rose Tavern and went into the pit at four, where, as they had not dined, they laid down their hats, one on each side of me and there I did sit to keep their places ... Luckily Dr Goldsmith came into the seat behind me. I renewed my acquaintance with him, and he agreed to keep the same place for the night. His conversation revived in my mind the true ideas of London authors, which are to me something curious and, as it were, mystical.[9]

In each theatre the classes were nominally segregated in pit, circle and boxes. But, however august, no theatregoer could ignore other theatregoers' noisiness, odours or sexual enthusiasms, as Rowlandson made clear in his cheerful print of 1809, which shows that the boxes weren't invariably for the great people (fig. 53). Audiences' opinions were intrusive. They rioted and invaded the stage in 1763 when Garrick tried to abolish half-price admissions for people who arrived after the interval to see the after-piece. Armed Grenadier guardsmen had to stand on either side of the stage to keep order. Protests at rising prices were violent, never more so than during Covent Garden's 'Old Price riots' in 1809.

Everyone who could afford it was as addicted to theatre as we are to television. Young literary men hoped to live off it. When Smollett came to London in 1739, he brought with him his tragedy *The Regicide*, and

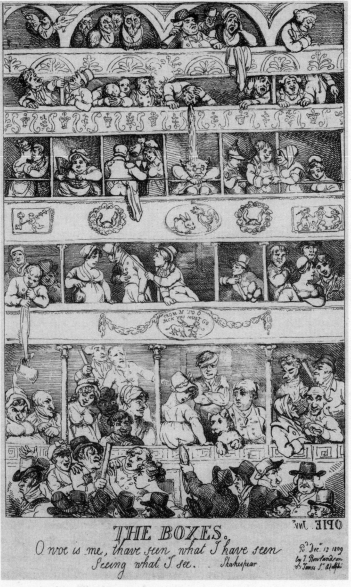

53. Rowlandson, *The Boxes* (etching, 1809)

described his battle to have it produced in his novel *Roderick Random*. Fielding ran his own company at the Haymarket theatre in 1736 and 1737. His ambitions in that direction ended with the passing of the Theatrical Licensing Act in 1737, with which Sir Robert Walpole silenced him and his ilk by limiting dramatic performances to the Drury Lane and Covent Garden theatres.

Artists were just as addicted. Theatrical allusions informed scores of prints and paintings throughout the century, and the theatres mediated some crucial cross-fertilizations. For Hogarth as for others, it was theatre rather than poetry that affected his imagination and understanding of the world. He was angered when theatre was meretricious. One of his earliest print satires was *A Just View of the British Stage* (1724) in which he castigated the staging at Drury Lane of a brainlessly 'harlequinised' history of the criminal Jack Sheppard. Conversely, he was so enchanted by *The Beggar's Opera* that he painted a scene from it several times (fig. 57). The 'Progresses' of his harlot and rake were in effect theatrical narratives (and were also theatrically performed), and he painted David Garrick and his actors and actresses often. Later, Johan Zoffany also portrayed actors and actresses and stage scenes. Edward Rooker was both an engraver and an actor, while the artist Robert Dighton sung at the Haymarket theatre in 1776 and played Macheath in *The Beggar's Opera* at his own benefit at Covent Garden eight years later. Rowlandson's closest friend was the actor Jack Bannister. And the teenaged and future caricaturists George and Robert Cruikshank had the young actor Edmund Kean as friend (his mother was a lady who 'divided her time between acting and prostitution'). The Cruikshanks' father led the three youths in amateur theatricals, permanently infecting them with a passion for the stage. They met in the bookseller John Roach's shop in Vinegar Yard, off Russell Court (where Mrs Roach would try to sell the boy Francis Place erotic prints), opposite the Theatre Royal's pit door.

Although leading actors and actresses were lionized, few theatrical careers were secure. Sheridan's peaked in the 1770s and 80s when, as the author of *The Rivals* and *The School for Scandal*, he followed Garrick as owner-manager of Drury Lane; but his drinking was spectacular. Gillray always caricatured him with a bulbous red nose and rubicund face. His career as Whig MP impoverished him in the new century, and he died in debt in squalid circumstances in 1816.

David Garrick was luckier. After he had climbed the theatrical hierarchy to become Drury Lane's actor-manager from 1747 to 1776, he lived in comfort at No. 27 Southampton Street (still standing), having paid 500 guineas for its lease in 1747 – 'dirt and all', his wife said. In his later house in the Adelphi, he surrounded himself by portraits of himself, because everybody painted him – Reynolds, Gainsborough, Hayman, Hogarth, Dance, Cotes, Hone, Worlidge, Sherwin, Pine, Wilson, Zoffany, Angelica Kauffman.[10] He revived Shakespeare, insisted on rehearsals, got rid of inherited parts, and banned spectators from the stage. Admittedly, the Lord Chamberlain's power from 1737 to ban or censor plays meant that few chances were taken. Garrick rewrote *Macbeth*'s ending to allow Macbeth to express remorse as hell opened for him. He thought Goldsmith's *She Stoops to Conquer* too advanced; it was saved only when George Colman took it for Covent Garden, thus opening the way to Sheridan's comic satires. Goldsmith in 1754 dismissed London's sentimental comedies as facile things which could be hammered out as easily as novels: 'almost all the characters are good, and exceedingly generous'.[11]

Good plays were seldom unaccompanied by bad. Open a random issue of the *Morning Post* – 3 January 1777 – and you find advertised *Semiramis* staged at Drury Lane together with a pantomime: boxes five shillings, upper gallery a shilling. *The Beggar's Opera* and *The Country Wife* were performed together at Covent Garden, with a country dance and hornpipe thrown in ('no person to be admitted behind the scenes, nor any money to be returned after the curtain is drawn up'). The Haymarket had an Italian comedy, *Gli Incantidi Circae et Atlante*, 'with beautiful transformations, and decorations, new songs, duets, and airs ... Harlequin will be turned into an ass, and his mistress to a cow ... Doors to be opened at six. To begin exactly at seven. Servants that keep places to be at the house at five.' People came and went as they pleased during performances. Audiences had the attention span of gnats. The sexual market interested them more. 'What an assemblage to *me*, who know all their histories,' Byron wrote of the mix of courtesans and ladies he surveyed in their Covent Garden boxes. The courtesans were '*understood* courtesans', he wrote, and these outnumbered the 'mercenaries'; but there was no difference between them except that the 'understoods' might enter the Prince of Wales's Carlton House

54. Peter Lely, *Portrait of a Young Woman and Child, as Venus and Cupid* (oil, no date); now agreed to be Nell Gwynn

while the professionals were confined to the opera and brothel. 'How do I delight in observing life as it really is!' he exclaimed in good cheer.[12]

As the district filled with upmarket actresses and downmarket whores – many achieving the status and business of both – the theatres did no favours for the neighbourhood's gentility. After the Restoration, the actress-mistress-whore arrived on the scene. On May Day 1667 Pepys 'saw pretty Nelly [Gwynn] standing at her lodgings door in Drury Lane in her smock sleeves and bodice, looking upon one – she seemed a mighty pretty creature'. By one account, 'pretty witty Nelly' was born in Coal or Cole Yard on the eastern side of Drury Lane – just north of the notorious Lewknor's Lane (later Charles Street) which was famed for its 'lewd women'. According to Pepys, she herself said she was 'brought up in a bawdy-house to fill

55. Rowlandson, *Madam Rose Resting after Rehearsal of a New Ballet* (ink, watercolour, no date)

strong water to the guests'.[13] She graduated to 'orange-selling' (a euphemism), and then to acting in the Theatre Royal. There she caught the king's eye and became his mistress, in an era when, as she herself pertly said, 'whoreinge was in fashion'. A few years later, she was painted naked by Sir Peter Lely in his Piazza studio 'at the express command of King Charles 2nd. Nay he came to Sr Peter Lillys house to see it painted when she was naked on purpose' (fig. 54).[14]

After glimpsing Nell so pretty in her smock sleeves and bodice, Pepys, himself no paragon, had walked further up Drury Lane to the Rose tavern on the corner of Russell and Brydges Street for a dalliance he had planned there with his friend Doll Lane. The Rose was an obvious drinking den for theatregoers and poets, and a venue for trysts and debauchery as well: the orgy scene in Hogarth's *Rake's Progress* was set there. Pepys went with high hopes. His negotiations with Doll had been long and tricky. In January, as he wrote in his code, he had managed to 'biber a good deal de vino' with her, and 'did tocer [touch] et no mas [and no more] su cosa [her thing]'; but she had left him then believing that 'in time and place jo creo que je pouvais faire [I believe that I could do] whatever I would con ella [with her]'. In the Rose, alas,

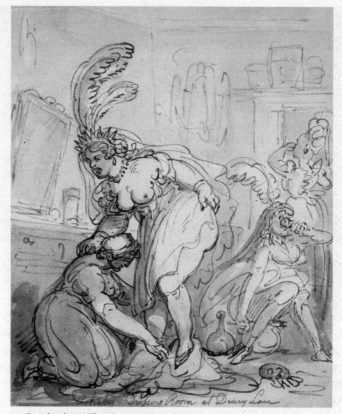

56. Rowlandson, *The Actresses' Dressing Room at Drury Lane* (pencil, ink, watercolour, *c.* 1800–1810)

he was to be disappointed. Doll was waiting; but it was 'mighty ouvert [public], so as we no poda hazer [could not do] algo [anything]', they decided to part and meet later and more discreetly at the Swan.[15]

Actresses' lifestyles drew most attention. From the cross-dressing that had titillated theatre audiences since the Restoration on to the revealing dresses of the French dancers Rose Didelot and Rose Parisot that Gillray and others lampooned at the end of the century, the theatre was where female manners were at their frankest and most exposed. In no respectable calling would a woman in male company stretch

57. Hogarth, *A Scene from 'The Beggar's Opera' VI* (oil, 1731)

herself out to rest on her dressing-room table as the exhausted Didelot did under Rowlandson's observation 'after rehearsal of a new ballet' (fig. 55). Nor in any other business would a woman feel free to urinate before a man, as an actress did before Rowlandson as he drew his *Actresses Dressing Room at Drury Lane* (fig. 56). (Rowlandson owed his privileged access to his friendship with the actor Jack Bannister.) The borders between actress and whore or occasional whore were fragile. Like actors, actresses came from humble roots. As need dictated, they would migrate between acting, being a mistress, or running a business. Most were as free with their favours as Nell Gwynn had been. After a few years' success, drink, debt and fading beauty propelled most down the ladder they had climbed by, and endings could be dire, as Betty Careless's was. On the other hand, this was a highly mobile world, and there were famed successes.

On the last night of *The Beggar's Opera* in 1728, the audience was unhappy to learn that Polly Peachum's part was to be played by Miss Warren rather than by the sensationally successful Lavinia Fenton. The

58. Hogarth, *Lavinia Fenton, Duchess of Bolton*
(oil, *c.* 1740–50)

latter had sensibly run off with the infatuated Duke of Bolton: he settled
'£400 a year upon her during pleasure, & upon disagreement £200 a
year'. They produced three sons and, give or take an affair or two or
three on each side, lived happily ever after, she as the Duchess of Bolton.
Hogarth's painting of a scene in *The Beggar's Opera* shows the duke gaz-
ing rapturously at her from his seat on the stage, as he had every night
until at last he got her (fig. 57). And in the 1740s Hogarth splendidly
painted what is almost certainly her portrait, a strong and unapologetic
woman (fig. 58).[16] The actress Fanny Abington was also painted – by
Reynolds in 1771; a half-dozen years later Sheridan wrote the part of
Lady Teazle for her in *School for Scandal*. By then she was the mistress
of the Marquess of Lansdowne; yet her father had run a cobbler's stall
in Vinegar Yard, she had grown up in the Drury Lane alleys, and as a girl
had sold flowers in Covent Garden market and sung ballads in the streets,
interspersed with spells of prostitution in Leicester Fields.[17]

*

'Bach, sir? – Bach's concert? – And pray, Sir, who is Bach? – Is he a piper?' Dr Johnson once asked his friend Charles Burney.[18] A full account of Covent Garden's creativity should obviously include the musicians. Johnson would have disagreed; but there was no ignoring them. In 1763 *The Universal Director* listed ninety-five 'Masters and Professors of Music' across London – mainly teachers. Moreover, a metropolis that attracted Handel, J. C. Bach, Haydn and the boy Mozart was clearly no musical desert. Handel lived at 25 Brook Street, Hanover Square, from 1723 until his death in 1759, and in 1764 young Mozart lodged briefly at the house of 'Mr Couzin hare cutter' in Cecil Court off St Martin's Lane. J. C. Bach, in London for twenty years from 1762 until his death in 1782 in Paddington, became Master of the Queen's Music. In the 1790s, Haydn lodged at 18 Great Pulteney Street, Soho. Handel's and Bach's looming presence rather silenced significant English composition. William Boyce was born in Maiden Lane, and Burney, father of the novelist Fanny, lived in St Martin's Street off Leicester Fields. Neither are widely remembered today. Thomas Arne wrote the music of 'Rule, Britannia' and 'A-Hunting We Will Go', for better or worse. He lived all his life in or near Covent Garden.

Dozens of instrumentalists and minor composers lived around the district to serve its theatres. Differing little in their manners and comforts from the more penurious writers and artists, they, too, were thought of as craftsmen of the middling kind, and earned little.[19] They seem to have kept their own company, or to have kept theatrical or clerical rather than artists' and writers' company, but there's no question that their music gladdened many artistic and literary lives. Hogarth joined the Academy of Vocal Music in 1729 (forerunner of the Academy of Ancient Music). Whether he really liked Palestrina, Victoria and Byrd is less certain than that his membership increased the likelihood of commissions.[20] Gawen Hamilton would visit the trumpeter John Grano for flute lessons when Grano was locked up in the Marshalsea debtors' prison in the late 1720s; Grano played in Handel's orchestra at the Haymarket opera house.[21] In his house in the Piazza, likewise, the painter Sam Scott hosted a musical club chaired by Sir Edward Walpole, the prime minister's libertine son. The no less libertine artist Marcellus Laroon III was the club's

deputy chairman. They were all skilled players. Gainsborough was intimate with many musicians. Innumerable artists had a musical father, brothers or sisters. There was singing, too – in glee clubs like the one Dighton drew in the 1780s, where the punchbowl lubricated the proceedings and wigs went awry. 'Which is the properest Day to

59. Robert Dighton, *Glee Singers Executing a Catch* (wash, watercolour, no date)

drink, Saturday, Sunday, Monday?' they sing cheerfully in the mezzo-tint taken from this drawing; then they answer, 'Why should I name but one day?' (fig. 59).

DISTRESSED ARTISTS

It was the artist's world that provided the best refuge from the prudish, polite and godly. The world in question wasn't that of society artists such as Reynolds, but of workaday painters and engravers, which was much more vigorous. Many of them had as difficult a time as the writers did, but they wrote less and drew more, so they left fewer records to tell us about their struggles.

It helped them that markets for painting and engraving were expanding, so the competent usually found patrons. Edward Harley, second Earl of Oxford, had supported quite modest artists; and many an Italian tour was made under an aristocrat's patronage. There were other niches to occupy. Christian Friedrich Zincke, the German enamellist, became the Prince of Wales's cabinet painter; William Hoare made a rare informal drawing of such a man at work, after poor eyesight forced his retirement (fig. 60). Drapery painting was another established business. Specialists in this couldn't 'fail of getting a fortune', Hogarth wrote. They often painted nine-tenths of a portrait, even though 'the fizmonger' (face-painter) got the credit. Peter Toms, one of the best of them, charged Reynolds fifteen guineas for the draperies on a full-length portrait, with the hands included in the fee. The relationship wasn't submissive. Toms once refused to replace the formal clothing he had given a female portrait with the 'rural habit' Reynolds wanted, telling Reynolds that 'you ought to be more explicit when you give the picture into my hands'.[22]

Some artists did very well indeed. Kneller and Thornhill died rich in 1723 and 1734 respectively. Kneller lost £20,000 in the South Sea Company bubble, but still he had an income of £2,000 a year. Hogarth was well off, too; but the most fashionable portrait painters did best of all. In an era when a skilled craftsman's family might earn £200 a year, Joshua Reynolds charged 150 guineas for a full-length portrait in the 1760s, while Gainsborough charged 100 or

60. William Hoare, *Christian Friedrich Zincke, Portrait-miniaturist in Enamel* (chalk, 1752)

120 guineas in the 1780s. Reynolds bequeathed £100,000 at his death in 1792 (as did David Garrick in 1779). Top incomes probably increased towards the end of the century and into the nineteenth. Thomas Rowlandson left a very comfortable £3,000 in 1827. Northcote left £1,000 in 1831 to pay for a monument to himself by Chantrey the sculptor. Angelica Kauffman was rich; Richard Cosway left about £12,000. The very wealthiest at death were Nathaniel Dance in 1811 (£200,000, thanks to a wealthy marriage), the sculptor Joseph Nollekens in 1823 (£200,000 and several London houses) and J. M. W. Turner in 1851 (an estate worth £140,000).[23]

Modest legacies were more common.* At the bottom came the sadder legacies of the derelict James Barry (£204. 14s. 9d) and of the ill J. R. Cozens (£80). Wenceslaus Hollar left £22 and some pots and pans. Countless artists and engravers knew or feared the debtors' prison, or like the hapless Mauritius Lowe died penniless. Sir Thomas Lawrence died in debt in 1830, though over £15,000 was raised from his art collections. Chatelaine the book illustrator had to be buried at the parish expense. One of the biggest earners, George Morland, drank it all away and left his long-suffering wife nothing.

So, although rewards at the top were substantial for a small minority, run-of-the-mill artists found that conditions were fiercely competitive, and many weren't good enough or well enough connected to flourish. 'Misery among the unsuccessful', Hogarth wrote, was such that they 'wished that they had been brought up cobblers'; there was no market 'in this Kingdom or in any part of the world that can maintain more than twelve artists in a way that may be thought an adequate recompense for so tedious a study'.[24] Although this was an exaggeration, even good artists ran into difficulties. As he fell out of fashion at the turn of the century, Paul Sandby had to take up oils in place of watercolour. His explanation is unexpected: 'the price of glass for [the framing of] drawings is now so high as to make it formidable, which had caused him to adopt a practice attended with less expense'.[25] Despite his fashionable market (he was Angelica Kauffman's engraver), William Wynne Ryland not only endured bankruptcy but also forged two bills in 1783 to cover his speculations. He went into hiding, so they advertised his appearance in the newspapers: 'about fifty years of age, about five feet nine inches high, wears a wig with a club or cue, and his own hair turned over in front; a black complexion, a thin face with strong lines; his common countenance very grave, but, whilst he speaks, rather smiling, and shows his teeth and has great affability in his manner'. They found him.

* George Vertue left £1,500 and his art and books, the sculptor John Flaxman £1,657, and Michael Angelo Rooker about £2,000. Hayman in 1776 left an estate of £300 a year to his daughter. Sam Scott at peak earned £700 to £800 a year. Romney made c. £700 a year, and in 1802 left a house in Hampstead and others in Westmoreland. J. H. Mortimer earned £900 from portraits c. 1777. John Collet left £850 in 1780, plus annuities and personal effects; young Thomas Girtin £600; and Joseph Highmore £550 and shares in the East India Company in 1780. *ODNB* entries.

He was hanged at Tyburn alongside a horse-thief, two robbers and a man who had impersonated a sailor to get his prize-money.[26]

Painters who failed, or men who couldn't afford to train as painters, resorted to the apprenticed craft of engraving. Although engravers had earlier been welcome in artists' clubs, and a couple were in the early Academy, Reynolds and his friends were soon dismissing their work as artisanal, imitative and mechanical, and excluding them from Academy exhibitions. When the dealer John Boydell asked Reynolds to paint pictures for him to have engraved, Reynolds sniffed that he would be 'degrading himself to paint for a print-seller'. The same spirit informed the treatment of the topographical artist Thomas Malton when he competed with John Soane for election to the Academy in 1794. 'Smirke came to us,' Joseph Farington recorded in his diary, 'and we conversed on the means . . . to prevent Malton succeeding.' It was decided to rule him out because he was 'only a Draughtsman of Buildings, but no Architect' – this despite the fact that Malton's drawings and designs had won premiums and medals from the Society of Arts and were many times exhibited at the Academy and the Free Society of Artists. Malton had taught drawing to the young Thomas Girtin and J. M. W. Turner.[27]

Increasing numbers of exhibitions, the wider dissemination of engraved art works, and the increasing social range of patrons meant that painters' standing advanced in the second half of the century. But, with rare exceptions, they never fully escaped a larger snobbery. Just as nobody among the Quality would dream of becoming a professional artist, so it was long disputed whether a professional artist could ever be a gentleman. This was still being debated in the 1840s when Thackeray mocked those who still asked it: 'Patronage – a plague on the word! . . . in the name of all that is sensible, why is a respectable country gentleman, or a city attorney's lady, or any person of any rank, however exalted, to "patronize" an Artist!'[28]

So far as the past was concerned, the answers were self-evident. Art, literature and music had always depended on patronage. It was and is pointless to lament the vast inequalities that mediated this great truth, though that doesn't mean we shouldn't notice them. The affectations of an exceptionally successful society painter like Reynolds, with his high fees, painted carriage, liveried servants and fine house on the good side of Leicester Fields, hide the fact that artists' collective social position

was akin to a skilled craftsman's. They were easily exploited. Lord Elgin offered the young watercolourist Thomas Girtin £30 a year to act as draughtsman on his Constantinople mission in 1799. This was less than half the salary of Elgin's valet. Girtin turned him down.

It is odd that well-bred art historians so ignore the fact that eighteenth-century art was predominantly the creation of middling and humble men, just as they sidestep its implications for the toadying that ensued from it. This book's Appendix lists the names and addresses of 146 artists and engravers from Covent Garden and neighbourhood, and it traces the father's occupation of most of them. Those with comfortable backgrounds were few. The painter John Vanderbank was the son of the prosperous owner of the Soho Tapestry Manufactory and chief arras maker to the Crown. James Thornhill's Dorsetshire father was modestly landed, Reynolds was the son of a well-connected Devon schoolmaster, Thomas Worlidge of a lawyer, Richard Wilson of an Anglican rector, Samuel De Wilde of a Dutch physician and the Sandby brothers of a 'framework knitter' in Nottingham, but one with property, it seems. Zoffany's father was a cabinet-maker and architect at a German court, and Peter Lely's was an infantry captain in Brandenburg.

Otherwise the predominance of craft or similarly modest status in the fathers' occupations is striking. A good number of sons simply followed their fathers in the same business (George Bickham, George Dawe, Marcellus Laroon III (the Younger), Thomas Malton the Younger, William Pars, Robert Edge Pine, Michael Angelo Rooker, William Ryland). This was especially true of engravers and artists born across the Channel (Bernard Baron, James Basire, Antoine Benoist, Louis-Philippe Boitard, Louis Chéron, Angelica Kauffman, Philippe de Loutherbourg, John Faber). John Flaxman's father was a plaster-cast maker. The occupations of the rest were both various and modest:

builder or bricklayer (James Barry); hosier (William Blake); sailor (George Chambers); farmer (Luke Clennell); joiner (John Cleveley the Elder); public office holder (John Collet, Nathaniel Dance); schoolmaster (of differing status: Richard Cosway, Hogarth, Reynolds); apothecary (Francis Cotes); house painter (Charles Brooking, Bartholomew Dandridge); bricklayer and publican (William Daniell); carpenter or master joiner (Arthur Devis, Elias Martin); printseller (Robert Dighton); chair-

maker and carver (Edward Edwards); *publican, clothier and postmaster* (Thomas Gainsborough); *soldier* (James Gillray, Charles Reuben Ryley); *brushmaker* (Thomas Girtin); *master tailor* (H.-F. Gravelot); *dancing master* (Valentine Green); *printer and bookseller* (Benjamin Haydon); *coal merchant* (Joseph Highmore); *master mariner* (Francis Holman); *surgeon* – a low status trade (John Hoppner, Arthur Pond); *pastrycook* (Thomas Hearne's uncle); *bookbinder* (James Heath); *victualler* (Thomas Hudson); *peruke-maker and mercer* (Ozias Humphry); *locksmith* (Elisha Kirkall); *menagerie keeper*, albeit a 'royal' one at Versailles (Louis Laguerre); *exciseman and publican* (Sir Thomas Lawrence); *Huguenot weaver* (Philip Mercier); *miller and exciseman* (John Hamilton Mortimer); *coppersmith, goldsmith* (George Moser, Theodore Gardelle, Hans Hysing); *watchmaker* (James Northcote); *mine carpenter* (John Opie); *shopkeeper and naval outfitter* (Samuel Prout); *bookseller* (Allan Ramsay); *silkweaver* (Jonathan Richardson); *furniture-maker and joiner* (George Romney); *silk merchant* – bankrupt (Thomas Rowlandson); *framework knitter*, though propertied (Paul and Thomas Sandby); *barber surgeon* (Samuel Scott); *watchcase maker* (Thomas Hosmer Shepherd); *stationer* (William Shipley); *publican*, Black Horse Inn, Long Acre (Thomas Stothard); *groom* (Luke Sullivan); *barber and wig-maker* (J. M. W. Turner); *tailor* (George Vertue); *merchant's manager* (William Ward); *innkeeper* (Benjamin West).

Artists were rough men by and large, and many had the characteristics of poor ones. Stunted growth was common. Hogarth, Samuel Scott, Zinke the enamellist, Gawen Hamilton, Richard Cosway and George Vertue were among the 'five foot men or less' whom Vertue himself noted. Scores of them were feckless and coarse-grained to a degree, and libertine too. In the previous century, Wenceslaus Hollar was 'shiftless to the world', according to his friend John Aubrey; he died owning little more than his bed and some pots and pans.[29] Later, the painter John Vanderbank, one of Hogarth's early mentors, lived 'very extravagantly. keeping. a chariot horses a mistres drinking & country house a purpose for her' – that is, he lived 'galantly or freely according to the custom of the Age'. John Peeters, also Dutch, was a 'lusty man of a free open temper a lover of good company and his bottle', according to Vertue.[30] The engraver William Toms was commonly 'in Liquor, and very Outrageous

and at such times striking his Servants and beating the wainscott with his fist'; in 1761 he was imprisoned in King's Bench for debt. Horace Walpole remembered Francis Hayman as 'a rough man, with good natural parts, and a humourist'. Hogarth's manners were too rough and combative for him to mingle comfortably with aristocrats or even with equals. 'A strutting, consequential little man,' the Academician Benjamin West called him (though Hazlitt thought West's vanity greater than Hogarth's).[31] Boorishness and worse characterized artists right to the end of our period. J. M. W. Turner could never conceal his cockney accent and manners. John Constable found he had 'a wonderful range of mind' but was otherwise 'uncouth' – how uncouth we'll see in the last chapter. The Academician George Dawe posed less easily ignored difficulties. Dawe was known for an 'ingrained economy in soap'; his friends called him 'the Grub'. Charles Lamb would be knocked backwards by his bodily odours. He described how Dawe

> would wash (on Sundays) the inner oval, or portrait, as it may be termed, of his countenance, leaving the unwashed temples to form a natural black frame round a picture in which a dead white was the predominant colour. This, with the addition of green spectacles, ... gave him a singular appearance when he took the air abroad; in so much, that I have seen a crowd of young men and boys following him along Oxford Street with admiration.[32]

Horace Walpole thought that in art's higher reaches low talk and manners were tabooed by the 1780s.[33] Hardly so. Fantasies about the greater sexual availability of foreign women beset many of these men. William Humphrey the printseller tried to tempt James Gillray to join him in Holland in 1802 by describing summer there as 'nothing but Singing, Drinking, Music, Balls, Plays – and getting the young Women with Child'.[34] Nor could there be a more genteel artist than Richard Cosway. He lived in Berkeley Street off Piccadilly, and he profited greatly from his exquisite miniature paintings of royalty and aristocrats. This didn't stop him from rhapsodizing in 1772: 'Italy for ever say I – if the Italian women fuck as well in Italy as they do here, you must be happy indeed – I am such a zealot for them, that I'll be damned if I ever fuck an English woman again (if I can help it).' Alas, Cosway never once made it to Italy, and since he was shorter in stature than

most, it was all boast and bluster really. This 'dapperest and dandiest of men' once turned up at the Turk's Head in Gerrard Street in red-heeled court shoes, and paid the price by being nicknamed the 'Macaroni Painter' when he wasn't being lampooned as a diminutive creature who climbed to eminence by flattering influential women.[35]

Unpolished educations were many. Hogarth as he aged could barely write a coherent sentence. The disorder and illiteracies of his 'autobiographical notes', scribbled on loose bits of paper in his mid-sixties in the most upsetting stage in his life (he died aged sixty-seven in 1764), reveal not only a splenetic mind but also a dysphasic and incoherent one: approaching dementia is possible (see chapter 5, n. 56). Misspellings abound in engraved print titles throughout the century. Hogarth's first proof of *Midnight Modern Conversation* had 'Moddern' (fig. 77 below), while Luke Sullivan's engraving of Hogarth's *March to Finchley* dedicated the print to the King of 'Prusia'. George Vertue's notes as cited throughout this book speak for themselves. They didn't greatly differ from the manner of the landscape painter Alexander Cozens when he proposed to 'studdy the beauty of Form & injoy elegant Ideas set the Image of a charming face fore my mind feed on its lovely Innocence & by it flatter my longing Soul with Visions of happyness tho' but in Picture for I will immure myself in solitude & paint the Graces act Truth and contemplate virtue'.[36]

Although there were many devout Catholics and Huguenots in the neighbourhood, religious belief didn't generally feature among artists' gentler attributes. Few seem to have paid more than lipservice to the Almighty, and to judge from the satires – satires were uniquely eloquent on the otherwise unspoken – anti-clericalism was reflexive (fig. 61). Dissenting parents were common, and their harsh child-raising practices could induce neurosis and guilt, but then also rejection. Blake and Gillray were sons of Moravians, Hogarth of a Calvinist. Blake developed his own mystical beliefs; Hogarth was latitudinarian and a freemason;[37] and the misanthropic Gillray seems to have lacked piety altogether.

The most urbane Covent Garden people were Enlightened – which meant latitudinarian, deist or atheist. In 1727–8 it was in Maiden Lane (with a French barber and perukier) that Voltaire chose to lodge when in London to supervise the publication of his essays. In the 1730s, Huguenot intellectuals met in Slaughter's coffee-house in St

61. Matthew Darly, *Divine Love* (etching, 1777)

Martin's Lane to discuss philosophy and religion with deepening scepticism.[38] The deist Club of Thirteen commenced its life in 1773 when Thomas Bentley, David Williams and Benjamin Franklin, the latter on his second lengthy sojourn in London, met over veal and potatoes at Slaughter's; thereafter, confining themselves to thirteen members, they met twice a month or so at Slaughter's or at Franklin's lodgings in 7 Craven Street off the Strand.[39] More widely, notions of virtue rested on sincerity and good faith rather than on devotion to the deity. Except in its rare big commissions – such as Thornhill's murals at St Paul's Cathedral (1715–19) – the established Church was

an insignificant art patron. Although no artist would refuse to illustrate biblical texts if so commissioned, or to exhibit biblical history paintings in the Academy if he could, most otherwise disregarded religion, when they didn't mock it in satire. All the way through to the 1820s, print satirists mocked evangelical enthusiasm as 'cant'.

It was never easy for the humble parents of the middling kinds to buy their sons an apprentice painter's training. Countless lads became engravers because their families' means were modest. In his teens Hogarth had to be apprenticed to a silver engraver in Cranbourne Street off Leicester Fields. He later complained that he learned from him only 'bad habits'. 'Engraving on copper was at twenty his utmost ambition,' he wrote of himself in his Notes; so duly, in 1720, he set up as a copper-engraver, a relatively low-status trade – though he took care also to learn figure-drawing in Chéron's academy. Much later, James Gillray, son of a Chelsea pensioner, was admitted into the Academy Schools in 1778, but then he, too, had to be apprenticed to a lettering-engraver in Holborn. Lodging in Little Newport Street in the hope of better custom, he tried in vain to establish himself as a portrait painter, but his efforts were dismal. His engraved portrait of Pitt teeters on the edge of caricature (Fores, who commissioned it, had to withdraw it), his shipwreck scenes are melodramatically overblown, his engravings of women sentimental. In his first year at the Academy, he produced a couple of mildly indecent satires for William Humphrey, and in his second year thirteen attributed satires. Only in the 1780s did he capitulate to his destiny as a satirist. He began then to work regularly for Holland, Fores and lesser printshops, until Hannah Humphrey took him under her wing in 1791.

William Blake's early career was similarly uncertain. His first contact with formal education came at the age of ten, when his hosier father sent him to Henry Pars's drawing-school in the Strand in 1767 (in what later became Ackermann the print-dealer's first showroom). Here he and other boys copied plaster-casts after the Antique in order to prepare them for the St Martin's Academy. He taught himself as best he could by haunting Langford's auction rooms in Covent Garden and Christie's in Pall Mall, their sales 'exclusively filled as yet with the pictures of the "old and dark" masters, sometimes genuine, oftener spurious, demand for the same exceeding supply'. But for Blake attendance at the St Martin's Academy remained an impossible dream.

Even if he had achieved it his future would still have been bleak, as his earliest biographer describes:

> The preliminary charges of launching Blake in the career of a Painter, were too onerous for the paternal pocket; involving for one thing, a heavy premium to some leading artist for instruction under his own roof, then the only attainable, always the only adequate training. The investment, moreover, would not after all be certain of assuring daily bread for the future.

Only an apprenticeship to an engraver would train 'the cunning right hand which can always keep want at arm's length: a thing artist and *littérateur* have often had cause to envy in the skilled artisan'. So Blake, too, had to enter 'the to him enchanted domain of Art by a back door' – by submitting 'his shining dreams to the humblest, most irksome realities of a virtually artisan life'.

In 1771, aged fourteen, he was apprenticed to the engraver James Basire of Great Queen Street off Drury Lane, even though Basire and his clients could introduce him only to 'the mechanical part of Art'. He made his living thereafter by engraving works by friends like Stothard and Flaxman, or by 'hackney work' in the *Wit's Magazine*. The folding plates he engraved for this last in 1784 were so little regarded that the British Museum's impression of his engraving of Collings's *May-Day in London* has a contemporary printseller's remainder price scribbled on it: '1 [penny] each or 7 for 6d' (fig. 62). Still, by then, in 1779, he had managed to enrol in the Academy Schools, with permission to study classical casts for six years.

In none of these conditions was Blake exceptional. Nor was he exceptional in his continuing poverty. He lived the last years of his life with his wife in two rooms at 3 Fountain Court off the Strand, immediately south of Covent Garden. In one room he displayed his own works and received visitors; the other room

> was, at once, sleeping and living room, kitchen and studio. In one corner was the bed; in another, the fire at which Mrs Blake cooked. On one side stood the table serving for meals, and by the window, the table at which Blake always sat (facing the light), designing or engraving. There was an air of poverty as of an artisan's room; but everything was clean and neat; nothing sordid.[40]

62. William Blake, after Samuel Collings, *May-Day in London* (etching, 1784)

Oddly, this is a very near description of the lodging of the French-born illustrator and engraver Louis-Philippe Boitard earlier in the century. We meet him several times in this book as a sharp observer of common life. He came to London around 1733 and lodged in Durham Yard (across the Strand towards the Thames, south from Bedford Street). Some time in the 1730s he sketched himself and two friends as they sat there at a rickety table (fig. 63). His room is simple though clean and neat. His curtained bed is on one side of it, and his workbench full of brushes is at the window on the other side; its sash seems to be propped open by a chair leg. The walls are pinned with drawings and small frames, and wine bottles stand on the chest to the rear. One small dog begs charmingly while the other shows a less charming interest in the chamber-pot.

Such as they were, artists' own comments on their fragile conditions

tend to date from the end of the period, and it was Thomas Rowlandson, primarily, who made them. Both the cult of genius and rising expectations were making failing artists more self-conscious than their predecessors had been. Rowlandson himself cared nothing about genius, even though he was one; but in the 1780s he gambled away all his aunt's bequest, and he was forced to live in dodgy lodgings at times. He had talents enough always to rise above his troubles, but even he was complaining in 1804 about the niggardly patronage of 'the long pursed gentry'. And once, in 1815, he complained to his friend Angelo that he was 'so poverty struck' that he could 'afford [Angelo] no assistance'.[41]

Rowlandson turned out many graphic comments on artists' as well as writers' tribulations. In parodic reference to Hogarth's *Distressed Poet*, his *Chamber of Genius* (drawn 1810, etched 1812) depicted a distracted young artist labouring to paint a wild Romantic head while ignoring the impoverished but vital family life behind him: bare-breasted

63. Louis-Philippe Boitard, *Self-Portrait with Two Young Men* (pen, ink, watercolour, 1730–40)

64. Rowlandson, *The Chamber of Genius* (etching, 1812)

young wife in bed and little children happily playing in the disordered-bedroom (fig. 64). It was a satiric comment on the excesses of academic training and its indifference to 'real life', and also on the rash pretensions of genius, for the room is littered by the discarded impedimenta of the artist's musical and scientific enthusiasms and failures.[42] In another drawing, *An Artist's Studio* (1814) (fig. 65), he caricatures the artist in his derelict attic. Working on a classical pastiche, his feet are bare, his stool rickety, his cats hungry (and ill-drawn: it's odd how few past artists could do cats), and he is badgered by a picture-dealer carrying a frame for the still unfinished work. The drawing recalls Rowlandson's now-dead friend George Morland's painful familiarity with such situations, though the artist here looks nothing like Morland.[43]

*

It's as unwise to generalize about the artistic temperament as it is to generalize about genius. Rudolf and Margot Wittkower long ago

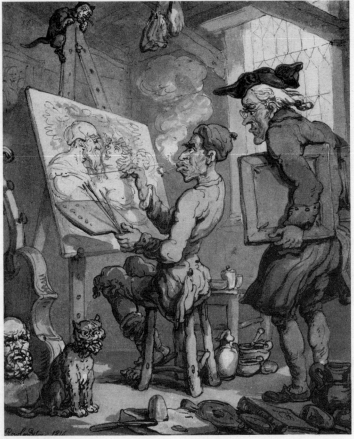

65. Rowlandson, *An Artist's Studio* (pencil, ink, watercolour, 1814)

scotched the myth that artists' personalities had uniform expressions.[44] All the same, Covent Garden in our era generated strange eccentricities among the successful artists and even stranger ones among the failures. A certain loucheness prevailed.

For a start, thwarted ambition destroyed many artists, and derelict artists were common. The paranoid James Barry was a classic case. A man of many enemies, he so abused his fellow Academicians that in 1799 he became the only Academician ever to be ejected from the

Academy. The consequences for him were dire. Shortly before he died in squalor in his house at 36 Castle Street (above Oxford Street) in 1806, the poet Robert Southey described him as wearing

> an old coat of green baize, . . . from which time had taken all the green that incrustations of paint and dirt had not covered. His wig was one which you might suppose he had borrowed from a scarecrow; all round it there projected a fringe of his own grey hair. He lived alone, in a house which was never cleaned; and he slept on a bedstead with no other furniture than a blanket nailed on the one side.

Someone else described the area before Barry's house as

> bestrewn with skeletons of cats and dogs, marrow-bones, waste-paper, fragments of boys' hoops, and other playthings, and with the many kinds of missiles, which the pious brats of the neighbourhood had hurled against the unhallowed premises. A dead cat lay upon the projecting stone of the parlour window, immediately under a sort of appeal to the public, or a proclamation setting forth that a dark conspiracy existed for the wicked purpose of molesting the writer and injuring his reputation.[45]

Barry wasn't the only one to live like this. Dr Johnson patronized a painter called Mauritius Lowe. He became godfather of Lowe's children and left them a small legacy. Lowe also happened, briefly in the 1780s, to be one of young J. M. W. Turner's first teachers. None of this helped, though. Living as she did around a corner or two, Fanny Burney knew him as a 'poor wretch of a villainous painter'; his face was scarred with smallpox and one of his eyes was missing.[46] In 1782 she reported how out of kindness Johnson persuaded friends to sit to Lowe for their portraits. One duly visited Lowe in his Hedge Lane lodgings, but found 'a room all dirt and filth, brats squalling and wrangling, up two pair of stairs, and a closet, of which the door was open, that . . . was quite Pandora's box – it was the repository of all the nastiness, and stench, and filth, and food, and drink, and – oh, it was too bad to be borne!' The gentleman 'poked the three guineas in [Lowe's] hand, and told him [he] would come again another time, and then ran out of the house with all [his] might'.[47]

There was a tendency to self-destruction. The engraver and miniaturist Luke Sullivan worked for Hogarth, but he was inclined to

disappear off the job when the mood took him, so Hogarth had to keep a sharp eye on him, 'for if once Luke quitted it, he was not visible for a month'. 'Much addicted to women, his chief practice lay among the girls of the town'; he died at the White Bear, Piccadilly, 'being too much attached to what are denominated the good things of this world, ... in a miserable state of disease and poverty'.[48] Jean-Baptiste Chatelaine was another who worked erratically. He often turned up at William Toms's workshop 'for half an hour [to] receive sixpence [and then] go and spend it amongst bad women in Chick Lane and Blackboy Alley'. 'If by accident he earned a guinea, he would immediately go to a tavern, and lay, at least, half of it out on a dinner.' At one point, because he thought he might find treasure there, he rented a house which was said to have belonged to Oliver Cromwell. He spent days lying on the floor, 'listening if, by the shaking, occasioned by the carriages passing to and fro, he could hear the chinking of money'. He, too, died in poverty at the White Bear in Piccadilly after an overindulgence, and had to be buried in 1758 in the 'Pest-fields, Carnaby-Market' at the parish's expense.[49] The fecund Robert Dighton of Charing Cross, designer of amiably risqué drolls, supplemented his two legitimate girls with four sons and two daughters born out of wedlock, and between 1798 and 1806 was found to have stolen uncounted Rembrandt and other prints from the British Museum to pay for them. At least two artists were hanged – Theodore Gardelle for murder in 1761, and Ryland for forgery in 1783.

Irregular sex lives went unremarked in these circles. Thomas Girtin died young in 1802 while entangled in his own murky love affairs, his wife's pregnancy notwithstanding. Gainsborough was so fond of indulging himself 'to the hilt', as his letters meaningfully put it, that gonorrhea nearly killed him. William Marlow the topographical painter moved from Leicester Fields to Twickenham to live with a butcher and his wife whom he had met in Vauxhall Gardens. 'He has lived more than 20 years with them,' Joseph Farington gossiped in 1808, '& there are now 6 or 7 children, some of them very like Marlow. A strange instance of infatuation.'[50] When in 1799 J. M. W. Turner left Maiden Lane for Harley Street, it was with his mistress Sarah Danby in tow; installed nearby, she bore him two daughters before the relationship ended around 1813. In 1846 he bought a house in Chelsea

to share with his one-time Margate landlady, Sophia Booth; he spent most of his last years there, concealing his identity by calling himself Admiral Booth.

Drink was the biggest peril. In that era, men knew how to drink themselves silly, and artists were masters of that skill. When Reynolds declared that great painters were never dissipated, William Blake, in his scribbled marginal notes to Reynolds's *Discourses*, corrected him by implying that dissipation was a condition of genius: 'He who has Nothing to Dissipate Cannot Dissipate; the Weak Man may be Virtuous Enough, but will Never be an Artist.' Painters were 'noted for being Dissipated & Wild', he added. Even 'Rafael Died of Dissipation.'[51]

Those whose livers survived their six bottles a day had gout to endure. According to Horace Walpole, James Thornhill, Francis Hayman and Sam Scott died of it. Once Hayman and the Drury Lane actor James Quin fell into a sewer in the Piazza so drunk that they couldn't climb out of it.[52] John Hamilton Mortimer led an adventurous life that once nearly lost him a hand from a sword attack. What did for him was the mistake, during one of his many drinking bouts, of eating a wineglass – 'of which act of folly he never recovered'. He painted on for years and married, but died aged only thirty-nine.[53] Samuel Collings, whose designs both Rowlandson and Blake engraved, died drunk on the steps of a Soho tavern. Isaac Cruikshank the caricaturist 'shortened his life by the fashion of the day', his son George wrote, by accepting a challenge to a drinking match that sent him into an irreversible coma at the age of forty-eight. George was himself a great toper. Dickens several times had to haul him from the gutter.[54] Another of Rowlandson's friends, G. M. Woodward, died in 1809 'with a glass of brandy in his hand' in the Brown Bear in Bow Street, so poor that his landlord had to pay for his burial.[55] Richard Wilson, a central figure in early landscape painting and one of the Academy's founders, developed a face as 'florid as Madeira wine' and a nose so bulbous that 'usually he held up his pocket handkerchief to hide it'. A year before his death in 1782, aged seventy, his utter incapability was presented as 'an awful lesson' to drinkers. In his last years he managed to paint few sketchy landscapes. He sold them for five shillings each from a shoemaker's and walking-stick dealer's shop in Long Acre.[56]

GEORGE MORLAND AND FRIENDS

Wilson's awful lesson was lost on the most wildly eccentric of all these men, the genre painter George Morland. Morland's artist father, Henry, who painted his portrait (fig. 66), had virtually imprisoned his son in his teens in their Haymarket house, forcing him to copy and forge Dutch and Flemish works which Henry then palmed off on dealers. George spent the rest of his life rebelling against the memory of this confinement; two of his brothers, equally abused, ran off to sea. In adulthood, George's alcoholic manias and chronic indebtedness were mythic. Feckless, reckless and profligate, he spent a fair amount of his life climbing out of windows and down ladders or changing addresses to escape creditors. 'It has been observed of Gray, the poet, that he never was a child,' wrote Morland's biographer, the unforgettably unwashed George Dawe, 'and it may with equal truth be asserted of Morland, that he never was a man.'

People always warmed to Morland's childlike openness, but he was the reverse of 'polite': he hated aristocrats, and he studied neither art nor books. He was one of the many artists who announced that his only school was 'nature', but he was also one of the very few whose favoured companions were 'jockeys, ostlers and carters, money-lenders, abandoned women, and gipsies'. It was easy to dismiss him as 'a painter of pigs', as Gillray did, among others.[57] But even at his drunkest he was the most prolific of artists – and, oddly, the most successful. He is thought to have produced up to 4,000 paintings in his lifetime – perhaps 800 in his last eight years. Today hardly a public or private collection in England lacks one or more of them. His talent, skill and sense of the demand for genre paintings of cosily domestic scenes were as impressive as his sales (fig. 67). He would knock out a saleable painting in an afternoon (two and a half hours was his record),[58] and sell it cheaply to the hangers-on who lived off him, to settle a debt or buy tavern company and its lubricants.

He was usually dashingly dressed, even while confined in the King's Bench prison for debt. But by the last months of his life, aged forty-two, he 'looked besotted and squalid [with] cadaverous, hanging cheeks, a pinched nose, contracted nostrils, bleared and bloodshot eyes, a bloated

66. Henry Robert Morland, *George Morland* (oil, *c.* 1779)

frame, swelled legs, a palsied hand, and a tremulous voice'.[59] No won-
der. In that last year he went to Brighton in the hope of repairing his
pickled body by sea-bathing. While there he scribbled down his own
epitaph and sent it to his brother: 'Here lies a drunken dog'. Decorating
it with a skull and crossbones, he added a list of the 'bub' that kept him
going through a single day when he had 'nothing to do':

Hollands Gin	} Before
Rum and Milk	} Breakfast
Coffee	—Breakfast
Hollands	}
Porter	}
Shrub *[rum and lemon]*	} Before
Ale	} Dinner
Hollands and Water	}
Port Wine with Ginger	}

Bottled Porter }

Port Wine —At Dinner and after

Porter

Bottled ditto

Punch

Porter

Ale

Opium and Water

Port Wine —At Supper

Gin and Water

Shrub *[rum and lemon]*

Rum on going to bed.[60]

Shortly before his miserable death in a debtors' sponging-house in 1804, Morland painted a forlornly ironic portrait of himself working on a rural landscape at his easel in a bare attic room. In this unforgettable icon of bohemian living, he is accompanied by his pet dogs and his man Gibbs, who fries sausages on the fire (**plate 8**). After his death,

67. George Morland, *St James's Park* (oil, 1788–90)

a magazine engraving commemorated him in a room similarly littered with straw and full of the sheep and donkeys that were his companions and models.[61] This would seem a heartless parody were it not that Morland's friend Collins reported that every room in his Paddington house 'was infested with guinea pigs, tame rabbits, or dogs of various breeds'. Dawe added that in his parlour Morland kept a donkey and scattered his room with straw for his stable scenes. In his last years Morland seldom left his attic. He cooked in it, and ate off a chair while surrounded by 'dogs of various kinds, pigeons flying, and pigs running about'.[62]

NETWORKS

Stories about Morland tell us much about the loucher elements in the artistic world, but nothing about the satisfactions of communal living in Covent Garden, or the networking, bonding and opportunities that artists and engravers enjoyed there. Networks were centred on taverns or coffee-houses or on shops or studios shared by masters and pupils. As time passed, societies and the Academy provided more formal affiliations. Through these channels influences were communicated, professional esteem strengthened, and pictures commissioned, engraved and sold. Moreover, customers were within easy reach. A signed impression of *Characters and Caricaturas* (1743), Hogarth's subscription ticket for the engravings of *Marriage A-la-Mode*, acknowledges receipt of the required half-guinea deposit from one John Millan, a bookseller in Charing Cross. We must imagine Millan walking up St Martin's Lane to 30 Leicester Fields to pay Hogarth his respects and his money (fig. 111 below).[63]

Each kind of artist was indispensable to the art community's sense of itself, and each contributed to the networks that sustained the best as well as the worst of them. Most oil painting involved collaborations between the master, the face-painters and drapery-painters and the pupils who did the backgrounds and skies. Johan Zoffany, who lived in the Piazza in the 1760s, painted drapery for Benjamin Wilson before making a pleasanter living by painting David Garrick in his stage roles. Thomas Gainsborough first worked under Francis Hayman similarly. The two Covent Garden theatres and later the theatre in the Haymarket

68. William Ward (attrib.), after George Morland (?), *Fanny Hill and Phoebe* (mezzotint, *c.* 1787)

created a high local demand for scene-painters and theatrical painters. And since every artist hoped for an engraver to disseminate his work, engravers' workshops and printshops were everywhere.

Even to Morland these provisions were important. To avoid his creditors he lived in the neighbourhood only occasionally, but his local associations were deep. In 1784 an unnamed Drury Lane picture-dealer enabled him to escape his father's control by offering him attic lodgings in Martlett's Court between Bow Street and Drury Lane. Morland was there persuaded to paint enough erotic pictures 'to fill a room, to which the price of admittance was half-a-crown'. The dealer might have been William Holland. He was the only printseller of substance in Drury Lane at the time (he traded there between 1782 and 1786), and he was associated with a publisher of flagellation literature, George Peacock.[64] The pictures referred to are almost certainly those mezzotinted in eight

hand-coloured 'nudities' or 'curiosities', as such things were called (the word 'pornography' was coined a century later), held by the British Museum. They illustrate explicit copulatory or lesbian scenes in Cleland's *Memoirs of a Woman of Pleasure*, Fielding's *Tom Jones*, Rousseau's *Nouvelle Héloïse* and Samuel Pratt's *Pupil of Pleasure* (fig. 68). The Museum dates them *c.* 1787 and tentatively attributes them to the mezzotinter William Ward 'after George Morland (?)'. One understands the doubt. The figures aren't well drawn, and the genital emphases are over-enthusiastic. On the other hand, there are stylistic similarities with Morland's public works at that date, and their emphases are consistent with the imaginings of a young man who could announce that his main relief from his father's control had come from kissing the servant girls.[65] Morland wasn't bashful. He spent much energy in extricating himself from rash promises to marry several of the servants, and, aged

69. John Raphael Smith, after George Morland, *The Tavern Door; Laetitia deserted by her Seducer is thrown on the Town* (stipple engraving, 1789)

nineteen, he paraded his current mistresses before his friends, in Dawe's words, 'from either a principle of candour, or an insensibility to shame'. He had also joined an artistic network that was well practised in erotica.

The network's central figure was the engraver and printseller John Raphael Smith. A trade leader and an accomplished pastel artist and engraver in his own right, Smith had a shop at 82 Oxford Street from 1781 to 1786 and another at 31 King Street, off the Piazza, from 1782 to 1806. Having cultivated a flourishing market in France before the Revolution, he published some 120 mezzotints and stipple engravings after Reynolds, Romney, Opie etc., and he became mezzotinter to the Prince of Wales between 1784 and 1799 – an honorific that rewarded efficient self-advertisement. With a stock of some 300 commissioned engravings by others, including key works like Fuseli's *Nightmare* of 1783 and Rowlandson's *Sketch from Nature* (1784) (fig. 31 above) and *Vaux-Hall* (1785), his entrepreneurial standing in London's art world was high.[66] He it was who trained Morland to milk the market, and it was in part thanks to him that Morland's sales remained buoyant deep into the next century.

In 1789 Smith suggested to Morland and then engraved for him a sentimental sub-Hogarthian narrative about the rise and predictable fall of an over-venturesome and eventually penitent girl called Laetitia, a familiar tale of seduction and desertion that made both men a lot of money (fig. 69). In 1790, too, Smith sold engravings after Morland's *African Hospitality* and his *Execrable Human Traffic; or, The Affectionate Slaves*. Both works endorsed the mounting campaign of the newly formed Society for the Abolition of the Slave Trade; the second one was the first ever painting to record a slave-trading scene. Smith also established a healthy continental demand for Morland's rustic mezzotints and sentimental genre pieces, and opened a 'Morland Gallery' in King Street to sell them. And it was Smith who must have introduced Morland to the printmaker William Ward. Ward had been Smith's apprentice, and he engraved many of Morland's plates. In 1786 he and Morland married each other's sister; for a time the two couples lived together.

By then Smith was at the centre of a web of connection and influence. Over the next twenty years his shop employed more than thirty printmakers, apprentices and pupils. The young William Blake, for instance, engraved at least two Morland plates for Smith in 1788. And the young

70. John Raphael Smith, *Rowlandson* (pencil, chalk, ink, *c.* 1787–95)

J. M. W. Turner and Thomas Girtin are generally agreed to have worked together as watercolourists at the back of the shop in the early 1790s, possibly introduced to Smith by Thomas Rowlandson, who was one of Smith's intimates. In 1787 the two men travelled together to France, and it was probably around then that Smith drew his friend's fleshily sensual features (fig. 70). Rowlandson extended the network exceptionally, because his friendships were extensive. He sketched Morland at least three times in the mid- to late-1780s, etched several Morland designs, and paid him the compliment of parodying his style.

These were well lubricated connections. Rowlandson, Morland and others cultivated a convivial familiarity with Smith's high-quality wine cellar, subsidized as it was by Smith's print exports to France. They were also united by the sexual candour common to men in that age. Rowlandson was the most prolific of all English eroticists whose

71. Rev. Matthew Peters, *Lydia* (mezzotint, 1776)

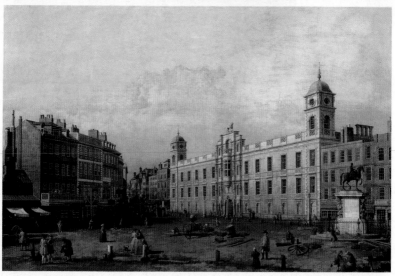

1. (*top*) Paul and Thomas Sandby, *The Piazza, Covent Garden*
(ink, watercolour, 1768–9) (p. 15)
2. (*bottom*) Canaletto, *Northumberland House* (oil, 1752) (pp. 22, 226)

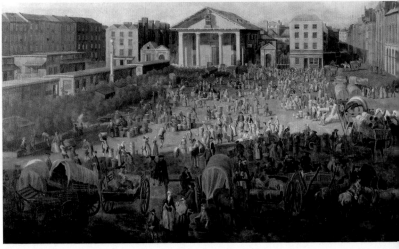

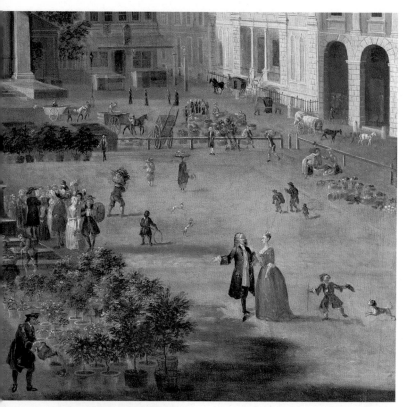

3. (*above*) Jan Griffier I, detail, *Covent Garden* (oil, 1704–18?) (p. 13)
4. (*left*) Samuel Scott, detail, *Covent Garden Piazza and Market* (oil, 1749–58) (p. 13)

5. (*left*) George Scharf,
Church Lane looking West
(pencil, watercolour, 1828) (p. 3)
6. (*below*) Robert Dighton,
The Westminster Election, 1788
(ink, watercolour, 1788) (p. 68)

7. (*top*) Thomas Rowlandson, *A Bawd on her Last Legs* (etching, 1792) (pp. 83, 295)
8. (*bottom*) George Morland, *The Artist in His Studio and His Man Gibbs* (oil, 1802) (p. 158)

9. (*left*) Joseph Highmore (attrib.),
Figures in a Tavern or Coffee-House
(oil, *c.* 1725 or after 1750) (p. 180)
10. (*below*) William Hogarth, detail, *A
Midnight Modern Conversation* (oil,
c. 1729–32) (p. 180)

11. (*top*) Hogarth, *Self-Portrait* (oil, *c.* 1735) (p. 183)
12. (*bottom*) Rowlandson, *French Valet and English Lackey* (ink, watercolour, no date) (p. 18

work has survived; Morland had the same tastes, while Smith was as fond of 'gay ladies of fashionable notoriety' and was as 'incapable of resisting the calls of pleasure' as any of them. At least ten erotic engravings are attributed to Smith.[67] He also did three engravings of Rev. Matthew Peters's winsomely bare-breasted women (one of them possibly J. H. Mortimer's sister, painted for Lord Melbourne). Peters lived not far from Smith in Great Newport Street and was another of Rowlandson's friends. Peters painted his *Lydia* for Lord Grosvenor, who kept it behind a curtain in the interests of decency and to increase its effect (fig. 71). When it was exhibited in the Royal Academy in 1777, the *Morning Chronicle* of 26 April was impressed by its audacity: it 'makes every gentleman *stand* for some time – and gaze at it', it wrote enthusiastically: 'We cannot, however, help thinking that the inviting leer of the lady, and her still more inviting bosom, ought to be consigned to the bed chamber of a bagnio, where each would doubtless *provoke* a proper effect.' Peters later regretted these fripperies. In 1781 he was ordained deacon and priest, having gone up to Oxford in 1779 for the purpose.[68]

These low interests touched those who later rebelled against their elders' values. J. M. W. Turner took it for granted that he should draw nudities of his own; their numbers and explicitness have been revealed only recently (below, ch. 10). It could hardly be otherwise. Born, bred and living in Maiden Lane, and employed by Smith, he came to consciousness in a male culture that was unsqueamish about such things.

NUDE MODELS

Artists needed pliant, cheap and sometimes naked models. In Covent Garden 'woman figures' from the alleys and courtyards were in plentiful supply. They were made to wash their hands and faces and drape themselves in sheets to prepare for painted immortality, while the prettiest of them were converted into naked nymphs and beauties.

Male artists were privileged witnesses of female nudity. They doubtless found life-models primary sources of information in an era when most love-making seems to have been conducted semi-clothed.[69] Chéron's St Martin's Lane academy of 1720 had offered 'the addition of a woman figure to make it more inviting to subscribers'. In the

72. Rowlandson, *Royal Academy, Sommerset* [sic] *House* (etching, 1801)

Academy female nudity caused some anxiety, however, and plaster-casts were preferred for the less expert pupils who might become over-heated. Rowlandson was said once to have been nearly expelled from the Schools for shooting his class's nude model with a pea-shooter, though this wasn't a transgression that he cared to include in his etching of his class (fig. 72).[70]

Prudishness didn't stop the Academy's supposedly celibate president painting his own nudes, and that lasciviously. Of course Reynolds could exploit the classical alibis that countless past artists had reached for when they painted their naked Venuses, and at least in breeching a pecu-liarly English taboo on the nude he showed that English tastes were now as advanced as those of his continental predecessors. But he took the subject beyond suggestiveness when, for example, his Cupid unties Venus's 'zone' (or girdle): follow the cues of that coy and winsome lady, and one may even today be shocked by the encounter that seems to be imminent (fig. 73). When the Yorkshire poet and amateur painter Wil-liam Mason sat in on the painting of Reynolds's first *Venus* in 1759, he thought its conception came from the engraving of some past Leda rather than from life, but he added that Reynolds was seldom without 'some beggar or poor child' as a sitter, 'because he always chose to have

73. Joshua Reynolds, *Cupid untying the Zone of Venus*
(oil, 1788)

nature before his eyes'. So on his next visit he wasn't surprised to find
Reynolds painting Venus's head from that of his servant's sixteen-year-
old daughter: her 'flaxen hair, in fine natural curls, flowed behind her
neck very gracefully'. On another visit, Mason found him painting
Venus's body from that of 'a very squalid beggar-woman, ... with a
child, not above a year old, naked upon her lap'. Squalid or not, Mason
admired the 'nude beauty of her rounded form' once she was on the
canvas.[71] The painter John Northcote told Hazlitt that 'none but those
who were past their prime would sit in this way', yet 'squalor' was a
handy word for gentlemen to use to camouflage voyeurism. Northcote
was similarly compelled to note that Reynolds modelled his naked Iphi-
genia on 'a *battered* courtesan'.[72]

Artists hired their own models off the streets if a passing face or

body took their fancy. John Thomas Smith's stories to this effect about the sculptor Joseph Nollekens were embellished with invented dialogue, but Smith's father had been Nollekens's assistant, so his comic account is reliable enough. Nollekens lived for fifty years in 9 Mortimer Street, north of Oxford Street, and died there in 1823 in his eighty-sixth year. He was an immensely successful sculptor, though yet another of the rough-hewn, unpretentious fellows with an artisan's manners who peopled the art world. Eccentric in his parsimony, clumsiness and ugliness, even his wife thought him uncouth.

He and Mrs Nollekens bickered constantly over Nollekens's fondness for nude ladies. She was the daughter of Hogarth's friend Saunders Welch the magistrate, and this virtuous connection impelled her to improve her husband. One day she learned that he had paid 'the abandoned women who sat to him for his Venuses' to dance for him. Unfortunately she witnessed their 'lascivious movements' and 'leers', and (if Smith is to be believed) she exploded: 'how you can agitate your feet as you do, at such strumming, is to me perfectly astonishing! See! look over the way at the first-floor window of the Sun and Horse-shoe, the landlord and his wife are laughing at you ... How can you so expose yourself, Mr Nollekens?' At which moment a servant announced the arrival at the yard door of a girl recommended by Mr Cosway:

> 'Indeed! There, Sir! there is another of your women! What! and you will go to her too! It's very well, Sir! mighty well, Sir! Oh fie! fie! The first year of our marriage, you told me you should dispense with such people; but you are like all the rest of your sex, always seeking for new beauties.'

Nor was it only Mrs Nollekens whom her husband had to placate:

> One May morning, during Mrs Nollekens's absence from town, Mrs Lobb, an elderly lady, in a green calash, from the sign of the 'Fan' in Dyot-street, St Giles's, was announced ... 'Tell her to come in,' said Nollekens, concluding that she had brought him a fresh subject for a model, just arrived from the country; but upon that lady's entering the studio, she vociferated before all his people, 'I am determined to expose you! I am, you little grub! ... Ay, ay, honey! ... It's all mighty fine talking in your own shop. I'll tell his worship Collins, in another place, what a scurvy way you behaved to young Bet Belmanno yesterday! Why the

girl is hardly able to move a limb to-day. To think of keeping a young creature eight hours in that room, without a thread upon her, or a morsel of any thing to eat or a drop to drink, and then to give her only two shillings to bring home! Neither Mr Fuseli nor Mr Tresham would have served me so . . . Never let me catch you or your dog beating our rounds again; if you do, I'll have you both skinned and hung up in Rats' Castle.'

Rats' Castle was a shattered house in Dyot Street, St Giles's, so called from the rat-catchers and 'canine snackers' who inhabited it and cleaned the skins of the stray dogs who had died that night. Nollekens paid Mrs Lobb five shillings to shut her up and keep the supply of models flowing.[73]

5

The Men's World

LADY ARTISTS

Outside the rituals of family, salon, courtship and bedroom artists of the less polished kind (not Reynolds) tended to avoid passing social time with polite women. They preferred what London's chronicler John Strype called the 'kinder sort of females', though still only in the appropriate venues. A wry French visitor observed in 1725 that English women were 'little injured by the tenderness of the men, who bestow but a very small part of their time upon them. In effect, most of them prefer wine and gaming to women, in which they are the more blameable, because the women are much better than the wine in England.'[1] Women who were both polite and artistic men found especially hard to take. Thanks to the increasing employment of peripatetic drawing masters in the second half of the century and the rising confidence and public participation of educated women in its later decades, amateur female artists were multiplying. Some men responded sympathetically to this movement. The young woman in Paul Sandby's fine drawing was probably his wife or a friend (fig. 74). But there was mockery, too.

The number of professional female painters was tiny. Admittedly, Angelica Kauffman and Mary Moser were among the thirty-six founding members of the Royal Academy. Their inclusion shows there was no Talibanesque misogyny in eighteenth-century London. But it also speaks for the power of connection. Mary was the daughter of the Keeper of the RA's Collection, while Angelica had a crush on Reynolds and Reynolds one on her. Otherwise, the Academy elected no further women until the twentieth century. Maria Cosway and the

74. Paul Sandby, *A Lady Copying at a Drawing Table* (chalk, *c.* 1765)

sculptress Anne Damer were admired in high circles, but then each was born and nurtured in high circles herself. Some males found their pretentions ridiculous. The printseller George Humphrey of 48 Long Acre signallized the kind of pictures Cosway emitted by lampooning her as 'Maria Closestool'.[2] Another parodied her as *Maria Costive at her Studies* (1786), at once suggesting her constipation and her kinship with a madwoman in Bedlam. William Holland's *The Damerian Apollo* (1789), apparently innocent of gossip about Damer's lesbian tastes, showed her surrounded by her nude statues and chiselling keenly into the buttock-cleft of a naked Apollo (fig. 75).

Accomplished and fêted though they were, these women were more remarkable for being female artists in that age than for being of major standing. To be sure, Kauffman's was no mean achievement when she shattered convention by becoming the first female 'history' painter. But none had the artistic panache of Élisabeth Vigée Lebrun on the other side of the Channel. A later commentator dismissed Kauffman's 'wishy-washy classicalities' as 'feeble'.[3] And Cosway drew or etched nymphs, goddesses and cherubs that were as sickly as those achieved by her husband Richard (many were after his originals). Most women worked in the lesser arts anyway. Mary Black was a drapery assistant to the Scottish painter Allan Ramsay, Katharine Read drew fashionable portraits in crayon, Mary Moser and Dorothy Mercier were flower painters, and Mary Slaughter, who lived with her portrait painter father in the Piazza, modelled portraits in wax. Female talents of these kinds went down badly with paint men. One day Henry Fuseli was button-holed by a gentleman on a coach journey: 'I understand, Mr Fuseli, that you are a painter; it may interest you to know that I have a daughter who paints on velvet.' Fuseli at once rose to his feet crying, 'Let me get out!'[4]

ACADEMIES

How, one wonders, did the modestly born men who made up the core of the art community, many of them deep provincials, manage to convert themselves into the neo-classical artists and history painters whose work elites would buy – many of them doubtless subordinating native inclinations and values to the tyranny of interest

Within the image: *Studies from Nature*, *A Model to make a Boy from*, PAN

75. [William Holland], *The Damerian Apollo* (etching, 1789)

and fashion? Most knew their Bible, but not too many classical myths. It was the pressure of the higher taste-makers and their own consequent training that did it. The best connected would extract from their patrons a continental tour for themselves, as Reynolds did; but the humbler sort, once in London, rarely left it. They learned their high artistic manners from their masters or in the Covent Garden academies. It was difficult not to see the world through bogus historical prisms after some of these indoctrinations.

The academies were of long standing. At first they were informal. In 1711, Sir Godfrey Kneller opened his academy in Great Queen Street;[5] then James Thornhill briefly ran it in his Piazza house; then the immigrants Louis Chéron and John Vanderbank opened their own academy off St Martin's Lane, running it from 1720 until Vanderbank had to leave for France to escape his creditors. In this last, the training was regarded as 'English' because students drew naturalistically from nude models rather than classical casts. The next initiative came from the coterie that gathered twice weekly in and after the 1730s around

Hogarth in Slaughter's coffee-house in St Martin's Lane. A cosmopolitan lot, they included the French-born sculptor Louis François Roubiliac, the Swiss-born enamellist George Michael Moser, the French miniaturists Louis and Joseph Goupy, and engravers like John Pine, the Dublin-born James McArdell and Paris-born Gravelot, as well as painters such as George Lambert and the Devon-born Francis Hayman and Thomas Hudson.[6] The young Thomas Gainsborough was briefly associated, and so was young Joshua Reynolds, never one to miss a chance of self-advancement; but they were too young to make it to the centre of this circle.

Hogarth and friends re-established the St Martin's Lane Academy in 1735; it enabled its students to draw a naked figure, and over the next thirty years most serious artists who could afford it trained here. They subscribed a reasonably modest two guineas for their first year of study and one and a half guineas thereafter. In its democratic organization it was said to be 'admirably adapted to the genius of the English: each man pays alike; each is his own master; there is no dependence'.[7] Similar principles were followed by the Free Society of Artists and the Incorporated Society of Artists, while the Society for the Encouragement of Arts, Manufactures and Commerce, set up at Rawthmell's coffee-house at 25 Henrietta Street in 1754, fused the artistic and the pragmatic, as its title stated.

Hogarth saw no need for an academy more formally organized than these. Least of all would he have seen the point of one that advised the emulation of foreign masters, so it was lucky that he died before the Royal Academy was established. As early as 1737 he was inveighing against the 'picture-jobbers' who were undermining the native integrity of English art by importing 'shiploads of dead Christs, Holy Families, Madona's [sic], and other dismal dark subjects, neither entertaining nor ornamental; on which they scrawl the terrible cramp names of some Italian masters, and fix on us poor Englishmen, the character of universal dupes'.[8] John Ireland's later attempt to impose coherence on the autobiographical notes from Hogarth's last years had Hogarth decry 'the eternal blazonry, and tedious repetition of hackneyed, beaten subjects, either from the Scriptures, or the old ridiculous stories of heathen gods', and deplore young artists' travels to study in Italy, since they 'seldom learnt much more than the names of the painters; . . . For

this they gain great credit, and are supposed vast proficients, because they have travelled.' And he laughed at connoisseurs, 'none daring to think for themselves', and at foreign 'quacks in colouring':

> if a painter comes from abroad, his being an exotic will be much in his favour; and if he has address enough to persuade the public that he has a new discovered mode of colouring, and paints his faces all red, all blue, or all purple, he has nothing to do but to hire one of these painted tailors as an assistant, for without him the manufactory cannot go on, and my life for his success.[9]

What mattered more to Hogarth were ways of exhibiting an 'English' art that diminished reliance on patrons and increased its visibility outside private and wealthy houses. To this end, he painted biblical murals free of charge for the staircase at St Bartholomew's Hospital a couple of stones' throw from his birthplace (though his apparent altruism was moved by a wish to publicize himself while preventing the commission going to a competing Italian). He followed this by giving free to the Foundling Hospital his fine portrait of its founder, *Thomas Coram* (1740). This challenged the tradition of aristocratic portraiture that stretched back to van Dyck (one of Hogarth's heroes) by showing what an English painter could achieve with a middle-class subject. (Rough-mannered and salty, Coram was a friend after Hogarth's own heart as well as a near-neighbour: in 1750 he lived in Spur Street, off Leicester Fields.) Hogarth next persuaded Rysbrack to join him in decorating the Hospital's boardroom free of charge. For it Hogarth produced another overblown history painting, *Moses brought to Pharaoh's Daughter*, but he got fifteen other artists to contribute as well, and in 1746 they joined him and Rysbrack as governors. Nine of these were Covent Garden locals and members of Hogarth's circle.[10]

In the 1740s and 50s meetings, dinners and exhibitions at the Foundling Hospital became the most respectable and profitable form of artistic self-display. In 1760 the artist-governors supported a free exhibition in the newly formed Society for the Encouragement of Arts, Manufactures and Commerce in the Strand. Over two weeks, 6,582 catalogues were sold, and many times that number of people attended. Admission was denied to 'improper persons' such as 'livery servants, foot soldiers, porters, women with children, etc.', and smoking and

drinking were banned. This marked a significant step towards fine art's social pedestalization which the foundation of the Royal Academy cemented in 1768, and which has never since been quite discarded.

Only with the Royal Academy's foundation was what Hogarth had regarded as the English artist's 'independence' betrayed. In its hierarchical organization, elected membership, and increasingly prescriptive Italianate and neo-classical fixations the Royal Academy modelled itself on the French *Académie de peinture*. Its founder members comprised twenty-eight painters (including a handful of engravers), five architects and three sculptors. Nine had been born on the continent. Many had seceded from the Incorporated Society of Artists after much feuding and plotting. The first Academicians were socially and artistically diverse, but this soon narrowed under Joshua Reynolds's presidency. The Academy's practice narrowed too.

The Academy's principles were predictable. It was argued long before the eighteenth century that only the history painting of mythological, allegorical or biblical subjects could depict man at his noblest and most exemplary, and that the best models were Greek, Roman or Renaissance. The portrait painter Jonathan Richardson had said as much in the most widely read of all discussions of art theory, his *Essay on the Theory of Painting* (1715): Reynolds later said it was this book that induced him to become a painter. In 1759 Reynolds himself had written three short articles on beauty and nature for Samuel Johnson's *Idler*. They were dry runs for the *Discourses* which he later delivered to the Academy. They too proclaimed the supremacy of history painting in the grand manner, and affirmed a hierarchy of value that relegated portrait and landscape painting to secondary status and still-life to the lowest, while leaving the arts that depicted common life beneath consideration. Artists who in the 'Dutch' way gave 'a servile attention to minute exactness' simply 'polluted' their canvases with 'deformity' and practised a 'merely mechanical' art suited only for 'the slowest intellect'. A painter of genius should not stoop to such 'drudgery', he wrote; for 'the Grand Style of Painting requires this minute attention [to detail] to be carefully avoided'. Instead, the painter should depict 'universal truths' by modelling himself on the past masters of the great tradition. The 'Dutch' style – domestic incidents, tavern scenes, etc. – must yield to the Italian:

> The Italian attends only to the invariable, the great, and general ideas
> which are fixed and inherent in universal Nature; the Dutch, on the
> contrary, to literal truth and a minute exactness in the detail ... The
> attention to these petty peculiarities is the very cause of this naturalness
> so admired in the Dutch, which if we suppose it to be a beauty is cer-
> tainly of a lesser order.[11]

In all this Reynolds was following Shaftesbury (and later Burke) in
teaching that art must communicate universal ideals and allow good
to triumph over evil – to achieve which the artist must emulate classi-
cal models and the old European masters: his best training lay in
respectful imitation.

Over time, the Academy delivered its most powerful effects through
its generosity to the young. Its Schools offered young artists six years'
free training in the copying of Old Masters, the drawing of antique
casts, and in life-drawing (for 'recommended' students whose poise
when confronted by a nude woman could be relied upon). Lectures
were delivered by professors and Academicians. The Schools pulled in
the best young talents that came to London, ranging from Flaxman,
Lawrence, Turner, Constable and Soane to dissidents like Rowland-
son, Blake and Gillray – 1,184 male students by 1820; women weren't
admitted.[12] The Schools weren't the least reason why in Reynolds's
lifetime history painters and neo-classicists seemed to have won the
argument about how the artistic career should be pursued. Thus were
the battle-lines between realists and fantasists entrenched.

CLUBBING

No less essential to the artist's business – and the writer's – were the
friendships and rivalries that waxed or waned through meeting, eat-
ing and drinking at several levels of frivolity or earnestness. Artists,
print-men, writers, actors, gentlemen or artisans, or all of these
together, would meet in coffee-houses, or Tom and Moll King's in the
Piazza, or in the Rose or other taverns, to debate, argue, gossip or
sing, cheered on by port, wine or punch. There was amusement to be
had in these places. 'Suppose me dead, and then suppose / A club
assembled at the Rose, / Where, from discourse of this and that, / I

76. Anon., *The Coffehous* [sic] *Mob* (engraving, 1710)

grow the subject of their chat' – Jonathan Swift quipped in comic verses that imagined the aftermath of his own death.

The coffee-house was a chief focus of social life. Although uncounted numbers of these were little more than brothels or drinking dens, the better regulated were male venues in which women were present only to serve – places, however, that would be 'stinking of Tobacco, like a Dutch Scoot, or a Boatswain's Cabbin'. In the Piazza, the Bedford coffee-house opened in 1726 and the Piazza coffee-house in 1754. Will's had been trading on the north side of Russell Street since the 1660s; Button's opened on the south side of the same street in 1712, and Tom's (not to be confused with Tom King's) followed shortly after.

Although there was some intermingling (Hogarth and actors in the Bedford, for example), workaday artists tended to favour their own coffee-houses – Old Slaughter's in particular, 'a rendezvous of persons of all languages and nations, Gentry, artists and others', as George Vertue described it – rather than the high-falutin' ones full of wits. One understands why. The literary figures who met in Will's or Button's were stellar. They included Dryden, Congreve, Pope, Prior, Addison and Steele, Gay, Henry and John Fielding, Smollett, Goldsmith, Churchill and Johnson, along with theatre men like Garrick, Sheridan, Quin, Foote and Murphy. This heady mix fostered the emulations and competitiveness upon which the literary world thrived, though also intellectual pretensions which were a little overcooked. 'Almost everyone you meet is a polite scholar and a wit,' someone wrote of the Bedford in 1754. 'Jokes and *bon-mots* are echoed from box to box; every branch of literature is critically examined, and the merit of every production of the press, or performance of the theatres, weighed and determined.'[13] Macaulay later gave an idealized account of the debates conducted in Will's – on 'poetical justice and the unities of place and time', or on whether *Paradise Lost* would better have been written in prose. Will's, he wrote, was full of 'Earls in stars and garters, clergymen in cassocks and bands, pert Templars, sheepish lads from the Universities . . . The great press was to get near the chair where John Dryden sate . . . To bow to him, and to hear his opinion of Racine's last tragedy or of Bossu's treatise on epic poetry, was thought a privilege. A pinch from his snuff box was an honour sufficient to turn the head of a young enthusiast.'[14]

It all seems wonderful until one hears Swift in curmudgeonly mood reporting that in Will's he heard 'the worst conversations I ever remember to have heard in my life' – a dig at Joseph Addison's perpetual presidency there: 'The Wits (as they were called), . . . that is to say five or six men, who had writ plays, or at least prologues, or had share in a miscellany, came thither, and entertained one another with their trifling composures, in so important an air, as if they had been the noblest efforts of human nature, or that the fate of kingdoms depended on them.'[15] An early print that shows a coffee-house gentleman throwing coffee over another coffee-house gentleman probably got closer to the manners of most gentlemanly coffee-houses than Macaulay's idealization did (fig. 76).[16]

Two paintings say a great deal about coffee-house boisterousness. One is a small unfinished oil sketch of *Figures in a Tavern or Coffee-House* (*c.* 1725) that has been attributed to Joseph Highmore (**plate 9**). A woman serves on the left and is being flirted with, while men in merry loquacity drink the coffee served by the boy and the punch in the bowl on the table. The other is a much larger painting which Hogarth produced around 1730 (detail, **plate 10**). He engraved it in 1733 as *A Midnight Modern Conversation* (fig. 77). Since the English had never before seen a picture quite as credibly raucous, it was his most successful and most pirated print to that date.

Hogarth and Highmore had both been in James Thornhill's circle in the Piazza, and might have been fellow-students in Chéron's earlier academy in St Martin's Lane; later both exhibited at the Foundling Hospital. The fact that the elongated format of Hogarth's painting (cropped in **plate 10**) repeats Highmore's suggests that he knew Highmore's oil sketch (if Highmore's it is), but he wanted to go several steps better, just as he then wanted his print to improve on his painting. The print's compression of the figures' relationship to each other and its added details

77. Hogarth, *A Midnight Modern Conversation* (etching, engraving, 1733)

and symbols (a chamber-pot replaces the dog) made its composition tauter as well as more sellable than the painting's.

Like the 'Highmore' sketch, Hogarth's *A Midnight Modern Conversation* subverted the orderly 'conversation' portraits that he (and Highmore) had recently been producing. He decided here to go 'Dutch', for his 'midnight conversation' pushed to extreme the mid-seventeenth-century drinking scenes by Steen, Jordaens and others which he knew from engravings. The print's subtext endorsed polite notions of satire: 'Think not to find one meant Resemblance there / We lash the Vices but the Persons spare': that is, his protagonists were *anonymous* and his purpose *moral*. But Hogarth was a convivial fellow who knew a great deal about Covent Garden loucheness, and he could no more resist the topical than deny his own talent. Perhaps he had attended such gatherings.

Friends assumed this as well. For years ahead they spent much time guessing at the real identities of the print's protagonists, taking it for granted that *A Midnight Modern Conversation* depicted reality, however exaggerated. Its topicality was underscored by its seventeen open wine bottles: these affirmed English liberties, for the print appeared in the month of Robert Walpole's Excise Bill which taxed wine and tobacco. Dr Johnson's friend Mrs Thrale, Johnson's biographer Sir John Hawkins and Hogarth's biographer John Ireland severally insisted that the debauch occurred in the St John's coffee-house in Sheer Lane up from Temple Bar. They thought that the parson ladlling the punch was Johnson's reprobate cousin, Parson Cornelius Ford, that the lawyer on his right was one Kettleby, known for his squint, and that the man in the white nightcap was a bookbinder named Chandler, who worked for Hogarth and who kept a tavern in Sheer Lane. Another figure was surely the tobacconist called Harrison, famous for singing songs loudly, while the doctor reeling drunk in the foreground was one of Hogarth's friends, and the man collapsed on the floor had to be the prizefighter James Figg, whence the sticking plasters on his damaged head – altogether just the kinds of friends Hogarth favoured.[17]

Attributions like these litter eighteenth-century commentaries on Hogarth. They had some credibility. The community was too intimate for them to be idle fabrications. *A Midnight Modern Conversation*

78. Gawen Hamilton, *A Conversation of Virtuosis . . . at the King's Armes (a Club of Artist)* (oil, 1735)

was sold by subscription 'next Door to the New Play-house in Covent Garden Piazza . . . the Price Five Shillings . . . [later] they will be Three Half Crowns Each'. When you charged as much as this, local knowledge had to be catered to if you were to sustain credibility. Hogarth was the last person to gainsay local knowledge.

<center>*</center>

In the artist's world, coffee-houses were important, but clubs were more so. The first artists' society in Britain was the Society of the Virtuosi of St Luke. Active between about 1689 and 1743, it was described by the art-world's chronicler and one of its members, the engraver George Vertue, as standing among 'the Tip top Clubbs of all, for men of the highest Character in Arts & Gentlemen Lovers of Art'. It met weekly or monthly, and every year it dined in a tavern to celebrate the painters' patron, St Luke. It was very high-minded. It

supported efforts to underpin artistic practice with theory, and it affirmed a new pride in what it meant to be an artist by encouraging equal meeting between artists and aristocrats and relating that to the improvement of manners. It was patronized by well-born taste-makers like Edward Harley, Earl of Oxford, and the great theoretician of politeness, the Earl of Shaftesbury. Artist-members included men who were climbing fast from modest origins and who could afford the exorbitant five-guinea annual membership fee that kept out the vulgar.[18] You can tell they thought well of themselves from the stiff postures, embroidered surcoats, and full wigs that thirteen of them adopted when one of their number, Gawen Hamilton, lined them up to paint his *Conversation of Virtuosis . . . at the King's Armes (a Club of Artists)* in 1735 (fig. 78).

Hogarth had the self-importance but lacked the pomposity and perhaps the education to be a member of the Virtuosi. Around the date of Hamilton's painting he produced a brilliant self-portrait in which he is as fully wigged as Hamilton's sitters, but one suspects that he wore the wig parodically to affirm his equality with the others (**plate 11**). He would later depict himself wigless and in working clothes – as the artist painting the *Comic Muse* (1758), for example, rather than the heroic one. He stood rather apart in this plainness. Clothing made statements about status, and as time passed artists felt a deepening need to display it. A Zoffany painting of artists at a life-class in the Academy (*c.* 1770–73) has them hatless but bewigged and wearing elaborately buttoned frockcoats and waistcoats. A drawing of artists at a class in the British Institution in 1805 shows them similarly dressed.

The Virtuosi took themselves too seriously for most tastes, and in the early 1740s they disbanded. Not only were other societies and acade-mies multiplying by then, but connoisseurship itself was fracturing. The aristocratic Society of Dilettanti, first meeting at the Bedford Head in the Piazza in 1736, took over the Virtuosi's antiquarian interests if not its high-mindedness. Horace Walpole considered it 'a club, for which the nominal qualification is having been in Italy, and the real one being drunk', adding that Lord Middlesex and Sir Francis Dashwood were seldom sober the whole time they were abroad.[19]

THE BEEFSTEAKS AND THE ROSE & CROWN

For 'bohemian' manners in artistic circles we must look to more boisterous clubs than the Virtuosi. One was the Sublime Society of Beefsteaks, a dining club founded in 1735 by John Rich and George Lambert, the former the manager of Covent Garden theatre, the latter its scenery painter. It had and continues to have twenty-four members (it meets to this day). The founder members are now mostly forgotten, but Hogarth was a member in the years 1735–40 and 1742–44, as was his painter crony Francis Hayman, with whom he visited Paris in 1748.

'Bohemian'? In a loose sense, yes. The Beefsteaks met every Saturday between October and June in Covent Garden theatre's scenery-loft to eat beefsteak, baked potatoes, chopped shallots, Spanish onions, beets and toasted cheese, all washed down with port, punch and whisky toddy. In Hogarth's time its wit was heavy-handed. One day Hogarth and fellow Beefsteaks persuaded a notorious fornicator that a beautiful woman he had met earlier was awaiting him in bed. He eagerly went to the appointed house, but when he parted the bed's curtains he found a black woman in it: the Beefsteaks erupted from their hiding places in convulsions of laughter. Hogarth thought the trick funny enough to commemorate in a print entitled *The Discovery* (*c.* 1743), over a quotation from Ovid which Hogarth probably hijacked from Fielding's just-published novel *Jonathan Wild*.[20] The copperplate was destroyed after a mere dozen impressions were taken; decades later a rare impression was copied by Samuel Ireland (fig. 79).

Later members were more polished than this. The Beefsteaks' glory-days came when it was joined by John Wilkes, the radical Whig politician and libertine, the poet Charles Churchill, Charles James Fox and the Earl of Sandwich, who probably invented the sandwich in its company.[21] It was among the Beefsteaks that Wilkes circulated his *Essay on Woman*, an obscene parody of Pope's *Essay on Man* which he and a friend wrote and dedicated to the courtesan Fanny Murray in 1754, the year in which he joined the Society:

> Awake, my Fanny! Leave all meaner things;
> This morn shall prove what rapture swiving brings!

79. Samuel Ireland, after Hogarth (*c.* 1743), *The Discovery* (etching, 1788)

> Let us (since life can little more supply
> Than just a few good fucks, and then we die)
>
> Expatiate free o'er that loved scene of man,
> A mighty maze, for mighty pricks to scan;
> A wild, where Paphian Thorns promiscuous shoot,
> Where flowers the Monthly Rose, but yields no Fruit.

Wilkes's enemy, Sandwich, publicized the *Essay* shortly after Wilkes had attacked the king in no. 45 of his *North Briton*, so Wilkes had to flee to Paris to escape prosecution on both grounds. He scored a neat parting shot, though. When Sandwich warned him that if he didn't mend his ways he would die either on the gallows or from the pox, he replied that that depended, 'my lord, on whether I embrace your lordship's principles or your mistress'.[22]

*

All this roistering had serious purposes and effects. An earlier club, the Rose and Crown, shows this well. Hogarth also belonged to this, as did a few of the Virtuosi. But the Rose and Crown eclipsed the Virtuosi by being affordable, larger and more convivial. Vertue, who among his many other commitments was the club's secretary, tells us that it met between 1704 and 1745 in a tavern in the Piazza. There is no record of a Rose and Crown in the Piazza, so its venue might have shifted from a tavern of that name on the corner of Hog Lane and Rose Street in St Giles's a half-mile away.[23]

The club's monthly gatherings were boisterous. Vertue's unfinished red-chalk *Sketch or View of the Rose & Crown Club as are Together when they Celebrate their Kalandae or Monthly Computations (c. 1724)* shows men disporting themselves at several tables, on one of which stands a bowl of punch (fig. 80). Someone's arms are flung up in a toast, two men sing at the harpsichord, others gamble at cards.[24] Vertue transcribed some of the exchanges at the gathering. Marcellus Laroon III (the Younger), wearing a 'feather in his Cap & sword by his side a l'Espagnole', meets the maid who is serving the drink: 'Catches at her belly, & shows her his Puntle [penis]. She looks back & hold one hand before her face . . . Turning to ye Maid, *My dear* let me F . . . you.'[25]

Vertue was able to recollect eighty-five Rose and Crown members over the club's lifetime, and it's possible now to flesh out information on over two dozen of them.[26] Most were painters or engravers, but there were several miniaturists, an enamellist (Zincke), an architect (Gibbs), a gem-cutter and a scientific instrument-maker. Well over half had studied at Kneller's academy in Great Queen Street between 1711 and 1720).[27] The most extraordinary feature of the list is that *most* of the identifiable members of the Rose and Crown were French, Flemish or German immigrants.[28] This alerts us to the most important character of this early to mid-eighteenth-century art world: its cosmopolitanism.

When the French court painter Antoine Watteau came to London in 1719–20 to consult a famous doctor about the tuberculosis that killed him a year later at the age of thirty-seven, he found the Rose and Crown a hospitable haven: his name duly appears on Vertue's membership list. His fame was considerable, and the club was well disposed to his rococo effects and *fêtes galantes*. These last were small easel paintings in which refined people prettily conversed or made music in parkland settings,

80. George Vertue, *Sketch or View of the Rose & Crown Club as are Together when they Celebrate their Kalandae or Monthly Computations* (red chalk, *c.* 1724)

hardly of the kind that engaged with 'real life'. Still, after Watteau's visit the club's Huguenot members and the Huguenot community more widely became the most significant conduits for the importation into England of the rococo's delicacy and its asymmetrical compositions and elongated curves. Baron, Simon, Du Bosc and Philippe Mercier engraved Watteau's works, Angellis based his style on him, and Marcellus Laroon III quoted from him.[29] Mercier finished some of Watteau's paintings and might have forged a few, too. To Mercier have been credited the first 'conversation pieces' in England: they brought the spirit of the *fête galante* to portraiture, and in the 1730s his sentimental 'fancy pictures' of everyday scenes embellished by invention or story-telling also acknowledged Watteau.[30] The Paris-born engraver Hubert-François Gravelot was regarded as a 'kind of oracle' when at Old Slaughter's he held forth on the beauties of 'S' and 'C' shapes.[31]

81. John Collet, *The Frenchman in London* (etching, 1770)

Hogarth began to cultivate sinuous composition in the *Rake's Progress* paintings, and he stole a Watteau pose for his lolling Rake in the Rose tavern. Hogarth's own much trumpeted 'line of beauty' – the elongated serpentine 'S' – was a rococo line, the opposite of the classical. The young Thomas Gainsborough, come to London from Suffolk in 1740 when aged an impressionable thirteen, was also influenced by Gravelot at the St Martin's Lane Academy, and by Hogarth and Hayman, whence the rococo effects in his own paintings.[32]

The natives' tolerance of these Frenchified incursions testifies both to their artistic seriousness and to their community's shared interests. Britain and France were natural enemies, after all, and the British had

a habit of dismissing the French either as emasculated peacocks or as starving oafs. In London's streets peacocks were treated badly. A man wearing a braided coat, a plumed hat or his hair tied in a bow would be called 'French dog' – 'the greatest and most forcible insult that can be given to any man'.[33] One of John Collet's works confirms this (fig. 81). Satirical jokes about French effeteness continued throughout the century. After twelve years in London Gravelot returned to Paris in 1745 because he became tired of being accused of spying.

Yet there was respect and affection for the French as well. Rowlandson's later drawing of an elegant French valet holding forth eloquently to an English lackey captures the relationship brilliantly (**plate 12**). Rowlandson's sympathies were doubtless softened by the Huguenot aunt who raised him in Soho; all the same, anti-French feeling couldn't eclipse the larger tolerance that had brought the French and others to London in the first place. In 1681 Charles II had offered 'comfort and support' to all 'afflicted Protestants' in France, and such 'priviledges and immunitys, as are consistent with the Laws, for the liberty and free exercise of their trades and handicrafts'. So when four years later Louis XIV revoked the Edict of Nantes which had guaranteed Protestants their religious and civil rights, up to a quarter of the 200,000 or so Huguenots who left France came to England, and a third of those came to London. Low Country engravers were joining them, spurred by the depression in the Dutch art market after France invaded the Netherlands in 1672. The inflow increased with the peace after the Treaty of Utrecht of 1713 and the 1717 Triple Alliance between Britain, France and the Dutch Republic. Both movements had the most extraordinary effects on London's artistic demography.

Immigrants with talent were easily assimilated, by and large, regardless of their religion and however unpromising their circumstances. Some had come to London after quixotic experiences that say a good deal about people's mobility in that world. The adventures that brought the marine painter Dominic Serres to London, for instance, were the stuff of the picaresque novel. Born in 1722 to a well-connected Catholic family in Auch in south-western France, he was being groomed for the Church when one day in his teens 'a disappointment in a tender connection' impelled him to throw it all over, leave home, and walk to Spain. There he shipped as a sailor to the West Indies, and in Cuba he

eventually became the master of a Spanish trading vessel. In the early 1750s he was captured by a British frigate and brought to prison in London. How he learned to paint in the course of these adventures is unclear, but on his release he seems to have been taken up by the marine artist Charles Brooking, a man of humblest origins who had been 'bred in some department of the dockyard at Deptford', but who was one of the best maritime artists of the century. Serres opened an old shop on London Bridge and then a small one in Piccadilly, and from these he sold his own seaviews and landscapes. His manners were polished, and he began to do well. He became a naval war artist, married and moved to Warwick Street, Soho, where Paul Sandby befriended him. By 1765 he was exhibiting in the Incorporated Society of Artists, and three years later he became one of the Royal Academy's founder members, helped by the fact that at that point founder members were in short supply. Some years later he moved in as Sandby's neighbour in St George's Row at the Tyburn end of Oxford Street. By 1784 Sandby was reporting that 'Dom is grown a very great man, has been to Paris, dined with the King's architect and is going to paint the *Grand Monarque*.' Serres would hoist the Union flag whenever the king passed on his way to Windsor; the king in his coach was gratified: 'There is honest Dominic's signal flying.' By the time of his death in 1793 Serres had exhibited 105 works at the Academy and was as 'English' as they came.[34]

By 1711, about two-fifths of the parish of St Anne's, Soho, were French. They were concentrated in Great and Little Newport Streets, Hog Lane, Moor Street, Romilly Street and Old Compton Street.[35] The period of peace between Britain and France from 1717 to 1743 brought more. French families turned the district round Green, Bear, Castle and Panton Streets into 'Petty France'. Hogarth's master, the gold and silver engraver Ellis Gamble, working in Cranbourne Street off Leicester Fields, had to inscribe his trade card in French as well as English. Hogarth's *Noon* in his *Four Times of Day* (1738) depicted the stylishly dressed French congregation emerging from their Hog Lane chapel and ignoring the neighbourhood's uncouth English. Even the future revolutionary Jean-Paul Marat turned up in 1765, to live in Church Street, St Giles's, a few doors from where young Thomas Rowlandson lodged with his Huguenot aunt. Marat published essays on eye disease, slavery and human rights, frequented Old Slaughter's

coffee-house, and boasted that he had seduced Angelica Kauffman, before returning to his appointment with destiny in Paris.[36] After Jane Hogarth's death in 1789 (she had spent twenty-five years of widowhood selling her husband's prints), the Hogarth house at 30 Leicester Fields was assimilated into the Sablonière Hôtel; it catered to 'lovers of French cookery and French conversation'.

The French incursions delivered a huge artistic bonus. On questions of taste, craftsmanship and stylistic innovation Huguenot weavers, furniture-makers, carvers, watchmakers and goldsmiths were unmatchable. Thomas Chippendale had to follow their lead by making curlicued rococo furniture at 61 St Martin's Lane. Roubiliac, Hayman and Moser decorated the booths at Vauxhall Gardens in the same style (see fig. 144). And seven of the twelve engravers who worked for Hogarth across his career were French-born; another was from Antwerp.[37] Hogarth travelled to Paris expressly to sign up French engravers for the six prints of *Marriage A-la-Mode* in 1744. War put paid to most of these commissions, but back home Hogarth employed Bernard Baron and Louis Gérard Scotin (both of the Rose and Crown club), and he also imported from France Simon Ravenet, who settled in St Martin's Lane. All three Frenchmen worked on the *Marriage* plates. Of all Hogarth's 'progresses', *Marriage A-la-Mode* was the most delicately engraved.

So this 'bohemia' was highly tolerant, fertile, and above all cosmopolitan. We can trace the birthplaces of 133 of the 146 artists and engravers associated with Covent Garden who are listed in this book's Appendix. While 51 were born in London, 28 elsewhere in England, 5 in Ireland and 3 in Scotland, about a third were born on the continent: 18 in France, 9 in the Low Countries, 7 in Germany, 4 in Switzerland, 3 in each of Italy and Sweden, 1 in Russia (Alexander Cozens: of English parents) and another in Pennsylvania (Nathaniel West).[38] In all the venues discussed above, therefore, in a metropolis whose population expanded from some 675,000 in 1700 to near on a million by 1800 – and this more thanks to immigration than to indigenous births – we must imagine a babel of tongues and accents:

'E juste come from France, a very pretty fancy,
'E juste come from France, *toute nouveau* . . .
Here de cunning French, de vise Italian, and Spaniard runne,
And vere can dey go else, *morbleu*, to get quarter of the money?[39]

The Paris-born engraver Gravelot once gnomically told Blake's master, the engraver Basire: 'De English may be very clever in deir own opinions, but dey do not draw de draw' [*sic*]. The German Godfrey Kneller never mastered 'th': he called Thornhill 'Dornhill'. G. M. Moser, Keeper of the Academy's Collection, would interrupt Goldsmith with 'Stay, stay, Tochtor Shonson is going to say something.' Fuseli's Swiss-German accent was impenetrable.[40]

The speech of the English-born wouldn't be much more intelligible than that of the immigrants. Both well-born and low-born Londoners replaced their 'v's with 'w's, dropped their 'h's, flattened their a's, and inserted glottal stops. Hogarth's cockney ''em' for 'them' is transferred directly into his captions (e.g. in *Masquerade Ticket*, fig. 114 below). In the fashionable purlieus of St James's, affected fops and 'macaronis' were beginning to pronounce 'o' as 'a' (turning 'lord' into 'lard') or to use

82. Thomas Bowles, *A View of Leicester Square* (etching, engraving, 1753)

canting slang.[41] Otherwise, before Victorian public schools established greater linguistic uniformity among their victims, most incomers of whatever class spoke with the accents and burrs of their birthplaces. The young painter Haydon recalled his fellow Devonian artist James North-cote asking him, 'Zo, you mayne to bee a peintur, doo ee; and whaat zort of peintur?' 'Historical painter, sir.' 'Hees-torical peintur!' raising his eye-brows; 'why, yee'll staarve – with a bundle o' streaw under yer heead.'[42]

BAD NEIGHBOURS: HOGARTH AND REYNOLDS

Great rivalries and feuds simmered in the artist's world, and the great-est of them was this one. For four years in the early 1760s Britain's two

most famous artists lived on opposite sides of Leicester Fields in a relationship that fell well short of neighbourliness. Hogarth and his wife Jane moved into number 30 on Leicester Fields's eastern side in 1733. On the far right of Bowles's print of 1753, you may just see Hogarth's square doorway surmounted by the model of Van Dyck's head, which he erected there to advertise his own stature (fig. 82). Then in 1760 Reynolds and his sister spoiled the Hogarths' view by moving into the much grander number 47 on the opposite western side. It boasted two proud obelisks outside its fine front door: nobody else had that.

Hogarth died in his house in 1764; Reynolds, thirty years younger, died in his in 1792. Just before his death Hogarth was telling the painter Edward Edwards that Francis Cotes 'excelled Reynolds as a portrait painter'.[43] Otherwise they never called each other names, and presumably bowed politely to each other when they crossed in the square. Hogarth held his tongue when he attended the sculptor Roubiliac's funeral in St Martin-in-the-Fields in 1762 alongside both Reynolds and Paul Sandby, two of his firm enemies.[44] Yet wariness was deep, not least because their four years' cohabitation in the Fields coincided with Hogarth's darkest and last years, so that most of the ill feeling flowed across the square from Hogarth's modest house to Reynolds's big one. At issue were questions of temperament, background, and artistic principle.

'Study the great works of the great masters for ever,' said Reynolds. 'There is only one school,' cried Hogarth, 'and that is kept by Nature.' What was uttered on one side of Leicester Square was pretty sure to be contradicted on the other.[45]

Leicester Fields had been developed on empty common ground by the second earl of Leicester in the 1670s: most houses went up at the end of that century. 'Square' was thought to be an affectation for such a site and came into common use only in the 1780s and 1790s; yet Strype in 1720 found it 'very handsome ... and graced on all sides with good built houses, well inhabited, and resorted unto by Gentry, especially the side towards the North, where the houses are larger'.[46] With its equestrian statue of George I in the centre, it was certainly no 'bohemia'. Important residents gave it cachet. They included Lord Chancellor Somers, the prime minister Henry Pelham, Speaker Onslow and Henry Dundas, Treasurer of the Navy from 1782. The

Whig politician and MP for Yorkshire Sir George Savile occupied
Savile House on the northern side. He was to introduce the Catholic
Relief Act in Parliament in 1778, and paid the price two years later
when the anti-Catholic Gordon rioters rampaged through the square
and burned his furniture and pictures on a bonfire.

Next door to Savile House was Leicester House (on the far side in
Bowles's print). Built in the 1630s, it had long been one of the biggest
houses in London, and was now 'the pouting place of princes' – the
home, that is, of the Princes of Wales, who pouted because they were
usually at loggerheads with their fathers. It was the centre of the cabal
that supported Prince Frederick Lewis in the 1740s. When that prince
was unhappily killed by a cricket ball, the cabal's support swung to
his widow, Augusta, and her son George, the future George III. The
royal connection ceased only in 1767 when the king's youngest brother,
Cumberland, left Leicester House – an unfortunate move into the wider
world for that cosseted man, since two years later he was caught with
Lady Grosvenor *in flagrante* at the White Hart inn in St Albans and
sued by her husband for £10,000 damages, amid much public delight
and several rude pictures.

Even in its heyday and despite its distinguished inhabitants, the status
of Leicester Fields never quite matched that of the seventeenth-century
Piazza or the squares of St James's. It was actually quite dangerous ter-
ritory. It provided a passageway from the Haymarket via Cranbourne
Alley to Covent Garden for a ceaseless flow of 'abandoned women and
pickpockets' (as the phrase always went). Reynolds had his house at
number 47 barred and bolted at night because 'the neighbourhood
swarms with loose characters'.[47] Sir John Fielding the magistrate counted
twenty brothels or 'irregular taverns' in Hedge Lane a hundred or so
yards from Reynolds's front door, as against thirty in the whole of the
Strand. With the Haymarket to the west, St Martin's Lane to the east,
and Charing Cross, Hedge Lane, the Royal Mews and its noisome dung-
hills to the south, Leicester Fields was balanced between two worlds.[48]

Nor were all houses of the finest. When the City was rebuilt after
the Great Fire, Parliament prescribed the varying qualities of its
replacement housing, and these rules shaped building outside the City
too. The houses erected in Leicester Fields were of the middle or 'sec-
ond sort', whereas St James's and Bloomsbury Squares boasted sorts

three and four, which were grander.⁴⁹ In any case, regulations were soon breached and uniformity lost. In the 1690s, the veto on shops was broken when wooden lock-up booths were erected in front of Leicester House on the northern side; they remained there for a century. Until the later eighteenth century, moreover, the Leicester estate's practice of granting reversionary leases to most occupants encouraged subletting to transient tenants and lodgers. Artists favoured the square for its consequently reasonable rents as well as the access it gave to fashionable clients.⁵⁰ The outcome was again that social mixing that was one of London's distinctions. Westminster's electoral pollbooks and ratebooks show it well.⁵¹ In the late seventeenth century there had been only three resident tradesmen in Leicester Fields: a house-painter, a peruke-maker and a tavern-keeper, each tucked away on a corner. By 1749, the Fields boasted eight voting gentlemen or esquires, a military general and a physician – but also (because Westminster was of all English constituencies the one most open to a popular enfranchisement) three voting cutlers, two victuallers, and one each of a cabinet-maker, a coal merchant, a coffee-man, a hatter, a hosier, a leather-case-maker, a linen-draper, a peruke-maker, a saddler, a stocking-maker, a tailor, a tea-man, an upholsterer, a vintner and a bagnio keeper. Some of these men were luxury providers in middling-sized properties: the linen-draper and the vintner paid middling rates at £20 and £36 respectively. But the leather-case maker, stocking-maker and two of the cutlers were rated at a miserable £8 a year.

The ratebooks allowed the inhabitants to read their own and others' economic standing rather accurately. The lowest rate on Hogarth's eastern side was £20 and the highest was £90. He paid £55 when he bought his house and £60 in 1756. It would have vexed him that Number 47, Reynolds's house, the third grandest in the Fields and the largest on its western side, was rated at twice his – at £110 in 1774. This was a quarter of the rates of Leicester House and half the rates of Savile House, but it had one of the finest staircases in London, a 28-foot frontage, and a garden extending back 104 feet to its stables in Whitcomb Street. Hogarth, gallingly to some, had trumpeted his own stature by setting that gilded bust of Van Dyck over his door to advertise his northern as distinct from Italian or French artistic affinities. His house accordingly became 'The Golden Head'. But this

couldn't match the obelisks that adorned Reynolds's pavement. By Hogarth's last years, he might have thought competition fruitless.

*

Hogarth and Reynolds had both attained comfort before they moved to Leicester Fields. In 1729 Hogarth had married Jane, Sir James Thornhill's daughter, after allegedly running away with her. They lived in the Little Piazza in 1730, and then with Thornhill in his number 12, one of the Piazza's larger arcaded houses, on the corner of James Street. They moved to 30 Leicester Fields on the profits made from *A Midnight Modern Conversation* and *A Harlot's Progress*. Hogarth bought the house from the estate of Lady Mary Howard, so it was probably well fitted. He built himself a painting room to the rear, and hung his own works in the main room downstairs.

By now his income was impressive – between £1,500 and £1,700 a year in the 1730s. This matched the income of a high City merchant. The profits from the *Harlot* subscription were over £1,500, which was spectacular; and he earned much the same from engravings of *A Modern Midnight Conversation* and then of *A Rake's Progress* a year later. In 1746 he sold almost 10,000 impressions of his portrait of the rebel *Simon Lord Lovat*.[52] But not everything was well. His prices for painted portraits were modest: around £8 for a head-and-shoulders and £60 for a large group. When he arranged an audacious auction of nineteen of his paintings in 1745, he raised £500, but to his disgust this couldn't compare with the prices being paid for the Old Masters that were flooding into the country.[53] In any case, he began to take more pleasure in painting modest portraits of modest people – of his Leicester Fields servants, for instance, or of his elder sister Mary's unaffected simplicity (fig. 83) – than from portraying grand people.

It didn't help his sales to richer clients that his personal manners were alienating, nor that his art exposed their follies. The engravings from *Marriage A-la-Mode* made good money, but the paintings burlesqued connoisseurship and the corrupted values of the people whom Reynolds, meanwhile, was flattering. Hogarth had to keep the six *Marriage* paintings for five years before auctioning them for a sad £22 apiece.[54] Later, there were a few profitable commissions. For the biggest, the vast

83. Hogarth, *Mary Hogarth* (oil, *c.* 1740)

triptych he painted in 1756 for the altar of St Mary Redcliffe, Bristol, he got £525. But by 1758 his paintings earned a quarter of what he got from prints. In his later years in Leicester Fields he steadily complained about the cost of running his carriage. And as Reynolds's fortunes rose, his sunk.

Hogarth was never averse to wounding those who disagreed with him, but he couldn't bear criticism himself. His first setback came in 1753 when his book *The Analysis of Beauty* rejected all academic theory and insisted that the true measures of beauty were to be found in natural forms (such as the elongated S) rather than in the work of past masters. This provoked derision. Paul Sandby published eight intricate satirical prints which depicted Hogarth as a pygmy mountebank

84. Anon., *Hogarth* (woodcut, letterpress, 1763)

painter and castigated him in their subtexts as an 'arrogant quacking analist' who was 'blinded by the darkest ignorance of the principles of painting'. Half a dozen years later, one of Hogarth's last attempts at an ill-advised sublimity, his history painting *Sigismunda Mourning over the Heart of Guiscardo* (1759), was rejected outright by the patron who had commissioned it. Horace Walpole excoriated the 'wretchedness' of its colouring, and dismissed the figure of Sigismunda as that of 'a maudlin strumpet just turned out of keeping', with her lover's heart lying in a bowl before her like 'a sheep's for her dinner'.

Thereafter, it has been said, England was a place that Hogarth no longer understood.[55] 'At a time when perhaps nature rather wants a more quiet life,' he wrote in his autobiographical notes in the embittered 1760s, the attacks caused him such anxiety that they brought on 'an Illness which continued a year'. The notes now read as the splenetic jottings of an old man either heading for dementia or in acute mental crisis.[56] When Horace Walpole visited Hogarth in his studio in 1761, he found him 'too wild' for sanity.

In this condition he picked his worst fight by attacking the minister

85. Hogarth, *Tail Piece – The Bathos* (etching, engraving, 1764)

Lord Bute and his own one-time friend Wilkes, in his emblematic satire on *The Times (1)* in 1762. Hogarth and Wilkes's mutual friend David Garrick thought the print clever but harmless, and Hogarth did try to make peace; but Wilkes retaliated viciously in no. 17 of his *North Briton* newspaper. After a title sheet bearing a woodcut caricature of Hogarth and his bulbous nose taken from Hogarth's self-portrait at the gate of Calais (fig. 84), Wilkes catalogued Hogarth's failings mercilessly. Hogarth was incapable of catching 'a single idea of beauty, grace, or elegance'; he never missed 'the least flaw in almost any [other person's] production of nature or of art'; 'gain and vanity have steered his light bark quite thro' life' and he had never

been consistent 'but to those two principles'. 'There is,' Wilkes added, 'at this hour scarcely a single man of any degree of merit in his own profession, with whom he does not hold a professed enmity'; but luckily, Wilkes concluded, 'he has long been very dim, and almost shorn of his beams': his sun was setting. When Hogarth fanned the flames next by publishing his famous print of Wilkes with his squint, Charles Churchill (Hogarth in his notes called him Wilkes's 'toadeater') replied with his poisonous *Epistle to Hogarth* (1763), which charged him not only with the betrayal of a friend but also with personal decreptitude:

> Thy body shrivell'd up, thy dim eyes sunk
> Within their sockets deep, thy weak hams shrunk,
> The body's weight unable to sustain,
> The stream of life scarce trembling through the vein . . .

Hogarth bore some responsibility for this sorry quarrel, but it also broke him. 'Being at that time at my worst in a kind of slow feaver, it could not but hurt . . . a feeling mind,' he wrote in his notes. His very last print he entitled with his now chronically allusive incoherence, *Tail Piece – The Bathos, or, Manner of Sinking, in Sublime Paintings, Inscribed to the Dealers in Dark Pictures* (1764) (fig. 85). Here he was still arguing against sublimity and foreign art imports. Though his cause was lost by then, the print was a moving if bleakly self-dramatizing emblematic masterpiece reminiscent of Durer's *Melancholia*. Its central figure was a dying Father Time from whose lips the word 'Finis' balloons as he contemplates the end of all things. He sits surrounded by a tombstone, a clock without hands, Phaeton falling from his sky-chariot, a tavern-sign for 'The World's End', a gallows and Hogarth's own print *The Times*, which has been set on fire. Hogarth died six months later. Reynolds was the coming man. Luckily Hogarth didn't live to see Reynolds become the founder President of the Royal Academy in 1768, or the knighthood that followed.

*

Reynolds had also made his mark before he went to Leicester Fields. He first came to London in 1740 as an apprentice in Thomas Hudson's

'portrait factory' in Great Queen Street, and he probably attended classes at the St Martin's Lane Academy. Returning then to Devon, he set up his own portrait factory. He did the heads while another artist painted the bodies. Output could be hasty. Once he and his helper managed to portray a man with a hat on his head and another under his arm.[57] Then he spent three years travelling in Italy, where he copied the fashionable pictures. Back in London in 1752 he took a studio at 104 St Martin's Lane, and must there have felt in the swing of things, since it had been earlier occupied both by Thornhill and by Francis Hayman.

Flatteries helped his progress. He got an aristocratic patron to persuade noblemen to sit to him, and 'very judiciously applied to such of them as had the strongest features, and whose likeness, therefore, it was the easiest to hit'. His first great success was with a portrait of Captain Keppel, whom he required to stand heroically on a stormy beach in the pose of the Apollo Belvedere (1752–3). By drawing complete figures and 'setting them well on their legs, &c., the attitude most natural to them', he soon eclipsed his old master Hudson, as well as Hudson's rival portraitist, Vanloo of Henrietta Street.[58]

By 1753 he could afford a large house on the fashionable northern side of Great Newport Street, and his business so increased that he could employ a drapery painter. In 1755, his pocket-books listed 120 sitters, and in 1758 his maximum of 150. They included the Prince of Wales and the Dukes of Cumberland and of York, as well as David Garrick and increasing numbers of society ladies and their daughters.[59] He raised his prices for head, half-length and full-length portraits to 25, 50, and 100 guineas (and to 150 guineas in 1764). This set the limits for top-of-the-range portraiture and was far more per portrait than Hogarth made. He was soon making £6,000 a year, and ready to take a long lease on number 47 in Leicester Fields. For this Reynolds paid £1,650, followed by another £1,500 for his later additions to it. These were very substantial sums. It helped that in October 1760, a month after Reynolds had moved in, George III was proclaimed king, so that Leicester Fields swarmed satisfyingly with courtiers' coaches and chairs. Reynolds was poised to become the fashionable world's 'chief chronicler'.[60] Three weeks after the coronation the king married. Within a year Reynolds had portrayed three of the queen's bridesmaids.

He built a gallery to show off his works, adding painting rooms for

himself and his pupils and drapery-men, and a room for his sitters. He held a ball to celebrate its opening. He dressed his servants in silver-laced livery and bought a Sheriff of London's chariot, 'newly done up'. He had emblems of the four seasons painted on its panels and its wheels gilded and ornamented with carved foliage. Then he obliged his reluctant and chronically shy sister Frances to go out in it 'to make a show', hoping that 'it would be inquired whose grand chariot this was, and that, when it was told, it would give a strong indication of his great success, and by that means tend to increase it'. He was a master of spin. As his pupil James Northcote observed later, Reynolds 'knew the use of quackery in the world'.[61]

Reynolds was nothing to look at. He stood at 5 foot 5 inches (people were shorter in those days), and he was portly, deaf, slovenly in dress, slightly hare-lipped and spoke with a Devon accent. He had nonetheless contrived to be moderately libertine in his younger days in Plymouth, and there are hints of a homosexual life in Rome. He liked women, but although in return they liked his calm geniality, they found him too pallid for love, and he never married. As his friend Hester Piozzi versified:

> Of Reynolds what Good shall be said? – or what harm?
> His Temper too frigid; his Pencil too warm:
> A Rage for Sublimity ill understood,
> To seek still for the Great, by forsaking the Good.[62]

He seems to have disposed of what sexual urges he had by painting society courtesans – Elizabeth Hartley, Nelly O'Brien and Polly Kennedy, and Kitty Fisher four times, once as a bare-breasted *Danaë*, before she died aged twenty-six in 1767, poisoned by the arsenic and lead in her cosmetics. A newspaper dropped heavy hints about their relationship: 'Catherine [Kitty] has sat to you in the most GRACEFUL, the most NATURAL, attitudes, and indeed I must do you the justice to say that you have come as near the ORIGINAL as possible.'[63] There is no proof that he got as near to Kitty as this writer imagined.

Youthful habits lived on in the cheerful anarchy of Reynolds's impromptu dinner parties and his gambler's inability to resist a pack of cards. His public geniality couldn't hide his harsh treatment of pupils like Northcote or of his sister Fanny, but everyone else liked

him. Urbane and convivial, he surrounded himself with talent – Johnson, Boswell, Goldsmith, Burke, Garrick or the Burneys, including the novelist Fanny. He held his own in Johnson's literary club, debating art, literature and taste with the best of them. He became Johnson's *dulce decus* (in Boswell's phrase, citing the Latin poet Horace's 'my joy, my guard, my sweetest good'). To fill such a role in Johnson's life was no mean thing. Edmund Burke approved his 'strong turn for humour', and liked the fact that he 'enjoyed every circumstance of his good fortune, and had no affectation on that subject'.[64] Later, Hazlitt put it more sharply. Reynolds's 'unruffled moral enjoyment' owed much 'to the coronet-coaches that besieged his doors, to the great names that sat at his table, to the beauty that crowded his painting-room ... These things do indeed put a man above minding little inconveniences.'[65] Among London's myriad social climbers Reynolds was the most energetic, successful and complacent.

86. Francesco Bartolozzi, after Edward Francis Burney, *Reynolds's Funeral Ticket* (etching, engraving, 1792)

In October 1764 Hogarth died of an aneurism in his sixty-seventh year. His death was only briefly noticed in the newspapers, and on the other side of the Fields Reynolds left no record of it. We have no record either of who attended Hogarth's burial in Chiswick church-yard near his rural villa at the now traffic-murdered Hogarth Roundabout – though both Garrick and Johnson provided epitaphs, and the stately tomb still stands.

By contrast, everyone who was anyone went to Reynolds's funeral in 1792. His body lay in state in the Academy's black-draped life-drawing room in Somerset House; then it was trundled along the Strand and Fleet Street to its burial in the crypt of St Paul's Cathedral. The cortège contained ninety-one carriages, and the ten pall-bearers included three dukes, two marquesses and three earls. If Bartolozzi's engraved funeral ticket is to be believed, a veiled woman and a putto came over from Florence to grieve at his tomb too (fig. 86).

6

Real Life

Be it known then, that the human species are divided into two sorts of people, to wit, high people and low people. As by high people I would not be understood to mean persons literally born higher in their dimensions than the rest of the species, nor metaphorically those of exalted characters and abilities; so by low people, I cannot be construed to intend the reverse. High people signify no other than people of fashion, and low people those of no fashion.

– Henry Fielding, *Joseph Andrews*

FANTASIES

When most of us think of eighteenth-century art, it is not to Paul Sandby's and others' representations of street life that we first refer (fig. 87). We call to mind, rather, the classical fantasies, history paintings, and elegant portraits that catered to the tastes and pretensions of Fielding's people of fashion – not least because our spirits have so often been numbed by their sheer quantity and repetitiveness in our lesser galleries and country houses. Long before the Royal Academy was founded, aspirational people with money who read the right books took it for granted that art that addressed real topography and real people was acceptable if tastefully handled, but that it was inferior to pictures painted in the grand historical manner because it lacked elevated moral purpose. When Reynolds elaborated these notions to advance a standardized neo-classical academic theory in his presidential *Discourses* to the Academy, he trod, as was his wont, on the very safest ground.

87. Paul Sandby, *Asylum for the Deaf* (ink, watercolour, no date)

Reynolds's windy appeals to universal truths, universal nature and the 'great glory of the human mind' that pursued 'general beauty' etc., went down well with his listeners and readers, for they sanctified the social utility of 'taste', and this has always helped high people to differentiate themselves from low ones. Taste certainly worked this way in the second half of the century, for the distance between the practitioners of high art and those who found their subjects in common life was widening. In that commercialized and mobile world, 'high' art became a language of hauteur and social differentiation. This was to mould artistic ambitions and the affectations of cognoscenti for decades to come – and down to our own day.

It took a brave Academician to gainsay these precepts, but one or two did so. In 1772 George III employed Johann Zoffany to portray his Fleet Street optical lens-maker in *John Cuff and his Assistant* in his workshop (**plate 13**). Zoffany so skilfully replicated the naturalism of Flemish low-life painting, and so flagrantly ignored Academic rulings, that art historians still excuse this as a parody, if a 'perfectly observed'

one. The unacknowledged and better truth is that it's an honest and rare image of a skilled London craftsman at work, and it tells us a great deal about workshops into which artists rarely take us. It caught exactly 'the awkwardness of tortoise-skinned, leather-aproned mechanics; the absurd clutter of incomprehensible pots, pans, tools and widgets; the daylight from a single window planting a droplet of light on each coarse but lovingly-rendered surface'. If this was an experiment on Zoffany's part, it didn't find favour. It might have been this painting among others that provoked Reynolds in his sixth *Discourse* to dismiss Dutch painters such as Brouwer, Teniers and Steen as tolerable only as subjects of parody: like modern critics, he assumed this painting could only be one. And, although he admired Zoffany, Horace Walpole dismissed the painting as 'extremely natural, but the characters *too common* in nature'.[1]

These responses were endorsed as classical education and the aristocratic Grand Tour deepened the adoration of the Italian masters and of antiquities alike. The importation of these things into London vastly increased between the 1720s and 1770s. During or after their Tours, Englishmen emptied Europe of some 50,000 master paintings, half a million engravings, countless antiquities and innumerable forgeries. Since patronage lay that way, the more fashionable English painters made their living by reaching for classical metaphor and allusion reflexively, and Italianate fantasies were their usual source.

The consequences could be bizarre. When James Barry returned from Italy in 1771, he declared that he had never before experienced 'any thing like that ardor, and I know not how to call it, that state of mind one gets on studying the antique. – A fairy land it is, in which one is apt to imagine he can gather treasures, which neither Raffael nor Michel Angelo were possessed of.'[2] Nor did one have to go to Italy to feel this. Hogarth's friend George Lambert was the first native painter to work entirely in landscape, but although he lived nearly all his life in the Piazza and never saw Italy, his muddy arcadian pastorals showed how easy it was to pretend that he had been there. The landscape painter Thomas Jones did go to Rome, in 1776. There, like Barry, he was struck by the 'new and uncommon Sensations I was filled [with] on my first traversing this beautiful and picturesque Country – Every scene seemed anticipated in some dream – It appeared

Magick Land.' Yet, long before he set foot there, he had been apprenticed to the Covent Garden painter Richard Wilson, and Wilson had set him to copy his own Italian studies in a training that amounted to brainwashing. So Jones was 'insensibly ... familiarized with Italian Scenes, and enamoured of Italian forms' well before he saw them.[3] Thus armed, he painted imaginary Italian landscapes and mythical scenes, collaborating, for example, with his friend John Hamilton Mortimer (who never went to Italy either) on a *Death of Orpheus* (*c.* 1770) set at the Temple of Venus at Baiae that neither had seen (fig. 88). Likewise, the young J. M. W. Turner, always anxious at this stage to prove himself in fashionable subjects, painted *Lake Avernus: Aeneas and the Cumaean Sybil* around 1798, and then repeated it in 1814–15 (fig. 89). Both versions were in Wilson's manner and based on a drawing by his current patron. In fact, Turner first saw Italy in

88. Thomas Jones (the landscape) and John Hamilton Mortimer (the figures), *The Death of Orpheus* (oil, *c.* 1770)

1819. The contagion spread to amateurs. William Taverner was a City lawyer who was the first to paint landscapes in freely applied water-colour (without prior ink or pencil drawing). His never visiting Italy didn't stop him regarding the English landscape through Italian eyes, and making naked nymphs disport themselves in a grove of distinctly English trees that he drew on Hampstead Heath (fig. 90).

Well might Horace Walpole find it extraordinary that just as English poets 'warm[ed] their imaginations with sunny hills, or sigh[ed] after grottoes and cooling breezes', so English painters neglected English scenes as mere 'homely and familiar objects'. Instead they painted 'rocks and precipices and castellated mountains, because Virgil gasped for breath at Naples, and Salvator [Rosa] wandered amidst Alps and Apennines'.[4] In similar spirit, John Ruskin a century later was to deplore the arid pedantry of the Academy classes the young Turner

89. J. M. W. Turner, *Lake Avernus: Aeneas and the Cumaean Sybil* (oil, 1814–15, after his own original of *c.* 1798)

90. William Taverner, *Woodland Scene, with Nymphs Bathing* (watercolour, bodycolour, no date)

attended, from whose indoctrinations he said it took Turner some thirty years to recover. Turner's early days were wasted 'in painting subjects of no interest whatever ... meaningless classical compositions, such as the fall and rise of Carthage, Bay of Baiae, Daphne, and Leucippus, and such others, which ... are yet utterly heartless and emotionless, dead to the very root of thought'.[5]

It would be crass to mock these things now without acknowledging that the best of them had beauty and accomplishment, and that the worst are at least worth regarding historically as measures of the self-imaging of the elites who bought them and the artists who made them. Nor is there any question that many artists brought to their work high degrees of earnestness and felt themselves enriched by their neo-classical vision; nor that neo-classicism increased the self-confidence and competence of the polite arts in England, and helped rescue their practitioners from their long-held sense of inferiority.

Even so, in too many such exercises, as well as in the often mawkish

sensibility of their Romantic successors, we may today feel imposed upon by the century's glaring inequalities, even as we're also confronted by high levels of insipid and sanctioned mendacity: in the acres of nymph- or goddess-strewn paintwork approved by the Academy, in the idealizations of its portraiture, in Angelica Kauffman's 'wishy-washy classicalities', or in the sensibility of a man like Richard Cosway who, as here, for the charming *frisson* of the thing, could portray a cossetted lady and child as beggars in picturesquely tattered clothes (fig. 91).[6] Despite exceptions (the elaborate brilliance and wit of Zoffany's group portrait of the Sharp family, for example), portraiture and 'conversation pieces'

91. Richard Cosway, *Miss Eliza O'Neil and Lady Wrixton Becher as a Beggar Woman and a Poor Child* (stipple engraving, 1816)

were just as artificial, with picture after picture showing 'young men immaculate in silk and satin, toying with a delicate china tea-cup, leaning forward with studied, careless charm to talk to young women as beautifully dressed as themselves'.[7] We live in a world which fetishizes fashionably approved art works and forgets the conditions of their production; but we needn't be reverentially smitten by all of them. The last thing they should be allowed to do is prettify our notion of the culture that produced them.

There's no getting away from the fact that work of this kind was done by craftsmen under hire to the great and the monied, nor that it was riddled with pretence. Through their portraiture, artists 'earned a despicable living by flattering the great' (to recall Dickens's lament for the plight of Grub Street writers).[8] It is from their brown-nosing that we today inherit our sugared notions of polite eighteenth-century life. Portraits and conversation pieces posed their subjects in dignified postures and the finest of clothes and settings, but they occluded their subjects' rotting teeth, their ill-fitting dentures in lead bases, stacked (as George Washington's was) with human, cow and ivory teeth and equipped with springs to make them open (fig. 92), their arsenical make-up, bodily smells, unwashed armpits and halitosis, not to mention their arrogance and affectation. Well might Thomas Lawrence complain that he felt 'shackled into this dry millhorse business' of painting portraits of grand people, or Joseph Wright of Derby, trying his chances as a portraitist in Bath, that 'the great people are so fantastical and whimmy, they create a world of trouble'.[9] The rare artist who broke with his submissive obligation and tried something new, as the young Gainsborough did when he painted *Mr and Mrs Andrews* of Sudbury, could do so because country clients were relatively free of metropolitan pretensions. He loathed his rich London clients. 'They think . . . that they reward your merit by your company and notice, but I know that they have only one part worth looking at, and that is their purse.'

It cheers one up, conversely, to realize that inflated artistic reputations were more often pricked in that era than the more reverent of us like to think: there were many contrary voices, and art-world malice was as sharp as it remains today. Thus everyone knew that, like most portraitists, Reynolds relied on assistants to finish his canvases. Over forty years he used one assistant to finish most of them, too. He had picked up the boy Giuseppe Marchi off the streets of Rome when

92. George Washington's dentures (1790s)

Marchi was fifteen and Reynolds twenty-one. Marchi had talents – artistic one hopes – so Reynolds persuaded the lad to share lodgings with him in the Piazza di Spagna before bringing him back to England – making him follow his coach on foot from Lyons to Paris because there was no space for him inside it. He painted Marchi's portrait in a Turkish turban, trained him as a finisher, and thenceforth treated him as a servant on a valet's wage. He treated his local pupils like this too. James Northcote, who worked under Reynolds in the early 1770s, remembered that if 'Sir Joshua had come into the room where I was at work for him and had seen me hanging by the neck, it would not have troubled him'.[10]

Much good his exploitations did Reynolds's paintwork, however. Paul Sandby thought of Reynolds as one of the 'pretended Connoisseurs & ... Imitators' who set 'the example of Scumble Asphaltum, & Varnish',[11] while Gainsborough hated Reynolds's 'poetical impossibilities', by which he meant his dressing his subjects in ridiculous costumes: 'so well do Serious people love – froth'.[12] Though no judge of art, George III found Reynolds's work 'coarse and unfinished', and worried that he painted trees in red.[13] Hazlitt pointed out that Reynolds's *Mrs Siddons*

93. Louis-Philippe Boitard, *Little Cazey: 'Sketch from Bridswell'* (ink, wash, watercolour, 1745–7)

as the Tragic Muse was 'neither the tragic muse nor Mrs Siddons'.[14] Reynolds's careless brushwork, his fading reds, and his use of bitumen for his blacks (it never dries and apparently keeps moving across the picture) earned him the title of 'Sir Sloshua' from the mid-Victorian pre-Raphaelite painters. One of them defined 'sloshy' as 'anything lax or scamped in the process of painting' and 'any thing or person of a commonplace or conventional kind'.[15] A recent critic points out how Reynolds abandoned technical care for the sake of fleeting effects, so that the faces in his portraits became ghostly and ghastly, even as the rest of the painting was blackened and buried in bitumen.[16]

Reynolds's persuasive powers came at their own comic cost. In 1747 Louis-Philippe Boitard included in his print *The Covt. Garden Morning Frolick* (fig. 43 above) the figure of the bare-footed and cross-eyed link-boy Little Cazey. He was one of the countless discarded urchins

94. Joshua Reynolds (after), *Cupid in the Character of a Link Boy* (mezzotint, 1777)

who made thin livings by showing people their way at night by the flare of pitch-soaked torches. Cazey was a familiar figure on the streets, and it may be that Boitard felt sorry for him or simply curious about him. He prepared for his *Covt. Garden* print by sketching Cazey, shoeless and in tattered clothing, while the lad was locked up for a misdemeanour in 'Bridswell' [Bridewell] (fig. 93).

Reynolds painted a very different and prettier link-boy in the 1770s. This one was commissioned by the rakish Duke of Dorset for his private cabinet: the picture's indelicacy lay in the fact that link-boys led people to sexual assignations and were preyed upon by pederasts. Reynolds's painting gestured towards urban realism in its background buildings, and the boy himself – Reynolds's 'favourite boy', brought in off the street – was prettily painted. However, his left hand clasps his right arm in the obscene gesture that signified copulation, and the burning brand was phallic. Fair enough, were it not for Reynolds's over-elaboration. To find

refuge for his indecency in a classical alibi, he gave the boy sinister black wings and called him *Cupid in the Character of a Link Boy* (fig. 94).[17]

Reynolds's wasn't the only vulnerable reputation. Hazlitt dismissed Benjamin West, who followed Reynolds as the Academy's president, as 'a thoroughly mechanical and commonplace person' with 'no idea of any thing in art but rules, and these he exactly conformed to':

> The whole art with him consisted in measuring the distance from the foot to the knee, in counting the number of muscles in the calf of the leg, in dividing his subject into three groups, in lifting up the eyebrows to express pity or wonder, and in contracting them to express anger or contempt.

Thackeray later mocked painters who preserved 'the golden mediocrity which is necessary for the fashion', as they knocked out portraits of 'new ladies in white satin, new Generals in red, new Peers in scarlet and ermine, and stout Members of Parliament pointing to inkstands and sheets of letter-paper, with a Turkey-carpet beneath them, a red curtain above them, a Doric pillar supporting them, and a tremendous storm of thunder and lightning lowering and flashing in the background'.[18]

*

In images like these lie clues to the importance and the necessity of satire. It was a source of mental health in the eighteenth century, for resort to its truth-telling enabled people to challenge absurdity, subvert their own deference and exact vengeance on their betters. Most notably, James Gillray, Thomas Rowlandson and William Blake had been exposed to Reynolds's regimen in the Academy Schools. Rowlandson studied there from 1772 to 1778, and Gillray and Blake entered the Schools in 1778 and 1779 respectively. The copying of classical casts and engraving taught them much, of course, but their contempt for Reynolds's control was withering, especially as their academic careers faltered and they were marginalized. For some thirty years, the Academy stifled free spirits like theirs, as it would have stifled Hogarth had he lived under it. They were far from the only casualties of the system, and their deep resentments and protests must have spoken for those of countless others. The intensity of their dissent shouldn't be underestimated. For such men, what a release

parody offered from cant! No wonder this was an age in which satire flourished.

Rowlandson's revenge was exacted in his many satires on wizened and grotesque *Connoisseurs* drooling over paintings of naked female flesh. His first such exercise is a drawing of *c.* 1790 (**plate 14**). It seems to have coincided with the distinctly populist turn that became apparent in his work after he had gambled away his aunt's fortune and

95. Rowlandson, *Connoisseurs* (etching with watercolour, 1799)

96. Rowlandson, *Cunnyseurs* (etching with stipple, no date)

turned his back on the Academy. He transferred the point into print in 1799, elaborating on it with cruel relish (fig. 95). Even then he couldn't let it go, for he rubbed it home in an obscene variant, *Cunnyseurs* (fig. 96). His comment on the great portrait tradition was just as powerful. His wonderful grotesque aristocrat, complete with broken teeth, must have afforded him both pleasure and relief (**plate 15**).

Gillray, nursing his resentments like the good hater he was, took revenge in several art-world travesties. Some, admittedly, were genial enough. In 1783, for instance, the Rev. William Peters had flattered the Duchess of Rutland by painting her as an *Angel carrying the Spirit of a Child to Paradise* (fig. 97). Any painter would have done the same if there was money in it, but Peters's opportunism was still egregious. The Duke of Rutland had presented him with one clerical living, and

97. William Dickinson, after Rev. Matthew William Peters, *Of Such is the Kingdom of God [Angel carrying the Spirit of a Child to Paradise]* (stipple engraving, 1784)

the Dowager Duchess had given him another: so Peters allowed himself to be smitten by piety and stopped painting the winsome bare-breasted ladies for which he was known in the 1770s (fig. 71 above). Memories in the art world were long, however. Nearly a quarter-century later Gillray's print parodied Peters's flattery by replacing the Duchess with the portly, merry-faced and comically winged figure of Mrs Fitzherbert, the Prince of Wales's mistress. Wearing the prince's feathers, she rises from the prince's Brighton Pavilion below, burdened by a rather large little girl, towards an altar surrounded by cherubs

98. James Gillray, *The Guardian Angel* (etching, 1805)

with Whig politicians' faces. Gillray's subtext explains that his 'hint' is '*taken from the Revd Mr Peter's sublime Idea of 'an Angel conducting the Soul of a Child to Heaven'* (fig. 98).

The most elaborate of Gillray's art satires are probably the biggest single-sheet print satires ever produced. Their complexities speak for the anger and contempt he brought to them. His *Titianus Redivivus; – or –*

The Seven Wise Men Consulting the new Venetian Oracle, . . . a Scene in yᵉ Academic Grove (1797) (541 x 408 mm) ridiculed the gullible Academicians who had paid ten guineas each to a young female charlatan, Mary Ann Provis. She had claimed that she had discovered the 'Venetian secret' of Titian's colouring. There Gillray puts her on a rainbow to dab at a figure intended for Titian, accompanied by a winged donkey. Reynolds's ghost emerges from the stone floor beneath, and behind him are ranged the seven Academicians who had fallen for the scam (Farington, Opie, Westall, Hoppner, Stothard, Smirke, Rigaud: this was a true story) (plate 17). Their speech bubbles confess their anxieties about their own falsities and their hopes that Titian's secret will cure them. In the background the Royal Academy splits apart as if in an earthquake, and in the foreground a grinning ape pisses on the portfolios of Cosway, Sandby, Bartolozzi, Rooker, Turner, de Loutherbourg, Beechey and Fuseli.

Gillray's *Apotheosis of Hoche* (1798), just as large, is perhaps the greatest of his satires, and certainly the most ambitious. Though it was a loyalist anti-revolutionary print in which the Academy wasn't the target, it parodied and subverted the pomp of the Michelangelesque altarpieces which Academicians were meant to adore (fig. 99). It was a daring gesture to replace the figure of Christ with that of the French revolutionary general Hoche, though the idea had first been proposed by his Tory patrons. (Hoche had planned to invade Ireland in 1796; he died two years later.) Holding a guillotine and with a noose around his neck, Hoche ascends to a secular heaven presided over by winged monsters guarding the commandments of 'Equality'. Little baby *sans-culottes* and decapitated and blood-spurting aristocrats occupy the clouds around him. They are comically drawn, as if Gillray couldn't sustain the print's epic ambition. But it is the detailing that always matters in Gillray's grand pieces; and in the subordinate landscape at the foot of the print, with its headless corpses, piles of heads, two bodies hanging from a tree, and the blazing churches and houses, one is not far short of one of Callot's seventeenth-century nightmare engravings of the horrors of war, which Gillray must have known.[19]

The most direct satire on history painting in general and Reynolds's advocacy in particular came from within the Academy itself. It led to one of the biggest scandals of the eighteenth-century art world, not to mention to hilarity among Reynolds's enemies. In 1775 the painter

The Apotheosis of HOCHE.

99. James Gillray, *The Apotheosis of Hoche* (etching and aquatint, 1798)

Nathaniel Hone submitted for exhibition in the Academy an elaborate painting entitled *The Pictorial Conjuror, Displaying the Whole Art of Optical Deception* (fig. 100). Hone, too, was one of the Academy's founder members, but he was a combative man, and he wanted to mock Reynolds's habit of augmenting the dignity of his portraits by inserting motifs and postures cribbed from the old masters.

So the picture emulates Reynolds's colour palette, poses and fancy dressing. Half of it is occupied by reproductions of Old Master prints Reynolds had borrowed from. In the other half Hone depicted a smiling young woman intimately resting her crossed arms and chin on the Conjuror's knee. The Conjuror stood for Reynolds, and was taken from one of Reynolds's favourite old-man models. The woman was Angelica Kauffman. Everyone knew that she and Reynolds were a little too sweet on each other. (How else would a woman have become one of the Academy's founder members?) The infatuation

100. Nathaniel Hone, *Sketch for 'The Conjuror'* (oil, 1775)

was probably unconsummated, but women weren't made to smile in eighteenth-century art without disreputable intent. In a top corner of the painting, half-a-dozen naked nymphs cavort in front of St Paul's Cathedral waving palettes and paintbrushes – a reference to Reynolds's and Kauffman's plan to decorate the church with religious paintings. Kauffman took offence because one of the nudes looked like herself. The Academy's committee duly rejected the painting for exhibition – though less because it exposed Kauffman than because it attacked Reynolds. Hone painted out the nudes and then defiantly made it the centrepiece of his own one-man exhibition (probably the first of its kind) at 70 St Martin's Lane. It is the painting's original and uncensored oil sketch that is reproduced here.[20]

REALITIES

The artists of the Royal Academy might belittle but they still had to coexist with a growing army of painters and engravers whose work catered to a competing market for the real. In the long term, these, and not Reynolds, were to be on the winning side, even if the Academy made sure that this wasn't apparent in the eighteenth century. The multiplication of printshops and engravers in the second half of the century testified even then to an accelerating shift from text-based commentary to the image-based commentary of modern times. To this we must add the increasing demand of middle and middling people for images of their own real world, or of the quasi-real. They were less in thrall to classical models than the well-travelled elites, and many if not all were secure enough in their worth to reject fashionable affectation. Professional people, mercantile folk and the higher craftsmen were men of business, after all – pragmatists always and inventors and entrepreneurs often, and well versed in the New Science's empiricism. And just as empire and war made maps and the topographical and scientific illustration of remote and newly explored places indispensable, so Enlightenment favoured argued and proven truths. In great swathes of picture-making, it was from this naturalistic ethos that the fusion of observational, informative and aesthetic qualities emerged which Zoffany, say, achieved in *John Cuff and his Assistant* (**plate 13**).

Beyond that, given the chronic image-hunger of a populace unaccustomed to pictures of itself, it's no surprise that middle people favoured a here-and-now realism. Most Londoners were unused to *any* images other than signboards, broadside woodcuts and those in printshop windows. Just as crowds would gather outside printshops to see the latest prints, so they gathered to gaze at the finer new signboards – at the full-length board of 'Shakespeare's Head', for instance, when it was first hung on the corner of Little Russell Street and Drury Lane in the 1760s. For a time the crowds rendered the corner impassable to coaches. When, within a couple of years, all London signboards were taken down as nuisances and dangers, the pictorial rewards of the streets were greatly diminished. Other emblems had to take their place – the Percy family lion that proudly topped Northumberland House at Charing Cross, for example (**plate 2**). When he was very small, Dickens was taken to look at the lion and never forgot how wonderful it was.[21]

The artists who favoured the real had their own tide to swim with. This era saw the birth of the novel, and no art form was more ostensibly rooted in reality than that. Defoe, Fielding and Smollett were as dismissive of high-blown classical whimsy as ever Hogarth was, whence Fielding's parodies in *Joseph Andrews*:

> That beautiful young lady the Morning now rose from her bed, and with a countenance blooming with fresh youth and sprightliness, like Miss –[A], with soft dews hanging on her pouting lips, began to take her early walk over the eastern hills; and presently after, that gallant person the Sun stole softly from his wife's chamber to pay his addresses to her.

'Reality', 'truth', and 'nature' became the novelist's watchwords. To be sure, there was little particularization of real place in their novels. People passed through 'Covent Garden' or 'Town', but these were never fully visualized or described as Hogarth, Bickham or Boitard described them. A sense of urban place in the novel was as yet undeveloped, so references were bald, as here in Smollett's *Roderick Random*:

> It being now near two o'clock in the morning, we discharged the bill, and sallied out into the street . . . Banter and I accompanied Bragwell to Moll King's coffee-house [in the Piazza], where after he had kicked half a dozen hungry whores, we left him asleep on a bench, and directed our course towards Charing-cross, near which place both he and I lodged.

The truth referred to, rather, was truth to character or situation – or to what they all termed 'nature'. Defoe insisted that the plot of *Moll Flanders* was true to nature, while in *Roderick Random* (1748) Smollett delared that 'I have not deviated from nature in the facts, which are all true in the main': he viewed 'those parts of life, where the humours and passions are undisguised by affectation, ceremony, or education; and the whimsical peculiarities of disposition appear as *nature* has implanted them.' In his novels Samuel Richardson 'wrote to the moment', too, minutely detailing every description to add to its realism – 'letters stowed under flowerpots, wafers of paper tucked into the hems of dresses, spare ink hidden in a broken China Cup', all expressing their own 'Defoe-like logistical literalism'.[22] John Cleland made clear in his *Memoirs of a Woman of Pleasure* (1749) that even 'decency' must yield to truth:

> Truth! stark, naked truth, is the word; and I will not so much as take the pains to bestow the strip of a gauze wrapper on it, but paint situations such as they actually rose to me in nature, careless of violating those laws of decency that were never made for such unreserved intimacies as ours; and you have too much sense, too much knowledge of the ORIGINALS themselves, to sniff prudishly and out of character at the PICTURES of them.

'Everything is copied from the book of nature,' Fielding declared of *Joseph Andrews*, 'and scarce a character or action produced which I have not taken from my own observations and experience.'[23] The same novel introduced into English the self-reflexive narrative in which the author is present in his creation, his commentary reminding us that we read something he has made. This itself acknowledged 'reality.' Altogether, Covent Garden artists and novelists shared the same assumptions, as well as the same territory, and since the artist often illustrated the books of the author, relations could be close. Fielding and Hogarth admired each other and worked together. Joseph Highmore painted scenes from Richardson's *Pamela*; Richardson suffered the stroke that heralded his death while they were drinking tea together.

The most Enlightened of men shared the aversion to artistic fantasy. The philosopher David Hume never once mentioned the pictures he saw in any of his travels, and he expressed no wish to see others,[24] while Dr Johnson allegedly declared, 'I had rather see the portrait of

a dog that I know than all the allegorical paintings they can show me in the world.'²⁵ To Mrs Piozzi he announced that 'he should sit very quietly in a room hung round with the works of the greatest masters, and never feel the slightest disposition to turn them if their backs were outermost'. He assured his friend Hawkins that he was 'never capable of discerning the least resemblance of any kind between a picture and the subject it was intended to represent'.²⁶

To be sure, Johnson's eyesight was as myopic as his visual imagination was challenged. It's nice to recall that if he had no time for allegory, he had no time for music either ('of all noises the least disagreeable') – or for sculpture ('the value of statuary is owing to its difficulty. You would not value the finest head cut upon a carrot') – or for rural beauty ('a blade of grass is always a blade of grass, whether in one country or another'). But so far as allegory, fable, or romance were concerned his objections weren't facile, and turned on the fact that they weren't *true*. He made clear what he thought of as true when he famously praised Shakespeare because 'his drama is the *mirror of life*'. Shakespeare described 'human sentiments in human language', so that from his scenes a hermit might 'estimate the transactions of the world'. Shakespeare, moreover, 'has no heroes; his scenes are occupied by men, who act and speak as the reader thinks he should himself have spoken or acted on the same occasion'. Art, in short, should extract its 'general and transcendental truths' from real life – though, that said, politeness might still impose its limits:

BOSWELL: Will you not allow, Sir, that he [Henry Fielding] draws very natural pictures of human life?

JOHNSON: Why, Sir, it is of very low life. Richardson used to say, that had he not known who Fielding was, he should have believed he was an ostler.²⁷

In Hogarth notably, outside his few heavy-handed history paintings, you'll look in vain for nymphs, shepherds and togas. The notion that artists should improve on nature he found absurd. 'I grew so profane,' he wrote in his autobiographical notes at the end of his life, 'as to admire Nature beyond pictures and I confess sometimes objected to the devinity [*sic*] of even Raphael Urbin Corregio and Michael Angelo for which I have been severly [*sic*] treated.' What he saw with

his eyes was 'more truly to me a picture', he wrote, than anything artificially composed in a *camera obscura*. There was a 'delicacy' in life that eclipsed all these dead forebears. 'Who but a bigot,' he asked in 1752, 'even to the antiques, will say that he has not seen faces and necks, hands and arms in living women, that even the Grecian Venus doth but coarsely imitate? And what sufficient reason can be given why the same may not be said of the rest of the body?'[28]

If any one of his works proved his point it was his oil sketch of *The Shrimp Girl* from the early to mid-1740s (**plate 16**). He never tried to sell the painting, and his wife kept it after his death and until her own, acknowledging the girl's local provenance by calling her *The Market Wench*. To contemporaries the painting would have looked unfinished. Its subject and its free brushwork are both reminiscent of Frans Hals's smiling boys or girls from over a century before, yet it is more impressionistic than Hals's paintings, and it is in any case unlikely that Hogarth saw much if anything of Hals in paint as distinct from engraving – least of all that he saw Hals's *Gypsy Girl* (*c.* 1630) with which *The Shrimp Girl* is often compared.[29] *The Shrimp Girl* is more likely to have recalled the milkmaid in Marcellus Laroon II's *Cryes of the City of London* (1688), another version of whom informs Hogarth's *Enraged Musician* of 1741. In boyhood Hogarth would have seen Laroon's *Cryes* in every printshop.

The Shrimp Girl carries no message other than a 'joy in nature' that was unavailable to women in higher life.[30] Hogarth celebrates her for her own sake. As Jenny Uglow puts it, 'Hogarth, with his brushes and pigments, had shown beauty and grace more erotically alive on a London street than in any classical sculpture.'[31] *The Shrimp Girl* simply celebrates the 'happiness of London' to which Dr Johnson later referred. If there is any single icon of eighteenth-century Londoners' zest for life, this must be it: the girl herself is happy, but she stands for the vitality of plebeian culture as well.

*

Hogarth led this taste for the real, and he gets his own chapter after this one; but let this be the place to note that his successors pushed realism further than he did. Although they paid tribute to Hogarth,

they discarded his moralizing and his emblematic detailing, simplified his compositions, and cultivated a lighter touch than his. The outcome was witnessed in all manner of images – not least about the rude commerce of the courts and alleys within stones' throws of their studios.

These men cared nothing for the copying of Italian masters, even if in their youthful training they had learned composition, colouring and figure-drawing by doing just that. They found classical nudity, togas and cherubs no more necessary to their effects than they were to street girls. Instead they depicted street people, street incident and communal life, or affairs and places rooted in their own experience – the subjects, to repeat, of a *people's* art, in that as like as not they concerned unnamed individuals engaged in common pursuits. Or else they located their images in a workaday and identifiable London, as Samuel Scott did, albeit picturesquely, when he followed Canaletto by painting life on the Thames (**plate 18**). In one or another form, the observation and representation of 'real life' was their touchstone.

The artists of stature among these men were relatively few in number. After Hogarth none proclaimed the elevated notion of their calling to which Johnson or the novelists aspired. But Hogarth's example did inspire them, and they were to include big hitters like Paul Sandby, John Collet, Thomas Rowlandson, and the topographical artists Samuel Scott and Scott's pupil William Marlow, not to mention legions of marine artists and satirical and humorous artists who were by definition just as entranced by the real world as these names were. Even the watercolourists Thomas Girtin and J. M. W. Turner launched themselves from this tradition. Although they broke from their predecessors in the 1790s and found their subjects outside London, both came to consciousness in Covent Garden and trained locally under topographical and architectural draughtsmen. Girtin painted a vast panorama of Thames-side London that he exhibited for payment in 1802–3 in Spring Gardens off Charing Cross. Measuring 18 feet in height and 108 feet in circumference, it sought to capitalize on the popularity of the panoramas that Robert Barker displayed in his newly built exhibition hall in Leicester Square. Three months after the exhibition, in his twenty-seventh year, Girtin died in Paris of 'ossification of the heart', but not before he had thus demonstrated his wonderment at London and his certainty that others would pay to share it.

Of the post-Hogarthian realists or quasi-realists, John Collet is today the most neglected. In part this was because his output got cruder as he catered to printshops' hunger for humorous mezzotint; Carington Bowles's and Sayer's shops all but lived off his designs in the last quarter of the century.[32] He had initially learned his craft as a landscape painter under Hogarth's friend George Lambert of the Piazza, and he exhibited landscapes at the Free Society of Artists. Around 1762 he switched to Hogarthian genre scenes from everyday life, and stayed with these for the rest of his very prolific career. One contemporary thought his colouring and humour beat Hogarth's. The fact that he was both affluent and famously shy may explain why, after living in the 1760s 'at Mr Belmond's, Hair Merchant, James Street, Covent Garden', he moved to Millman Street near the Foundling Hospital and then to a house he inherited in Chelsea. Nonetheless, Hogarth and Covent Garden were in his bloodstream.

Collet had his moments. He was at his best in the overcrowded, fully lived and detailed 'Dutch' manner of, say, *The Press-Gang* (1760s) (fig. 101), a painting as theatrically arranged and incident-laden as any of Hogarth's, with the atmosphere and detail of a Dutch interior. The press-gang brings its victim to the tavern where the naval agent waits aloofly; his wife kneels in supplication. Dogs sniff, babies suck, people converse, life goes on as fully as in any Dutch painting. Similarly, his elaborate street scene, *The Bath Fly* (1770), remembers the fourth tableau in *A Rake's Progress*; it may also have a lost theatrical allusion (**plate 19**). It depicts a brawl occasioned by the arrival of the 'Bath fly'. (This was an unprecedentedly speedy coach – though every newspaper reference to it was to its being attacked by highway robbers.) The green-trousered man centre-left seems to have robbed someone; he has been arrested after the hero's intervention. It's a Hogarthian touch that other people's lives continue despite the drama. As the young woman leaves her sedan chair, the chairman checks how much she puts in his hat; the drinking man and his girlfriend on top of the coach cavort regardless. Collet anchors the painting by locating it outside the 'New Bagnio'. There was a bagnio by that name, advertised in 1767, on the corner of Russell Court and Drury Lane ('where gentlemen may depend on the most genteel usage').[33]

Paul Sandby was another realist – in the sense that neither togas

101. John Collet, *The Press-Gang* (oil, 1760s)

nor nymphs tainted his work. He was born in Nottingham in 1731, thirty-four years after Hogarth, and he died in 1809. Trained by a Nottingham surveyor alongside his elder architectural draughtsman brother Thomas, he belonged to a new generation and a new professional class. Dapper, handsome and stylish in every way that Hogarth was not, he had a fine sense of himself as 'artist', as his 1761 portrait by the fashionable West End portraitist Francis Cotes memorably discloses. Cotes has him in the coming pose of genius – observant, engaged and amused by the here-and-now, and rejecting the stiff formality of the older portrait tradition (fig. 102).Sandby's polish helps explain why he couldn't bear Hogarth. Returning to London in 1751 from his employment in Scotland by the Board of Ordnance after the 1745 Rebellion, he vented his spleen in vitriolic satires that mocked Hogarth's boorish self-aggrandizement. His prints gave the diminutive Hogarth the legs of a goat, lampooned his notion of grace and

Fra: Cotes pinx. *E. Fisher fecit.*

Paulus Sandby.

Ruralium Prospectuum Pictor.

publish'd according to the of Parliament 1763.

102. [After] Francis Cotes, *Paul Sandby* (mezzotint, 1763)

103. Paul Sandby, *A Girl and her Lover say Good-bye* (pencil, wash, no date)

beauty, and dismissed him as an egomaniac mountebank and a 'sense-less, tasteless, impudent, Humm Bugg'.[34]

Sandby is esteemed today for his watercoloured landscapes (see **plate 26**); he helped turn these into an exhibition medium in their own right. He had lodged with his elder brother Thomas in Soho until in 1772 he moved to St George's Row just beyond Tyburn to the north of Hyde Park: this was almost rural. He lived there until he died, in the same row of houses as the Academician Dominic Serres and later Thomas Girtin. But although his rural landscapes under-standably outnumber his urban pictures, the best of his figure-work was honed in London. He shared the immediacy of Hogarth's and then Rowlandson's responses to their surroundings and never reneged on his eye for street-people and their incidental businesses. He might dislike Hogarth, but could still refer to him. His undated watercolour, *Asylum for the Deaf* (fig. 87) parodies Hogarth's *Enraged Musician*, for instance. Yet in it he goes beyond Hogarth in his sympathy for the musicians and the pleasure they give people: what results is a celebra-tion of an urban *happiness*. By the same token, his notebook sketches – of a girl saying goodbye to her cart-driving sweetheart, say (fig. 103)

Fun upon Fun, or the first and second part of Miss Kitty Fishers Merry thought. No Joke like a True Joke. Come, who'l Fish in my Fishpond?

104. Paul Sandby, *Fun upon Fun, or the first and the second Part of Miss Kitty Fishers Merry Thought. No Joke like a True Joke. Come, who'l Fish in my Fishpond?* (etching, 1760)

– are Rowlandsonian in their affectionate observations. The title of his *Cries of London*, published in book form in 1760, pointedly added that they were *Done from the Life*. In fig. 104 a family of ballad singers (the mother with her hand cupped to her ear to help get the notes right) peddle a rude song about Reynolds's favourite courtesan model, Kitty Fisher: 'Come, who'l Fish in my Fishpond?'

Turn from these names to any number of satirical or humorous prints

105. Carington Bowles, *High Life Below Stairs* (mezzotint, 1770)

in the second half of the eighteenth century, and you'll find the same deepening interest in 'reality' married to a staunch belief in the importance of its representation. Even caricature and satire, which distorted reality, in theory did so to get to the truth of what was. Satire's engagement with the real touched all social classes. A Carington Bowles mezzotint such as *High Life Below Stairs* (1770) (fig. 105) was too expensive at a shilling plain or two shillings coloured for servants themselves to buy. Rather, it catered to the servant-employing classes' curiosity about their underlings' gaiety. The impression reproduced here comes from the Duchess of Northumberland's collection. Even a female grandee could engage with the commonalty, occasionally and distantly.[35]

It is less in their quality (though many had that) than in their numbers and their attitudes that pictures like these signify. The London they open to us was variegated and increasingly *enjoyed*. What was developing was a metropolitan aesthetic that turned out images to record, inform, celebrate, amuse, mock or comment, rather than score

grandiose points about taste. History painting and neo-classicism consolidated their high ground in the second half of the century, and continued to sustain the moneyed and the commercial art world; yet the informality of this other art chimed better with Londoners' deepening delight in their metropolis, as well as with the print revolution and the more open markets of the next century.

THE LOW COUNTRIES' LEGACY

The artists in question inherited a tradition that extended back to the genre art of the anonymous and everyday subject that had been practised in the seventeenth-century Low Countries by artists like Adriaen and Isaac van Ostade, Adriaen Brouwer, Teniers the Younger and Jan Steen – and by Rembrandt and the French Jacques Callot also, in their etchings of beggars and street people. Aesthetic theorists were right to complain that these men's subject-matter neither improved the mind nor excited noble sentiments. Rembrandt's beggars peed and defecated, while Teniers's, Brouwer's and Steen's peasants roistered in taverns, lifted women's skirts, urinated in fireplaces or onto tavern floors, and cuddled with or sat drunken girls on their laps (fig. 106). None of this went down well with eighteenth-century aesthetes. 'When they attempt humour, it is by making a drunkard vomit,' Horace Walpole was to lament about such pictures; 'they take evacuations for jokes, and when they make us sick, think they make us laugh'.[36]

None of this stopped their works finding favour in a London market stacked with just the kinds of mercantile and professional purchasers to whom the Low Country artists had themselves catered. Here (to repeat) was a prospering bourgeoisie that was unsubmissive to courtly tastes, wasn't deeply educated in the classics, and cared as little for cherub-surrounded madonnas as they did for nymphs. With money enough to satisfy its own tastes, it hungered more for representations of the world it had created and recognized. It helped its demand for innumerable Dutch works or works in that tradition that they had been about laughter, drink, conviviality, music, singing, dance and flirtation, whatever the moralized glosses laid over these subjects. This life-affirming content was easily transposed from rural inns full of

106. Adriaen Brouwer, *Interior of an Inn* (oil, *c.* 1630)

Dutch peasants to the boisterous streets and taverns of Britain's metropolis.

Realism in art fascinates viewers more than myth-making does. One delights as much in the figures and landscapes in the background of the Renaissance Madonna as in the Madonna herself; and nobody fails to peer closely at the circumambient life that fills a Carpaccio. Low Country artists catered to that taste when they exploited the sixteenth-century Flemish reinvention of oil painting by developing a fine-tipped brushwork and virtuoso precision in the depiction of material and bodily detail. Landscape painting sprung from the same sources, though in England it wasn't until patrons began to buy depictions of their estates in the 1730s that it found elite favour. It was probably commercial men who were most impressed by the swelling numbers of landscapes and townscapes by Hobbema, Ruisdael and Cuyp (and Lorrain, Poussin and Dughet) that were entering London. View paintings and riverscapes

by Low Country immigrants such as Knyff, Tillemans and Jan Griffier paved the way for Canaletto's London successes at mid-century.

English print-making also learned from Dutch and Flemish models. As early as the 1660s the London mezzotinter Francis Place (not to be confused with the later Radical) was engraving tavern scenes after Teniers and Brouwer for the publisher John Overton of Little Britain, the booksellers' street off Smithfield. Place also worked in London with the Prague-born Wenceslaus Hollar, and might have travelled with Hollar to the Low Countries. Robert Pricke, one of Hollar's pupils, imported Dutch, French and Italian books and prints, and replicated the Dutch taste for the plebeian picturesque in his *Cryes of London* in 1655. John Smith, too, in and after the 1680s, sold prints after Teniers the Younger and Egbert van Heemskerck I at the Lion and Crown in Russell Street, Covent Garden. Born in Harlem, Van Heemskerck came to London in 1674, and died there in 1704 famous for the 'drunken drolls and lewd pieces' that were then 'in vogue amongst waggish collectors and the lower rank of virtuosi' (including the libertine Earl of Rochester for whom he produced 'several pieces').[37] He provided a direct link back to Brouwer and Teniers upon whose works he modelled his own. One Hogarth biographer wonders whether he might not have been the 'neighbouring painter' Hogarth recalled from his boyhood, whose art lessons first 'drew my attention from play'.[38] Likewise, Vertue's master, Gerard Vandergucht, son of the Antwerp-born Michael Vandergucht who had come to London in 1688, was the first English-born engraver to blend etching with engraving in the French style in order to combine the fluency of free drawing with engraved detail and tonal gradation.[39]

Another Low Country immigrant of certain influence was Marcellus Laroon II (the Elder). Born at The Hague *c.* 1648, he travelled widely (including to Hull in Yorkshire of all places, where he claimed to have met Rembrandt of all people). He moved to London after 1660, married a rich builder's daughter, set up house in Covent Garden at 4 Bow Street in 1679, and became one of Kneller's drapery painters. He was a 'man of levity, of loose conversation & morals suteable [*sic*] to his birth & education, being low & spurious', as Vertue sniffed haughtily.[40] His nose and lip had been almost severed in a street sword-fight, which said something about his manners. Yet his artist son, Marcellus Laroon III (the Younger), testified to the education his father had given him in

French, music, fencing and dancing; and when the family pictures were auctioned after the son died in 1772, they included his father's collection of works by Cuyp, Teniers, Vandevelde, Hobbema, Ostade and Brill – Dutchmen or Flemings all.[41] From Will's coffee-house on the corner of Russell and Bow Streets Marcellus Laroon II sold Dutchified etchings and mezzotints of tavern bawdry and erotica (fig. 107). His *The Cully Flaug'd* ('fool flogged') (fig. 108) is one of the earliest surviving examples of home-grown English erotica; before this, such images were imported from France. (The subtext reads: 'What Drudgery's here, what Bridewell-like Correction! / To bring an Old Man, to an Insurrection. / Firk [beat] on Fair Lady, Flaug the Fumblers Thighs / Without such Conjuring th' Devil will not rise.') Laroon's *Cryes of the City of London* were published in 1687–9 by another Covent Garden inhabitant, Pierce Tempest. These seventy-four etchings of street traders (a 'curtezan' included) provided the model for Sandby's *Cries* of 1760, for Rowlandson's etchings of street life at the end of the century, and for John Thomas Smith's beggar etchings in his *Vagabondiana* (1817). They all echoed Rembrandt's compassionate curiosity about beggars and street people: they passed no judgement.

107. Marcellus Laroon II (the Elder), [*Tavern bawdry*] (etching, 1680–1700)

108. Marcellus Laroon II (the Elder), *The Cully Flaug'd*
(mezzotint, *c.* 1674–1702)

By such routes the Low Countries' influence infiltrated the art
world of early eighteenth-century London. Teniers's and Brouwer's
tavern and genre prints were many times re-engraved and republished,
while printshops advertised Dutch and French as well as Italian
engravings, as originals or as copies, into the 1760s and beyond. Later,
the production of 'drolleries' in this tradition was to keep Carington
Bowles's, Sayers's and other printshops in business well into the later
century. At least one of Rowlandson's end-of-the-century copulatory
etchings had two couples vigorously at work in *A Dutch Serglio*
['seraglio'], a travesty of a seventeenth-century Dutch kitchen-
bedchamber (fig. 109). He drew peasant tavern scenes after Brouwer
as well.

*

109. Rowlandson, *A Dutch Serglio* ['*seraglio*'] (etching and stipple, *c.* 1790–1810)

The dependence of English art on immigrants – French as well as Dutch and Flemish – was of long standing. In the first two thirds of the seventeenth century London printsellers sold far more imported prints than English ones.[42] Everyone also knew that the native tradition was impoverished. George Vertue (1684–1756), born near Covent Garden and himself an engraver who had studied under Michael Vandergucht, explained that English engraving was at a low ebb by 1700 because 'warrs & parties Revolutions & Religion had been a hindrance

for artists to come and settle here'. Horace Walpole thought that the arts continued at a low ebb throughout George I's reign (1714–27). Kneller, he wrote, fell into a 'dissolute' kind of painting that neglected 'drawing, probability, and finishing', and Dahl, Dagar, Richardson, Jervas and others lacked the genius to do better.[43] Much later, Macaulay couldn't recall a single English painter or sculptor of note from the later seventeenth century. Lely and Kneller were Germans, the marine painter Van de Velde, the flower painter Varelst and the wood carver Grinling Gibbons were Dutch or Flemish, the sculptor Cibber was Danish. Macaulay lamented further that the baroque muralist Antonio Verrio from Naples earned more from his 'performances' in 'Gorgons and Muses, Nymphs and Satyrs, Virtues and Vices, Gods quaffing nectar, and laurelled Princes riding in triumph' than Dryden had earned in forty years of literary life. 'Even the design for the coin were made by French artists.'[44] The majority of the twenty-three 'painters of Note in London' whom George Vertue listed in 1723 were foreigners. It was thanks to them, he wrote, that engraving in London was at last making a 'tolerable figure'; a quarter-century later he found 'the late and daily encrease of Engraved works . . . in London is much beyond in any degree ever was in London before – or in England'.[45]

Foreigners sneered at English artists. In 1747 the Abbé Le Blanc announced that no country other than England would have taken Kneller seriously, and of Sir James Thornhill the question was 'not in what part the painter excelled, but that in which he is less faulty'. English portraits were dismal: 'some have the head turned to the left, others to the right', all otherwise had 'the same neck, the same arms, the same flesh, the same attitude', the artists knowing 'how to lay colours on the canvas, but . . . not how to animate it'. Luckily, he wrote, the French court portraitist Jean-Baptiste Vanloo had come to Covent Garden in 1737 to revivify English art (a claim the English disputed). English artists were good only at burlesque and satire, he thought, but only because they relished 'low disgusting objects' (unlike the French). Hogarth was a genius in this way, but he was a bad painter. It was astonishing that the nation was so 'infected' by his *Rake's Progress*: 'I have not seen a house of note without these moral prints.' But Hogarth's fame merely showed that the English were 'not

so fine and delicate as ... the people of the Southern countries. They breathe a thicker air, and seldomer see the sun: and that is sufficient to cause a great difference in their organs.'[46] (It took over half a century before English artists could credibly return the insult. When a party of Royal Academicians made it to Paris following the Treaty of Amiens in 1802, they were at one in their disparagement of David's works. According to Farington, Opie was pleased to think that 'the French artists are conscious of their inferiority to the English', and West thought the French could only 'paint statues'.)[47]

Italians weren't rare birds in London's art world. Several became Academicians, and there was a colony of them in Soho; but most left their strongest mark as decorative painters in the great houses.[48] Canaletto was the most influential. During his London decade (1746–56), he lodged with Richard Wiggans, cabinet-maker, in Silver (now Beak) Street, Soho. He was a reclusive fellow, but he knew that the London gentry familiar with his Venetian paintings would buy his English ones. Nurtured in sunshine and thin air though he had been, he wasn't at odds with the northern tradition. With rococo delicacy and an excess of mechanical precision, he endorsed the naturalism and observation of detail and incident that the English admired in the Dutch. 'Canaletto's excellence lyes in painting things which fall immediately under his eye,' an English agent wrote from Italy.[49] This remark ignored his perspectival adaptations, his imaginative caprices, and his ability to indicate tiny figures with a couple of impressionistic slashes of colour. Yet of course his works were also finely observed and informative. One trusts the finicky, short and sharp accents of the penwork with which, for example, he reported both the higgledy-piggledy accretions on old London Bridge before the rebuilding of the central spans in 1758–62, and the sheer busy-ness of the Thames as workplace and passageway (**plate 20**). Men toiling, people conversing, never fail to enliven his paintings and drawings. Canaletto was a Venetian, after all; Carpaccio's and Bellini's paintings from a quarter-millennium earlier invite just the same response. Well might Joshua Reynolds claim in 1759 that the Venetian school stood for 'the Dutch part of Italian genius'.

Canaletto's riverscapes and townscapes influenced artists like Samuel Scott, William Marlow (Scott's pupil) and Paul Sandby. Scott's

studio produced a mediocre version of Canaletto's *Northumberland House* (**plate 2**), it helping that the Duke of Northumberland at some point patronized both Scott and Marlow.[50] Scott and Marlow drew on Canaletto's riverscapes frankly, even down to Scott's replication of a view through the arches of Westminster Bridge during its building, not to mention in their human figures. Paul Sandby tried to replicate Canaletto's panoramic Thames view from the Somerset House terrace.

That said, it was the influx not of sunny Italians but of dank Protestant northerners that did most to revitalize English art. Across the first three-quarters of the eighteenth century, artists and engravers born in France, Germany or the Low Countries made up one in three or so of those in or around Covent Garden. And many of them were 'realists'. Although some would knock out neo-classical works with the best of them, many dismissed the Italianate manner as Catholic, alien and disconnected from life. This was bound to upset London's art-world politics. Reynolds, for instance, wished that Jan Steen had been born in seventeenth-century Italy rather than Holland. Steen might then have become one of the 'great pillars and supporters of our Art', and would have painted what was 'great and elevated in nature' rather than the character and passions of 'vulgar people'.[51]

BATTLE LINES

In his *Third Discourse* to the Academy in 1770, Reynolds named Hogarth at last, and patronized him with faint praise:

> As for the various departments of painting which do not presume to make such high pretensions, they are many. None of them are without their merit, though none enter into competition with this universal presiding idea of the art. The painters who have applied themselves more particularly to low and vulgar characters, and who express with precision the various shades of passion, as they are exhibited by vulgar minds (such as we see in the works of Hogarth), deserve great praise; but as their genius has been employed on low and confined subjects, the praise which we give must be as limited as its object.

Then, invoking alongside Hogarth the names of Teniers, Brouwer and Ostade ('excellent in their kind'), as well as Watteau, Lorrain and Vandervelde, Reynolds averred that 'all these painters have in general the same right, in different degrees, to the name of a painter, which a satirist, an epigrammatist, a sonnetteer, a writer of pastorals or descriptive poetry, has to that of a poet' – that is, not as much right as Reynolds had, in his greater profundity.[52]

Although Hogarth's reputation enjoyed a posthumous revival in the 1780s and 90s, the charge stuck in Academic circles that, while he might be a clever commentator on the vices of streets and taverns, he was also the next best thing to being Dutch. Fuseli dismissed his work as 'the chronicle of scandal and the history-book of the vulgar'.[53] James Northcote deigned to think in 1819 that Hogarth's 'small pictures possess considerable dexterity of execution,' but his large pieces 'appear to be the efforts of imbecility; he was totally without the practice required for such works'.[54] And in 1783 James Barry, himself later to be no mean victim of the Academy's politics, damned Hogarth with the faintest praise by admitting that he deserved 'an honorable place among the artists' because 'his little compositions' were full of humour, character and observations 'on the various incidents of low, faulty, and vicious life'. They were, Barry added, 'very ingeniously brought together' to tell their story – indeed 'with more facility than is often found in many of the elevated and more noble inventions of Raphael and other great men'. The trouble was that Hogarth's figure drawing was 'so raw and unformed, as hardly to deserve the name of artist'. Worse, it was 'dangerous' or 'worthless' for an artist to spend too much time exposing 'meanness, deformity, and vice': time was better spent on 'that species of art which is employed about the amiable and the admirable, as it is more likely to be attended with better and nobler consequences to ourselves'.[55]

We know who had the last laugh. Hogarth endures; few today recall Reynolds's time-servers. Blake, who respected Reynolds as little as Gillray and Rowlandson did, vented his spleen in handwritten marginalia in his copy of Reynolds's *Works* and in his rhymes 'On art and artists' in 1800–1803:

Having spent the vigour of my youth & genius under the oppression of Sir Joshua & his gang of cunning hired knaves without employment &

as much as could possibly be without bread, the reader must expect to read in all my remarks on these books nothing but indignation & resentment. While Sir Joshua was rolling in riches Barry was poor & unemployed except by his own energy, Mortimer was calld a madman & only portrait painting applauded & rewarded by the rich & great. Reynolds & Gainsborough plotted & blurred one against the other & divided all the English world between them. Fuseli indignant almost hid himself – [as] I am hid.

At the opening of the new century, Blake was still complaining that 'the enquiry in England is not whether a man has talents and genius, but whether he is passive and polite and a virtuous ass: and obedient to noblemens opinions in art and science. If he is, he is a good man: if not he must be starved.' 'Such artists as Reynolds are at all times hired by the Satans, for the depression of art,' he fumed, and then delivered this heartfelt and not inaccurate prophecy:

> When Sir Joshua Reynolds died
> All nature was degraded:
> The king drop'd a tear into the queens ear:
> And all his pictures faded.[56]

7

Hogarth and Low Life

The connoisseurs and I are at war, you know, and because I hate them, they think I hate Titian – and let them.

– Hogarth to Hester Piozzi, when she was a little girl[1]

HOGARTH AND 'DUTCHNESS'

Joshua Reynolds's criticisms of the Dutch manner in general and Hogarth's relationship to it in particular ignored just how far Hogarth tried to distance himself from the Low Countries tradition. Not only did he parody it to affirm the 'Englishness' of his own works, but French artists influenced him far more directly than Dutch artists did.[2] He had attended the life-classes run by the Huguenot refugee Louis Chéron in 1720–24; for a time he shared a studio with Louis Roubiliac (who sculpted a great terracotta bust of him); his favourite haunt in Old Slaughter's was clamorous with French accents; he was well informed about French art theory and paid his respects to Chardin and De La Tour when he visited France in 1743 and 1748; and he employed French engravers to engrave *Marriage A-la-Mode* in 1745.[3]

Nor did his narrative skills owe anything to the Dutch. 'My Picture was my Stage,' he wrote in the fractured English of his last notes, 'and men and women my actors who were by Mean of certain Actions and express[ions] to Exhibit a dumb shew.' Again, no principle could be more 'English' – or more locally generated – than this one, for his first major success was his scene from *The Beggar's Opera*, the first-ever painting of a stage performance, which he produced in several versions

between 1728 and 1731 (fig. 57 above). Although it was first staged in the Lincoln's Inn Fields theatre, Gay's 'opera' was of Covent Garden's essence. Replacing formal arias by popular ballads and airs and classical gods and goddesses by low-life characters from town life, it was tailor-made for a man of Hogarth's tastes and education. Both its ecstatic public reception and its effect on Hogarth are unsurprising. The growing hunger for representations of real life that was evidenced here wasn't lost on the artist as he transferred the *Opera*'s theatricality to his own narrative dramas. Thus even the composition of his famous set-piece at Tyburn for his series *Industry and Idleness* (1747) was conceived theatrically, as for presentation on a stage (fig. 110). Similarly, within a year of the completion of *A Harlot's Progress*, the Theatre Royal in Drury Lane was advertising 'a grotesque pantomime entertainment' in verse to provide 'a key to the Six Prints lately Publish'd by Mr Hogarth'; it ran well into the following year.[4] A couple of years later, *A Rake's Progress* began its own longer theatrical and eventually operatic history that extends into modern times. Even the debauchery of his *Midnight Modern Conversation* was dramatized at Covent Garden in 1742.[5]

110. Hogarth, *The Idle 'Prentice Executed at Tyburn* (pencil, ink, wash, 1747)

The 'novels' which were becoming a dominant literary form in Hogarth's lifetime also influenced his narratives' episodic structures. 'Other pictures we look at – his prints we read,' Charles Lamb was to say of his work. Hazlitt was to compare Hogarth with Fielding and Smollett as well as with Vanbrugh and Molière. In the past, texts had laid constraints on artistic work, but Hogarth established an equality of image and word that provides a good measure of the developing energy of visual culture.

His affinities with the Henry Fielding of *Tom Jones* and *Joseph Andrews* were close. Their friendship began when Hogarth supplied Fielding with a frontispiece, and it deepened through their mutual sense that they were both artists of the comic – by which they meant 'real life'. Hogarth parodied affectations in painting as keenly as Fielding did in writing. And 'Englishness' mattered as much for Fielding as it did for Hogarth, whence in *Joseph Andrews* his mockery of the gentleman who returned from the Grand Tour 'furnished with French clothes, phrases, and servants, with a hearty contempt for his own country; especially what had any savour of the plain spirit and honesty of our ancestors'.

Above all, when each congratulated the other on his fidelity to 'nature', it was to the moralities of 'real life' that each referred. In his preface to *Joseph Andrews*, Fielding complimented 'the Ingenious Hogarth' on engravings that did more to serve the cause of virtue 'than all the Folios of Morality which have ever been written'. Hogarth was, Fielding insisted, a 'Comic History Painter' rather than a practitioner of low burlesque or 'Caricatura': it was truth to 'character' that mattered in Hogarth. In *Tom Jones* (1749) he several times cited Hogarth's characters to illuminate his own – Bridget Allworthy, Mrs Partridge and Thwackum: Allworthy, he wrote, was like the elderly lady crossing the Covent Garden Piazza in Hogarth's *Morning*. 'O, Shakespeare! had I thy pen! O, Hogarth! had I thy pencil!' he exclaimed. In 1751 the two colluded in condemning drunkenness – the one in *Gin Lane*, the other in his *Enquiry into the Late Increase of Robbers*. And Hogarth depicted himself face-to-face with Fielding in *Characters and Caricaturas* (1743), his subscription ticket for *Marriage A-la-Mode* (fig. 111). Their laughing profiles (Fielding's long nose, Hogarth's snub one) confront each other in the main panel, second from the bottom in the middle.

111. Hogarth, *Characters and Caricaturas* (etching, 1743)

The ticket stated Hogarth's conviction that character was more impor-
tant that mere 'caricaturas', and it cited Fielding's preface to *Joseph
Andrews* to prove it.[6]

In view of all this, what validity could there be in Reynolds's charge
that Hogarth polluted his canvases with *Dutch* deformities? What
evolved in his work was utterly English; yet there were affinities, of
course, and the most obvious was that both Hogarth and the Dutch

attended to low life and its material environments. Another was that his background emblems would have been familiar to those earlier artists (cracked jugs symbolizing unchastity, female cats with raised backsides symbolizing lust, etc.). Yet another is that he structured many pictures around popular icons, proverbs and chapbook moralities. And his conviction that his narratives should rub home the wages of sin was learned both from his Calvinist parents and from the Dutch artists who shared it.

Most of his contemporaries were taken in by his moralism. David Garrick was, when he composed the epigraph for Hogarth's Chiswick tomb: 'Farewell great Painter of Mankind / Who reach'd the noblest point of Art / Whose pictur'd Morals charm the Mind / And through the Eye correct the Heart.' Yet in Hogarth and in Low Countries genre painters alike a habit of cheerful vulgarity would insist on cutting through the sobriety of their lessons. Both Jan Steen and Hogarth would warn against luxury and debauchery even as their works celebrated luxury's and debauchery's pleasures. The business of correcting the heart by chastising vice provided both with alibis for the most eloquent improprieties.

We can say oddly little about Hogarth's sexual life. His closest relationships were with men, some perhaps homosexual;[7] but his tastes weren't libertine and his personal life seems to have been unusually chaste for that era. His marriage to Jane Thornhill was affectionate and lasted thirty-five years, even if it was childless. He had no known mistresses. On the other hand, he knew a great deal about the interiors of Covent Garden's brothels, bagnios and drinking dens, and he had no problem whatever with bawdry. His low-mindedness was that of the common people. It was hatched in an earthy carnivalesque humour with ancient and popular roots. His farts-and-bums exuberance, his scatology and his turning of worlds upside-down drew on a language that went back to medieval times and that endured in English satire until the decorum of the 1830s and onwards tabooed it. Moreover, his was a robust age. Few moral missionaries had as yet started troubling Londoners, and those that had were mocked. In the 1730s the Society for the Reformation of Manners folded for lack of support. As a result, Hogarth might very well chastise vice and indulgence, and he had no pity for criminals;

W. Hogarth Inv.ᵗ

Sam. Ireland fe.

FRONTIS-PISS.

112. Samuel Ireland, after Hogarth, *Frontis-Piss* (etching, 1763)

but his pictures rarely invited his viewers into full-blown disgust at their subjects. Only his indictment of man's cruelty to man and animals really did that, in his prints on *The Four Stages of Cruelty* (1751).

Take the deft scatology, for instance, of a squib like *Frontis-Piss* (1763) (fig. 112). In this design Hogarth lampooned the Hutchesonian sect that castigated Isaac Newton for reducing God to mere matter and that argued that 'glory' was a force stronger than gravity. Hogarth allows gravity to retaliate by projecting the witch's urine downwards upon the rats that crawl over a telescope and gnaw at a volume labelled 'Newton'. In younger days, likewise, he showed a clyster (syringe or enema) stuck up Gulliver's bottom in his satire on prime minister Walpole's corruption, *The Punishment Inflicted on Lemuel Gulliver by applying a Lilypucian fire Engine to his Posteriors for his Urinal Profanation of the Royal Pallace at Mildendo* (1726) (fig. 113). Gulliver represents the abused English people whose humiliation is presided over by the arrogant homunculus Walpole in the bucket-chair bottom right.

113. Hogarth, *The Punishment Inflicted on Lemuel Gulliver by applying a Lilypucian fire Engine to his Posteriors for his Urinal Profanation of the Royal Pallace at Mildendo* (etching, engraving, 1726)

114. Hogarth, *Masquerade Ticket* (etching, engraving, 1727)

The state of the nation is so debased that a priest looks on ineffectually from his teapot-lectern while giant rats eat babies and women worship Priapus in the background.

A year later, his mock *Masquerade Ticket* satirized the mania for masquerades with similar earthiness (fig. 114). Ostensibly the print exposed the moral danger of people's masked anonymity at the supercharged events which the Swiss entrepreneur Johann Heidegger was staging in the Haymarket Theatre, but he was offended as much by Heidegger's Swissness as by his masquerades. Again there is too much comic hyperbole in the print's emblems for us to think otherwise: the altar to Priapus adorned with cuckold's horns on the left, on the right the nude interlocked Venus and Cupid heated by the fireplace beneath, the notices that advertise 'Supper Below', and the lion and the unicorn above, lying wantonly on their backs to play with their – tails. The scene is flanked by 'Lecherometers shewing the Companys Inclinations as they approach em'. One lecherometer is inscribed 'Expectation',

'Hope', 'Hot desire', 'Extreem Hot', 'Moist', 'Sudden Cold'; the other is inscribed 'Dry', 'Changeable', 'Hot', 'Moist' and 'Fixt'.

As one might anticipate, Hogarth released his exuberance best in his privately commissioned 'cabinet' paintings which were not for public display. His first pairing of a *Before* and an *After* (1731) (**plates 21 and 22**) was commisioned for the private delight of one John Thompson MP. In wonderful parody of one of Watteau's *fêtes galantes*, *Before* depicts the girl's demure resistance to the boy's efforts at a woodland seduction, and *After* shows the couple post-coitally, their parts all but uncovered, dumbfounded by their own audacity. (As paired paintings, incidentally, these marked Hogarth's first gesture towards graphic narrative: he began *A Harlot's Progress* in the same year.) He was said to have regretted painting another and later *Before* and *After* pairing commissioned by the libertine Duke of Montagu. But it was a late eighteenth-century biographer who assumed that he regretted it: there's no proof of regret otherwise.[8] Hogarth became

115. Hogarth, *Francis Matthew Schutz in his Bed* (oil, 1755–60)

more sedate as he aged, but in the late 1750s he could still paint a cabinet picture of Francis Schutz, the Prince of Wales's cousin, sitting up in bed to vomit into a chamber-pot. A dimmed inscription along the upper edge cites the Latin poet Horace to celebrate the memory of his fading erectile powers, '*Vixi puellis nuper idoneus &c*' ('Till recently I lived fit for Love's battles and served not without renown'). It was said to have been commissioned by Schutz's wife to shame her husband into more sober conduct (fig. 115).

<p style="text-align:center">*</p>

Hogarth's kinship with Netherlandish artists was most obvious in his attention to the incident and material detail of the immediate environment – which usually meant Covent Garden and neighbourhood. His taste for the real became apparent while he was training in figure-drawing in Chéron's academy. He had seen then that 'there were many disadvantages attended going on so well continually copying Prints and Pictures . . . nay in even drawing after the life itself at academys . . . it is possible to know no more of the original when the drawing is finish'd than before it was begun'.[9] He began to train his visual memory instead. As his last notes continued:

> He never accustomd himself to coppy but took the short way of getting objects by heart so that wereever he was [he] cau[gh]t some thing and thus united his studies with his pleasure by this means he was apt [to] catch momentary actions and expressions Whoever can conceive part [of] a Human [figure] with all its circumstances variation[s] [,] when absent [,] as distinct as he doth the 24 letters with their combination[s] is perhaps a greater painter sculptor than ever yet existed.[10]

Stories about his eye for incident and character were many. There's his alleged sketch of the girl spitting gin into another girl's face in Tom and Moll King's coffee-shed (fig. 44), and another tale about his witnessing a tavern quarrel in which a man struck another on the head with a tankard: 'the blood running down the man's face, together with the agony of the wound, which had distorted his features into a most hideous grin, presented Hogarth . . . with too laughable a subject to be overlooked. He drew out his pencil, and produced on the spot one of the most ludi-

crous figures that ever was seen.' In the Bedford coffee-house he was remembered for pencilling people's likenesses on his thumbnail. And one day in 1753 he stopped his coach and leapt out because he glimpsed 'a large drawing (with a coal) on the wall of an alehouse . . .; it was a St George and the Dragon, all in strait lines'. He 'made a sketch of it with triumph'. He studied walls for their graffiti and signboards for their devices – 'with delight', he wrote, drawing them as a 'pleasing labour of the mind to unfold mystery Allegory and Riddles'. In his prints he filled many of his walls with remembered graffiti.[11]

What ensued from watchfulness of this kind was the closely observed spatial grounding of his works. The first plate of *A Harlot's Progress* is set in a Drury Lane inn yard; the orgy in *A Rake's Progress* is set in the Rose tavern, Drury Lane; *The Four Times of Day* (1738)

116. Hogarth, *Marriage A-la-Mode, V. The Bagnio* (etching, engraving, 1743–5)

are set in Covent Garden market, Hog Lane in St Giles's, Charing Cross and Sadler's Wells. And in the fifth tableau of *Marriage A-la-Mode* (1743–5), Silvertongue murders the Earl in the Turk's Head bagnio in Bow Street after the Earl has caught him in bed with his wife (fig. 116). The wicked couple have already made a night of it, for the Countess wears a shift, her feet are bare, and her clothes litter the floor. As her husband the Earl entered, her lover has leapt from bed in his nightshirt and pierced the Earl with his sword, and now escapes through the window (he is later caught and hanged for murder). As the night-watch arrives, the Countess kneels to beg forgiveness as the Earl totters theatrically to his death.

How real was this place? A paper on the floor is inscribed '*Bagnio*' and bears the drawing of a Turk's Head. The *Daily Advertiser* advertised at least three Turk's Head bagnios in London in the early 1740s, but this one was almost certainly the most local of them, in Bow Street. It had seen a well-reported prostitute-theft a year or two before. The girl was acquitted, but the victim's evidence conveys the kinds of transaction which made it an apt setting for a crime of passion:

> I was coming home the 29th, or 30th of June last, a little late, and a little in Liquor, – 'twas between 2 and 3 in the Morning, – and as I was going towards my own home, – towards Covent-Garden, a Woman took me up, and carried me . . . to Jones's Bagnio, at the Sign of the Turk's-Head, in Bow-street, Covent-Garden: and there I believe I was put upon the Bed, and being in Liquor, I fell a-sleep [other witnesses proved that he was more active than this]; . . . and being awake, – I called up some of the People of the House, to tell me where I was. The Keeper of the Bagnio came up, and told me I was at the Turk's-Head Bagnio, in Bow-Street. I informed him I was robbed of my Gold Watch, a silver Snuff-box, and silver Tooth-pick Case.[12]

Nabokov wrote in *Lolita* that 'reality' is 'one of the few words which mean nothing without quotes'. But later critics had no doubt what they meant by the word in relation to Hogarth, and they didn't mean mindless reportage either. Hogarth was never just 'a serious, prosaic, literal narrator of facts', Hazlitt insisted in 1819. Concerned as he was with the 'manners and humours of mankind in action', he painted 'nothing but comedy or tragi-comedy' – whereas a simple

realist (he had David Wilkie in mind) 'paints neither one nor the other'. Charles Lamb in 1811 wrote that Hogarth was akin to Shakespeare in that he conveyed 'the drama of *real life*, where no such thing as pure tragedy is to be found'. Both Hogarth and Shakespeare intermingled 'merriment and infelicity, ponderous crime and feather-light vanity'; both confront us with the 'everyday human face', and refuse to affect 'that disgust at common life ... which an unrestricted passion for ideal forms and beauties is in danger of producing'. Hogarth was adept at conveying 'the ridiculous and prominent features' of both high and low life. He 'was a painter, not of low but of *real life*'.[13]

It was this drawing from 'real', local and topical life that is Hogarth's distinction. The high-minded were easily misled by this into contempt, for, as Leigh Hunt later put it, Hogarth's 'intentions were less profound than his impulses; that is to say, he sometimes had an avowed commonplace in view'. What his enemies didn't see was that his *execution* of the commonplace was 'full of much higher things and profounder humanities'.[14] The animating force behind the execution was simple, however: never other than that curiosity about common actuality that more fashionable artists were taught to suppress in themselves.

HOGARTH AS COMMON MAN

A huge distance yawned between Hogarth's street-wise art and Reynolds's faith in the grand style. It was partly determined by differences in age and by shifts in the market, but chiefly by differences in class, opportunity and manners. 'Never were two great painters of the same age and country so unlike each other; and their unlikeness as artists was the result of their unlikeness as men.'[15]

Hogarth was born in 1697 in Bartholomew Close off Smithfield market, where London's livestock were sold; it was under a mile-and-a-half from the Covent Garden Piazza. Reynolds, conversely, was born a quarter-century later in the affluent stannary town and rotten borough of Plympton in Devon. Both fathers were schoolmasters, but while Hogarth's became a bankrupt whom Horace Walpole could dismiss as a 'low tradesman', Reynolds's was related to rectors, prebendaries and a famous mathematician; he had been a scholar of Corpus Christi,

Oxford, and a fellow at Balliol, and was headmaster of Plympton Grammar School. Joshua was drilled in classics, mathematics, geography, arithmetic and drawing. Hogarth, though apparently well read, could hardly pen a sentence; friends polished his public writing. And while young Reynolds could afford to spend three years (1749–52) looking at pictures in Italy and France before moving to Covent Garden with the intention of modelling himself on Rembrandt, young Hogarth travelled not at all. He came to consciousness in London's courts and alleys, and his mind remained bounded by a square mile or so of London. While Reynolds learned some of his craft from Hudson the portraitist, Hogarth was apprenticed as a lowly silver engraver. While Reynolds became fashionable among the polite and the high-minded, Hogarth was too rough-hewn ever to do so.

The Bartholomew Close in which Hogarth was born predated and escaped the Great Fire of 1666; his house was probably built of timber-and-lath. According to his baptismal entry in the Great St Bartholomew's church register, it was 'next doore to Mr Downinges the printers'.

117. John Wykeham Archer, *Bartholomew Close, Smithfield* (pencil, watercolour, 1850)

118. A. and J. Bool, *St Bartholomew the Great and Cloth Fair* (photograph, 1877)

Other neighbours included a joiner, a tobacconist, a physician, a chandler, a baker, an upholsterer, a tailor, a plasterer, a draper, a victualler and a stonecutter, most of them solidly Nonconformist.[16] A hundred and fifty years later John Wykeham Archer pictured Bartholomew Close in watercolour (fig. 117), and its environs were photographed *c.* 1877 (fig. 118 and fig. 119).[17] Despite anachronism, the pictures say much about the intimate and antique warrens in which Hogarth was raised.

His father, Richard, son of a Westmoreland farmer, was a penurious schoolteacher who took lodgings in the Close with a grocer. He married his landlord's daughter and opened a little school in which he

119. A. and J. Bool, *Cloth Fair* (photograph, 1877)

taught their children and a few others. He soon found that his son's talents were unbookish. As already noted, William later admitted that a neighbouring painter 'drew my attention from play' so that 'evry oppertunity was employd in attempt at drawing'. He was better at drawing than at spelling or grammar:

> I had naturally a good eye shews of all sort gave me uncommon pleas-
> ure when an Infant and mimickry common to all children was
> remarkable in me . . . when at school my exercises were more remark-
> able for the ornaments which adorn'd them than for the Exercise itself
> I found Blockheads with better memories beat me in the former but I
> was particularly distinguishd for the latter.[18]

The family moved to other lodgings locally, then in 1704 to rooms a third of a mile north, above the battered medieval St John's Gate, Clerkenwell. Here Richard Hogarth opened a coffee-house. He advertised it as a venue in which Latin was spoken: it failed unsurprisingly. Bankrupt, Richard was confined to the 'Rules' of the Fleet debtors' prison (specified streets and alleys immediately outside the prison in which debtors with residual money could pay the Keeper to let them live). So again the family moved, this time several hundred yards south of their original Bartholomew Close lodgings to Black and White Court, virtually under the walls of the Fleet and off the Old Bailey.

This was yet another ancient neighbourhood on the very edge of the City, and it was riddled with courtyards which retained their medieval patterns despite partial rebuilding after the Fire. Strype in 1720 found Black and White Court 'a good large and open Place, with handsome Buildings', but neighbourhood houses were humble and crumbling.[19] Here Mrs Hogarth scratched a living for them all by selling gripe remedies for babies while her husband tried in vain to publish his Latin dictionary. In 1709 two of William's younger brothers died. The Hogarths' struggles were little different from those of countless other middling people down on their luck, but the stigma of his father's confinement must have hurt William. He never once mentioned it in later years, but imprisonment haunts his later work (as it later did Dickens's for the same reason). The Rake was confined to the Fleet before he ended in Bedlam.

What Hogarth did later mention was that his 'Fathers Pen' was so unprofitable that he, William, had to 'shift for himself' by working between the ages of fifteen and twenty-three as an apprentice in Ellis Gamble's silver workshop in Cranbourne Street off Leicester Fields. He later complained that here his skills were weakened by 'bad habits'. Still, 'engraving on copper was at twenty was [sic] his utmost ambition', so at last in 1720 he set himself up on his own account as an engraver of prints and of metal. He enrolled in the life-classes in the small academy off St Martin's Lane run by John Vanderbank and Louis Chéron, and when it closed in 1724 he studied in James Thornhill's similar academy in the Piazza. In this way, his career took wing.

*

Hogarth's adult addresses show how little he moved out of the Covent Garden and Smithfield of his boyhood: 1714–20, Cranbourne Alley, Leicester Fields; 1720, his mother's house in Long Lane, Smithfield; 1724, Cranbourne Alley again, and Little Newport Street; 1730, the Little Piazza, followed by residence in his father-in-law's house in the Piazza (he married Jane Thornhill in 1729); and from 1733 until he died in 1764, 30 Leicester Fields. This is where he focused his works. He tinkered with topographies, and sometimes ventured westwards or eastwards in London. He did enjoy the Chiswick retreat he bought in 1749, and presumably he painted his one-off altarpiece in Bristol; but, give or take the odd foray into Essex, he hardly visited the rest of the country. He depicted the Thames only once and incidentally (in *Industry and Idleness*). Otherwise, barely a dozen of his works are located outside the Covent Garden or Smithfield neighbourhoods.*

His pleasures were local too. In his younger years he would take Sunday walks to Highgate or into the country up Tottenham Court Road; and in 1732, just before he married, he went on a five-day 'peregrination' down the Thames to Sheerness. The friends accompanying him on this were as local and as socially middling as he was: Sam Scott (the Covent Garden topographical artist), John Thornhill (Hogarth's brother-in-law, who had just followed his father as the king's 'sergeant-painter' – as Hogarth was to follow him when he died), William Tothall (brought up a fishmonger in Dover, he ran away to sea, and was eventually a Covent Garden brandy merchant and draper) and Ebenezer Forrest (a lawyer or merchant). Scott was a major painter, but the others are chiefly distinguished for their joining Hogarth as founder members of the Sublime Society of Beefsteaks in 1735. In their peregrination the party spent its time sightseeing, flirting, drinking, eating, singing and throwing cow-dung at each other – 'a

* *The Cock-pit* is set in the Royal Cockpit, Birdcage Walk, St James's. *The Rake* has his bad times in St James's Street and Bedlam. *Industry and Idleness* is set in the City, in Blood Bowl Alley off Fleet Street, and at Tyburn. *The March to Finchley* was located at the Tottenham Court Road turnpike. One of his *Four Times of Day* was at Sadler's Wells. *Country Inn Yard* (1747) is set either on the Dover road or at Chelmsford in Essex. Plate 2 of *Four Stages of Cruelty* is set at the entrance of Thavies Inn Gate and Coffee-house in Chancery Lane, Holborn; and in plate 4 of the same series Tom Nero's body is dissected at Surgeons' Hall, Old Bailey. *Four Views of an Election* (1755–8) purport to depict the Oxfordshire election of 1754.

jolly party of tradesmen engaged at high jinks', as Thackeray described them.[20] Having embarked at Billingsgate wharf, they travelled to Gravesend by boat and then by foot to Rochester and Chatham. Returning to Billingsgate, they quitted their boat for a wherry which took them on to Somerset [House] Water Gate, whence 'we walked altogether and arrived at the Bedford Arms Covent Garden, in the same good humour [as] we left it to set out on this pleasant expedition'. Scott's sketches of the adventure are jolly. One shows Hogarth crawling in terror on his stomach along a very short gangplank to get to their small boat. Probably he couldn't swim (fig. 120).

Hogarth's wider travels gave him less pleasure. Naked chauvinism got in his way. He might admire French art, but his French visits confirmed his view that the country itself stood for 'a farcical pomp of war, parade of riligion and Bustle with little with very little bussiness

120. Samuel Scott, *Embarking from the Isle of Grain*, from Ebenezer Forrest's manuscript *Hogarth's Peregrination* (ink, watercolour, 1732)

in short poverty slavery and Insolence (with an affectation of polite-ness)'.[21] On foreign ground he was as loutish as any football hooligan: 'What then? But it is French! Their houses are all gilt and beshit.'[22] His painting of *Calais Gate, or O! The Roast Beef of Old England* (1748) was saturated in insults, including the taunt that, unlike the English, the French couldn't afford beef. It served him right that while he was drawing the Gate he was briefly arrested as a spy.

He did enjoy the support and even affection of influential men. As his feud with John Wilkes heated up in 1762, David Garrick entreated Wilkes not to 'tilt at' Hogarth: 'He is a great & original Genius, I love him as a Man, & reverence him as an Artist – I would not for all ye politicians in ye Universe, that You two should have the least Cause of Ill will to Each other.'[23] All the same, Hogarth never overcame the rough manners of his origins, nor his tetchiness and petulance, nor his egalitarian instincts. They all cost him dear. He never flattered the great: to the contrary, he showed that the moral distance between harlot, rake and the couple who married *à-la-mode* was narrow. His early biographer, Nichols, declared of his manners that his 'powers of delighting were restrained to his pencil': for 'having rarely been admitted into polite circles, none of his sharp corners had been rubbed off, so that he continued to the last a gross uncultivated man'. Horace Walpole once invited Hogarth and Thomas Gray the poet to dinner, only to find that 'what with the reserve of the one and a want of colloquial talents in the other he [Walpole] never passed a duller time . . . being obliged to rely entirely on his own efforts to support conversation'.[24] When Hogarth's *Marriage* paintings fetched a mere £22 apiece in 1751, George Vertue described how this failure

> so mortified [Hogarth's] high spirits & ambition that threw him into a
> rage cursd and damnd the publick. and swore that they had all combind
> together to oppose him . . . by this his haughty carriage or contempt of
> other artists may now be his mortification . . . – and on that day follow-
> ing in a pet he took down the golden head that staid over his door.

Vertue knew Hogarth as 'a man whose high conceit of himself & of all his operations' matched Kneller's and Van Dyck's. Though he was 'a true genius in the art of painting', he had 'little and low-shrubb instructions' [*sic*]. The chips on his shoulder were many:

by his undaunted spirit, [he] despisd, under-valued all others present, &
and precedent painters. such as Kneller, Lilly, Van-dyke . . . such reason-
ings or envious detractions he not only . . . made the subject of his
conversations and observations to Gentlemen and lovers of Art but such
like invidious reflections he would argue & maintain with all sorts of
artists painters sculptors &c.[25]

Yet Hogarth's 'little and low-shrubb instructions' were mainsprings
behind his originality. If his world was narrow, it was on that account
more intensely experienced and more intimately known.

CRIME AND PUNISHMENT

The best measure of this was Hogarth's fascination with local, low and
particularly criminal life. In his younger days, what Leigh Hunt later

121. Hogarth, *Cunicularii or The Wise men of Godliman in Consultation*
(etching, 1726)

called the 'avowed commonplaces' that propelled his narratives were usually hatched from topical and comically shocking *stories*.[26] An example is his pleasure in mocking the gullible doctors who took seriously the country-woman, Mary Toft of Godalming, when in 1726 she discovered in herself a tendency to give birth to rabbits (fig. 121). Pamphlets were written in wonder at this miracle, and eminent doctors debated it, until at last she was brought to the Leicester Fields bagnio for investigation and exposure. Hogarth's *Cunicularii* showed her in labour, with the 'Occult Philosopher searching into the Depth of things', and lots of smuggled rabbitkins scuttling across the floor. The gullible doctors were named and shamed.

But it was crime that moved him most, so much so that only a sense of its ubiquity in London, of the high visibility of its punishment, and of its deep permeation into metropolitan mentalities, can give a full understanding of why and how Hogarth's work was grounded in its reality.

Dickens was to note later that a strange fascination with crime and punishment has always stirred 'tens of thousands of decent, virtuous, well-conducted people, who are quite unable to resist the published portraits, letters, anecdotes, smilings, snuff-takings, &c &c &c of the bloodiest and most unnatural scoundrel with the gallows before him'; it is in our 'secret nature to have a dark and dreadful interest' in such things.[27] This fascination was in Hogarth's nature too – along with something of the boy Dickens's 'profound attraction of repulsion' whenever he thought of the rookeries of Seven Dials and St Giles's ('What wild visions of prodigies of wickedness, want, and beggary arose in my mind out of that place!').[28] To these impulses to engage with the forbidden and the dangerous Hogarth added the callousness of his time and upbringing, a manichean satisfaction at the punishment of wrongdoers, and not the least pity for their miserable ends. Well might Hazlitt observe that nobody 'had a less pastoral imagination than Hogarth ... His pictures breathe a certain close, greasy, tavern air.'[29]

It doubtless helped in this that the boy had first lived just off London's most ancient hanging- and burning-ground. The last Smithfield burning, of Alice Millikin for clipping coins, had happened in living memory, in 1686.[30] Then he had lived within the Fleet's 'Rules' a

couple of hundred yards from the Old Bailey and Newgate prison. He would often have witnessed the procession of felons being carted to Tyburn. Beyond that, the stories he set in low venues were informed by local knowledge. He either knew the venues – like the infamous Black Boy Alley in Smithfield – or had read about them. The sources of information were several. There were the 'Newgate Calendars', a form of compendium initiated in 1714 by Alexander Smith's *Complete History of the Lives and Robberies of the most Notorious Highway-Men, Foot-pads, Shoplifts, and Cheats*. Then, after every batch of Tyburn hangings, there were the *Accounts* of crimes and executions published by the clerical Ordinary of Newgate prison. And then there was the richest source of all, the Old Bailey *Proceedings*, which by the 1720s were reporting the more important trials verbatim and which became more elaborate in content and frequent in publication as time passed. In 1725 a French observer thought that 'Tho' these Criminal Proceedings are very moving, yet we see them often attended with such gay and airy Circumstances, (no way agreeable to so melancholy a Subject) that the printed Accounts of them are in the Opinion of many People one of the most diverting Things a Man can read in London.'[31]

As a random example of this last, for sixpence you could buy the account of seventy-eight trials that were heard at the Old Bailey in January 1731. Most of the crimes were commonplace and the reports were brief. Yet even a trial for a crime of total insignificance for all except the victim would be reported in vivid, simple and direct English prose whose narrative pace finely affirmed London's disordered excitements and 'gay and airy circumstances':

> Margaret Lamb, alias Niggy, of St Martins in the Fields, was indicted, for that she, together with Carroty Peg, was indicted for assaulting Noel Lubert, putting him in Fear, and taking from him a Silver Watch, in the Dwelling-House of Sarah Dunbar, the 13th of December last.

> The Prosecutor being a Walloon, told his Story in scarce intelligible English, to the Purpose following:

> That he going along Windsor-Court, near, or in Drury-Lane, stopp'd to make Water, and Carroty Peg took hold of his Coat, and ask'd him, to go with her to drink; that he said, she had nothing to do with him; but she reply'd, that he should go with her; that he told her, he had but Six-

Pence, and he had rather spend it, than have his Coat tore; that she held him by the Coat, and carried him to a House in Windsor-Court, and he not being willing to go in, she forc'd him in, and call'd for a Candle, and a Candle was brought by a little dirty Creature; that she holding him by the Coat, led him up Stairs, he following her, not to have his Coat torn, that she opened the Door, threw him upon the Bed, fell upon him, laid her Left-Hand upon his Breast, that then the Prisoner came up, and he said, you need not be so merry for a six-penny Piece; that the Prisoner pull'd out his Watch, and tore his Fob, and he caught hold of it, and lay upon his Arms, and Carroty Peg got hold of the Watch, and Carroty Peg got it from him, they putting their Hands on his Mouth, that he could not hold it long, and Carroty Peg gave it the Prisoner, and she ran down directly, and Carroty Peg ran down, and ran away, and he ran down after them, and follow'd them where they went in, but they shut the Door against him, and he call'd the Watchmen, and this Gentlewoman (the Prisoner) jump'd out at a Window one Pair of Stairs, and a [sedan] Chairman said, he caught her in his Arms, and so she got away.

The Prisoner in her Defence deny'd the Fact, and pleaded, That the Prosecutor had drank with her since that time, and never charg'd her with the Watch, which he own'd, but said, it was for fear, because he had heard a Man had had his Eyes pick'd out in that House; after a full hearing of the Matter, the Jury acquitted her.[32]

Rocque's 1746 map gives the best sense of the Windsor Court in which the prosecutor so unwisely passed his water: the location of his mistake is in the centre of fig. 122.

The names in these trials were marvellous. 'Niggy' and 'Carroty Peg' share kinship with the names John Gay gave the characters in his *Beggar's Opera*: Polly Peachum, Lucy Lockit, Sukey Tawdry, Filch, Wat Dreary, Ben Budge. But truth beat fiction in the randomly chosen Old Bailey *Proceedings* of 1732–3. The names and alibis there wouldn't be out of place among Shakespeare's plebeians, but they surely predate Shakespeare: Sarah Laverstitch, Clarety-face Hannah, Jeremiah Scruby, Zachariah Mines, Thomas Bonnamy, Mr Tabbery, Benedict Duddle, Richard Punt, Sarah Trantum, Brogden Poplet, Matthew Monger, Martha Negus, Charles Bosantine, Susan Marriage,

122. John Rocque, map detail, Drury Lane and Windsor Court (1746)

Michael Roop, Robert Bugbeard. Dip at random into another volume of the *Proceedings* and you'll meet people such as Ann Barefoot and Ann Duck. As members of the Black Boy Alley gang – the kinds of people who 'robbed together, lay together, were taken together, and at last were hanged together', as Defoe's Moll Flanders defined a common fate – they were executed at Tyburn in 1744 alongside their colleagues Gentleman Harry, Captain Poney, Long Will, Nobby, Scampy, Dillsey, Jack the Sailor, Ninn and Country Dick. 'Barefoot' was a nickname or surname that was common enough in eighteenth-century trials to say much about these people's poverty. Across the whole century, forty-six Old Bailey trials involved someone named 'Barefoot'. A Jonathan Cockup was the victim of a man hanged in 1730, and a Toss-off Dick met his end in 1745. The just as wonderfully named Francis Hackabout was a thief, hanged in 1730. A year later Hogarth appropriated his sister Kate Hackabout's name for his Harlot, knowing, as everyone did, that 'hack' or 'hackney' ('hackney carriage') was slang for whore.[33]

If the literature of crime was one of Hogarth's inspirations, the visibility of punishment was another. No Londoner could evade it. A dozen years after Christopher Wren's Temple Bar was built in 1669–72 to mark the boundary between the City of Westminster and the Liberties of the City (the Strand on the Westminster side of it, Fleet Street on the other), the gate was turned into what a lawyer termed the City's Golgotha, the age-old use of London Bridge for that purpose having lapsed. Eight severed heads and rather more quartered limbs and torsos were stuck on iron spikes on Temple Bar between 1683 and 1745, and some remained visible for much longer. First up went a quartered chunk of the body of one of the Rye House plotters in 1683 (they had planned to assassinate Charles II and his brother); his head was sent independently to be stuck up at Westminster Hall. His bits were followed in 1695 by the heads, limbs and headless trunks of two more rebels; then in 1723 by the head of one of the Pretender's supporters; and then by another Jacobite head, Christopher Layer's. This one stayed there like a weathered black football of shrivelled skin, hair and bone until it blew down one windy night in 1753; a passing attorney picked it up to keep as a relic. The sixth and seventh heads belonged to Townley and Fletcher, two of the nine Jacobites who were hanged, disembowelled, beheaded and quartered on Kennington Common in 1745. Desiccated and ghastly, they were blown down thirty years later. Deepening civility then put a stop to displays of this kind, though hanged traitors' heads were publicly chopped off right up to the Cato Street conspirators' execution in 1820. People would flock to see a newly impaled head; and its display entered the collective memory too. Among the last to recall it was the aged poet Samuel Rogers, born in 1763 and dying in 1856: he remembered one of the heads on a pole as 'a black shapeless lump. Another pole was bare, the head having dropt from it.' An old lady in Queen Victoria's time recalled that on the Bar she had seen 'two human heads – real heads – traitors' heads – spiked on iron poles. There were two; I saw one fall. Women shrieked as it fell; men, as I have heard, shrieked: one woman near me fainted. Yes . . . I recollect seeing human heads upon Temple Bar.'[34]

Hogarth illustrated the display incidentally in the background of his *Burning ye Rumps at Temple-Barr* (1726), one of his illustrations

123. Hogarth, *Burning ye Rumps at Temple-Barr* (etching, engraving, 1726)

for Samuel Butler's *Hudibras* (fig. 123).* Admittedly, it was the crowd he was interested in here. This was one of his several representations of carnival-riot, and it shows an imaginative intimacy with 'That Beastly Rabble that came down / From all the Garrets in the Town' – with their mocking rituals, effigies and emblems (here the barbecued beef rumps that expressed popular revulsion at the Rump Parliament after Cromwell's death). The heads on Temple Bar are a locational anchor, however – as they were in virtually every representation of Temple Bar throughout the eighteenth century, even when heads were impaled no longer.[35]

Then there were the prisons and the hanging places. 'There are in London, and the far extended bounds,' Daniel Defoe wrote in 1725, '. . . notwithstanding we are a Nation of Liberty, more publick and private Prisons, and Houses of Confinement, than any City in Europe, perhaps as many as in all the Capital Cities of Europe put together.' He went on to list twenty-seven 'publick prisons' and 119 'spunging houses' (where debtors were held), among a dozen other 'tolerated' or 'private' prisons.[36] One couldn't escape these things. The sites of punishment stretched eastwards from Tyburn (at the west end of Oxford

* In the Rump's time Temple Bar was a decayed wooden structure, Wren's version in Portland stone as yet unbuilt.

Street where Marble Arch is now) all the way to the naval gibbets at Wapping on the Thames, and from Bedlam in the north down the string of criminal and debtors' prisons (Newgate, Ludgate, the Fleet, Bridewell) that stretched along the then open sewer of the River Fleet, and across the Thames to the Clink, the Marshalsea and the King's Bench. At Tyburn (or outside Newgate after 1783) there were eight hanging-days a year, one for each Session at the Old Bailey, where up to a dozen men and women might be choked to death before large crowds. Hogarth invented the iconic representation of this spectacle for the demise of his Idle Apprentice. Fig. 110 at the head of this chapter shows the unpublished preliminary drawing for this much reproduced engraving, before the composition was reversed on the copper plate. But Hogarth's 'reality' was highly controlled, and it was one John Hamilton, an amateur, who in 1767 left the most credible drawing of Tyburn as the makeshift and ramshackle site it was. *A Back View or Scetch of Tybourn*, he called it, adding that he drew it 'on the day that Guest the Bankers Clark was Hanged' for coining. In a note Hamilton added over twenty years later, he explained the odd scaffoldings in his drawing by recalling that 'it was the custom of Lamplighters (in those days) to errect their Ladders together, for persons to mount them, at 2d or 3d each, to see the Executions. Some of their partys frequently puled down the ladders to get fresh customers to mount' (**plate 23**).[37]

Those who didn't care to see Tyburn found it difficult not to see executions elsewhere. A housebreaker who killed a watchman was hanged in 1704 at the junction of Long Acre and Drury Lane, 'that it might be so much the more Exemplary'. Two Dutchmen and a woman were hanged for murder outside the Hartshorn brewhouse in East Smithfield during Hogarth's infancy (and Downing, the printer who lived next door to the Hogarths, printed the Ordinary's reports on the case). Sarah Malcolm the murderess met her end in 1733 on a gallows erected in Fleet Street. The Leicester Fields murderer Théodore Gardelle was hanged in Panton Street in 1761, a few hundred yards from Hogarth's and Reynolds's houses. John Perrott was hanged in Smithfield in the same year for concealing his wealth and effects after his bankruptcy. His demise was illustrated by Samuel Wale, one of Hogarth's St Martin's Lane associates and the most prolific book

124. Samuel Wale, *John Perrott hanged at Smithfield*
(ink, wash, *c.* 1768)

illustrator of the century (and a Royal Academy founder) (fig. 124). As
late as 1780, Gordon rioters were hanged across London at the sites of
their crimes, including two hanged on the corner or Russell and Bow
Streets. If people missed a procession or hanging, they couldn't be deaf
to the hanging ballads sung on the streets. Hogarth inserted a ragged
and baby-burdened singer into the centre of his Tyburn drawing, her
hand cupped to her ear to get the notes right. Paul Sandby and Row-
landson drew these women too (fig. 125 and fig. 126). Their 'chaunting'

125. Paul Sandby, *Last Dying Speech and Confession*
(pencil, watercolour, *c.* 1759)

of hanging ballads and rude ballads must have been among the most
memorable and disturbing music London offered. Francis Place
recalled their performing up and down the Strand, and recorded the
forceful demotic of their words.[38]

The sites for the erection of pillories were also thick on the ground in
early-modern London. We've forgotten just how thick. In the late sev-
enteenth and early eighteenth centuries, the Piazza had its own pillory
site. So did Bow Street, Catherine Street, Stanhope Street and the Hay-
market. Three more sites were ten minutes' walk away in the Strand
– near St Mary-le-Strand Church, at the New Exchange and at the
Fountain tavern.[39] The most used pillory stood under Charles I's statue
in Charing Cross. Culprits would be locked into it for an hour or two
around noon, when crowds were thickest. A paper pinned to their
chests stated their offences. People were expected to bring cats, eggs,
cabbages and dung with which to pelt the victim, women being allowed

126. Rowlandson, *Last Dying Speech and Confession* (ink, wash, 1798–9)

to throw from the front if they tipped the constables first. Women were the keenest attendants and assailants. Some victims could appeal to the mob's political sympathies, as Daniel Defoe did when he was pilloried for his pamphlet satires on high church Tories: in his case the crowd threw flowers at him. More commonly, eyes were lost and blood flowed on these occasions, and some died – usually those pilloried for 'unnatural' crimes. When two corrupt thief-takers were pilloried in 1755, they were so 'attacked with potatoes, turneps [sic], cabbage-stalks, stones, &c. that Egan was struck dead in less than half an hour, and Salmon was so dangerously wounded that it was thought impossible for him to recover'.⁴⁰

Hogarth was alert to the profits that might be extracted from a market that was as hungry for underworld tales and images as he was himself. Plays and novels were fanning awareness of crime. The criminal novel was embarking on its long career with Defoe's *Moll Flanders* (1722) and Fielding's *Jonathan Wild* (1743), even as *The Beggar's Opera* succeeded wildly at the Lincoln's Inn Fields playhouse in 1728. They established the key protagonists in the criminal narrative that shaped imaginings for decades to come: the criminal gang and its captain, the highwayman anti-hero, the receivers and whore-accomplices, the betrayed or the treacherous girlfriends, and the final endings in Newgate and at Tyburn. All this determined people's ways of thinking about the murky goings-on in alleys, dives and dens. It also drew attention to their high-life equivalents. The parallels were self-evident between the corrupt Robert Walpole, the corrupt thief-taker Jonathan Wild and Peachum: in *The Beggar's Opera* Peachum stood for both villains. In all these ways, consciousness of crime and punishment, and of a larger corruption, had become part of London's great masquerade, a part of its febrile excitements, part of its darkness, too.

HOGARTH'S HARLOT

An early indication of Hogarth's fascination with the Covent Garden underworld lies in an extraordinary unpublished sketch which launched the idea that grew into *A Harlot's Progress*, the first of his narrative series. When he drew it, his apparent aim was simply to engage with a

local reality; but it led further. According to George Vertue's notes, the *Progress* was launched after Hogarth made 'a small picture of a common harlot, supposd to dwell in drewry lane'. It showed her

> just riseing about noon out of bed. and at breakfast, a bunter [servant] waiting on her – this whore's desabillé careless and a pretty Countenance & air. – this thought pleasd many ... [Friends] advisd him to make another. to it as a pair. which he did. then other thoughts encreas'd, & multiplyd by his fruitfull invention. till he made six. different subjects which he painted so naturally ... that it drew every body to see them.[41]

The paintings were later destroyed in a fire; but he engraved the six prints taken from them in 1732, and it was thanks to their high sales that he 'rose completely into fame' (Vertue), his profits enabling him and his wife to move to Leicester Fields a year later.

The sketch, now in the British Museum (fig. 127), may be either a

127. Hogarth, *A Harlot in her Garret attended by her 'Bunter'* (chalk, 1731?)

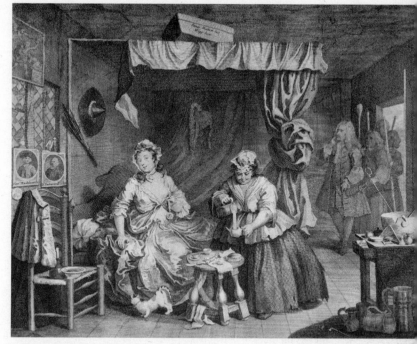

128. Hogarth, *A Harlot's Progress*, plate 3 (etching, engraving, 1732)

tester for the 'small picture' or the picture itself. Drawn in red chalk, squared up for transfer, and measuring 250 x 359 mm, it foreshadows plate 3 of the *Harlot* (fig. 128). But the squalor of the first harlot's chamber is far grimmer than the harlot's in the final print. Improprieties are uncensored here, and the observation is needle-sharp. The whore's face is marked by syphilitic sores; she bandages sores on her arm; and she is iller and leaner than the *Harlot's* robust Moll Hackabout. On the rickety table by her side lies a syringe for injecting mercurial mixtures to extinguish the 'Venereal Fires that had unhappily taken hold of the Instruments of Generation'.[42] Next to it are two tie-on catgut sheaths, a medicine bottle, a broken comb and a mug. More sheaths hang on the line across the room, along with ragged washing. The bed hangings are tattered, and an open close-stool stands under the window. The old bawd who lives off the harlot's

leftovers has a wooden leg. On the floor a cat gnaws a bone. There too lie the girl's discarded clothing, a bundle of birch twigs for flagellation, and a book whose inscription announces that it is *Aristotle on F – [ucking?]* – that is, the sex manual *Aristotle's Masterpiece*.

There is no knowing how closely Hogarth sketched this from life, though he must have entered such a place. The drawing is packed with just about every source of disgust he could muster: pockmarks, disease, bandages, prostitution, condoms, dirty clothing, torn bedlinen, defecation, feline and female predatoriness, one-leggedness. No other eighteenth- or nineteenth-century art work notices the misery of lowest life as unflinchingly as this does. It may be that *A Harlot's Progress* sold well because of its prurient glimpse into a whore's life. But the sketch makes it clear that his alleged eroticization of the harlot's body wasn't as 'absolutely fundamental to the whole project of its representation' as modern academics fashionably think; nor did it aim to 'provoke a form of consumerable fantasy for the male viewer'.[43] Hogarth could more easily distinguish between a titillatory scene and one of wholesale desolation than these commentators can, and there is as much eroticism in this notion of the harlot's condition as there is in a casualty ward.

If the drawing marked the origin of *A Harlot's Progress*, the series' completion drew on Hogarth's eye for topical and sellable sensation. The protagonists in the harlot's tale had real-life equivalents in the targets of the campaign by the zealous Westminster magistrate, Sir John Gonson, to suppress Drury Lane's brothels in 1730–31. It's Gonson and his constables who enter the harlot's bedroom to arrest her in the finished plate 3 (fig. 128). Shopkeepers and householders had been complaining about the lewd and idle persons who disturbed their nights; arrests and convictions followed. The procuress Mother Needham was sentenced to stand twice in the pillory, first opposite Park Place where she kept her bawdy house and then in New Palace Yard. The crowd pelted her so badly on her first exposure that she died a few days later without having to endure the second; and, as was the easy way in those days, the coroner delivered a verdict of 'natural death'. (She duly appears in Hogarth's plate 1, enticing into her service the innocent Moll Hackabout, freshly arrived in town.)

Meanwhile, again in reality, one Sarah Vincent was convicted of keeping a disorderly house at the corner of Vinegar Yard, Drury Lane.

1080.m.32
2

A GENUINE
NARRATIVE
OF ALL THE
Street Robberies
Committed since October last, by
James Dalton,
And his ACCOMPLICES,
Who are now in *Newgate*, to be try'd next
Sessions, and against whom, *Dalton* (call'd their
Captain) is admitted an Evidence.

SHEWING

I. The Manner of their snatching off Womens Pockets;
with Directions for the Sex in general how to wear
them, so that they cannot be taken by any Robber
whatsoever.

II. The Method they took to rob the Coaches, and
the many diverting Scenes they met with, while they
follow'd those dangerous Enterprizes.

III. Some merry Stories of *Dalton's* biting the Women
of the Town, his detecting and exposing the **Mollies**,
and a Song which is sung at the **Molly-Clubs**; With
other very pleasant and remarkable Adventures.

To which is added,

A KEY to the Canting Language, occasionally
made Use of in this Narrative.

Taken from the Mouth of JAMES DALTON.

LONDON:
Printed, and sold by J. ROBERTS, at the *Oxford
Arms* in *Warwick-Lane*. 1728.

(*Price* 1 s.)

129. *A Genuine Narrative . . . [of]
James Dalton* (letterpress, 1728)

She was sent to beat hemp in the Tothill Fields Bridewell for six
months, and so provided Hogarth with his subject for plate 4. Four
other women were also sent to hard labour in the Bridewell – three
for 'exposing their nakedness in the open street to passengers and
using most abominable filthy expressions'. The newspapers tell us (as
they told Hogarth) that the fourth was Kate Hackabout. She was

> noted in and about the Hundreds of Drury, for being a very termagant,
> and a terror, not only to the civil part of the neighbourhood by her fre-
> quent fighting, noise, and swearing in the streets in the night-time, but
> also to other women of her own profession, who presume to pay or pick
> up men in her district, which is half one side of the way in Bridges-street.[44]

This real Hackabout had several times appeared before the justices
for disorderly conduct in the mid- to late-1720s. She is likely to have
witnessed her 28-year-old brother Francis's Tyburn hanging in 1730
for a highway theft. The quickening pace of her decline and fall Hog-
arth appropriates for the *Progress*. In plate 2 she betrays her wealthy

Jewish protector, in plate 5 she is ill and dying, and in 6 she is in her coffin surrounded by faithless friends. It is in plate 3 that Hogarth elaborates on the scene that his chalk drawing had rehearsed. Here she rises from bed in *déshabillé*, surrounded by the accoutrements of her trade: flagellatory birch twigs, masquerade clothing, pillboxes, a stolen watch. A cat on heat arches her back in lust; the ageing and diseased 'bunter' serves her. Her highwayman-lover's wig-box is kept above her bed. It is inscribed with James Dalton's name. He was the real-life robber and associate of the infamous thief-taker Jonathan Wild, and he also met his end at Tyburn in 1730. His 'Narrative' sold well. Hogarth must have read it (fig. 129).

HOGARTH IN THE UNDERWORLD

In 1733 Hogarth took his father-in-law, James Thornhill, from the Piazza to Newgate prison a mile away to visit the murderess Sarah Malcolm in her condemned cell. Thornhill had made just such a visit nine years earlier when he went to Newgate to draw the miraculous escapee Jack Sheppard awaiting his doom: this was the kind of sightseeing that one could do then in the name of curiosity – or sensibility, as some were calling it. Much later, recall, Hazlitt wrote that Hogarth's works would have lost their humanity had he been blind to 'wit or enjoyment in a night cellar' and to the fact that the cripple could 'dance and sing'.[45] But it wasn't dancing and singing that Hogarth showed in his more noisome locations. As regards Sarah Malcolm, his humanity, if it can be called that, was steely-eyed.

Malcolm, aged twenty-two, was a County Durham immigrant who was employed at the Black Horse in Boswell Court near Temple Bar before becoming a laundress to people lodging in Temple Chambers. She was convicted of being an accomplice at the robbery and brutal murder there of an elderly widow and her two servants; £300 worth of currency and silverware were taken. The bodies were discovered the following afternoon. Some of the silver was found in Malcolm's room. In her five-hour trial at the Old Bailey it didn't help her that she claimed that the blood on her clothing was her own menstrual blood and not that of one of the victims: the mention of such a subject

confirmed her looseness. She protested her innocence to the last, but in vain. In the words of the Ordinary of Newgate, 'Because of the atrociousness of her Crimes, by a special Order, and for Terror to other wickedly disposed People, [she] was appointed to be Executed in Fleet-street, at a Place nigh where her henious Crimes were committed.' So, fainting and weeping, she was taken in a cart to a scaffold opposite Mitre Court. (The crowd was so dense that one woman was able to cross the street via the heads and shoulders of onlookers.) Malcolm was neatly dressed in a crape mourning gown, white apron, sarcenet hood and black gloves, and her face was plastered with

Price 6.ᵈ

Sarah Malcolm Executed in Fleet street, March yᵉ 7ᵗʰ 1732 for Robbing the Chambers of Mrˢ Lydia Duncomb in yᵉ Temple, and Murdering Her, Eliz. Harrison & Ann Price
W. Hogarth (ad Vivum) pinxit & sculpsit

130. Hogarth, *Sarah Malcolm Executed in Fleet street, March ye. 7ᵗʰ. 1732 for Robbing the Chambers of Mrs. Lydia Duncomb in ye. Temple, and Murdering Her, Eliz. Harrison & Ann Price W. Hogarth (ad Vivum) pinxit & sculpsit* (etching, 1733)

cosmetics. She collapsed on the scaffold and prayed as she died, a Catholic. After execution, her body was dissected and her skeleton sent to Cambridge where it was kept in the anatomy shed in the then Botanical Gardens.[46]

Hogarth painted her in the condemned cell two days before her death, her rosary on the table. (The print's subtitled date should read 1733 in the New Style.) He wasn't moved by her plight. 'This woman, by her features, is capable of any wickedness,' he allegedly told Thornhill.[47] Actually, she was so ordinary-looking that you wouldn't have looked at her twice in the street. When she sat to Hogarth she 'put on red to look better'; and she and Hogarth together contrived a portrait interesting enough for Horace Walpole to pay five guineas for it to hang in his house at Strawberry Hill. Hogarth took a profitable print from it (fig. 130). He charged only sixpence for it, but this didn't stop it from being widely pirated.

The most that can be said for Hogarth's delicacy in the face of punishment is that he never depicted an execution in close-up, as Rowlandson did much later. Nor did he look into the staring eyes of the about-to-be-hanged, as Géricault did in London in 1820.[48] And in the first two plates of *The Four Stages of Cruelty* (1751), he depicted almost unbearably what he termed 'that cruel treatment of poor Animals . . . [that] makes the streets of London more disagreable to the human mind than any thing whatever'.[49] On the other hand, his larger point here was that cruelty to animals led to cruelty to humans. And he was blind to the irony that to illustrate those consequences he produced the most lasciviatingly sadistic of all his prints. In plate 4 the cruel Tom Nero gets his just deserts as the surgeons anatomize his hanged and naked body, presided over by the blind magistrate Sir John Fielding. His guts spill into a bucket and his heart is nibbled at by a dog (fig. 131).

In another morality tale of sorry decline and demise, *Industry and Idleness* (1747), his criminal stories reached their climacteric. The British Museum has his preliminary sketches for the series, and when matched to their prints they show how the prints developed from roughly sketched ideas. In one sketch, reversed when engraved for plate 7, the accidental descent of a cat down the chimney could hardly have been invented; Hogarth had entered such a place. In an unspeakably

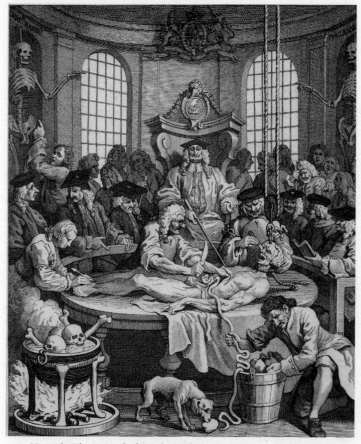

131. Hogarth, *The Reward of Cruelty* (etching, engraving, 1751)

derelict room, Tom Idle is in bed with his doxy while she greedily checks his loot (fig. 132 and fig. 133). And it's in a night cellar, next, in plate 9 of the series, that she betrays him to the magistrates. The rowdy company includes a serving girl with a leather patch over her syphilitic nose, and Tom Idle's one-eyed accomplice. A fight has broken out in the background; and in the nick of time a dead body is stuffed down a trapdoor as the constables arrive (fig. 134). (It's Tom Idle, incidentally, who meets his end in Hogarth's Tyburn tableau in fig. 110.)

132. Hogarth, drawing for *The Idle 'Prentice return'd from Sea, and in a Garret with a Common Prostitute* (pencil, ink, wash, 1747)

133. Hogarth, *The Idle 'Prentice return'd from Sea, and in a Garret with a Common Prostitute* (etching, engraving, 1747)

134. Hogarth, *The Idle 'Prentice Betray'd by his Whore, & taken in a Night Cellar with his Accomplice* (etching, engraving, 1747)

As in all Hogarth's more vicious tales, this one co-opted for its set-ting a dive that had lately become notorious. Discouragingly known as the 'Blood Bowl', it was located in Hanging Sword Alley off Water Lane, in the maze of courts and lanes between Fleet Street and the Thames. It was so called because customers who complained about having their pockets picked were told that a bowl was kept in the house to collect troublemakers' blood.[50]

Hogarth probably learned about this dreadful place from news-papers, or from the Old Bailey *Proceedings*, or from the Ordinary of Newgate's fourpenny *Account of the Behaviour, Confession, and Dying Words, of the Malefactors Who were Executed at Tyburn the 15 March 1744*.[51] For one of the hanged then commemorated was the Blood Bowl's owner. He was the pickpocket-burglar James Stansbury, twenty-nine years old; and his career was the blueprint for Tom Idle's. The Ordinary tells us that although he was trained as a watchmaker, he was 'inclin'd to Idleness and the worst of Company both of Men

and Women, especially the latter'; his face was scarred by smallpox. To cure his ways his father sent him to sea, but he returned as wicked as ever. He and his wife Margaret lived

> upon the Sharp [criminally], and he allow'd her to turn common Whore and pick up Men; by which Means he by his Industry in robbing, and she by whoring were supported. At last James took a House in Hanging-Sword Alley, and there they kept that noted Baudy-House, so fatal to People, call'd, The Blood Bowl House, which he left to the Management of his Wife.

Unfortunately for the family economy, a drunken gentleman was one night enticed into the Blood Bowl after a drunken time in Covent Garden. One woman kept him busy in bed while Margaret Stansbury robbed him of money, silver buckles, hat and wig. Coming to his senses, he 'saw what a House I was got into; that it was more for Robbery than Pleasure', so he made a mighty row and fought his hosts with vigour. Margaret was arrested, tried at the Old Bailey, and condemned to death. Because she was pregnant, she was shunted off to the American plantations for fourteen years instead, and disappeared from history. James Stansbury was acquitted on an alibi and continued his thieving life. Around the Covent Garden theatres, he stole £10 a week on average, so he lived 'in Favour with the Women, but those chiefly of the Town, who highly esteem'd him for Singing, which recommended him to Publick Houses, where People when they Drink often cheer their Liquor with a Song'. Not for long, however. A year later a couple of ill-judged burglaries in Whitechapel did for him. He died at Tyburn as the Catholic he was, praying to the saints above.[52]

*

Hogarth returned to low-life subjects in 1751 in his *Four Stages of Cruelty* and in *Gin Lane*, but he never again attempted the close observation of the criminal underworld that he achieved in *Industry and Idleness*. So as he recovered from the failure of his much mocked history painting *Sigismunda* and his feud with Wilkes and Churchill, the tired old man made nothing of a grim procession that passed by

his Leicester Fields house one Saturday in April 1761. Yet it was the closest he got to association with a really atrocious crime.

Its perpetrator was the 39-year-old Swiss enamellist and miniaturist Théodore Gardelle. He had arrived in London two years before. He frequented Slaughter's coffee-house, and he lodged with a Mrs King in 36 Leicester Fields, on the square's southern side. Since Hogarth lived at number 30, he and Gardelle must have been on bowing terms. Gardelle's manner of despatching his landlady Mrs King was unequalled for gruesomeness until the Greenacre murder of 1837. Either in the course of a row or during a failed seduction – she was 'a woman of easier virtue than temper', 'a gay showy woman, of a doubtful character, who dressed fashionably, and was chiefly visited by gentlemen' – Gardelle knocked her down and caused her head to hit the corner of the bedstead. Panicking, he cut her throat to finish her off and hid her body. A week or so later, he chopped her up, fed her head and bones into a fire in the garret, and concealed other bits in the roof. Her intestines and bowels he shoved down the privy because they smelled. Samuel Wale neatly illustrated the butchery in *The Tyburn Chronicle* of 1768 (fig. 135). During the ensuing trial the details of the crime – who did what and when, who smelled what and when, the drain stuffed with Mrs King's clothes, the servant's surprise when she unplugged it – kept London agog for weeks. The diarist William Hickey recalled that

> a large mob assembled in front of the house, every person in turn putting their noses to the keyhole of the front door, when each individual went away perfectly satisfied that they smelt the burning of the flesh and bones. The house remained untenanted for several years, but the story being at last forgotten it became once more inhabited and continues so.[53]

Gardelle was convicted. So his hanging procession duly trundled from Newgate prison along Fleet Street and the Strand and up St Martin's Lane to Leicester Fields. Gardelle sat in the cart with his hands tied, trying to read the Bible, as one would. The cart stopped for three minutes outside the scene of the crime. He couldn't be hanged there, however, because the king's youngest son lived on the northern side of the square in Leicester House, and royal feelings must be spared. So the cart moved on down Panton Street to the Haymarket, at the

135. Samuel Wale, *Theodore Gardelle having murdered Mrs King* (engraving, 1768)

corner of which the scaffold waited. There he was hanged 'amidst the shouts and hisses of an indignant populace'. Then his body was carted to Hounslow Heath where it was hung in chains on a gibbet. It was still hanging there two years later when young William Hickey rode past it one morning on his way from Twickenham. He idly struck at the toes of one of the feet, and was horribly shocked when they fell off.

In view of Hogarth's unavoidable knowledge of Gardelle and his crime, as well as the noise at his hanging two blocks away, his silence on the sensation is vexing. The description of the crowd's tumult at Greenacre's Newgate execution in 1837 suggests what must have been

13. (*top*) Johann Zoffany, *John Cuff and his Assistant* (oil, 1772) (pp. 207, 225)
14. (*bottom*) Rowlandson, *Connoisseurs* (pencil, ink, watercolour, *c.* 1790) (p. 218)

15. (*top left*) Rowlandson, *An Aristocrat* (ink, watercolour, no date) (p. 219)

16. (*top right*) Hogarth, *The Shrimp Girl* (oil, c. 1740–45) (p. 229)

17. (*bottom*) James Gillray, *Titianus Redivivus; – or – The Seven Wise Men consulting the new Venetian Oracle, ... a Scene in yᵉ Academic Grove* (etching, aquatint, watercolour, 1797) (p. 222)

18. (*top*) Samuel Scott, *The Old East India Wharf* (oil, *c.* 1757) (p. 230)
19. (*bottom*) John Collet, *The Bath Fly* (oil, 1770) (p. 231)

20. (*above*) Canaletto, *Old London Bridge* (ink, watercolour, no date, but before the removal of houses in 1758) (p. 244)

21. (*left*) Hogarth, *Before*
(oil, 1731) (p. 256)
22. (*below*) Hogarth, *After*
(oil, 1731) (p. 256)

23. (*above*) John Hamilton, *A Back View or Scetch of Tybourn (Taken Oct. the 14ᵗʰ 1767 the day that Guest the Bankers Clark was Hanged)* (ink, watercolour, 1767) (p. 275)

24. (*top*) Rowlandson, *'Tis Time to Jump Out* (ink, watercolour, 1805) (p. 316)
25. (*bottom*) Rowlandson, *Smithfield Sharpers, or, The Countrymen Defrauded*
(etching, coloured, 1787) (p. 322)

26. (*top*) Paul Sandby, *The Encampment at Blackheath* (ink, watercolour, 1780) (p. 356)
27. (*bottom*) James Heath, after Francis Wheatley, *The Riot in Broad Street on 7 June, 1780* (etching, 1790) (p. 359)

28. (*above*) Francis Swain, detail, *Figures by Chelsea Waterworks observing the Fires of the Gordon Riots, 7 June 1780* (oil, 1780) (p. 36)
29. (*left*) J. M. W. Turner, *St Erasmus in Bishop Islip's Chapel, Westminster Abbey* (pencil, watercolour, 1796) (p. 385)

136. Samuel Ireland, after Hogarth (?), *Theodore Gardelle Executed in the Hay-Market near Panton Street, on Saturday ye 4ᵗʰ. Apr. 1761, for the Murther of Mrs. King at her house in Leicester Square* (etching, aquatint, no date)

audible in Leicester Fields in 1761. Greenacre too had dismembered his female victim before disposing of her parts around London. As he stumbled to the noose, he was 'greeted by a storm of terrific yells and hisses' and by 'a loud, deep and sullen shout of execration'. There were more cheers as he dropped. 'So loud was the shout which hailed the exit of the poor wretch, that it was distinctly heard at the distance of several streets, and penetrated to the innermost recesses of the prison ... The crowd seemed as if they never could satisfy themselves with gazing at the hanging murderer. The women were, if possible, more ruthless than the men.'[54] Reynolds also lived in Leicester Fields within earshot of the crowd, and, like countless thousands of the high people, he did go to

occasional executions out of 'curiosity' until he realized it was impolite to do so; but his April 1761 notebooks mention neither the murder nor the noise. They list nineteen sitters for portraits instead.[55]

So there is only one sad relic of Gardelle's passing. It's a not very good etching of the wretched man reading his Bible in the cart, and it was said to have been drawn as he passed Hogarth's window by John Richards, Hogarth's godson. Samuel Ireland etched and published it years later (fig. 136). While Richards was sketching, Hogarth is said to have entered the room. 'Seeing what [Richards] was about, [he] snatched up the paper, and hastily taking a pen out of the ink-stand, marked in the touches that are exhibited in the etching, and then returning the paper, said, "There Richards! I think the drawing is now as like as it can be."'[56]

MOTHER DOUGLAS

The depiction of local criminals, bawds or procuresses in graphic print, speculation about who exactly was depicted, and then owners' frequent inscriptions on prints of such identifications as they could muster, indicate a fascination with criminal celebrity that paralleled its high-society equivalent. People wanted to know who prints' protagonists were. Knowing facilitated story-telling, and might have catered to nostalgia for a disreputable world fast disappearing. The trouble is that these habits often corrupted the identifications we inherit. How myth-making inflated the standing of the procuress Jane Douglas (*c.* 1700–1761) is a case in point. It provides a last illumination of how Hogarth was topically engaged in his world, for he played a part in the myth-making process.

Douglas was one of a dozen well-known Covent Garden bawds. In 1739 she took over Betty Careless's bagnio-bordello in Tavistock Row in the Piazza, furnishing it so lavishly that her girls were soon enjoying the patronage of the highest, the Duke of Cumberland included, and fleecing them 'in proportion to their dignity'.[57] She supposedly even had a child by Lord Fitzwilliam. In 1748 Henry Fielding staged a version of his own *Covent Garden Tragedy* at the puppet-show he ran in Panton Street; one character was called Mrs Duggleass. The rakes in his novel *Amelia* (1751) regarded her brothel as their

favourite resort. Charles Johnstone's description of her in his satirical novel *Crysal* of 1760 was graphic:

> Her face, though broken by debauchery and disease, preserved the remains of a most pleasing sweetness and beauty; but her body was bloated by intemperance almost out of every resemblance of the human form. She wore on her head a richly laced cap, over which half a dozen fine handkerchiefs almost concealed a piece of greasy flannel. Her gown, of the richest silk, flowed loosely round her, under a velvet cloak lined with ermin; while her legs and feet, swoln out of all shape, and too tender to bear any ligature, were wrapt up in flannels.[58]

The novel went through many editions, so it might have been this description that Rowlandson had in mind when he depicted similarly afflicted limbs in his *Bawd on her Last Legs* thirty years later (see **plate 7**). In her later years she was described by the diplomat Sir Charles Hanbury-Williams as 'a great flabby fat stinking swearing hollowing ranting Billingsgate Bawd' well known to 'most men of Quality and Distinction in these Kingdoms'.[59] She died of drink, but also comfortably moneyed.[60]

She owed her posthumous fame to the fact that a Mother Douglas figure, renamed Mother Cole, stood at the centre of a web of reference in novel, drama and print. 'Mother Douglas' features in three satirical prints down to 1820, and a 'Mother Cole' features in nine. Her renaming she owed to John Cleland's *Memoirs of a Woman of Pleasure* (1748–9), which was partially set in Covent Garden. She was the genteel bawd under whose aegis Fanny Hill embarked on her career – her bordello 'the safest, politest, and ... most thorough house of accommodation in town, every thing being conducted so that decency made no intrenchment upon the most libertine pleasures'. Her fame peaked a dozen years later both in Johnstone's *Crysal* and more importantly in Samuel Foote's farce *The Minor*, which played in the Haymarket Theatre and then at Drury Lane in July 1760. Foote also called her Mrs Cole, but Mother Douglas was assumed to be his model.[61]

Foote lampooned her because she had apparently been converted to Methodism, and because his real target was the Methodist preacher George Whitefield, alleged agent of her much publicized religious conversion. In Covent Garden Whitefield's name was dirt. In a chapel

in Long Acre in 1755, he had preached hell-fire for theatregoers and tavern-singers with such conviction that protesting crowds interrupted his services and people sent death threats. Whitefield wisely removed himself and his enthusiasms to a calmer life in a new Tabernacle in Tottenham Court Road. But 'playhouse people' like Foote didn't forgive Whitefield his bigotry, and *The Minor* took revenge. The play deeply offended the righteous. Whitefield's early biographer charged it with such impiety and 'profane ridicule' that 'a sober minded Mahomedan would blush at'.[62] Hardly so – if the Mahomedan had wit. Foote's portraits of two great hypocrites, Dr Squintum (Whitefield was squint-eyed) and Mrs Cole (Douglas), were bitingly comic and accurate. With justice, the play was repeatedly staged throughout the rest of the century:

MRS COLE: Ay, I have done with these idle vanities; my thoughts are fix'd upon a better place. What, I suppose, Mr Loader, you will be for your old friend the black ey'd girl, from Rosemary Lane. Ha ha! Well, 'tis a merry little tit. A thousand pities she's such a reprobate! – But she'll mend; her time is not come: all shall have their call as Mr Squintum says . . . Sixteen years have I liv'd in the Garden, comfortably and creditably, and, tho' I say it, could have got bail any hour of the day . . . no knock me down doings in my house. A set of regular sedate sober customers. No rioters . . . During the whole time, no body have said, Mrs Cole, why do you so? Unless twice that I was before Sir Thomas De Val [the magistrate de Veil] and three times in the round-house [lock-up] . . . We are to have, at the Tabernacle, an occasional hymn, with a thanksgiving sermon for my recovery. After which, I shall call at the register office, and see what goods [girls] my advertisement have brought in . . . Or if that shou'd not do, I have a tid bit a home, will suit your stomach. Never brush'd by a beard. Well heaven bless you.

It would be pleasant to think that Hogarth exploited Mrs Douglas with Foote's satirical intent. Modern commentators tell us that she is the fat female spectator at the Tyburn scaffold in *The Idle 'Prentice executed at Tyburn* (fig. 110 above): gin glass at her lips, she stands in a cart complacently watching Tom Idle going to his doom. They also say that, in a neglected detail in Hogarth's *March of the Guards to Finchley* (1750), she is the sanctimonious bawd praying enthusiastically from

137. Hogarth, *A Representation of the March of the Guards to Finchley* (detail) (etching, engraving, 1750)

the bottom-right window of her Tottenham Court Road 'cattery' (cats on the roof!), while her girls peer excitedly at the soldiers and crowd below (fig. 137). Alas, neither of these identifications was confirmed in Trusler's commentary on Hogarth's works in 1768, written with the widow Jane's endorsement and sold from the Leicester Fields house.[63]

There is less doubting her presence in an extraordinary Hogarth engraving a decade later – though there's still some. Between 1760 and 1762, perhaps prompted by Foote's play, Hogarth produced proof impressions of a satire on 'the strange effects of literal and low

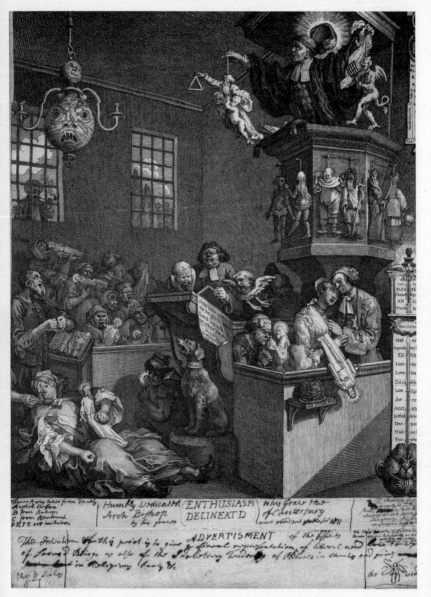

138. Hogarth, *Enthusiasm Delineated* (etching, engraving, 1760–62)

interpretations of Sacred Beings'. Its mockery of worshippers of Christ's graven idol and of Methodist 'enthusiasm' was so obviously ignorant of what Methodism stood for that, better advised, he soon re-engraved and sanitized the composition under the title *Credulity, Superstition and Fanaticism*. In this he replaced the Mother Douglas figure with the bogus progenitor of rabbits, Mary Toft; this is the version now best known. But two impressions survive of the original proof; the one in the British Museum bears Hogarth's manuscript commentary (fig. 138). His original title for it was *Enthusiasm Delineated*,[64] and it attacked Methodism's supposedly 'papist' challenge to Anglican proprieties and also Reynolds's recent praise of the sublimity of the Counter-Reformation masters. What resulted was a symbolically saturated composition which parodied both the archetype of the ecstatic Counter-Reformation female and George Whitefield's 'enthusiasm' (his name is on his dog's collar). Wearing a harlequin tunic, Whitefield rants from the pulpit so zealously that his wig falls off and exposes a Jesuit tonsure beneath it, while the figure assumed to be Mother Douglas swoons in ecstasy on the church floor, clutching a holy statuette. She is clearly a whore because she has Hogarth's trademark pox-mark on her cheek. However, she looks too young for a lady about to die in her sixties; and (again) the strongest affirmation that this was Jane Douglas came thirty years after the engraving.[65]

Be that as it may, the swooning figure is one element in Hogarth's disturbing vision of a greater insanity around him. The grotesque congregation attempt to devour their statuettes: their madness is measured by the barometric gauge on the right. The surreal chandelier above the congregation is etched with a map showing Eternal Damnation, the Bottomless Pit, etc.; it presents a ghastly face. The whole print is extremely imagined. Like his *Tail Piece* of 1764 (fig. 85), it expresses Hogarth's deepening manias in his last years of life.

8

Rowlandson's London

LONDON'S MISERIES

The comic tone of Thomas Rowlandson's entrancing drawing of *Elegant Company on Blackfriars Bridge* (fig. 139) was the outcome of a significant shift in attitudes to the metropolis in the last quarter of the eighteenth century that Rowlandson himself did a great deal to promote. Undated but probably from the 1790s, the drawing is typically Rowlandsonian in its saturation with incident, movement and types and in its firm anchorage to place. At its centre are the cheery soldier and his girl, but everyone else is just as happy as they are. The beggar and his patrons are merry, and the dog stealing naughtily from the butcher-boy's tray is an innocent image from a child's story-book. Rowlandson's vision here can be defended as an impression of one kind of reality in London; yet earlier generations would have dismissed it as an irresponsible and trivializing response to London's grim realities, and the more earnest kinds of historians today might think the same. Certainly most people before Rowlandson wouldn't have cared to see London like this. Their view was more pessimistic. The picture has its meaning therefore, and it will be a profound one, we'll see.

Go back in time now. In 1775 William Humphrey published a print by an anonymous engraver which made a point that was rare for its time. *Six-Pence a Day* depicts a knock-kneed soldier and his pregnant wife and crying children in the very picture of wretchedness, and comments on his exposure 'to the Horrors of War, Pestilence and Famine, for a Farthing an Hour' (a quarter of the old penny). It compares his plight with the relative comforts of the sedan chairman, coachman

139. Rowlandson, *Elegant Company on Blackfriars Bridge*
(ink, watercolour, 1790s)

and chimney-sweep on the left, who earn three shillings, two shillings, and one shilling a day respectively. The emaciated figure of Famine beckons the soldier from the right even as two American rebels shoot at him. The banner on the ground ironically cites the pretence that on soldiers' deaths their families will benefit from the subscriptions then being raised to encourage recruiting: 'COURAGE BOYS! / If you Gentn [gentleman] Soldiers should die & be damn'd / Your Wives & yr Infants may live and be cramm'd' [well-fed] (fig. 140).*

The print is exceptional because it breaks a silence. The scum of the earth, as the Duke of Wellington described his soldiers, were never otherwise given a voice in graphic satire before 1800, nor were their deaths and maimings memorialized. It was the preening generals,

* The print has been attributed to the young James Gillray (D. Hill, *Mr Gillray the Caricaturist: A Biography* (1965), p. 19). Gillray's father did lose an arm at the battle of Fontenoy in 1745, but thereafter he lived as a Chelsea pensioner, which wasn't the soldier's fate this print referred to. The print also looks too clumsy for Gillray; he was allegedly a wandering player at this date.

140. Anon., *Six-Pence a Day*, 'Exposed to the Horrors of War, Pestilence and Famine, for a Farthing an Hour' (etching, 1775)

admirals and dukes who got the portraits. In *Roderick Random*, Smollett gave such an unsparing account of sailors' pitiful injuries on British warships at the Battle of Carthagena that he forced the Navy to provide better medical attention; but market-aware artists were more timid or less informed than writers, and avoided such dispiriting subjects. Truth-telling about poverty was rare, too. When artists in the first three-quarters of the century addressed the poor it was chiefly to notice how picturesque they were, or how depraved.

The near absence of depictions of war's grimmer consequences seems perverse in a country which since medieval times had never been so lengthily and bloodily at loggerheads with France as Britain was across the eighteenth century. British manpower losses in war then amounted to about 314,000 men. This was light when compared to those of the continental powers; yet 43,000 were killed during the war

of the American Revolution, a number that exceeded British war losses in the whole nineteenth century after Waterloo.[1] By the turn of the century one in six adult males over fourteen was in the armed services, and soldiers and sailors on leave were visible in every street and tavern. Discharged with one leg or arm or with none, or with one eye or none, or with tin plates screwed over holes that had been bulleted or trepanned into their skulls, they swelled the numbers of beggars on every corner and of lawbreakers in every prison. Beggars were so common that they lived beneath the radar of most passers-by. In scores of topographical or satirical images they appear incidentally, tucked against walls. Fluctuations in harvest, trade and employment cycles deepened the misery. In London as elsewhere trade and family disasters were recurrent. The incomes of shopkeepers and tradesmen were as insecure as the wages of the unskilled, unemployment was rife, disease and squalor endemic, children died young, and few beggars were merry.

The literate classes had their own more self-indulgent miseries, and the tone they imparted to metropolitan life in the first half or so of the century was almost as sobering. Literary men lived penurious Grub Street lives, but also lives of unmitigated envy and malice. Despite their pretensions, civility could be wafer-thin; the life of a wit was a warfare upon earth, Richard Steele wrote. Nobody knew better than Alexander Pope how to 'damn with faint praise, assent with civil leer, / And, without sneering, teach the rest to sneer'.[2] He denounced the literary 'dunces' by naming names and deploying scatological abuse shamelessly. The nastiness with which he attacked lesser men was matched by theirs back to him.

Pope had been crippled and dwarfed in infancy by tuberculosis of the bone. His enemies seized every chance to ridicule his puniness. In 1742 the poet Colley Cibber (appointed poet laureate in 1730 in preference to Pope) retaliated to Pope's mockery by publishing his recollection of a brothel incident in 1716. At Button's coffee-house, Cibber recalled, a 'late young nobleman' (the Earl of Warwick) had persuaded Pope and Cibber to go with him to take tea (!) at 'a certain House of Carnal Recreation, near the Hay-Market', telling Cibber privately that they would then see 'what sort of Figure a Man of his [Pope's] Size, Sobriety, and Vigour (in Verse) would make, when the frail Fit of Love had got into him'. Tea was forgotten when

the serving-girl tempted the 'little-tiny Manhood of Mr Pope into the next Room'. Cibber charitably worried that the greatest of poets might catch the pox and die, so he burst into the room and found 'this little hasty Hero, like a terrible *Tom Tit*, pertly perching upon the Mount of Love! But such was my surprise that I fairly laid hold of his Heels, and actually drew him down safe and sound from his Danger.'[3] The printshops couldn't resist this. One print, unsigned, depicted *The Poetical Tom-Titt perch'd upon the Mount of Love*. Pope, one third the size of the woman, is shown with his breeches down (fig. 141). Thus did feuds and cruelties sour creative lives both great and small.

The POETICAL TOM-TITT perch'd upon the Mount of Love
Being the Representation of a Merry Description in M.r Cibber's Letter to M.r Pope.

Price 6.d

Does not Satiric Pope your Laughter move | How much had British Poetry to fear | What Greater Good from Cibber could we hope
Thus pertly perching on the Mount of Love? | Till 'twas retriev'd by Colley's kindly Care? | Who gave us Homer by his saving Pope?

141. Anon., *The Poetical Tom-Titt perch'd upon the Mount of Love, Being the Representation of a Merry Description in Mr Cibber's Letter to Mr Pope* (etching, 1742)

It compounded the gloom that the literary figures of the age felt obliged to see London as a place of vice, alienation and woe. Idealizing the supposed harmony of ancient Rome or Athens, they stressed this modern Babylon's dangers. For Pope, it was the city of 'dullness', its literature the product of 'dunces'. For Defoe, it was 'founded upon crime', a place of 'rapine and danger', and a breeding ground for plague, thieves and whores. Swift dwelt on its

> sweepings from butchers' stalls, dung, guts, and blood,
> Drown'd puppies, stinking sprats, all drench'd in mud,
> Dead cats and turnip-tops come tumbling down the flood.

Johnson saw London as aiming to 'Get money, money still! / And then let virtue follow, if she will'. A bleakly Hobbesian view of London was fashionable: criminality and deceit provided the best metaphors for the understanding of human nature:

> Through all the Employments of Life
> Each Neighbour abuses his Brother;
> Whore and Rogue they call Husband and Wife:
> All Professions be-rogue one another.
> The Priest calls the Lawyer a Cheat,
> The Lawyer be-knaves the Divine;
> And the Statesman because he's so great,
> Thinks his trade as honest as mine.

The 'statesman' here referred to by the villainous Peachum in *The Beggar's Opera* was the prime minister, Robert Walpole (Horace's father). This malign force tainted the whole culture with his corruptions, and his equivalences with the criminal were emphasized innumerable times. 'Now, suppose a prig [thief] had as many tools as any prime minister ever had, would he not be as great as any prime minister whatsoever?' asked Fielding in *Jonathan Wild*. 'I will, from time to time, as I see occasion, transport and hang at my pleasure; and thus (which I take to be the highest excellence of a prig) convert those laws which are made for the benefit and protection of society to my single use.' The most terrifying image of Walpole was George Bickham's *The late P-m-r M-n-r* [Premier Minister] (1743). Walpole yawns, too cynical in his power to bother to wield it: 'All Nature

nods: / What mortal can resist the Yawn of Gods?' – quoting from Pope's *Dunciad*. 'Lo!' the subtitle asks, 'What are all your Schemes come to?' (fig. 142). Yet the sense of a sinister world ruled by corrupt and scheming soundrels suffused most of the literature and satire of ensuing decades. Fielding might be a comic novelist, but his last novel, *Amelia* (1751), was constructed around the treacheries of people who were other than they seemed. Few could be trusted; good fortune was always fragile and passing.

In this culture it was difficult before mid-century to find a verbal or visual language to express a positive response to London, let alone to find happiness in it. Gay's *Trivia: Or the Art of Walking the Streets of London* (1716) managed it in verse, but that was unusual. Tourists' responses inclined to banality: '[we] made the tour of the city: we saw Bedlam, the lions, and whatnot; and finished with a view of that noble engine [the water pump] under London Bridge'.[4] 'That tiresome, dull place!' the tiresome dull poet Thomas Gray sniffed joylessly in 1762, 'where all people under thirty find so much amusement.' Artists were infected, too. It can't be said that Hogarth added to London's gaiety. His *Gin Lane* might be offset by its cheering companion, *Beer Street*, and his *Shrimp Girl* shows his delight in the energy of common people. Born into the rough-and-tumble cultures he depicted, he didn't on the whole betray them. Still, his stories are tragic or moralized, their wit muted and cruel, his protagonists as corrupt as any in the novels. Augustan notions of satire required him always to make a useful, moral and generally punitive point. And the sobering effect of his black-and-white engraving, like that of all black-and-white engraving, itself darkens our sense of his subject-matter. Charles Baudelaire much later wrote of Hogarth's 'cold, astringent, and funereal ingredient'. He saw in him 'the death and burial of the comic spirit', thanks to 'that indefinable breath of the sinister, the violent, and the ruthless which characterises almost every product of the land of spleen'.[5] Modern people don't smile *with* or *at* Hogarth, except in surprise at his inventiveness or his scatology.

Search further, and the rococo delivers more cheerful effects – in the joyousness of Louis-Philippe Boitard's undated drawing of a couple dancing, for instance (fig. 143). This image is so infectiously happy that Paul Sandby copied it into one of his Scottish drawings in 1750.[6]

THE late P—m-r M-n-r.

1743 Dec.³ 3

Lo! What are all your Schemes come to?

Published by GBickham in Maps Buildings

More he had said, but yawn'd——All Nature nods:
What Mortal can refift the Yawn of Gods?
Churches and Chapels inftantly it reach'd,
St. James's firft, for leaden G-lb-t preach'd,
Then catcht'd the Schools; the Hall fcarce kept awake;
The Convocation gap'd, but could not fpeak.
Loft was the Nation's Senfe, nor could be found,

While the long folemn Unifon went round;
Wide, and more wide, it fpread o'er all the realm;
Ev'n Palinurus nodded at the Helm;
The Vapour mild o'er each Committee crept;
Unfinish'd Treaties in each Office flept;
And Chief-lefs Armies doz'd out the Campaign;
And Navies yawn'd for Orders on the Main.

DUNCIAD.

142. George Bickham (the Younger), *The late P-m-r M-n-r* (engraving, 1743)

143. Louis-Philippe Boitard, *A Village Dance* (ink, watercolour, no date)

But it was a rural scene, not a London one. In the 1740s, likewise, Francis Hayman painted scenes of pretty rococo people enjoying themselves (for the boxes of Vauxhall Gardens). Yet his milkmaids dancing on May Day (fig. 144) were as authentic as Marie Antoinette was when she pranced about Versailles in her milkmaid outfit.

LONDON'S HAPPINESS

It took over a quarter-century before people were ready to buy un-didactic depictions of workaday happiness and for an urban humour

144. Francis Hayman, *The Milkmaid's Garland, or Humours of May Day*
(oil, 1741–2)

in that sense to take root. This extraordinary shift now feels like the lift-
ing of a deep historical shadow. London's coming lead in the production of
humorous images owed everything to the growing market power of
modestly prospering middle- and middling-class Londoners. These
people were to be as shocked by the loss of the American colonies and
by awesome disturbances like the Gordon Riots as everyone else who
read the newspapers. The likes of Blake and Wordsworth could still
bewail the anonymity, alienation and cruelty of metropolitan life. And
war darkened the last years of the century, as did clampdowns on free
expression. Yet material conditions were improving for many of them.
Police and poor law regulations were beginning to bite, which made
them feel safer; fine buildings, squares and bridges were multiplying,
which made them prouder; and civil life offered ever more pleasures,
while manners were softening. Public horrors were curtailed. No more
heads were impaled on Temple Bar, and public hangings were moved
from Tyburn to the outside of Newgate in 1783. As the public violence
of men was curbed, the later decades of the century witnessed a new
cultural confidence among women. All these things made it increasingly
possible after mid-century to cultivate a gratified sense of belonging to

a benign as well as a great city – of enjoying in it 'a vast museum of all objects', as James Boswell put it, and of thinking 'with a kind of wonder that I see it for nothing'. He felt 'all life and joy' at the prospect of it. Boswell's joyousness was one of the first hints of things to come. 'I sung all manner of songs,' he wrote in 1762 as he beheld London's spires from Highgate Hill after travelling from Scotland,

> and began to make one about an amorous meeting with a pretty girl, the burthen of which was as follows: 'She gave me *this*, I gave her *that*; / And tell me, had she not tit for tat?' I gave three huzzas, and we went briskly in . . . The noise, the crowd, the glare of shops and signs agreeably confused me. I was rather more wildly struck than when I first came to London. My companion could not understand my feelings. He considered London just as a place where he was to receive orders from the East India Company.

You find the same delight in Samuel Johnson. Once when friends woke him up at three in the morning to invite him to join them in a 'ramble', he gamely replied 'What, is it you, you dogs! I'll have a frisk with you': so 'they sallied forth together into Covent-Garden, where the greengrocers and fruiterers were beginning to arrange their hampers, just come in from the country':

> Johnson made some attempts to help them; but the honest gardeners stared so at his figure and manner, and odd interference, that he soon saw his services were not relished. They then repaired to one of the neighbouring taverns, and made a bowl of that liquor called 'Bishop', which Johnson had always liked; while in joyous contempt of sleep, from which he had been roused, he repeated the festive lines, 'Short, O short then be thy reign, And give us to the world again!' They did not stay long but walked down to the Thames, took a boat, and rowed to Billingsgate.

Johnson it was who later celebrated that 'happiness of London' that was 'not to be conceived but by those who have been in it'. 'When a man is tired of London, he is tired of life; for there is in London all that life can afford.'[7]

The most developed expression of this engaged and interested attitude of mind dates from the turn of the century, and is to be found in

Charles Lamb's celebration of the 'fulness of joy at so much life', as he called it.[8] In 1801, living penuriously with his sister Mary in Mitre Court Buildings off Fleet Street, Lamb sent William Wordsworth this marvellous encomium on London life:

> The lighted shops of the Strand and Fleet Street, the innumerable trades, tradesmen and customers, coaches, waggons, play houses, all the bustle and wickedness round about Covent Garden, the very women of the town, the watchmen, drunken scenes, rattles; – life awake, if you awake, at all hours of the night, the impossibility of being dull in Fleet Street, the crowds, the very dirt & mud, the sun shining upon houses and pavements, the print shops, the old book stalls, parsons cheap'ning books, coffee houses, steams of soups from kitchens, the pantomimes, London itself a pantomime and a masquerade, – all these things work themselves into my mind and feed me without a power of satiating me. The wonder of these sights impel me into night-walks about her crowded streets, and I often shed tears in the motley Strand from fulness of joy at so much life.

'Streets, streets, streets,' he wrote to another friend,

> markets, theatres, churches, Covent Gardens, shops sparkling with pretty faces of industrious milliners, neat seamstresses, ladies cheapening, gentlemen behind counters lying, authors in the streets with spectacles (you may know them by their gait), lamps lighted at night, pastrycook and silversmith shops, beautiful Quakers of Pentonville, noise of coaches, drowsy cry of mechanic watchmen at night, with bucks reeling home drunk if you happen to wake at midnight, cries of fire and stop thief ... These are thy pleasures, O London-with-the-many-sins. O city abounding in whores, for these may Keswick and her giant brood [the Lake District poets] go hang.

Lamb was so pleased with this vision that he amplified it for Wordsworth in 1802 (whence, probably, Wordsworth's '*Dull* would he be of soul', composed on Westminster Bridge):

> The man must have a rare recipe for melancholy, who can be *dull* in Fleet-street ... Often, when I have felt a weariness or distaste at home, have I rushed out into her crowded Strand, and fed my humour, till

tears have wetted my cheek for inutterable sympathies with the multi-
tudinous moving picture, which she never fails to present at all hours,
like the scenes of a shifting pantomime.

In 1817 Charles and Mary moved into lodgings above a brazier's
shop at 20 Russell Street, off the Covent Garden Piazza. They lived
there for six years, and were delighted to do so. As Mary wrote to
Dorothy Wordsworth, she found the streets there 'all alive with noise
and bustle':

> Drury Lane Theatre in sight from our front, and Covent Garden from
> our back windows. The hubbub of the carriages returning from the
> play does not annoy me in the least; strange that it does not, for it is
> quite tremendous. I quite enjoy looking out of the window, and listen-
> ing to the calling up of the carriages, and the squabbles of the coachmen
> and linkboys.

Her brother then added in a postscript:

> We are in the individual spot I like best in all this great city. The theatres,
> with all their noises. Covent Garden, dearer to me than any gardens of
> Alcinous, where we are morally sure of the earliest peas and 'sparagus.
> Bow-street, where the thieves are examined, within a few yards of us.
> Mary had not been here four-and-twenty hours before she saw a thief.
> She sits at the window working; and casually throwing out her eyes, she
> sees a concourse of people coming this way, with a constable to conduct
> the solemnity. These incidents agreeably diversify a female life.

Now lodging squarely in Hogarth's territory, the Lambs self-evidently
shared Hogarth's fascination with the noisy, rude and risqué life they
saw from their windows, and they saw much of it through his eyes.
Charles in 1811 had written admiringly on Hogarth's 'Genius and Char-
acter' while sitting in his own 'Hogarth Room' in which he displayed his
framed Hogarth prints. Yet it wasn't in Hogarth that the Lambs would
have found the best depictions of the life referred to in these letters, but
in a man of their own era, whom Lamb mentioned only once, and then
dismissively and in passing.[9] It is a striking fact that every one of the
subjects catalogued in Lamb's letters is included in the drawings and
etchings of Thomas Rowlandson (fig. 145). Covent Garden's energies

145. Rowlandson, *Covent Garden vignettes: Heres your Potatoes four full Pound for two pence; Buy my Moss Roses or dainty sweet briar; Light, your Honor, Coach unhired; Pray Remember the blind* (etching, 1811)

agreeably diversified not only the Lambs' lives, but Rowlandson's life too – and in rather the same way. He led the way in celebrating this new urban joyousness – internationally, too. In Paris Delacroix was copying

Rowlandson caricatures as late as 1825 and Louis-Léopold Boilly was repeating Rowlandson scenes in 1830.[10]

*

Humour is less aggressive and more sympathetic than wit or satire. It enables one to be genially or affectionately amusing or amused, and to participate in other people's similar responses to life's oddities; it celebrates the unthreateningly accidental and unexpected and hence comic. Humour has many histories, however. Its nature changes with time, culture and place.

Before the 1770s or so the business of being humorous posed all manner of difficulties for artists. It had no place in formal artistic values, and its geniality was rarely expressed in non-academic art either. The genre painters of the seventeenth-century Low Countries amused through cheerful vulgarity. While caricature amused, its distortions of face and figure were aggressive. And although Hogarth could be witty, there was that chilly intellectualism in his work that ensued from tight compositional calculation and didactic intent. Moreover, outright laughter was tabooed among the elaborately polite classes. Lord Chesterfield thought it acceptable to be seen to smile, but not to laugh: for laughter 'is the manner in which the mob express their silly joy at silly things; and they call it being merry'.[11] A profound softening of taste and manners had to suffuse the middle classes before the artist's or other people's joy in life, and especially the common people's joy in life, could become artistic subjects. Although English satire remained as merciless as ever in the second half of the eighteenth century, a gentler benevolence came to be more valued.

The pictorial trendsetters in this regard were the printshops of Robert Sayer in Fleet Street and of Carington Bowles in St Paul's Churchyard. In and after the 1760s, they built on a continuing demand for earlier Dutch prints by creating a flourishing market for modern 'drolls' and genre mezzotints by the likes of Robert Dighton and John Collet. Comedies of manners were the subjects of these images, but with time their social reference shifted interestingly downwards.[12] For the first time art was being claimed as the people's entitlement.

It was the prolific Dighton who did most to open the way to a more popular if rough-hewn comedy. He was a man of several parts. He had entered the Royal Academy Schools in 1772 (in the same year as Rowlandson), and then settled in Charing Cross as a drawing-master and painter of miniature portraits. He occasionally exhibited at the Free Society of Artists and at the Royal Academy. A talented singer, he even performed in 1784 at his own benefit in Covent Garden theatre as Macheath, the highwayman-hero of *The Beggar's Opera*. By then his artistic ambitions were declining. His drawing of the Devonshire sisters at the Westminster hustings of 1788 shows that he could still pull out the artistic stops (**plate 6**). But after various forms of adulterous and criminal fecklessness, including the generation of several illegitimate children and the theft of invaluable Rembrandt prints from the British Museum to pay for them, he was driven to make fast pennies by deploying caricature, sex and cruder colouring in his designs for Bowles. The most exuberantly joyous of these was *Whitsuntide Holidays* (1783) (fig. 146).* A perilously overcrowded coach is taking a party of flirtatious sailors, soldiers and girls on their holiday jaunt from Charing Cross to Greenwich, in whose park Londoners commonly took their pleasures. Perched on top of the coach, they teeter absurdly on the edge of disaster as they play trumpet, fife, fiddle and drum; a mother wipes her baby's bottom. The scene is marginally darkened by the beggar, the dragged-along dog and the grotesque faces on top of the coach. And topical references to the quack Doctor Graham and to Admiral Rodney's victory at the Battle of the Saintes anchor it to a precarious reality. Dighton mishandles the horses' proportions, and the coach's load is comically implausible. Yet the print contains neither judgement nor commentary. Only a rollicking *joie de vivre* informs drafting and subject alike.

There's no knowing whether Philippe-Jacques de Loutherbourg had Dighton's joke in mind when he painted his own *Revellers on a Coach* (fig. 147), or whether it was the de Loutherbourg painting that influenced Dighton.† What signifies is that by the 1780s, both in print

* The print is unsigned, and neither the British Museum nor the Guildhall Library names its artist. But the style is unmistakeably Dighton's; the ill-proportioned horses are replicated in his named *Two Impures of the Ton driving to the Gigg Shop* (BM).
† YCBA dates the de Louthebourg 'between 1785 and 1790'.

146. Robert Dighton, *Whitsuntide Holidays* (etching, 1783)

and in painting – and in a painting by a Royal Academician, moreover, an unmoralized sense of the humorous had become permissible and sellable. This shift was irrevocable by the time Rowlandson chipped in with his own coaching extravaganzas – with his *London Citizen*, a cheerful swipe at the carriage-driving incompetence of the new-rich and overfed City 'cits' (fig. 148), or with his most ridiculously exhilarating work of this kind, *'Tis Time to Jump Out* (**plate 24**)

The importance of the shift can't be stressed enough. The entitlement and the confidence to deliver an art of such genial informality that was rooted in the here-and-now, its absorption into satirical, humorous and illustrative print, and the growth of a market hungry for it, count among Georgian culture's greatest innovations. It changed the content and the meanings of the visual over the next century and more, and provides not the least of the reasons for the gradual erasure in nearly all forms of art of neo-classical pretensions.

147. Philippe-Jacques de Loutherbourg, *Revellers on a Coach* (oil, 1785–90)

148. Rowlandson, *The London Citizen* (pencil, ink, watercolour, no date)

ROWLANDSON'S HUMOURS

Thomas Rowlandson was in the vanguard of this great movement.[13]
He was the most spontaneous of all eighteenth-century artists, and the
most versatile, and the greatest comic artist Britain has produced, and
among Britain's greatest draughtsmen. Nobody else has so variously
celebrated the energy of urban life and so communicated his delight in
it. 'His powers . . . were so versatile, and his fancy so rich, that every
species of composition flowed from his pen with equal facility,' wrote
Rowlandson's friend Henry Angelo; he 'has sketched or executed more
subjects of real scenes, in his original, rapid manner, than any ten art-
ists, his contemporaries, and etched more plates than any artist, ancient
or modern.' Then Angelo added that 'his misfortune . . . was . . . that of
possessing too ready an invention'.[14] This was fair comment. Across
his working life Rowlandson seems to have turned out sketches and
drawings after every venture into the streets or the countryside. His
life-time output of drawings has been put at over 10,000 – and doubt-
less hundreds more are lost or hidden.[15] Moreover, over 1,000 of his
satirical and humorous print titles are listed in the British Museum
catalogues before 1820. Hundreds more are held in other libraries,
and more still are buried in the seventy books he illustrated from 1784
onwards, including Fielding's, Goldsmith's, Sterne's and Smollett's.[16]
Rowlandson's work is still uncatalogued.

His abundance and carelessness alike have always provoked pos-
terity's condescension. One expert affirms that 'Rowlandson saw
everything in the same way; everything he touched became Rowland-
sonian' – as if everything that (say) Blake or Fuseli touched didn't
become Blakeian or Fuselian. He pays no attention to the range of
Rowlandson's emotional registers, and he dismisses his prints as 'bare
indications of the richness of the drawings on which they are based'
– thus aloofly waving aside the social and cultural world in which
Rowlandson worked, the growing significance of print culture, and
the fact that many prints elaborated brilliantly on preliminary
sketches.[17] In a blaze of contradictions, another expert complains that
Rowlandson poured out drawings 'as Schubert did songs', which
would have been no mean thing if true.[18] Yet another has found the

quantity of his work 'depressing' because it showed that 'Rowlandson does not feel, or think, very deeply.'[19] These lazy judgements are tainted by the snobbery of old-fashioned art history. Critics and collectors have always felt safest with conventionally reputable genres and narrow understandings of aesthetic effect, so they have approved the inoffensive delicacy of Rowlandson's watercolour drawings, not least because they sell safely. But the meanings of his comic vision they have ignored, while his prints and his 'coarseness' have caused them the very deepest unease.

Rowlandson's 'coarseness' upset critics from early days. He was nurtured in an impolite world whose earthy honesty was precisely what history painting and neo-classical art were designed to veneer over. Yet Fuseli and Turner drew copulatory pictures. Most artists, including these, kept mistresses. And everyone who frequented Covent Garden's fleshpots knew that masculine identity was constructed around the pleasures of what they called fucking, while bums-and-farts humour was a language shared by gentlemen and princes alike, and by some ladies, too.[20] Oddly, one of Rowlandson's distinctions is that he was all but alone among satirists in eschewing scatology.

Manners were changing fast in the 1820s, however, and Rowlandson's robust humour fell out of fashion. Thanks to the increasing assertiveness of evangelical and upwardly mobile opinion-makers, more domesticated and respectable tastes were gaining ground. Only one obituary noticed Rowlandson's death in 1827, and only Angelo, Ackermann and Bannister the actor are recorded at his funeral in St Paul's Covent Garden. For half a century thereafter few collectors were said even to remember his name.[21] Thackeray deplored 'the hideous distortions of Rowlandson, who peopled the picture-books with bloated parsons in periwigs, tipsy aldermen and leering salacious nymphs, horrid to look at'. Dickens had no time for Rowlandson or Gillray because their satire was 'rendered wearisome and unpleasant by a vast amount of personal ugliness'. Another Victorian thought Rowlandson 'more violent than strong, more odd than droll, and often more disgusting than either'.[22] This view endured into the twentieth century. 'Accumulations of pictured filth, incredible elaborations chalked by gutter-snipes on street walls or worse,' was all one critic could say about his erotica. What could be worse than street walls is

not explained, but until lately everyone found it appropriate to agree. Only very recently has there been serious discussion of the relationship between his erotic prints and the values of his age.[23] Posterity's immense condescension nowadays seems wearisome in turn.*

Rowlandson was born in 1757 to cloth-merchant parents in Old Jewry in the City of London. His father was bankrupted when he was aged two, so he and his sister were put under the guardianship of their prosperous silk-weaver uncle and aunt in Spitalfields while the rest of the family decamped back to their ancestral turf in Yorkshire. When she was widowed, their aunt moved with the children to join the Huguenot community in Soho. She sent Thomas to Dr Barwis's Academy in Soho Square, where he formed lifelong friendships with Angelo and the actor John Bannister.[24] Then she got him admitted to lessons in the Duke of Richmond's sculpture gallery in Whitehall's Privy Gardens, and again supported him at the Royal Academy Schools for several years beginning in 1772. Thanks to her, Rowlandson was among the better educated and more widely travelled of artists. Her Huguenot origins explain his fluency in French and interest in Paris. She probably paid for his two visits to that city in the 1770s and for three in the 1780s. On the eve of Revolutionary war in 1791–2, he went on a drawing expedition to the Low Countries and northern Germany with his then patron the Strand banker Matthew Michell. He visited Italy at least once. His sketchbooks are filled with studies after Rubens, Poussin and Correggio, and his collection of Old Master prints, drawings and paintings was considerable.

In early years his prospects were bright. At the Academy in the 1780s he exhibited twenty or so watercoloured drawings, and more at the Society of Artists. They included elaborate tableaux like his *Vauxhall-Gardens*, demure pastoral landscapes or riverscapes, and flattering if amusing representations of high life. Their fusions of narrative, topography and figures, and their grey washes and pastel tints, reflected the illustrative techniques he had learned in Paris. He was widely collected. Newspaper advertisements show that his drawings featured in dozens of auctions during his lifetime, and Old Masters such as Rembrandt and modern ones like Gainsborough were auc-

* See the note on 'Rowlandson's posthumous reputation' at the end of this chapter.

tioned with them. Even in far-away Newcastle the great wood-engraver
Thomas Bewick's library boasted of '2 large Fols of Rowlandson's
Sketches'. Michell the banker bought over 550 of his drawings.[25]

In Soho and Covent Garden, and with forays westwards into St
James's, Rowlandson strutted as fashionable young dog-about-town.
Good-looking if portly, affable, educated, and lubricated by his aunt's
money, he was a pleasure-seeker, sensualist and flirt.[26] As a failed trades-
man's son, he would never be accepted on equal terms in high society,
but he seems to have gambled with high people. And this was his flaw.
Flush with his aunt's £2,000 bequest after her death in 1789, he played
at fashionable gaming houses for thirty-six hours on end, winning and
losing large sums without emotion.[27] William Ward's mezzotint of *The
Gamesters* (1786), after a painting by Rowlandson's friend the Rev. M.
W. Peters, shows Rowlandson (right) cheating the young aristocrat
William Courtenay at cards with an accomplice's help (fig. 149). And in

149. Rev. M. W. Peters (after), *The Gamesters* (mezzotint, 1786)

Smithfield Sharpers (**plate 25**), engraved from a lost drawing that Row-landson exhibited at the Academy in 1787, he depicts himself (second from the left) in the swelling pleasure of beating a young country lad at cards, surrounded by shady-looking tavern companions and helped by the broken mirror on the right, while the lad's father snores.

These pictures were said to have been elements in a teasing joke about his addiction among Rowlandson and his friends.[28] But if he did cheat, he got his come-uppance soon enough. He gambled away his legacy and fell on hard times. He had to lodge in what the rate-books termed a 'dismal' basement at 2 Robert Street in the Adelphi just off the Strand, and then above a Pall Mall printshop in rooms next to his friend, the dissolute George Morland. For a year or so he lived in the Strand in lodgings just vacated by the artist Valentine Green. His fall from grace, however, forced him to reinvent himself, so it had a creative effect.

After 1790, the people of quality disappear from his drawings as central subjects, and reappear only in his cruellest satires. They were replaced by a deeper interest in the life of people in streets or taverns or on the Thames than had seemed profitable in the 1780s. He began to depict the whole gamut of metropolitan pleasures high and low – from masquerades and pleasure gardens to theatres and fairgrounds, on to the holiday fun of rolling over and over with pretty girls down One-Tree-Hill at Greenwich.[29] Henceforth he avoided Academicians, and they ignored him in return, though Sir Thomas Lawrence later collected his drawings. Contemporary reference to him in a bare handful of letters and books is scanty. Horace Walpole never once referred to him, and the diarist Joseph Farington mentioned him only a couple of times in passing, as attending this or that dinner. Approving references in newspapers disappeared. His closest friends were raffish – his old Soho schoolfriends Bannister the actor and Angelo the fencing master, and artists and caricaturists such as Morland, Collings, Isaac Cruikshank and G. M. Woodward, some of whose work he engraved. Occasionally he is said to have shared a tavern quaff with the laconic Gillray. Accord-ing to a perhaps fanciful recollection, the two men would

> exchange half-a-dozen questions and answers upon the affairs of copper
> and *aquafortis* [acid]; swear all the world was one vast masquerade; and

then enter into the common chat of the room, smoke their cigars, drink their punch, and sometimes early, sometimes late, shake hands at the door, look up at the stars, say 'It is a frosty night', and depart, one for the Adelphi, the other to St James's Street, each to his bachelor's bed.[30]

From now on Rowlandson published large numbers of prints on his own account from his Adelphi address. He also used Humphrey's and Holland's Covent Garden printshops and from 1807 Thomas Tegg's printshop in the City. His most helpful employer was the German immigrant Rudolph Ackermann, who ran his 'Repository of Arts' at 96 and then at 101 Strand. From 1797 onwards Ackermann rescued Rowlandson from relative penury by directing him towards book illustration.

In 1804 Rowlandson was lamenting the niggardly patronage of 'the long pursed gentry' who had patronized him in his younger days. He needn't have worried. War cut the export of art prints, but domestic demand for cheaper print and book illustration was booming, and his watercoloured drawings never lacked buyers. The better satirists could get a guinea or more for an engraved plate (after paying for the copper); and Rowlandson at full tilt could bang out a dozen or more of these a week. In the 1800s many of his prints produced by Tegg were shoddy, since Tegg cut prices by using old plates and garish watercolouring. Still, in 1809, probably his most productive year as print-maker (the British Museum catalogues 171 titles for that year), his work for Tegg included fourteen portraits and fifty-six satires (sometimes two a day) on the Duke of York's scandalous affair with the courtesan Mary Anne Clarke; dozens of comic prints for *Tegg's Caricature Magazine* and for Tegg books on cockney sports; several prints on *The Beauties of* [Laurence] *Sterne*; some single-sheets for Ackermann; and aquatints for Ackermann on Dr Syntax and for *The Microcosm of London* (1808-10), the profitable survey of metropolitan sights on which he collaborated with Augustus Charles Pugin.

Hard labour was required for publications like these. As this account explains very well, Rowlandson would be

summoned to the [Ackermann] Repository from his lodgings in James Street, in the Adelphi, and supplied with paper, reed-pen, Indian ink, and some china saucers of water-colour. Thus equipped, he could dash

150. Rowlandson, *Caricature of a French Hunt* (ink, watercolour, 1792)

off two caricatures for publication within the day; but in the case of the coloured books he worked with greater care. With his rare certainty of style, he made a sketch, rapid but inimitable. This he etched in outline on a copper plate, and a print was immediately prepared for him on a piece of drawing-paper. Taking his Indian ink, he added to this outline the delicate tints that expressed the modelling of the figures, and the shadowing of interiors, architecture, or landscape. The copper plate was then handed to one of Ackermann's numerous staff of engravers, Bluck, Stadler, Havell, and the rest. When Rowlandson returned in the afternoon he would find the shadows all dexterously transferred to the plate by means of aquatint. Taking a proof of this or his own shaded drawing, the artist completed it in those light washes of colour which are so peculiarly his own; and this tinted impression was handed as a copy to the trained staff of colourists, who, with years of practice under Ackermann's personal supervision, had attained superlative skill.[31]

Despite much hasty hack-work, Rowlandson's techniques and inventiveness were re-energized in these years. His early etchings had

been finicky; but now he was achieving masterly drawings, carica-
tures and etchings that were alive with dynamic and swirling lines and
rich colours (fig. 150).[32] He was still selling picturesque rural draw-
ings, but arguably his greatest works were his seventy-four aquatints
for *The English Dance of Death* (1815–16), which Ackermann bound
in two volumes and sold at the hefty price of three guineas. Here
Rowlandson adapted the ancient genre of the skeletal dance to com-
ment on modern manners, but his pictures are unique for their
discordant jauntiness. They meld the gruesome, the grotesque and the
sardonic in poignant combinations, with the comic (because human)
figure-work (bone-work?) achieved in brilliant draughtsmanship,
composition and etching. Death is admitted into the heart of life, and
print after print in these volumes is a small masterpiece. 'I [en]list
you,' says the skeleton in *The Recruiting Party*, 'and you'll soon be
found, / One of my regiment under ground' (fig. 151).

Rowlandson prospered. By the late 1790s he had moved back to the
Adelphi just south of the Strand. He installed his own printing press in
1 James Street and lived there until his death in 1827. He left nearly
£3,000, along with a collection of Old Master paintings (Andrea del

151. Rowlandson, *The Recruiting Party* (aquatint, 1815–16)

152. Rowlandson, *Hyde Park Corner* (pencil, ink, wash, no date)

Sarto, Paris Bordone, Marco Ricci, Van Dyck, Teniers), engravings (Rembrandt, Rubens, Dürer, Hogarth) and drawings (Rembrandt). The collection took thirty-five pages to list and Sotheby the auctioneer four days to sell. This whole estate he bequeathed to 'Betsey Winter Spinster'. For twenty years she had been his commonlaw wife; we know next to nothing else about her.[33]

THE DARKER NOTES

At times Rowlandson's cheeriness is so unremitting that one yearns for other registers. Lovers canoodle in his prettiest landscapes. Old men are grotesque. And the mishap and chaos that propel his more dynamic pieces put them on the edge of slapstick. As a snobbish newspaper critic put it long ago, 'He is the master of the horse-laugh, the most persistent and implacable of all adepts of the English tradition of Philistine humour ... The path of humanity is strewn with banana skins and the French go head over heels at Waterloo with the same richly satisfying

effect as when old women tumble in the streets of London.'[34] We see him in the very throes of invention in this mode in an undated sketch of people, horses and coaches at *Hyde Park Corner* (fig. 152), which he scribbled impromptu across two sheets of notebook. Although he touched it in with grey wash later, it was apparently done neither for sale nor for etching, but just for the driving pleasure of the thing. In it he couldn't resist elaborating on what had probably been a quite orderly scene. A phaeton collides with horses on the left, the stumbling horses are about to knock down pedestrians, excited dogs race and bark, in the roadway a young man kisses the young wife's hand behind the old husband's back, and a leaping horse knocks over a fat man and woman on the right. None of this was the usual way of things at Hyde Park Corner. Houses and toll-gate apart, this wasn't 'realistic' representation.

Yet in truth Rowlandson's humour had several registers, and some weren't at all genial. People usually suffer in his work. If it weren't for his reported affability and images that suggest otherwise, one would wonder whether his fusion of emotional detachment and talent put him somewhere on the autistic spectrum. His obsessionally triangular sexual narratives and his fascination with disaster[35] suggest cruelty, while

the grotesques he experimented with in the 1800s and 1810s have a nastiness about them that exceeds the satirist's needs. His bucolic landscapes ignore rural poverty and degradation, and, because his eye was fixed on London and the English south and west, you'd never know from his work that an industrial revolution was immiserating workers in the midlands and north (though you could say the same of Jane Austen as well as many others). His human subjects are undifferentiated, his young women curvaceously identical. He was no good at portraits, and he was seemingly blind to pathos. When he and Henry Angelo visited Portsmouth together to view the return of Lord Howe's battle-battered fleet in 1794, Angelo found the evidence of ghastly carnage unbearable and had to leave. He was amazed that Rowlandson insisted on staying longer in order to draw the agonized death throes of a hideously wounded French prisoner, his natural feelings apparently eclipsed by curiosity.[36]

Rowlandson's latest biographers observe that he passed through his age without leaving a deep impression of his inner self.[37] Yet the same could be said of most artists of the time. What was Reynolds's inner self like? If the modern self was invented in these years, it didn't necessarily express itself in self-reflection or self-display. Puzzlement about others' emotional promptings and the need to explain one's own are modern afflictions.

The difficulty lies rather in our sense that we *must* read Rowlandson's motives because, unlike Reynolds, indeed unlike nearly everyone else, he recorded so much in his England that was disturbing as well as pleasurable, and because in the sheer range of his repertoires, from picturesque to satirical to grotesque to comic, he poses the very deepest questions about artistic witnessing. Yet in the end our enquiries are bound to be frustrated. We're left with his images, never his words, and the directions in which they point can be contradictory. He leaves the closest impression of his inner self, but not one that's easy to read.

For instance, did his unflinching gaze on that naval ship speak for something more than a sick curiosity? In this era 'curiosity' might express a form of honest witnessing, an avoidance of cant, a testing of courage and manhood. In Rome, Byron watched 'horrible' executions by decapitation because one shouldn't flinch from life's realities; one

153. Rowlandson, *A Gibbet* (pencil, ink, watercolour, no date)

needed to watch another's death to experience it as one would one's own.[38] Such determined observation of misery was still rare in Rowlandson's time. The only European contemporary who dared look closely at wartime horrors through an unblinking lens was Goya in Spain. Likewise, Géricault's sketch of a *Public Hanging,* made on a London visit in 1820, was the first to look deeply into the staring eyes of a man standing on a scaffold with a noose around his neck. Yet Goya's work came long after Rowlandson's encounter with the dying casualties at Portsmouth. And although Géricault's intensity lay beyond Rowlandson's talents, Rowlandson's ghastly gibbeted bodies still shock (fig. 153).*

* The Géricault is in the Musée des Beaux Arts, Rouen: reproduced in Gatrell, *The Hanging Tree,* p. 182. Rowlandson did look as closely as he could at a husband-murderess on

154. Rowlandson, *A Happy Couple* (pen and ink, no date)

It helps his accessibility that the comedies of sex fascinated him, since that better connects him to our modern sensibility. His fascination had many outlets. There's no knowing what passing fit of loving domesticity impelled him to produce some of his gentlest drawings – of this sweetly *Happy Couple*, for instance (fig. 154); but there were few of these. He picked up with ease pretty and obliging models from all social levels, while brothel madams could always provide him with nude ones. Among metropolitan sophisticates like himself libertine

her scaffold in his *Execution of Mary Evans at York August 10 1799 for Poisoning her Husband* (York Art Gallery) – though it's true that the grotesque clergyman and hangman undercut the pathos.

values were deep-rooted. As he discarded the ambitions he might have nurtured in the 1780s, his work began to reflect these sexually incontinent manners more frankly. Men's efforts to seduce women and women's to seduce men recur in hundreds of his later prints, while his erotic prints depict an impressive variety of sexual practices and positions which imply expert experience and knowledge. The Prince of Wales is said to have been a leading client for his erotic prints, though there were plenty of other aristocrats to buy them if he wasn't.[39]

Rowlandson's sexual vision reflected something darker than the libertine values of the age, however. His repeated depictions of the seductive or voyeuristic relationships of grotesque old men and busty young women were as compulsive as were his triangulations of young wife, young lover and betrayed old husband. These pictures always took the side of youth and were full of contempt for the old. Did they reflect the effect of his failed, neglectful and twice-marrying father? Relations between father and son were cool: his father bequeathed Rowlandson and his sister a shilling each when he died in 1805.[40] Or perhaps all we need say is that at the root of his sexual comedy was a fear of death – 'a clawing, nagging fear of falling apart,' as the critic Robert Hughes puts it, that compelled him to remind his viewers that age is what we all come to: 'gouty, poxed, many-chinned, snouted, toothless, cunning, gross and mangy, peering with lust and censure at the beautiful juicy young, who mainly ignore them'.[41]

As a satirist Rowlandson was never as deep a hater as Gillray, nor did he have George Cruikshank's political bravado. Despite an innate Toryism and loyalism, he wasn't a deeply political animal. Most of his many political satires were lacklustre, and he changed colours as printshop owners or patrons dictated. It was probably thanks to the Prince of Wales's patronage that he was the only major satirist not to join others' mockery of the prince in the 1790s and during the Regency.[42] On the other hand, his mockeries of *social* pretension, privilege and folly were fierce and well aimed. There is no question that the artist who could produce scores of prints exposing the absurdity of ageing husbands with young wives or of ageing connoisseurs ogling naked female flesh, or whose cruellest grotesques could touch the perverse sublimity of *A Sporting Cove* (fig. 155) or *An Aristocrat* (plate 15) – was a feeling man well equipped with the satirist's capacity for anger

and contempt. And while he is not commonly thought of as a defender of social justice, some prints and drawings explicitly attacked the pretensions of the wealthy, sanctimonious or socially aspirant – in satires on gluttonous clergymen, pretentious tradesmen, cruel tax collectors and press-gangs, or on the moral equivalences between the wealthy ladies of St James's and the poor women of St Giles's.[43]

Still, a final verdict points elsewhere. Rowlandson was more often amused than mocking. He had less edginess than Gillray, and far more of Lamb's 'fulness of joy at so much life' than any other artist had mustered up to that date. For the most part, he depicted his humble subjects because he was fascinated by their oddities, and it would seem that he liked them. Furthermore, his energy propels his work

155. Rowlandson, *A Sporting Cove* (pencil, ink, watercolour, 1815–20)

into the wilfully disordered and surreal, while his jokes rest on his capacity to push a situation to the edge of absurdity. His sense of the comic rested less on slap-stick than on a need to remind people of their mortality. If he delighted in anything more than youth's carnal pursuits, it was in the disorder that revealed pretension and fallibility. Or else he relished simply the comical interplay of incident, caricature, punning title, and medium, the contrast between the exuberance of his subject and the elegance of his penwork and colour becoming part of the joke.[44] Beyond that, if you pick your way through scores of weaker, rushed or duplicated works, and ignore the botanical oddity of his trees and the repetitive rotundities of his young women, you'll find scores of landscapes, townscapes and shipping scenes in which the brushwork, pastel washes and compositions are exquisite. Some are conventionally picturesque because he knew what would sell; but more are finely observed, and nearly all are enlivened by energetically realized people, horses, dogs, wagons, coaches or ships. He was a draughtsman of genius. In his speedier sketches from life, his restless calligraphy effortlessly captures character in gesture and movement. The dashing impromptu calligraphy of *A Black Leg Detected Secreting Cards* (fig. 156), or his *Study of a Shouting Man* (at the gaming table) (fig. 157), have a vigour and spontaneity that Hogarth's line never achieved. The same goes for his ability to capture imminent catastrophe in his 'disaster' drawings of horses and coaches, or even simply to catch the rear view of postilion and horses from a bouncing cart or coach behind (fig. 158). He has been fairly called the greatest master of pure line and the finest draughtsman that Britain has produced.[45]

*

Rowlandson was never one to issue theoretical statements about his work, but he was as contemptuous of Academic values as ever Hogarth, Blake and Gillray were. His parodies of Academic art were many.[46] He continued with his picturesque landscapes for many years, but he gave up exhibiting at the Academy in 1787, well before he blew his fortune on gambling. Despite his training in the Schools (and plenty of evidence in his sketchbooks that he studied hard), he would have agreed with Hogarth that 'the eternal blazonry, and tedious repetition

156. Rowlandson, *A Black Leg Detected Secreting Cards* (pen and ink, no date)

of hackneyed, beaten subjects, either from the Scriptures, or the old ridiculous stories of heathen gods' weren't worth the paint thrown at them.[47] Hogarth was his bedrock, and his work quotes from him repeatedly. Like Hogarth, he never failed to go for the real, workaday subject, however surreally he elaborated it. It's thanks to this that he has become the artist who has most informed (though also misled) posterity's sense of what later Georgian London was like: he has been corralled into 'illustrating' countless histories, as he does this one.

His independence had a price, however. It explains why he was and is undervalued. To this day we most approve of experimental artists or of pathbreakers whom we like to think of as pointing 'forwards'. Rowlandson was utterly indifferent to this effect. He also ventured further away from the protection of the Academic barricades than any other contemporary except Blake. One result of his populist turn around 1790 was that the great changes in artistic fashion passed him by. His rococo manner, which he had learned in France and admired in Gainsborough, stayed with him throughout life. It led him to emphasize surface activity and to flatten out mass, depth, distance and the effects

157. Rowlandson, *Study of a Shouting Man* (ink, no date)

of light and atmosphere, so that his townscapes became shadow-free ideographs whose main point was the framing of human activity.[48] He never dispensed with the preliminary pencil or pen sketch, and he ignored young Thomas Girtin's free painting in colour washes and Turner's later experiments with light and atmosphere. Romanticism's emotional exhibitionism he simply parodied, just as he made unseemly jokes at the expense of fashionable 'sensibility' and its central principle, 'sympathy'. *Sympathy* (1785) he reduces to no more than the sympathetic urge of a travelling family of husband, ugly wife, pretty daughter, coachman, dog and horses together to 'lay the dust' – i.e. urinate by the side of their coach (fig. 159). He etched a genitally exposing version of *Sympathy* as well (people doing the same thing, more explicitly and obscenely); and a further eroticized pun on *Sympathy* reduced sensibility's central principle to the enthusiasm of animals and humans alike for fucking. One has to wonder at the anger hidden behind this repeated joke at the expense of a generous emotion.[49]

But the real problems for the *cognoscenti* have been first that he

158. Rowlandson, *An English Postilion* (pencil, ink, watercolour, *c.* 1785)

attended to low life, and secondly that he was *comic*. And such is the enduring power of eighteenth-century artistic hierarchies that many critics still therefore find it difficult to take him seriously. The *milieux* he worked in, his deepening indifference to the Academy's disciplines, and his irreverent subject-matter all guaranteed condescension. All the same, his rejection of cant and the darkness in his humour led him to strive for effects that lay beyond others' range. Countless pictures convey not the coolly amused detachment of the emotionally stunted, but an affection for his characters and for their submission to the small conditions of daily living that took him into humbler places and among humbler people than any previous English artist, Hogarth excepted, had ventured to face, and that few have faced since. Unlike Gillray or the genre artists, he might laugh at or with common people, but he never belittled them. This demotic or democratic, not to say Dickensian, generosity was his way of looking forward – towards an art that didn't have to be sublime or earnest in order to be true.

In this sense there was a magnitude to him that no other eighteenth-century artist matched. He was rather like a Dickens before his time – a Dickens without sentimentality or sexual reticence. Both men shared what Dickens's biographer Forster called 'animal spirits, unresting and

SYMPATHY, OR A FAMILY ON A JOURNEY LAYING THE DUST.

159. Rowlandson, *Sympathy, or a Family on a Journey laying the Dust* (etching, 1785)

supreme'. Each was a *flâneur*, compelled, as Dickens put it, 'to wander about in [his] own queer way' to relish and record street life. Each had Dickens's 'profound attraction of repulsion' to visions 'of wickedness, want, and beggary'.[50] Each achieved scathing satire as well as high geniality. Most important, each allowed humble people as much visibility as rich people – even a greater entitlement to happiness. Both, too, had a capacity at will to re-imagine their audiences and to shift their emotional registers. Steering our way through Rowlandson's abundance, we may be brought up short by fine drawings of ships or exquisite Gainsboroughesque landscapes, followed by flashes of the most perverse bawdry.

The word 'protean' is often applied to creative spirits like these. Few other English artists have embodied this quality as Rowlandson did. He is a far more significant artist than has been commonly recognized – an unequalled master of line who was more alert to the small negotiations of daily life than even Hogarth, and who was in this respect a pathbreaker who engaged with human subjects and said new things.

Rowlandson's posthumous reputation

After his death in 1827, Rowlandson was either forgotten or dismissed. We've noted that Thackeray, Dickens and others couldn't bear him. His name returned to public attention only with the publication in 1880 of Joseph Grego's *Rowlandson the Caricaturist: A Selection from his Works, with a Sketch of his Life*. This, however, didn't stop *The Times* declaring on 11 Aug. 1882 that he was 'of a rather bad school': he had lived a 'disreputable and very reckless life', and his 'coarseness' revealed him as the product of a rougher age. On 21 Jan. 1895 *The Times* again sneered at his 'ugly pictures of low life and tavern life', while in the old *Dictionary of National Biography* (1897) Austin Dobson patronized his 'lightly wrought and felicitous little idylls' and the 'grace and accuracy' of his women (even if they were of 'a somewhat overnourished and voluptuous type'), but then deplored his 'coarse and indelicate' caricatures.

Some parts of his work began to be taken seriously as his pastoral drawings started to fetch high prices; thereafter critical writings about him multiplied. In 1901, some of his drawings were bequeathed to the Victoria and Albert Museum, and a dozen years later a private collection of 113 drawings was sold at Christie's for £1,983, some at high prices (including the original of *Smithfield Sharpers* for 300 guineas). By 1923 A. P. Oppé's *Thomas Rowlandson: His Drawings and Water Colours* was affirming Rowlandson's standing as one of the great English watercolourists, while in 1927 the centenary of his death was celebrated at the Tate in an exhibition of ninety drawings, alongside watercolours by Cozens, Girtin, Cotman and Cox; a decade later he shared an exhibition with Blake, Rosetti, Fuseli and Girtin. On 27 Oct. 1931, *The Times* hailed another twenty drawings bequeathed to the Victoria and Albert Museum as the work of 'one of the great draughtsmen and landscape painters of the British school'.

Bernard Falk's *Thomas Rowlandson: His Life and Art* (1949) outlined what little was known of his life, and the Arts Council exhibited 150 of his drawings in 1950. *The Times* still ponderously worried that 'his rough outlook on life . . . prevented him from developing that last refinement of style which his specifically artistic gifts seem peculiarly

fitted to achieve' (10 Oct. 1950), but by now his best work was fetching big money. In 1945, a commercial traveller found *Vauxhall-Gardens* in a Walthamstow antique shop and bought it for a pound. It sold in the same year at Christie's for £2,730 and in 1967 at Sotheby's for £11,000 (*The Times*, 28 July 1945, 13 July 1967). In the same sale a Turner watercolour fetched £4,200 and a Samuel Palmer drawing £1,300.

In the 1960s, Robert Wark introduced and reproduced the Huntington Library's originals of *Rowlandson's Drawings for the 'English Dance of Death'* and *Rowlandson's Drawings for 'A Tour in a Post Chaise'*. Thereafter academic studies multiplied. The best was Ronald Paulson's *Rowlandson: A New Interpretation* in 1972. John Hayes's lazy judgements in his *Rowlandson: Watercolours and Drawings* of the same date have been noted above. The Huntington Library's holdings were catalogued in Wark's *Drawings by Thomas Rowlandson in the Huntington Collection* (1975); and in 1977 the Mellon Center in Yale published its catalogue by Baskett and Snelgrove, *Drawings of Rowlandson in the Mellon Collection*, and another by John Riely, *Rowlandson Drawings from the Paul Mellon Collection*, to coincide with an exhibition held jointly with the Royal Academy.

As late as 24 Feb. 1981, *The Times*'s critic at last felt safe in discerning 'an ambiguity, and a poetry, in Rowlandson which sets him apart from his contemporaries', and in thinking that 'however rough and ready Rowlandson's subject-matter, the watercolour technique is of an airy delicacy very hard to match'. Then he added that 'for all his reputation for vulgarity, Rowlandson is really not vulgar, at least where it counts, in the art'. This last contortion betrayed the critical confusions that echoed on still. Rowlandson's etchings he ignored. Only in 2010 was Rowlandson given a sympathetic biography by M. T. W. and J. E. Payne, *Regarding Thomas Rowlandson, 1757–1827: His Life, Work and Acquaintance*, while this chapter develops the more positive appreciation of my essay on 'Rowlandson's London' in Patricia Phagan, Vic Gatrell and Amelia Rauser, *Thomas Rowlandson: Pleasures and Pursuits in Georgian England* (2011).

9

The Gordon Riots: An Ending

In 1778, Parliament passed a Catholic Relief Act that allowed Catholics to run schools and to inherit or buy land if they swore an oath of allegiance. It asked for trouble. Soon the Protestant Association led by the maverick Scottish aristocrat Lord George Gordon was vigorously campaigning for the Act's repeal. On 2 June 1780 some 40,000 Protestants marched from St George's Fields south of the Thames to present a monster petition against the Act to Parliament in Westminster. Men with 'long lank heads of hair, meagre countenances, fiery eyes', they vowed that they would die in the streets rather than endure Popish government.[1] It didn't take long before fiercer elements in the crowd were abusing and stoning the coaches of Members of Parliament, bishops and lords as they arrived for the debates. Never before had the Quality been so treated or so frightened. Horace Walpole reported with some relish:

> There were the Lords Hilsborough, Stormont, Townshend, without their bags [wigs], and with their hair dishevelled about their ears, and Lord Willoughby without his periwig, and Lord Mansfield, whose glasses had been broken, quivering on the woolsack like an aspen. Lord Ashburnham had been torn out of his chariot, the Bishop of Lincoln ill-treated [dragged from his coach, in terror he escaped through a gentleman's house and then over the rooftops] ... Alarm came that the mob had thrown down Lord Boston and were trampling him to death – which they almost did. They had diswigged Lord Bathurst on his answering them stoutly, and told him he was the Pope and an old woman.[2]

For nearly a week thereafter, magistrates dared not read the Riot Act for fear of reprisals upon themselves. 'No Popery' crowds rampaged,

looted and burned with little to check them – people whose roughness Charles Reuben Ryley's extraordinary drawing didn't exaggerate (fig. 160). The Gordon Riots of 2 to 7 June 1780 changed all manner of assumptions in London, and in England too.

'A metropolis in flames, and a nation in ruins': that's how the poet William Cowper saw it.[3] In the event, the riots delivered only a few corners of London to flames, and the nation wasn't ruined, but they still count among the most alarming of all London's historic convulsions, and Covent Garden's communities were deeply shaken by them. Erupting during a dangerous moment in the American War, they exposed the depths of popular lawlessness and the fragility of the veneers that shielded elite cultures: social deference could never again be taken for granted. The riots were long remembered by the propertied classes. The caricatured and drunken 'No Popery' rioters in Dickens's gothic melodrama, *Barnaby Rudge* (1841), and Dickens's lament for the 'disgrace' they delivered upon their era, helped project the contemptuous image of the 1780 'rabble' deep into the Victorian imagination.

Bullets, soldiers and nooses won the government's argument with the crowd then, but they didn't stop more radical stirrings. The courtyards to the south of Chandos Street, Maiden Lane and Exeter Street had been radical hot-beds ever since John Wilkes's agitations in the 1760s. Though deeply damaged in 1780, the informal alliance between progressive and popular politics was reactivated in 1784 when Fox canvassed energetically in the Piazza and won the era's most famous election. In January 1792, nine artisans gathered in the Bell tavern in Exeter Street to hear the views of one Thomas Hardy, a Scottish shoemaker who attended a Dissenting congregation in Russell Street. This was the inaugural meeting of the London Corresponding Society – 'corresponding' with the French radicals, that is:

> After having had their bread and cheese and porter for supper, as usual, and their pipes afterwards, with some conversation on the hardness of the times and the dearness of all the necessaries of life, which they, in common with their fellow citizens, felt to their sorrow, the business for which they met was brought forward – *Parliamentary Reform*.[4]

Later that year a government spy was reporting on the meeting of a hundred of the Society's members in the Scotch Tavern in Round

160. Charles Reuben Ryley, 'No Popery' (pencil, ink, wash, 1780?)

Court and on another meeting of 'extremely low' people in the Red
Lion, Long Acre. In 1794, Hardy, Horne Tooke and John Thelwall,
son of a Chandos Street mercer, were tried and acquitted for treason.
It was also in the Scotch Tavern that in 1820 the butcher James Ings,
soon to be hanged and decapitated as one of the Cato Street Con-
spirators, plotted to murder the cabinet at dinner.[5]

Altogether, then, respectable Covent Garden had good reason to fear
that the low people were poised to take over. It was in good part thanks
to this anticipation that the Gordon riots helped destroy the 'town' as a
cosmopolitan and creative bohemia. The quest for urban civility was
redoubled, and tolerance of the low diminished. The local firing and
looting in Great Queen Street, Leicester Fields, St Martin's Street, Clare
Market and Bow Street, and the burning of Newgate prison a mile from
the Piazza (fig. 161), drove ever more of the comfortable as well as the
artistic classes to the safety of Mayfair, Kensington or Marylebone).

Sacked by the rioters, Savile House in Leicester Fields was taken over in turn by a carpet manufacturer, a bookseller and Miss Linwood's needlework exhibition. On his widow's death in 1789 Hogarth's house became part of the Sablonière Hôtel for 'foreigners'. Leicester House, long the home of the Princes of Wales, was demolished in 1792. Philippe de Loutherbourg built a moving-picture 'Eidophusikon' round the corner in Lisle Street in 1782, and Robert Barker his panorama theatre in Leicester Square in 1793, thus initiating Leicester Square's long descent to the sorry mess it is today.

Meanwhile, in Soho's St Anne's parish, the sixty to eighty titled residents of the 1690s declined to about twenty by 1741 and to seven by 1791, while the MPs who lived there declined from twenty-seven in 1733 to four in 1793.[6] Carlisle House in Soho Square, where the Viennese courtesan Theresa Cornelys had staged her fashionable masquerades, was closed in 1783 and demolished in 1793. A couple of

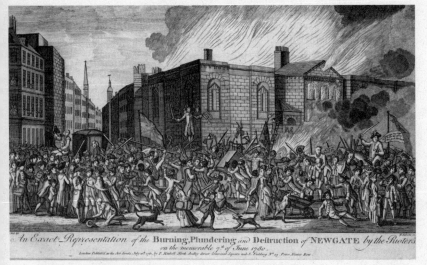

An Exact Representation of the Burning, Plundering and Destruction of NEWGATE by the Rioters on the memorable 7.th of June 1780.

161. J. H. O'Neale, *The Burning, Plundering and Destruction of Newgate by the Rioters* (detail) (etching, engraving, 1781)

decades later, John Nash's Regent Street was carved north from Piccadilly to Portland Place. This was nominally to establish a grand route from the Regent's Carlton House to the new Regent's Park, but in 1810 Nash admitted a political purpose. It aimed, he wrote, to establish 'a boundary and complete separation between the [western] Streets and Squares occupied by the Gentry and Nobility, and the narrower Streets and meaner houses occupied by the mechanics and the trading part of the community' – the turbulently opinionated people of Soho and Covent Garden, in other words.[7] The segregation of town and West End was set in stone.

The riots had deep stylistic consequences too. They impelled some artists to move away from the Academic neo-classicism and the reportorial realism of past decades to the dream language of the gothic sublime. Henry Fuseli's *The Nightmare*, painted a year after the riots, shows an evil incubus crouching on the breast of a sleeping young woman, watched by a mysterious horse's head. 'Shockingly mad', wrote Horace Walpole, who always thought moderation a good thing, 'madder than ever, quite mad': which was exactly what many people

believed their world was becoming. A critic was soon complaining that artists had become obsessed by 'Gypsies, Witches, and flying Devils'.[8] Out poured sublime landscapes and seascapes that spoke for new sensibilities in watercolour and oil and made space for Turner's freer colour palette. The market still left room for the likes of Paul Sandby and Thomas Rowlandson; their styles changed little. And David Wilkie's genre paintings continued an earlier realism. All the same, the Gordon riots bring us closer to the demise of Covent Garden's artistic tradition – and so to a convenient end of our story.

'PULLING DOWN' COVENT GARDEN

People said in June 1780 that 'a new species of mob' quickly took over from the sober Protestant one. This last had comprised 'better sort of tradesmen, . . . exceeding quiet and orderly and very civil'. But now 'all the lank and puritanical faces . . . disappeared, and rogues and robbery were the order of the day'. 'Vile looking fellows, ragged, dirty and insolent, armed with clubs,' George Crabbe the poet found them.[9]

On the first evening, some of them hived off to burn down a couple of presumed Catholic chapels in Warwick Street and Soho Square. As days passed, they attacked the homes of MPs who supported Catholic Relief and sent the Irish women and children in Moorfields in the City 'screaming'. They burned down prisons and released prisoners. The burning of Newgate was symbolically more terrifying than all the attacks on Catholic chapels and property; it was later recalled as equivalent to the fall of the Bastille. The crowd also tried to storm the Bank of England. They sacked the Catholic Thomas Langdale's distillery on Holborn Hill and liberated 120,000 gallons of spirits: 'the low women knelt and sucked them [the spirits] as they ran from the staved casks'. At one point, thirty-six fires lit up the night sky. From afar 'blazing London seemed a second Troy', wrote Cowper – the mob daring to look its masters in the face, worse than 'galley-slaves, broke loose'. To placate it, householders chalked 'No Popery' on their door, and Jews chalked 'This House True Protestant!', and in Charing Cross and the Haymarket they lit their windows with candles – a supportive symbol in this era. Pedestrians had to wear Gordon's symbolic blue

cockade as a talisman. Horace Walpole came into town only after decking himself 'with blue ribbands like a May-day garland'.[10] The rioters did more damage to London's fabric in a week than the French Revolution did to Paris's fabric a decade later.[11]

There's no denying the pleasures that mayhem on this scale offered deprived lives, nor the contagious exhilaration of collective rampaging, nor the effects of an underclass's countless grievances about past insults and provocations. But most crowd behaviour wasn't as mindless as its enemies liked to think. Journeymen and apprentices directed events, not unskilled casual labourers. Most leaders were locally known and were given good characters at their trials. Far less property was looted than was burned in protest. And class resentments added to the volatile mix of motives, along with ancestral hatred of magistrates and soldiers. Beyond that, the cry of 'No Popery' had echoed since the days of the Commonwealth; religious Dissenters lived by the phrase. The poorest children had heard of Catholic atrocities. November 5 commemorated Catholic iniquity; and many could cite stories from the Book of Martyrs. The American war had sharpened suspicions of Crown and Church, not least thanks to the 1774 Quebec Act which had emancipated Catholics in the former French colony.[12]

So there was rationality in the choice of richer Catholic targets in preference to poorer ones. Grievances were settled in attacks on tollbooths and debtors' prisons. When the Fleet prison was burned down on 7 June, inmates were told to remove their belongings before the fires were lit.[13] And as Susan Burney, the novelist Fanny's sister, watched the sacking of Justice Hyde's house from her parents' home in St Martin's Street off Leicester Fields, she noticed that people brought a fire pump to protect neighbouring houses from fire – 'a precaution wch. it seems has been taken in every place that these lawless Rioters have thot. fit to attack'.[14] The Parisian journalist Louis-Sébastien Mercier was amazed by such 'inborn political sanity': 'The Londoner, even up in arms, ... concentrates his rage upon some definite object [and] draws a line of conduct beyond which, though provoked, he will not go.' Mercier, admittedly, wasn't the best of judges. He thought that 'dangerous rioting has become a moral impossibility in Paris', and eight years later the Bastille was stormed.[15]

The Covent Garden neighbourhood got more than its fair share of

attention. On the first day of destruction, rioters set fire to the Sardinian ambassador's Catholic chapel in Duke Street off Lincoln's Inn Fields. Three nights later, on the 5th, a crowd assembled in Leicester Fields to sack Savile House, the opulent home of Sir George Savile, who had introduced the Catholic Relief Bill in 1778. Susan Burney described what happened in a letter to Fanny in Bath.

> Thursday Eveg. June 8th. Ah my dear Fanny! – How frighten'd & how miserable would you have been had you known what has been passing in St Martin's Street, & indeed in almost every street in London since my last paquet . . . Monday Eveg. last, . . . after my Father &c return'd home, & I was regretting having missed a delightful party at Mr Reynolds, where Dr Johnson, Dr Percy, Mr Horneck, Mrs Bunbury &c were, we heard violent shouts & huzza's from Leicester Fields – & William [a manservant] who went to see what was the matter return'd to tell us the populace had broke in to Sir Geo: Saville's House were then emptying it of its furniture which having piled up in the midst of the square, they forced Sir George's servant to bring them a candle to set fire to it – They would doubtless have set the House itself on fire had not the Horse & Foot Guards prevented them – since this time it has been full of soldiers to prevent it from being pulled to the Ground, wch. the Rioters have since attempted to do – the windows & even window Frames are however almost all demolished, & it cuts a terrible figure . . . In our Observatory the flames before Saville House illuminated the whole square – & my knees went *knicky knocky* like the Frenchman's in Harlequin's Invasion at the sight – at about two in the Morng. all seemed quiet again & we went to bed.

That night in Covent Garden popular hostility to the law surfaced, too. A tallow-chandler's house in Stanhope Street and a coachmaker's in Little Queen Street were both destroyed because their owners had testified against rioters at the Bow Street magistrates' office. And when on 6 June the magistrate William Hyde read the Riot Act at Palace Yard and ordered the crowd to disperse or be shot, a sailor named James Jackson hoisted a black and red flag and shouted 'Hyde's house a-hoy', and the crowd trooped after him to Hyde's house in St Martin's Street, and within an hour they had sacked it. Watching from her window again, Susan Burney saw a 'great Bonefire':

I found my Mother & Charlotte half out of their wits – they told me that about half an hour before, many hundred People came running down our street, huzzaing & shouting, wth. a Blue Flag – [Hyde] was fortunately not in his House, for had he fallen into their hands, I believe he wd. have been torn to pieces . . . From our windows we saw them throw Chairs, tables, Cloaths, in short everything the House contained, & as there was too much furniture for *one* fire they made several, at distances sufficiently great to admit of one or 2 People passing between them – at one time I counted *six* of these fires, wch. reached from the bottom of the street up to the crossing wch. separates Orange and Blue Cross street. [Then] the Mob tore away the windows & window Frames, & began to pull up the Floors, & the pannels of the Rooms, till some of the Neighbours, (Who had however hung *blue Ribbons* from their Windows the whole time *to prove their Religion*, & many of whom perhaps had particular reasons to rejoice in the Justice's Disaster,) entreated them not to keep up so strong a fire before their Houses, as they had the greatest reason to fear they would soon catch, & that the whole street wd. be in a blaze not-withstanding the Engine – Upon this the Ringleaders gave the word, & away they all ran past our windows to the bottom of Leicester Fields, with lighted firebrands in their hands, like so many furies – Each carried something from the fires in our street, that nothing might escape – they made in Leicester Fields one Great Bonefire of them – the Women like the Furies were more active & busy in the business than the Men – & they continued pulling down Pannels, Doors, &c till between two & 3 in the Morning to keep up the Bonefire & totally destroy the Poor House.

At this point the cry went up: 'To Newgate! To Newgate!' – and again James Jackson led the way. Several hundred followed him the mile or so to the prison, aiming to release the arrested rioters who had been put there. As they streamed from Long Acre along Great Queen Street, the young William Blake was caught in their crush as he walked to his master Basire's house. Propelled to Newgate, he witnessed its burning and the release of its 300 inmates – 'a peculiar experience for a spiritual poet', his first biographer observed.[16]

At about eleven o'clock that night sixty or so 'women and men and boys' had broken off from the main body of the crowd to attack Mr Justice Cox's house in Great Queen Street. They hacked at it until four

162. James Winston, *The Police Office, 4 Bow Street*
(watercolour, 1825)

or five in the morning until only a small part of the front wall was
standing. The flooring, wainscoting and furniture were thrown into
the street. One man 'had an iron crow[bar] in his hand, a little before
eleven, knocking down the pier in front of the two-pair-of-stairs. I
saw him there twenty minutes or half an hour; he was working with
the sharp end; he put it under the bricks and threw them down.'[17]
When people were said to have 'pulled down' houses in eighteenth-
century riots, they did it literally. Jerry-building helped.

Next came Sir John Fielding's Bow Street office. After the prisons,
this was the most symbolically loaded target. It had long been the

source of ever-tightening supervision and discipline, staffed by magistrates who were understood to be corrupt. And many of the lately arrested rioters had been committed to trial here. The office occupied a house built in 1704 at number 4 on the western side of Bow Street, four doors north of the Russell Street corner (fig. 162); the Westminster magistrate Thomas de Veil had opened it there in 1740.[18] Exploiting the opportunities for corruption that came with the despised office of 'trading justice', de Veil boasted that he made £1,000 a year – 'the dirtiest money upon earth', his successor Henry Fielding called it (he reduced his own income in office to £300). De Veil had been Hogarth's near neighbour in Leicester Fields, and Hogarth had depicted him in *Night* (1738) as the drunken freemason upon whose head a woman empties her chamber-pot. When de Veil tried to enforce the 1736 Gin Act, 1,000 people had gathered and threatened to pull his house down if he didn't turn over 'two informers against Spirituous Liquors'. At the ensuing trial, Westminster Hall was so full that 'one might have walk'd on the People's Heads', and, when people heard that a ringleader was acquitted, they 'were so insolent as to *Huzza* for a considerable time, whilst the Court was sitting'.[19]

In 1749 Henry Fielding succeeded de Veil at Bow Street. He too had popular hatred to cope with, for the once louche and witty novelist proved to be another law-and-order zealot. He thought of London as 'a vast wood or forest, in which a thief may harbour with as great security, as wild beasts do in the deserts of Africa or Arabia', and he set himself the mission of cleansing it. That year he established his Bow Street Runners, the ancestors of the modern detective. And two years later his *Enquiry into the Causes of the Late Increase of Robbers* castigated the high people for their luxury and the low for their fecklessness, and justified his campaign against ginshops and gambling houses on the principle that 'tho' Mercy may appear more amiable in a Magistrate, Severity is a more wholesome Virtue'.

Henry Fielding's popular standing never recovered from his mercilessness in his first year in office. One night in July 1749, a sailor was cheated in a bawdy-house on the Strand and summoned his mates from Wapping to exact revenge. A troupe of sailors duly arrived to sack the goods of the 'cock-bawds' (male pimps) who owned the Strand houses. Fielding summoned troops under the Riot Act, and

thus appeared to align himself with the brothel-keepers. Later, ignoring the jury's recommendation for mercy, he achieved the hanging of a young Cornish peruke-maker named Bosavern Penlez. It didn't help that Penlez might have been falsely identified by Wood, the prosecuting cock-bawd. ('Do you believe Wood or his wife are persons to be believed upon their oaths?' – 'Upon my word, I think not ; for my part I would not hang a dog or a cat upon their evidence.')[20] Penlez's execution tarnished Fielding's reputation and still does. Boitard's energetic commentary on the riot, *The Sailor's Revenge, or the Strand in an Uproar* reminded purchasers that it showed 'the scene where the unfortunate Penlez lost his life': everyone knew why he did (fig. 163).

When Henry died in 1754 he was succeeded by his blind half-brother, John Fielding. He shared Henry's disciplinary notions, urging

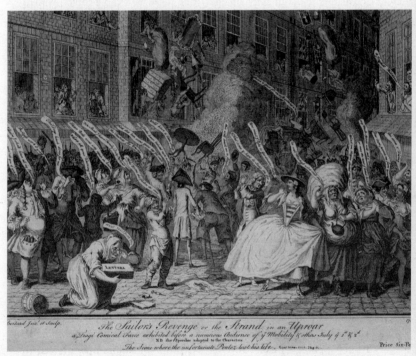

163. Louis-Philippe Boitard, *The Sailor's Revenge, or the Strand in an Uproar* (etching, 1749)

351

David Garrick not to stage *The Beggar's Opera* at Drury Lane lest it fill the vulgar with wrong ideas. He developed the Runners, and began to collect data about national as well as local crime. This aimed at drawing 'all Informations of Fraud and Felony into one point [Bow Street], registering Offenders of all Kinds, quick Notice and sudden Pursuit, and keeping up a Correspondence with all the active Magistrates in England'. Thus began the first criminal registers. They ensured that previously convicted people got heavier sentences for further offences, including execution. Just as unwelcome was Fielding's effort to reform Drury Lane street-walkers by training them up as domestic servants in the new Magdalen Hospital. Most of the girls had no more zeal for being reformed than their men had for Fielding's registers.

All this explains why on that June night in 1780 people on their way to Newgate thought of Bow Street. Soon Bow Street and the streets leading to it were filled with excited men and women wielding clubs, iron bars and axes. A publican from Arundel Street, just south of the Strand, claimed at the trials that he recognized 'all the mob' that night. This suggests that many were from the Hundreds of Drury. By ten o'clock, Fielding's office was all but destroyed:

> the windows were all broke and the wainscoting was torn down, some of the window frames were cut out with choppers; part of the frames were left and part taken away ... I saw Roberts breaking the stair-case with a crow[bar], or an instrument of that nature, and carrying down the wood and throwing it into the fire, which was in the middle of the street, opposite the door ... the windows, the wainscoting, and every thing came out ... a great many chairs and a good deal of furniture were thrown out and set on fire in the street in five different places. I saw Roberts throw out several chairs, and a good deal of bed linen; by this time the fires were so large that one might have seen to pick up a pin in the street ... The inside of the first, second, and third floors was totally destroyed as far as I could see ... The doors were broke to pieces, the window shutters were broke, the glass and frames of the windows were broke, and the household goods had been thrown out and burnt.[21]

Among the goods thrown out and burned were Fielding's criminal registers.

REPRISALS

'As yet there are more persons killed by drinking than by ball or bay-onet,' Horace Walpole wrote at the height of the crisis on 9 June. Probably not, one has to say. When the Bank of England was threat-ened on the 7th, Sarah Hoare, the daughter of a Quaker banker who lived in Broad Street, watched the militia arrive from her window. She wrote to her mother next day that the soldiers fired 'near a hundred pieces' and left '4 unhappy men dead on the spot and 15 wounded'. The militia's leader, the sugar refiner, Alderman and Sheriff of London Sir Barnard Turner, later admitted that his men fired 'for four or five minutes' before the crowd dispersed; at the looters' Old Bailey trial he thought that 'about twenty shots were fired'. How many people really fell he didn't mention.[22]

That was just the beginning of it. In the riots' final days, government and magistrates recovered their nerve. Some 20,000 soldiers moved into the capital, the one-hour warning of the Riot Act was suspended, and the army was allowed to attack any group of four or more that refused to disperse. Walpole saw bayonets 'steeped in blood'. Accord-ing to the military later, 210 people were killed in the streets, and another seventy-five died of their injuries. This is a certain underesti-mate. Nathaniel Wraxall reported that many troops declared that they wouldn't shoot the people, but he put the killed and wounded at 700 or so; and a modern historian boosts that to 850.[23] Amazingly, there is no evidence that the rioters were responsible for a single fatality.

Some 450 people were arrested and sixty-two condemned to death. Lord George Gordon, at first imprisoned in the Tower, was acquitted at his treason trial the following year. Within a month of the riots, twenty-five rioters were hanged. They were executed at the locations of their crimes in ones, twos or threes; as many as six died together on St George's Fields south of the river for burning down the King's Bench prison. The total included five women (one black), a one-armed ex-soldier, a Jew and 'a poor, drunken cobbler' who had extorted pennies from passers-by. Many were young. A fourteen-year-old boy was sen-tenced to die, but mercy prevailed and he was transported to Australia.[24] Richard Roberts, active in the Bow Street sacking (a 'mere lad in

appearance, barely seventeen years of age'; 'a child I call him', a witness said), was hanged alongside one Thomas Taplin, a 'captain-rioter' who had menaced a Russell Street shopkeeper into contributing a half-crown to the Protestant cause. These two died on the Bow Street and Russell Street corner. The sailor James Jackson, who had led the people to Hyde's house and then to Newgate, was hanged outside the Old Bailey. When a witness at his trial was asked whether he was strong enough to do damage, she answered, 'He came out of the country very ill.' 'And was weak in consequence of that illness?' 'Yes, he spit blood for a good while' (before the riots). Horace Walpole vented his measured disgust at 'the numbers of boys that have been executed for the riots, for the bulk of the criminals are so young, that half a dozen schoolmasters might have quashed the insurrection'.[25] 'I never saw boys cry so!' Greville recalled, as he observed the judge condemn them to death at their trials.[26]

There was anxiety about the vindictiveness of these reprisals. Edmund Burke famously warned that 'the sense of justice in men is overloaded and fatigued with a long series of executions, or with such a carnage at once, as rather resembles a massacre than a sober execution of the laws'.[27] Walpole worried about the threat to liberty posed by military rule: 'The sword reigns at present, and saved the capital! What is to depose the sword?' And Charles James Fox said he would 'rather be governed by a mob than a standing army'.[28] Yet these sentiments couldn't eclipse relief that military rule had been so effective. 'I bless every soldier I see,' Charles Burney wrote to Fanny: 'we have no dependence on any defence from outrage but the military.'[29]

Londoners' lives soon resumed their old patterns, as they usually do in some degree, even as nations convulse. Just as Charles I and his army on the morning of the battle of Edgehill were astonished to meet a country gentleman quietly riding his foxhounds to cover, so Wraxall, watching the burning of Langdale's distillery, was astonished to see 'a Watchman, with his lanthorn in his hand . . . calling the Hour, as if in a time of profound Tranquillity'.[30] Susan Burney, watching the sacking of Justice Hyde's house from her window, saw the opera singers Manzoletto and Sepultini 'walking arm in arm, & was half surprised that [as Italian catholics] they dared' to do so. 'No alarm seemed yet to have arisen among the Foreigners,' she added.

People went sightseeing. Samuel Johnson went to look at Newgate and found it 'in ruins, with the fire yet glowing'; then he watched 'the protestants . . . plundering the sessions-house at the Old Bailey' and enjoying the impunity of 'men lawfully employed in full day'. He was told to be careful; but he passed unmolested, and within a couple of days was satisfied that 'there is no longer any body of rioters, and the individuals are hunted to their holes, and led to prison'.[31]

For weeks yet, tourists nosed around the distillery ruins on Holborn Hill, the charred beams of Lord Mansfield's house in Bloomsbury Square, and the blackened rubble of Newgate. Even a month later, William Hickey and his mistress coached around in wonderment to take in the ruins of the Holborn distillery, the prisons north and south of the river, and the hated toll-houses that the rioters had destroyed on Blackfriars Bridge.[32] And when military lines were drawn across the Strand and Holborn to stop troublemakers coming westward, the West End resumed its fashionable ways. On 8 June Horace Walpole told Lady Ossory that the panic was over: 'Lady Ailesbury has been at the play in the Haymarket, and the Duke [of Gloucester] and my four nieces at Ranelagh [pleasure gardens] this evening.' Four days later five people applied for tickets to view Walpole's Strawberry Hill house. Walpole thought this an act of insensibility, when the world had just been turned upside-down.[33]

Joshua Reynolds seems to have been phlegmatic in the crisis, despite the sacking a stone's throw from his front door in Leicester Fields. On Monday 5 June he had held the 'delightful party' with Johnson as guest which Susan Burney was sorry to miss. Later that night he would have heard the violent shouts outside, and would have peered out to see the bonfire on the northern side of the square where Savile House was being sacked. We know from Susan's letters that Reynolds called on the Burneys next day to tell them that he was going to see Burke, whose St James's house had been threatened. And on 'Black Wednesday', the worst day of the rioting, his pocket-book recorded a visit to the Academy in Somerset House which was marked for attack that day. This was rather brave of him, though in the event it escaped because by then the soldiers were shooting. He was alarmed enough to draw lines through his appointments for Monday, Tuesday and Wednesday. But Lady Laura Waldegrave resumed sittings for her portrait on Thursday.

The riots then left no further trace in Reynolds's notebooks; the even tenor of his life resumed.[34]

HOW THE ARTISTS SAW IT

Reynolds was by no means the only artist whose life quickly resumed its even ways. After the riots, Paul Sandby engraved two slim volumes that each contained *Ten Views of Encampments in Hyde-Park and Black-Heath* (1780). In other drawings and prints he depicted the military stations at Montagu House and St James's Park. Since all these accommodated the soldiers whose guns and bayonets had laid the people low, the exquisite prettiness of his drawings is disconcerting (**plate 26**). You'd never know to what uses those men had been put. Sandby designed these while he was living in 4 St George's Row across the way from Hyde Park, so the soldiers remained a part of his landscape for months. Fashionable people brought their children to visit them in their sylvan summer setting. 'The novelty of such spectacles in London, together with their excellent bands of music, who performed some of our best compositions morning and evening, naturally captivated the multitude.'[35] Sandby sold his pictures as picturesque mementos. The gritty reportorial realism of the previous generation seems to have been retreating.

Momentous though it was, the week of the Gordon riots would seem to have left a scanty visual record, though it laid down a deep artistic residue in the long term. Only two or three prints show the burning of Newgate, the King's Bench, the Fleet and other prisons. A dozen satirized the authorities' incompetence in controlling the riots, or Gordon's culpability in provoking them – and rather more attacked the crowd's 'barbarity'. One was Gillray's *No Popery or Newgate Reformer* (fig. 164):

> Tho' He says he's a Protestant, look at the Print,
> The Face and the Bludgeon, will give you a hint,
> Religion he cries, in hopes to deceive,
> While his practice is only to burn and to thieve.

164. James Gillray, *No Popery or Newgate Reformer* (etching, 1780)

Beyond these, we have only one serious depiction of the crowd, though it's a distinguished one. This was that fluent and dynamic drawing in brown ink and wash by the now forgotten Charles Reuben Ryley in fig. 160 above. Its composition replays the classical groupings he had learned in the Academy Schools; but its squabbling women and babies, one-legged beggar and drinkers with hats waved or askew spring from Hogarth's scaffold crowd in *Idle 'Prentice Executed at Tyburn.* It

catches well the crowd's febrile excitement, and this without carica-
ture. There's no knowing why Ryley drew it. In 1780, he lived in Great
Titchfield Street, north of Oxford Street, so he was out of the way of
the riots. The physically deformed son of a trooper in the Horseguards,
he had studied under J. H. Mortimer and won medals at the Royal
Academy for small paintings of literary and classical subjects. Increas-
ingly ill, he ended up scratching a living from book illustration. He
died impoverished in his forties in 1798.

The riots' stylistic consequences, however, extended well beyond these
few immediate images. A clue to what was coming is provided by observ-
ers' reflexive resort to the language of Revelation when they described
the riots ('and the sun became black as sackcloth of hair, and the moon
became as blood'). This was generated out of long biblical education; yet
the unprecedented frequency of apocalyptic and infernal metaphors sug-
gests the coming of sensibilities that were very remote from neo-classicism.
The historian Edward Gibbon, for instance, saw in the rioters a 'dark
and diabolical fanaticism'. George Crabbe described them at Newgate
as 'rolled in black smoke mixed with sudden bursts of fire – like Milton's
infernals, who were as familiar with flame as with each other'.[36] The
dramatist Frederick Reynolds, also at Newgate, described

> the wild gestures of the mob without, and the shrieks of the prisoners
> within, expecting an instantaneous death from the flames; the thunder-
> ing descent of huge pieces of building; the deafening clangor of red hot
> iron bars, striking in terrible concussion the pavement below; and the
> loud triumphant yells and shouts of the demoniac assailants, on each
> new success.[37]

From her home next to the Countess of Huntingdon's chapel in
Clerkenwell, the pious Dissenter Lady Anne Erskine found herself

> surrounded by flames! Six different fires – with that of Newgate among
> the rest towering to the clouds – being full in our view at once . . . The
> flames all around had got to such a height that *the sky was like blood
> with the reflection of them*. The mob so near we heard them knocking
> the irons off the prisoners; which, together with the shouts of those
> they had released, the huzzas of the rioters, and the universal confusion
> of the whole neighbourhood make it beyond description![38]

And while Charles Burney gazed from Newton's old observatory at the top of his St Martin's Street house on a scene 'which surpassed the appearance of Mount Vesuvius in all its fury' (Vesuvius had erupted in 1779), his daughter Susan at her window described how

> as it grew dusk, the wretches who were involved in smoak & cover'd wth. dust at the bottom of the street, wth. the flames glaring upon them & the fires between them & us, seemed like so many *Infernals*, & their actions contributed to assist the resemblance they bore, for more fury & rage than [?] they shewed in demolishing everything they met with cannot be conceived.

The 'fiends', 'demons', and 'furies' who made up the crowd, and the vision of a capital city in flames, now entered very deeply into Londoners' fears and imaginings.[39]

Two representations of the riots played directly to the sense of gothic horror that these responses indicated. One was an engraving of the confrontation between looters and militia in Broad Street (in the City) on 7 June which Sarah Hoare had described. The City printseller John Boydell had commissioned the original painting from Francis Wheatley, and had then had it engraved by James Heath (just before the painting was accidentally lost in a fire). Ten years after the riots Boydell published and sold the print at a guinea per impression (**plate 27**), for events in France – the abolition of the nobility and the Oath of the Clergy in Paris – had given it a new topicality, so that it could remind purchasers what to expect if they capitulated to mobs. Boydell was soon to be Alderman and Lord Mayor of London, so when he had the print's subtext applaud the 'patriotic conduct' of the Light Horse Volunteers and Military Foot Association his interest in publicizing his own sense of civic duty was transparent. Its publication also coincided with the abolition of the nobility and the Oath of the Clergy in Paris, so it reminded purchasers of what Britons might expect if they capitulated to mobs. The composition has its difficulties. The crowd's attack on the Bank of England had been led by a brewery drayman. He had waved handcuffs and fetters above his head and ridden a carthorse bedecked with chains appropriated from Newgate. Here, on the right, he seems to be walking the horse into a wall. And the crowd continues to loot relaxedly even as one of their number falls and is succoured by

a soldier, and other soldiers shoot. Nonetheless, the print's dramatic moon- and fire-lit chiaroscuro is finely conveyed in its sepia proof impression, and its gothic effect was palpable.

The second image was a miniature oil sketch by the marine painter Francis Swain (1719–1782). Entitled *Figures by Chelsea Waterworks Observing the Fires of the Gordon Riots, 7 June 1780*, it was too small to be influential (it measured 150 x 200 mm), and it would be inconsiderable were it not for its awesome representation of London on fire (**plate 28**). But it deserves its place, for it recalled Jan Griffier I's blood-red paintings of London's Great Fire of 1666, and mid-century paintings of naval ships on fire by Sam Scott, Charles Brooking and others,[40] and Joseph Wright's Vesuvius paintings in the 1770s – and it then reapplied those horrors to modern London. In this sense it anticipated de Loutherbourg's internal visions of *The Great Fire [of London]* (*c.* 1797) and of *Coalbrookdale by Night* (1801), and Turner's and Constable's Vesuvian fantasies some years later (as well as Turner's *The Burning of the Houses of Parliament* in 1834).[41] By such means, the riots cemented the image of awesome conflagration in the Romantic imagination. Their memory informed William Blake's *London* in 1794, for instance. In an era when millennial movements among the poor were multiplying, and spies were reporting treason and subversion, Blake's radical-Romantic critique of exploitation simply turned its back on the cheery London celebrated by Charles Lamb and Rowlandson (fig. 165).

> How the Chimney-sweeper's cry
> Every black'ning Church appalls.
> And the hapless Soldiers sigh
> Runs in blood down Palace walls.

The same was true of the self-evidently pertinent imagery of the Apocalypse: 'Behold a pale horse: and his name that sat on him was Death, and Hell followed with him. And power was given unto them over the fourth part of the earth, to kill with sword, and with hunger, and with death, and with the beasts of the earth.' Well before the Gordon riots, John Hamilton Mortimer in 1775 exhibited a pen and ink drawing of *Death on a Pale Horse* at the Society of Artists. Mortimer died in 1779, but in January 1784 one of his pupils etched it and his widow published and

165. William Blake, *London* (etching, watercolour, 1794)

sold it, as if to claim its copyright.[42] They had reason to do so, for in 1783 Benjamin West filched the idea for his own *Death on the Pale Horse* (fig. 166). This was part of a commission by George III, but the

166. Benjamin West, *Death on the Pale Horse* (pen, brown ink, wash and gouache, 1783)

King rejected it as a 'Bedlamite scene'. West nonetheless exhibited it at the Royal Academy in 1784 and reworked it in oil in 1796 and again in 1817 in an explosion of movement and colour which repudiated his earlier neo-classical style.[43]

Oddly, the stylistic shift that followed the Gordon riots was also demonstrated in Gillray's satire, *A March to the Bank: Vide. The Strand, Fleet Street, Cheapside &c. Morning & Evening* (1787) (fig. 167). After the rioters had tried to attack it, the Bank of England was ritually protected by Guards. Every morning they marched in double file from the Strand to Cheapside and in the evening they marched back again. When someone complained that they had pushed him off the footway, the City proposed the ritual's ending. The negotiations to that effect, along with Gillray's comically exaggerated comment on the matter, suggest that confidence in London's security had returned.

Yet *A March to the Bank* wasn't at all 'normal'. In the 1780s, influenced by Fuseli, Gillray was turning to an art of free association. He many times adopted a dreaming protagonist, and by this and similar devices he was to transform graphic satire as conclusively as Fuseli transformed the 'sublime'. Indeed, one critic has argued that the restraints of classicism were as surely silenced by Gillray's taste for excess as they were by Fuseli and Blake. Through 'abbreviation, not careful finish;

167. James Gillray, *A March to the Bank:* Vide. *The Strand, Fleet Street, Cheapside &c. Morning & Evening* (etching, engraving, 1787)

physical imperfection, not graceful form; and distortion, not controlled and idealized forms',[44] Gillray began to claim a new licence that took him from the emblematic language of his and others' earlier satires to the expression of a point through fantasy and extreme bodily distortion.

Hitherto, caricature had exaggerated facial expressions and features. Here Gillray caricatured the body itself. The Guards officer struts balletically across the scattered pedestrian bodies, his impossibly wasp-like waist the essence of popinjay arrogance. Surreally elongated and distorted figures populate several of Gillray's prints in and after 1786, while several years later deepening fears of revolution accentuated his and others' new fluidity.[45] So towards the end of the century, the new art of a new era began to declare itself, and no longer was either 'realism' or the emulation of past masters its prime objective.

10

Turner, Ruskin and Covent Garden:
An Aftermath

TURNER GOES WAPPING

It was unfortunate for the view of J. M. W. Turner taken by the respectable people who were in the know that in 1851 the great artist chose to die in the Chelsea cottage which he secretly shared with his mistress. She was his semi-literate one-time Margate landlady Sophia Booth, and while living with her in Chelsea he had called himself Admiral Booth to remain incognito. He was an uncouth and surly man, but he was also supposed to be one of England's finest, so his friends found this indication of moral turpitude hard to take. Before his death could be publicly announced, his body was smuggled back to the disordered house and studio in Queen Anne Street where he officially lived and painted. There he lay decorously in state before being safely buried alongside Joshua Reynolds in St Paul's Cathedral, as a national treasure.

The person privy to and most upset by the unseemly circumstances of Turner's death was the critic John Ruskin. In the first volume of his *Modern Painters* in 1843 Ruskin had passionately affirmed Turner's stature both as an artist and as a moral being, in order to rebuff hostile reviews of Turner's work. Affirmation in this vein was necessary because the hostility ran deep. Turner's mastery of colour was early recognized, but since his method was to 'drive the colours abt. till he has expressed the idea in his mind' (as Joseph Farington put it in 1799), and since this resulted in something unintelligibly akin to impressionism, many critics disliked the outcome. *Blackwood's Magazine* in 1836 thought that even his best canvases were 'thrown higgledy-piggledy together, streaked blue and pink and thrown into a flour tub'. He threw 'handfuls of white, and blue, and red, at the can-

vas', the *Literary Gazette* objected in 1842, and the *Athenaeum* complained that he painted in 'cream, chocolate, egg yolk and currant jelly'.[1] Although he changed his mind later, Mark Twain's comments on the physical implausibility of Turner's masterpiece *Slavers Throwing Overboard the Dead and Dying* (slave-chains floating on the waves, etc.), may be those that live longest:

> What a red rag is to a bull Turner's 'Slave Ship' is to me. Mr Ruskin is educated in art up to a point where that picture throws him into as mad an ecstasy of pleasure as it throws me into one of rage. His cultivation enables him to see water in that yellow mud; his cultivation reconciles the floating of unfloatable things to him – chains etc.; it reconciles him to fishes swimming on top of the water. The most of the picture is a manifest impossibility, that is to say, a lie; and only rigid cultivation can enable a man to find truth in a lie. A Boston critic said the 'Slave Ship' reminded him of a cat having a fit in a platter of tomatoes. That went home to my non-cultivation, and I thought, here is a man with an unobstructed eye.[2]

William Hazlitt had put his finger on the obvious difficulty in 1816: the world wasn't ready for abstraction. Turner was 'the ablest landscape painter now living', but his pictures were 'too much abstractions of aerial perspective, and representations not so properly of the objects of nature as of the medium through which they are seen' – light, water, earth. 'All is "without form and void",' he added. 'Someone said of his landscapes that they were pictures of nothing, and very like.' Then came a most interesting declaration: Turner's work, he wrote, had lost 'sympathy with humanity'.[3] Even today some feel that 'Turner just seems to be in production, churning out ocean-going turmoil and vortices of water, air and sunlight and then locking them in focus with little figures . . . The Rhine or an avalanche would do just as well. So would a vertiginous view of the Alps.'[4] It's an old joke that all Turner's works might be called *Sun Rising through Vapour*.

The gist of Ruskin's reply was conveyed in the original subtitle to *Modern Painters*: *Their Superiority in the Art of Landscape Painting to all the Ancient Masters, proved by Example of the True, the Beautiful and the Intellectual, from the Works of Modern Artists, especially those of J. M. W. Turner, Esq., R. A.* No other artist, Ruskin asserted,

had observed the natural and material world as closely as Turner. His landscapes achieved a truth that past masters had never matched – 'a moral as well as material truth, – a truth of impression as well as of form, – of thought as well as of matter'. In a passage that lapsed into the windy tosh so favoured by Victorian sages (sensibly deleted from later editions), he saw Turner as

> glorious in conception – unfathomable in knowledge – solitary in power – with the elements waiting upon his will, and the night and the morning obedient to his call, sent as a prophet of God to reveal to men the mysteries of His universe, standing like the great angel of the Apocalypse, clothed with a cloud, and with a rainbow upon his head, and with the sun and stars given into his hand.

Or, as he later told Frank Harris, 'Goodness and Wisdom and Purity and Truth went together with great talent.' In Turner 'the good and the pure and the beautiful' were joint 'manifestions of the Divine'.

In view of these overblown plaudits, it is no surprise that Ruskin experienced the tactlessness with which Turner expired in the arms of Mrs Booth in Chelsea as 'one of the worst blows of my whole life'. Worse horror was to follow. In 1857–8, Ruskin and the Keeper of the National Gallery had to spend several months sorting through the 30,000 or so sketches, watercolours and oils that Turner had bequeathed the nation. One day Ruskin came across a portfolio filled with sketch after sketch of Turner's that he believed must have been 'drawn under a certain condition of insanity'. They were 'of the most shameful sort – the *pudenda* of women – utterly inexcusable and to me inexplicable'. As he told Frank Harris:

> I went to work to find out all about it and I ascertained that my hero used to leave his house in Chelsea and go down to Wapping on Friday afternoon and live there until Monday morning with the sailors' women, painting them in every posture of abandonment. What a life! And what a burden it cast upon me! What was I to do? . . . I took the hundreds of scrofulous sketches and paintings and burnt them where they were, burnt all of them.[5]

He kept back a handful of sketches 'as evidence of the failure of mind only'.

Ruskin allowed the story of the burning to spread until it became as familiar as similarly toe-curling tales about Byron's publisher's burning of Byron's diaries. His reaction expressed his congested sexual and religious anxieties as well as his shock. It didn't help that he was entering the crisis of faith that led him to abjure Evangelical beliefs, and it helped even less that for six years after 1848 he was too shaken by his wife's nakedness to consummate his marriage, and so left her. He might also have been protecting his reputation in a country lately afflicted by the 1857 Obscene Publications Act. For whatever reasons, we now know that he was fibbing. In 2003 the Tate Britain curator, Ian Warrell, found near on a hundred erotic sketches scattered through Turner's copious notebooks, and no evidence that pages had been torn out for burning or portfolios destroyed.[6]

Ruskin had at one point planned to write his hero's biography, but as tales of Turner's sexual improprieties spread, he realized that his own reputation would be sullied if he did so. So he allowed the journalist Walter Thornbury to take it on instead, apparently after slipping him some helpful information. So it was Thornbury's spatchcocked biography of 1862, and not Ruskin's, that first publicized Turner's misdemeanours:

> He would often, latterly, I am assured on only too good authority [i.e. Ruskin's], paint hard all the week till Saturday night; he would then put up his work, slip a five-pound note in his pocket, button it securely up there, and set off to some low sailors' houses in Wapping or Rother-hithe, to wallow till the Monday morning left him free again to drudge through another week. A blinded Samson indeed – a fallen angel, forgetful of his lost Paradise.

Thornbury also let it be known that Turner 'left four illegitimate children, and bequeathed money to the mistress with whom he had spent the later years of his life'. Turner was 'full of contradictions', he decided: 'The head gold, the feet clay. A man, like others of us, not all black, nor all white, but of a mixed colour; a divine genius, but yet a man of like passions with us: with faults in his art, as in his life. The pure gold runs here and there to schist, the dross now and then is scurfing upon the surface.'[7] Since gold was what must surely flow through Royal Academic veins, these revelations were scandalous and

exciting to contemporary readers, though Thornbury was vilified for the vulgarity of providing them.

In the event the erotic imagination now revealed by the drawings turns out to have been muted, furtive and constrained – not least by comparison with Rowlandson's boisterous erotica or George Morland's *Fanny Hill* mezzotints. For that matter they are muted and furtive when compared with Turner's painterly exuberance elsewhere. One of the more developed and decipherable of them is reproduced as fig. 168. Many are utterly perfunctory pencil scribbles of women with pubic shadows demurely noted or hinted at. There is a fellating woman, one perhaps masturbating, a smudged handful of copulations, a few excited satyrs, and some free-floating male and female genitals. A nude woman touches her breast in a way not favoured in the Academy, and one colour sketch from his Swiss tour in 1802 might or might not depict lesbian lovemaking: the figures are too poorly defined to be certain. Altogether they are among the least titillating scribbles in the annals of erotic art.

Where the English pictures were drawn is an open question. As

168. J. M. W. Turner, *Erotic Figure Study* (ink, wash, c. 1805)

Ruskin reminded Thornbury, Turner had ready access to low life in Wapping, the Thameside shipping parish a mile downstream from the Tower. In 1820, his great-grandfather bequeathed him 7 and 8 New Gravel Lane there, and a few years later Turner allowed their lessee to convert them into a tavern called the Ship and Bladestone; Turner would visit it to collect rent and attend to repairs. Wapping had long been notorious for its riotous taverns, sailors and easy girls: indeed, 'wapping' was an ancient canting term for copulation:

> Wapping thou I know does love,
> Else the ruffin cly the mort; [devil take the woman otherwise]
> From thy stampers [feet] then remove
> Thy drawers [stockings], and let's prig in sport.

Or, to put the point in other terms:

> When my dimber dell I courted
> She had youth and beauty too,
> Wanton joys my heart transported,
> And her wap was ever new.
> But conquering time doth now deceive her,
> Which her pleasures did uphold;
> All her wapping now must leave her,
> For, alas! my dell's grown old.[8]

Turner might well have sketched some nude ladies in Wapping. Alas, however, we have no proof that he did wap or prig there. Many of the sketches predate his inheritance of the Wapping property, and the Ship and Bladestone seems to have been respectably managed.[9] In any case, models poor enough to expose themselves were easily come by in most parts of London. Men like Turner could wap and prig where they chose.

Today the story of Ruskin's comical discomfiture carries obvious warning against the idealizations that distorted judgement in the art world – and still distort it. We have so often been told to adore Turner (Tate Britain's website unblushingly claims that he was 'one of the greatest painters of all time') that we forget the stodgy derivativeness and classicized gloom of many of his earlier works and his slavish copies of classical landscapes by Richard Wilson and others. We forget,

too, that in watercolour, Girtin was arguably the better painter, though his misfortune was to die young, in 1802. Turner's oft-cited comment, 'had Tom Girtin lived, I should have starved', might have been one of Thornbury's inventions, but the painter John Linnell confirmed in 1811 that Turner was 'the inheritor of all that Girtin had discovered'. He wasn't the only contemporary to say so.[10]

Nobody now denies the splendour of his experiments in colour and light in great set pieces such as *Trafalgar* (1806–8), *The Fighting Téméraire* (1838), *Rain, Steam and Speed* (1844), or the private painterly experiments of his maturity. We rightly admire and chiefly remember his luminous colourscapes – the scrapings, the thumb- and finger-smudges, and the wet-on-wet spread of the pigment that even now feel improvisationally modern. But a Tate Britain exhibition on 'Turner and the Masters' has demonstrated how he looked backwards as much as forwards, how bad a painter he could be as well as how good, and how desperately he tried to out-Claude Claude Lorrain. Indeed, many of his early works endorse Ruskin's lament about his 'having suffered under the instruction of the Royal Academy'. Turner 'had to pass nearly thirty years of his life in recovering from its consequences', Ruskin wrote with fine insight: 'The one thing which the Academy *ought* to have taught him (namely, the simple and safe use of oil colour), it never taught him ... The first condition of his progress in learning, was the power to forget.'[11] Forget he triumphantly did. Even so, this driven, competitive, as well as gifted man was of his times, training, and class.[12]

Figure 169 shows how he painted himself when in 1799 he left Maiden Lane 'to derive advantages', as he put it to Farington, 'from placing himself in a more respectable situation'. He had been made an Associate of the Royal Academy, a rare distinction for so young a man; so he moved to one of the lately built houses in Harley Street as better suited to his new standing, and discreetly installed his mistress Sarah Danby nearby. She was to bear him two daughters, but he left her a dozen years later. There is a degree of self-satisfaction in this intelligent and sensual 24-year-old face – calculation too.

What the story about Turner's rude pictures most obviously exposes is the distance between the relaxed sexual manners of the eighteenth century and the prudishness of the nineteenth. For if Ruskin was horrified by Turner's sexual laxity, and if Thornbury had to pretend that

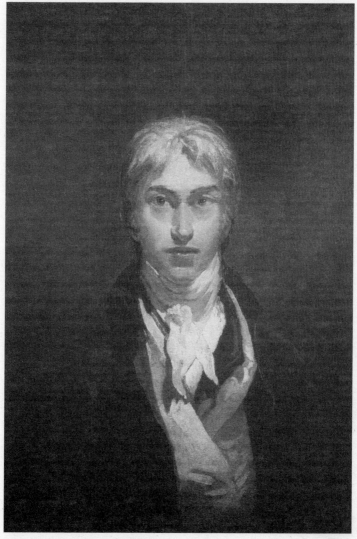

169. J. M. W. Turner, *Self-portrait* (oil, *c.* 1799)

he was horrified, most artists working during Turner's younger years would have thought his delinquencies both sensible and manly. Turner is unlikely to have felt guilty about them, either.

Born in 1775 in 21 Maiden Lane, south of the Piazza, the son of a barber-cum-wigmaker and an increasingly deranged mother whom he later committed to an asylum, a descendant of butchers, saddlers and fishmongers, and a speaker of cockney, he grew up in the most louche and vibrant part of London, and consorted in that proto-bohemian world with artists across whose lips the word 'respectability' never passed. According to the *Oxford Dictionary* the word was first coined in the year of Turner's birth. It anticipated the puritan pieties that later curbed many of the nation's primal pleasures; but, despite his move to Harley Street, Turner was born too early and too humbly to care much about that.

RUSKIN AND COVENT GARDEN

In volume five of *Modern Painters*, published in 1860, Ruskin devoted a chapter to excuses for Turner's low tastes. Turner was still his hero; but his coarseness had to be dealt with. He tackled it by addressing the effects of the painter's Covent Garden birth and boyhood.[13]

For its time his exercise in psycho-geography was rather innovative, but it falls flat today because everything that eighteenth-century Covent Garden had offered artistic spirits lay outside Ruskin's comfortably padded experiences and sympathies. No matter that in Turner's youth that sleazy territory had been a bohemia as creative as any known in London's history. Writing in an era of determined urban improvement, when great swathes of the district seemed ripe for demolition, Ruskin could only reimagine Covent Garden as benighted. It had 'thin-walled, lath-divided, narrow-garreted houses of clay; booths of a darksome Vanity Fair'. A place 'busily base' and defined by 'meanness, aimlessness, unsightliness', it was lacking in true religion, and had nothing more glorious to offer the boy than 'deep furrowed cabbage leaves at the greengrocer's; magnificence of oranges in wheelbarrows round the corner; and Thames's shore within three minutes' race'.

Ruskin took it for granted that Turner's birthplace was not far off a stygian pit.

No building dating earlier than 1806 survives in Maiden Lane today to allow us judge for ourselves, but, even as Ruskin wrote, J. W. Archer depicted by moonlight in 1852 one of the Turner family's unpretentious brick-built and perfectly habitable lodgings (fig. 170). Ruskin and Archer both described or depicted not Turner's birthplace at 21 Maiden Lane, but number 26, on the northern and opposite side, in which the family lived in the 1790s. The archway leads to Hand Court, which Turner's small studio overlooked. At any rate, the drawing hardly matches Ruskin's account of it:

170. John Wykeham Archer, *Turner's Birthplace* [sic] *in Maiden Lane, Covent Garden* (watercolour, 1852)

Near the south-west corner of Covent Garden, a square brick pit or well is formed by a close-set block of houses, to the back windows of which it admits a few rays of light. Access to the bottom of it is obtained out of Maiden Lane, through a low archway and an iron gate; and if you stand long enough under the archway to accustom your eyes to the darkness, you may see on the left hand a narrow door, which formerly gave quiet access to a respectable barber's shop, of which the front window, looking into Maiden Lane, is still extant, filled in this year (1860), with a row of bottles, connected, in some defunct manner, with a brewer's business.

Apart from the sky, Ruskin rumbled on, 'the only quite beautiful things' that Turner might see in the neighbourhood were the ships on the river a few blocks to the south and the 'red-faced sailors' who manned them – 'the most angelic beings in the whole compass of London world'. According to Ruskin, Turner's admiration of these men led him first to a '"Poor Jack" life on the river' – but then to become the greatest of all maritime and landscape artists, for he was repelled by the squalor of his youthful surroundings and was thus driven to paint 'the strength of nature' wherever he could.

The only moment when Ruskin's views become nearly interesting is when (contradictorily) he suggested that Turner's interest in nature co-existed with an attachment 'to everything that [bore] an image of the place he was born in':

No matter how ugly it is, – has it anything about it like Maiden Lane, or like Thames's shore? If so, it shall be painted for their sake. Hence, to the very close of life, Turner could endure ugliness which no one else, of the same sensibility, would have borne with for an instant. Dead brick walls, blank square windows, old clothes, market-womanly types of humanity – anything fishy and muddy, like Billingsgate or Hunger-ford Market, had great attraction for him; black barges, patched sails, and every possible condition of fog . . . [T]o the last hour of his life . . . Turner devoted picture after picture to the illustration of effects of din-giness, smoke, soot, dust, and dusty texture; old sides of boats, weedy roadside vegetation, dung-hills, straw-yards, and all the soilings and stains of every common labour.

Covent Garden's soiling and stains, Ruskin wrote, also gave Turner a high regard for poor people. He 'loved, and more than loved – [he] understood' them. He also understood 'the poor in direct relations with the rich. He knew, in good and evil, what both classes thought of, and how they dwelt with, each other.' Turner lacked Reynolds's or Gainsborough's country-bred reverence for the squire and his lady. Covent Garden had taught him to see the squire as 'a dark figure, or [as] one of two [figures], against the moonlight' (engaged in sexual adventure, in other words, explicitness not being in Ruskin's gift).

None of this tackled Ruskin's main dilemma. This was that 'vulgarity' in Turner that had so shaken Ruskin when he discovered scribbled genitalia in the National Gallery's basements. In a passage notable for its condescension to the great unwashed, but even more wonderful for its laborious contortions, he worked his way round the difficulty by having Turner's character look two ways at once – heavenwards, that is, and earthwards. The puffing overstatement and the final admission of his own incomprehension show how little Ruskin had allayed the Wapping horror to which at last he was driven to allude. One has to laugh:

> Picking up his first scraps of vigorous English chiefly at Deptford and in the markets, and his first ideas of female tenderness and beauty among nymphs of the barge and the barrow, – another boy might, perhaps, have become what people usually term 'vulgar'. But the original make and frame of Turner's mind being not vulgar, but as nearly as possible a combination of the minds of Keats and Dante, joining capricious waywardness, and intense openness to every fine pleasure of sense, and hot defiance of formal precedent, with a quite infinite tenderness, generosity, and desire of justice and truth – this kind of mind did not become vulgar, but very tolerant of vulgarity, even fond of it in some forms; and, on the outside, visibly infected by it, deeply enough; the curious result, in its combination of elements, being to most people wholly incomprehensible.

*

For his own constipated reasons, Ruskin exaggerated Covent Garden's effects on Turner's art. The last thing the painter wanted to be was an urban realist, and he soon discarded such interest in street life,

human subjects or architectural topography as he might once have nurtured. On this point Thornbury the biographer contradicted Ruskin, even as he emulated his rotund pomposity. In Thornbury's view, Turner saw no 'poetry' in London whatsoever: he had

> no sense of the dumb grandeur of the myriads of houses over which the
> black globing dome dominates; the old gable-ends he never sketched;
> the memory-haunted places he did not care for; he could find nothing
> there in what seemed to him black windows and smoky streets, vaulted
> half the year with a sky of gloomy lead, to rouse his poetry or stimulate
> his imagination.

Thornbury had never met Turner, and he was quite as windy and wrong as the great man who used him. But he was right that Turner took no pleasure in cities *as* cities. Except for a few early sketches, he depicted little of London away from the Thames, and although he often painted Oxford, there are only a handful of pictures of places like Leeds and Newcastle taken from safe distances, and one or two distant views of London from Greenwich. When he depicted dinginess, smoke, fog and soot, it was to contrast radiant light and colour elsewhere, or to dramatize natural catastrophes at sea in a world threatened by violent dissolution. Moreover, hardly any of Turner's pictures noticed market-womanly nymphs or relished the urban fishiness and muddiness to which Ruskin had referred.[14] Fisherfolk populated his seasides as unindividualized bit-players. And if he did avoid the portrayal of 'squires', that didn't stop him seeking their patronage or viewing their pictures when he dined at Petworth or shot grouse at Farnley Hall. As for honest labour, there is little of it to see. To be sure, in his youthful notebooks there are sketches of street or country people which are pleasantly attentive, but they are very few in number.[15] And in 1807 there is the most un-Turner-like *Country Blacksmith Disputing upon the Price of Iron, and the Price Charged to the Butcher for Shoeing his Poney* (its ponderous title referred unpoetically to the 1806 Pig Iron Duty Bill) (fig. 171). This was Turner's one major exercise in Dutch naturalism, and it certainly exhibits his versatility. It has a warmth, depth and subtlety of colour that beat anything that Morland, say, achieved in the same genre; and its figure-work is accurately observed. Outside that door in the background there is a sense of great

171. J. M. W. Turner, *Country Blacksmith Disputing upon the Price of Iron, and the Price Charged to the Butcher for Shoeing his Poney* (oil, 1807)

events afoot; it opens onto a militarized world in which the price of iron mattered as much to the nation as it did to the butcher. All the same, this was a characteristically self-serving picture, for the 32-year-old Turner painted it only to put the up-and-coming Scottish realist David Wilkie in his place – i.e. well behind Turner in the Academy's pecking order.

Wilkie had come from Fife to London in 1805, aged twenty-one, to try his luck as an artist. He entered the Academy Schools and was then taken up by the third Earl of Mansfield. A year later, he had scored an instant success when the Academy exhibited his Teniers-like genre study of *Village Politicians*. Hung in a prime position, the painting had moved Fuseli to warn Wilkie that it was 'dangerous', for the Teniers-like realism of its tavern interior and its low tavern characters defied the Academy's Reynoldsian values. Despite this, the RA's president Benjamin West declared that Wilkie was a 'great artist', and this was

news that Turner had not the slightest wish to hear.[16] So the following year he delivered Wilkie his come-uppance. When in 1807 Wilkie exhibited his *Blind Fiddler* (fig. 172), Turner made sure that his *Country Blacksmith* was hung next to it. Turner was anxious enough about the comparison to exploit the Academician's privilege of a 'varnishing' time between a picture's hanging and the exhibition's opening. The result was gratifying. The *Blacksmith*'s quality brutally exposed Wilkie's heavy colouring and sentimentalized peasantry. Not that Turner's manoeuvre worked fully, however. Wilkie was admitted to the Academy as an Associate in 1809, as young as Turner had been when he had won the same honour ten years earlier. By 1811 Wilkie was a full Academician in his twenty-sixth year, his standing as the most popular of pre-Victorian genre painters henceforth unchallenged.

Turner's *Blacksmith* was a one-off case. He had no real interest in the doings of 'humanity'. Early reviewers were right to note that his style was 'too rough and negligent for familiar scenes of domestic enjoyment', for he drew loosely with brush in wash or oil rather than with pencil or pen, and he was in any case concerned with the ways in

172. David Wilkie, The *Blind Fiddler* (oil, 1806)

which vistas and colours were 'churned by the engine of the air'. So in his rare streetscapes like *The Horse Fair, Louth, Lincolnshire* (*c.* 1827), he paints foreground street traders as little more than dismal marionettes whose indifferently indicated humanity, so apparent when enlarged, is subordinated to the gleaming background of light and sky (fig. 173 and fig. 174).

173. J. M. W. Turner, *The Horse Fair, Louth, Lincolnshire* (watercolour, *c.* 1827)

174. detail of above

The landscape artist isn't obliged to depict common life or be a figurative artist when his skills and purposes lead elsewhere. But Turner's indifference to the London streets (as distinct from the Thames) is striking and peculiar. It suggests that Ruskin's insistence that Turner's Covent Garden boyhood left its mark wasn't misconceived, even if that influence turned on his reaction *against* the denatured city. On the other hand, further and more positive Covent Garden influences operated on Turner than those that Ruskin was equipped to note. These included the people and networks Turner learned from, his driven ambition and competitiveness, his use of his art for self-advancement, his determination to climb in the Academy, his deference to monied patrons. Beyond these lay his parsimony and his need to accumulate property, his taciturnity, inarticulacy, vanity, coarse speech and manners, and slovenly dress and housekeeping. At least some of these unlovely qualities were determined by the pinched, unpolished, and self-interested but aspirational mindsets of the Covent Garden middling people among whom he matured. Even his interest in the erotic was probably acquired from his early associations with the likes of Morland and Rowlandson in John Raphael Smith's workshop. Goodness, Wisdom, Purity and Truth had less to do with his making than these mundane things.

MAIDEN LANE AND AFTER

The Turner parents moved into 21 Maiden Lane after they married in August 1773. Joseph Mallord William was named after his mother's brother, a butcher in Brentford. Conditions in their ground-floor wig-shop must have been cramped. The basement was occupied by the tavern and singing-saloon called the Cider Cellar, while an upper part of the house was an auction room. In view of the prodigy born downstairs, it was an odd coincidence that the Free Society of Artists had used that space for their annual exhibitions in 1765–6, and again that the Incorporated Society of Artists rented it in 1769–73 for their academy of painting, drawing and modelling – though less of a coincidence in Covent Garden than would have been the case elsewhere.[17]

In 1776 the family moved for unknown reasons. When Turner's

younger sister died in 1786 she was buried in St Paul's, Covent Garden: so they clearly stayed in the parish. Perhaps because of his mother's mounting insanity, the boy spent time with his Brentford uncle and with another, a fishmonger in Margate, where he went to school. Each place opened his eyes to unspoiled countryside or to wild sea. The family returned to number 26 on the northern side of Maiden Lane in about 1790. One entered their lodgings through 'a sort of gloomy horizontal shaft, or paved tunnel, with a low archway and prison-like iron gate of its own'. A 'coffin-lid door' led to the wig-maker's shop.[18] A room looking onto Hand Court, 'small and ill calculated for a painter' (Farington noted), served as Turner's studio until 1799.

Between 1763 and 1777, seven artists had addresses in Maiden Lane. Most were obscure, but one was the well regarded landscapist Thomas Hearne. He later remarked that Turner's skies must have been painted by 'a mad man'.[19] Otherwise, Maiden Lane was a very ordinary and narrow little street, as it still is. In 1720 Strype found it 'well built' but 'narrow, and of little Trade'; but by the Turners' time businesses had multiplied. It was full of craftsmen and shopkeepers of middling kinds. The ratebooks for 1784 name thirty-five Maiden Lane ratepayers who paid an average rate of just over £36. The high-est rates were paid by a glazier (£55) and by one of the two 'gentlemen' in the street (£52); the lowest was the £12 paid by a stay-maker. Joseph Mooring, once the Turners' auctioneer landlord, was rated at £35 for number 21. Figures like these spoke for small though not necessarily uncomfortable houses.[20]

The street also accommodated its fair quota of the 'kinder sort of females', as Strype called them. A few dozen yards away, the alleys and courtyards leading to the Strand were full of bawdy-houses. In Chandos Street, too, stood the Three Tuns and the Key taverns. It had been in the Three Tuns that the courtesan Sally Pridden, once painted by Kneller, had used a breadknife to stab the son of the Earl of Not-tingham in an argument over a theatre appointment. And when the Key tavern burned to the ground in 1806, the neighbours provided covering and shelter for 'the half-dressed gallants and shivering nudes' who escaped the blaze, proving their tolerance of the Key's fame for 'the magnificence of its furniture, the quantity of its plate, and the

voluptuous manner in which the beds were furnished', the last being the convenience that most of its customers requested.[21] In Turner's time, the Cider Cellar would erupt into raucous late-night vigour, while a few doors away the Brilliants club met in the Swan on the corner of Chandos and Bedford Streets. This was the print-men's and actors' late-night drinking club that Rowlandson drew in boozy conviviality, vomit and song in 1798.[22] In short, young Turner came to consciousness in the full razzle-dazzle of Covent Garden low living.

*

Ruskin later declared that 'what help Turner received from this or that companion of his youth is of no importance to any one now'.[23] He would say that, however. Turner's first helpers were not of the grandest, and Ruskin was more interested in the help Turner might have had from Raphael, Giorgione and Claude. The truth was that Turner's father spent a decade scratching around for affordable teachers and employments for his son, an effort that says much about the family's limited resources, but even more about the networks and improvisations peculiar to artistic living in Covent Garden.

His father wasn't doing badly in his wig-shop. He was well placed to pull in smart trade and gossip about art and theatre, and also to sell his son's drawings for a couple of shillings each; he pinned them up in his window. By doing morning rounds to shave local gentlemen and dress their hair, and by making or servicing wigs as well (before wigs fell out of fashion), it is estimated that father Turner might have made £300 a year. So there was no real poverty in Turner's life-story.[24] Still, pennies had to be pinched and help found wherever it offered. The first of the boy's helpers was deeply unprepossessing. He was the one-eyed and smallpox-scarred Mauritius Lowe, the 'poor wretch of a villainous painter' on whose squalid Hedge Lane lodgings Fanny Burney reported in 1781 (p. 153 above).

Oddly, Ruskin did acknowledge Lowe's existence in Turner's life, even if only in passing. One of his footnotes in *Modern Painters* tells us that Turner's 'first drawing master was . . . that Mr Lowe, whose daughters, now aged and poor, have, it seems to me, some claim on public regard, being connected distantly with the memory

of [Samuel] Johnson, and closely with that of Turner'. The reference was to a campaign mounted by Thomas Carlyle, Dickens and John Forster to get a government pension for Lowe's penurious daughters: one of them was indeed Dr Johnson's goddaughter. The fact that Lowe was also associated with Turner was discovered subsequently – and must have caught Carlyle and Ruskin by surprise. In November 1855, Carlyle reported that he had just learned (presumably from Miss Lowe) 'that it was Mauritius Lowe their Father, actually, who saved the late immortal Turner from his Barber's shop, and made a *Weltberühmter* [world-famous man] of him; – and that poor Miss Lowe learned drawing beside him, under her Father's tuition.'[25]

This was a daughter's exaggeration of her father's importance, for such a man had little to offer the boy Turner. Lowe had been one of the first pupils to enlist in the Academy Schools in 1769, and had won a gold medal and a scholarship to Rome, but in Rome he was so indolent and dissipated that the scholarship was withdrawn. Still, he exhibited at the Society of Artists in 1776 and 1779 (perhaps in Turner's birthplace: was this their connection?), and he was liked by Samuel Johnson, which was no mean thing. Johnson had him to dinners with Boswell and urged his friends out of charity to sit to him for their portraits. Boswell recorded how Johnson once stopped their hackney coach at the bottom of Hedge Lane and went to leave a letter '"with good news for a poor man in distress," as he told me'.[26] And when Lowe's painting *The Deluge* was rejected by the Academy's exhibition committee in 1783, Johnson (with no taste in such matters) announced that the picture was 'noble and probable', and pressed Reynolds to show it in a room of its own. There it made everyone laugh for the wrong reasons – 'execrable beyond belief', wrote the Academician Northcote.[27] It would not have been long after this that the boy Turner visited Lowe in Hedge Lane to share lessons with his daughter.

This encounter was typical of those a young artist without connections had to make in his training. Probably the master–pupil relationship didn't last long. Fortunately, Covent Garden offered plenty of other ports for Turner to call in. As boy and teenager, he spent hours visiting Covent Garden's auction rooms, or copying

engravings by Paul Sandby (whose classes he might have attended), or working as a draughtsman for the architect Thomas Hardwick (who refashioned the exterior of St Paul's church, Covent Garden, in 1788). In 1789 he visited an uncle in Oxford, the first of many excursions. He also enrolled in the Royal Academy Schools, and joined Thomas Malton's drawing school in Soho. 'My real master, you know, was Tom Malton of Long Acre': according to the unreliable Thornbury, this was Turner's tribute many years later. There's no doubt that Malton taught Turner much of what he knew about perspective. The first watercolour Turner exhibited (of Lambeth Palace, when he was aged fifteen, in 1790) had about it the careful style of the aquatints Malton was producing for his *Picturesque Tour through the Cities of London and Westminster*. Thomas Girtin was also one of Malton's pupils. Of the same age, he and Turner became friends. We owe again to Thornbury the information that both young men coloured prints for John Raphael Smith in his shop in King Street.

An odder and less expected, if in the end negative, influence on Turner might have followed from Thomas Malton's friendship with – of all people – Thomas Rowlandson. Rowlandson is the last person to expect in a Turner biography, but the interdependencies of the local artistic community permitted stranger conjunctions than this one. Malton and Rowlandson knew each other well. They had been fellow-pupils at the Royal Academy Schools in the early 1770s. In 1791, Malton aquatinted at least four of Rowlandson's drawings for Fores's Piccadilly printshop.[28] He and Malton had both lived in Poland Street, Soho; and when Malton was teaching Turner and Girtin, Rowlandson lived only three Soho blocks away in Carlisle Street, off Soho Square. It's reasonable, therefore, to believe that Rowlandson would at some point have met the younger men at work with Malton. For that matter he might have met William Blake, since Blake was then lodging at 28 Poland Street. If the three younger men did work for Smith in King Street (Turner and Girtin as colourers, and Blake as the known engraver of at least two Morland plates published by Smith), Rowlandson might have been the go-between: Smith and Rowlandson were also firm friends. If again so, it may be no wonder that Turner would later take his own erotic sketching for

granted. Smith, Rowlandson and Morland were accomplished eroti-
cists themselves.

All this is speculative, and Turner's biographies are already full
enough of speculation; yet the plot does have a little further to run. In
the early to mid-1790s Turner and Girtin attended the informal even-
ing 'academy' conducted by Dr Thomas Monro at 8 Adelphi Terrace,
overlooking the Thames. As Farington reported in 1798,

> Turner & Girtin told us that they had been employed by Dr Monro 3
> years to draw at his house in the evenings. They went at 6 and staid till
> Ten. Girtin drew in outlines and Turner washed in the effects. Turner
> afterwards told me that Dr Munro had been a material friend to him,
> as well as to Girtin.[29]

Monro employed them to copy drawings by J. R. Cozens among others.
He paid them 3s. 6d. a night, with an oyster supper thrown in. While
working for Monro neither Girtin nor Turner could have avoided Row-
landson: from 1792 he lived round the corner in Robert Street and then
James Street. He also knew Monro: Monro collected his drawings.[30] As
their paths unavoidably crossed in that lightly trafficked and pedestrian
town, the two young watercolour-revolutionists-in-waiting would at
least have been on bowing terms with their senior.

There is no hint of further contact between them, not surprisingly.
The distance between their generations yawned unbridgeably. The
watercolourist of Rowlandson's time had usually laid his colour tints
over a preliminary ink or pencil drawing: he 'sketches his scapes with
a lead-pencil; then he pens them all over, as he calls it, with Indian-
ink, rubbing out the superfluous pencil-strokes; then he gives a
charming shading with a brush dipped in Indian ink; and last he
throws a light tinge of watercolours over the whole.'[31] Turner and
Girtin would by now regard Rowlandson, Smith, Morland and others
as passé vulgarians, their tinted drawing as contemptibly old-fash-
ioned, just as Rowlandson et al. remained unimpressed by their broad
strong washes.

In 1794 the nineteen-year-old Turner exhibited his first water-
colour at the Academy, followed two years later by his first oil.
Alongside the latter he also showed his great watercolour of *St
Erasmus in Bishop Islip's Chapel, Westminster Abbey* (**plate 29**), a

masterpiece of architectural draughtsmanship and atmospheric colouring in which 'the natural gloom of the abbey on a dull day is transformed into glowing golden stone', as Kim Sloane writes:

> All the lessons Turner learnt from his early study of perspective, the prints of G. B. Piranesi and the water-colours of Louis Ducros have been put to use: . . . he has manipulated light and shade to minimise and strip the surfaces of the distracting accretions of hundreds of years, leaving the pure lines of the architecture to emphasise the upward thrust and glorious soaring space.[32]

A work like this lay completely outside the older men's range. On a grave-slab in the foreground Turner proudly and self-consciously signed himself and inscribed his birthdate: 'JMW TURNER NATUS 1775'. He was the coming and the young man. Even so, such encounters left deposits. Turner and Girtin would have acknowledged Rowlandson's place in the tradition they reacted against. When they turned their backs on the urban and topographical art in which they had been trained by Malton and others, Rowlandson must have been one of several reference points that defined how they wished not to be.

*

With his mother getting madder (and soon to be sent to St Luke's hospital and then to Bedlam), and work in the house ever more difficult, Turner left Maiden Lane for 64 Harley Street in 1799. Some twenty years later he expanded that house backwards into 47 (now 22 and 23) Queen Anne Street, just round the corner. This remained his official studio and home until he died in 1851.

It was apt that Turner left Maiden Lane at the very end of the century. His move consummates the great artistic exodus from Covent Garden that the 1780 Gordon Riots had accelerated. By 1816, only ten out of some 480 London painters were listed with an address that referred to 'Covent Garden'. Only another five lived in Leicester Square, and a mere dozen along or off the Strand. By contrast, 'Soho' had twenty-six and 'Marylebone' seven artists; ten lived along Oxford Street or in Oxford Market, and twenty-three in seedy Newman Street

to the north of it. Not far from Turner's house, eleven artists lived in fashionable Portland Place or Portland Street.[33]

As the century drew to a close, these addresses suggest a diminished understanding of and need for the old bohemian lifestyles and networks. In an increasingly professionalized art world and a more diversified market, artists followed the money. Farington understood Turner's move to Harley Street: 'The district is very respectable and central enough,' he wrote. 'Respectability' had never been an issue in the Covent Garden of Turner's youth, but now it was the coming word.

So Turner put himself on the respectable side of the *cordon sanitaire* between the high and the low people that John Nash the architect was laying down in the new Regent Street. He now lived in the rectangular street grid of the Portland Estate. It had been grandly laid out by Robert Adam on the fields between Cavendish Square and Park Crescent off what is now Marylebone Road. At key entry-points iron gates and watchman's boxes guarded its inhabitants (the boxes at the Crescent's entry still stand). Yet much good his new location did him. He no longer had to woo buyers, and by Covent Garden standards the world he had entered was boring. Shortly after his death *The Times* acknowledged that 'in that region of dull and decorous streets which radiates to the north and west from Cavendish-square, Queen Anne-street is one of the dullest and dingiest'. Turner became ever more curmudgeonly to visitors and ever fonder of his secret retreat with Mrs Booth in Chelsea. Although he was lionized, and loved his fame, he was cut off from his roots, and his paintings became his all in all. They were produced one after another, sometimes in exuberant manias of colour, or else in deepest depression.

But in some sense he brought Covent Garden's low manners with him to Queen Anne Street. *The Times* described his house's soot-grimed, brown-painted walls and paper-patched windows, dark with dirt and foul with cobwebs. The front door was paintless and the area rails were rusted; it looked like 'a place in which some great crime had been committed'. Inside all was filthy, gloomy and dark. 'The great pictures were displayed in utter dereliction, so many holes in the roof and windows that umbrellas were recommended indoors [even] in warm weather.' One visitor in the 1840s recalled having to hold up

his umbrella to keep dry in the entrance hall. And 'in this sordid den were all the thirty thousand proofs of engravings rotting and mouldering, uncared for by any one but the cats'. These last were his housekeeper's sinister tribe of tail-less Manx cats that lived and defecated among, or on, his piles of pictures, prints and drawings.[34]

Appendix

146 ARTISTS AND ENGRAVERS OF COVENT GARDEN

(addresses, birthplaces, fathers' occupations)

This Appendix lists the addresses, birthplaces and fathers' occupations (where known) of 146 artists and engravers (and some printshop owners), most of whom at some point lived in the square quarter-mile or so around the Piazza of Covent Garden. A few lived a little further away, particularly in Soho. Wardour, Poland and Broad Streets were and are conventionally counted as part of Soho and are included here, though they lie in the parish of St James's, Westminster.

Sources (by order of use): *Oxford Dictionary of National Biography*; British Museum research website; Tate Britain website; Oxford Art Online; F. H. W. Sheppard (ed.), *Survey of London*: vol. 36: *St Paul, Covent Garden*, and volumes 33 and 34: *St Anne, Soho* (1966, 1970); Edward Edwards, *Anecdotes of Painters who have Resided or been Born in England* (1808); Hugh Phillips, *Mid-Georgian London: A Topographical and Social Survey of Central and Western London about 1750* (1964); T. Mortimer, *The Universal Director: or, the Nobleman and Gentleman's True Guide* (1763); Royal Academy website list of Academicians; newspapers (Burney collection online); T. Dodd, 'Memoirs of English engravers, 1550–1800', BL, Add. MSS 33394–33407; L. Worms and A. Baynton Williams, *British Map Engravers: A Dictionary of Engravers, Lithographers and their Principal Employers to 1850* (2011); British Book Trade Index, University of Birmingham (www.bbti.bham.ac.uk).

1. **Ackermann, Rudolph** (1764–1834), publisher, *b.* Germany, to London 1787: *1794*, 7 Little Russell St, Covent Garden; *1795–6*, 96 Strand; *1796–1827*, 101 Strand (429 Strand was Ackermann's 'original house')

2. **Aitken, James** (*fl.* 1788–1801), publisher, printer, birthplace unknown: *1788*, 18 Little Russell Court, Drury Lane; *1788, 1790*, Bear Street, Leicester Fields; *1789–1801*, 14 Castle Street, Leicester Fields

3. **Angellis, Pieter** (1685–1734), painter, *b.* Dunkirk, to London *c.* 1716: *1719–28*, 'in Covent Garden', working with Tillemans, Vanderbank etc.; *1728*, to Rome; *d.* Rennes

4. **Baron, Bernard** (1696–1762), engraver, *b.* Paris, father engraver, to London 1716–17: *1727*, Change Court, Durham Yard, Strand; *1732–*, Orange Street, Leicester Square; *1745–62*, Panton Square, Leicester Fields (engr. two plates of *Marriage A-la-Mode*)

5. **Barry, James** (1741–1806), history painter, printmaker, *b.* Cork, father builder or bricklayer, to London 1764: *c. 1772–85*, 29 Suffolk Street; *1788*, 36 Castle Street East, Oxford Street (ARA 1772, RA 1773, expelled 1799)

6. **Bartolozzi, Francesco** (1728–1815), engraver, *b.* Florence, to London 1764: *1764*, Warwick Street, Soho; *1778–80*, Bentinck Street; *1780–*, Broad Street; *1789*, Fulham (RA founder member)

7. **Basire, James (the Elder)** (1730–1802), engraver, William Blake's master, *b.* London: *1773–1802*, 34 Great Queen Street

8. **Benoist, Antoine**(1721?–1770), printmaker, *b.* Noyon, father artist, to London *c.* 1737 to work for Du Bosc, returns to London *1742*, sells from 'his Lodgings at Mr Jordan's a Grocer ye North East Corner of Compton Street So-ho'; *1744*, to Paris, returns again: *1763–*, opposite Long's Court, St Martin's Lane

9. **Bickham, George** (the Younger) (*c.* 1704–1771), publisher, printmaker, *b.* London, father engraver: *1737*, Bedfordbury; *c. 1740–41*, Surrey Street, Strand; *1741–63*, May's Buildings, Bedford Court, Covent Garden; *1763–*, Kew

10. **Blake, William** (1757–1827), engraver, artist, poet, *b.* Broad Street, Soho, father hosier: *1773–8*, either Broad St, Soho, or Great Queen Street (apprenticed to Basire, engraver); *1782–*, 23 Green Street, Leicester Fields; 27 Broad Street, Soho; *1785–90*, 28 Poland Street, Soho; *1790–1803*, Hercules Buildings, Lambeth, and Sussex; *1803–21*, South Molton Street; *1821–7*, 3 Fountain Court, Strand

11. **Bockman, Gerhard** (1686–1773), portrait painter, engraver, *b.* Amsterdam, to London 1711: *c. 1737*, Great Russell Street, Bloomsbury; *1740s*, King Street, Covent Garden; *d.* Tash Street, Gray's Inn Lane

12. **Boitard, Louis-Philippe** (*fl.* 1733–1767), engraver, designer, *b*. France, father designer, to London *c.* 1733: Golden Pineapple, Durham Yard, Strand

13. **Brooking, Charles** (1723–1759), marine painter, *b*. London ('bred in some department of the dockyard at Deptford'), father house-painter in Greenwich Hospital: –, Castle Street, Leicester Fields; buried St Martin-in-the-Fields

14. **Burney, Edward Francisco** (1760–1848), artist, *b*. Worcester, father dancing-master, nephew of Dr Charles Burney, cousin of Fanny: *1780*, York Street, Covent Garden (? at Gregg's coffee-house, owned by Dr Charles Burney)

15. **Caldwall, James** (1739–1822), engraver (often for Collet), *b*. London: *1792*, Angel Court, Great Windmill Street, Haymarket

16. **Canaletto [Canal], Giovanni Antonio** (1697–1768), painter, *b*. Venice, to London 1746: *1746–56,* 16 Silver Street (now 41 Beak Street), Soho

17. **Casteels, Peter** (1684–1749), flower-painter, designer, *b*. Antwerp: *1726–31,* 'his house, formerly the Bagnio, Long Acre'

18. **Chéron, Louis** (1660–1725), history painter, *b*. Paris, father miniature painter and engraver, to London 1690s: *1711–20,* taught at Kneller's academy; *1720–24,* founder of and teacher at first St Martin's Lane Academy; buried St Paul's, Covent Garden

19. **Cipriani, Giovanni Battista** (1727–1785), decorative painter, *b*. Florence, to London 1755: *1769,* Broad Street, Carnaby Market; *1770–,* 'Next to the Meuse [royal mews] Gate, Hedge Lane' (later Whitcombe Street); *d*. Hammersmith (RA founder member)

20. **Closterman, John** (1660–1711), history and portrait painter, *b*. Germany, to London 1681: *1692–?1711,* 3 Great Piazza, Covent Garden

21. **Collet, John** (*c.* 1725–1780), painter, *b*. London, father portrait painter or public office holder: *1765,* 'at Mr Belmond's, Hair Merchant, James Street, Covent Garden'; then Millman Street and Cheyne Row, Chelsea

22. **Cozens, Alexander** (1717–1786), landscape painter, *b*. Russia, father shipbuilder to Peter the Great: *1763,* Tottenham Court Road; *1764–86,* Leicester Street, Leicester Fields

23. **Cozens, John Robert** (1752–1797), landscape watercolourist, *b*. London, father painter (son-in-law of John Pine): *1763,* Tottenham Court Road; *1763–71,* with father at Leicester Street, Leicester Fields

24. **Cruikshank, Isaac** (1764–1811), caricaturist and painter, *b*. Edinburgh, to London 1783: *c. 1784–5,* 53 Stanhope Street, Clare Market; *1789,* St Martin's Court, St Martin's Lane; *1792,* Duke Street, near Montagu House; *before 1807,* 117 Dorset Street, Salisbury Square

25. **Dahl, Michael** (1659–1743), portrait painter, *b*. Sweden, to London 1689: *1696*–, Leicester Fields; *1725*, Beak Street, Golden Square (ARA 1771)

26. **Dance, Nathaniel** (*later* Sir Nathaniel Dance Holland) (1735–1811), painter, politician, *b*. London, father clerk of works for the City: *1766*, *1770–82*, 13 Tavistock Row, Covent Garden (RA founder member)

27. **Dandridge, Bartholomew** (1691–1754), portrait painter, *b*. London, father house-painter: *1712*–, at Kneller's Academy; *1720*, at St Martin's Lane Academy; *1729*, Lincoln's Inn Fields; *1731*, acquired Kneller's studio and house, Great Queen Street

28. **Darling, William** (*fl*. 1770–1799), publisher, printmaker: *1770–99*, Great Newport Street

29. **Darly, Matthew** (*c*. 1720–1781?), married **Mary Darly** in 1760 (*fl*. 1760– 1781), designers, caricaturists, printsellers, birthplaces unknown: *c. 1749*, Duke's Court, St Martin's Lane; *1750s*, facing Hungerford, Strand; *1752– 4*, Seymour Court, Chandos St; *1760*, The Golden Acorn, Long Acre; *1762–6*, Ryder's Court, Cranbourne Alley, Leicester Fields; *1767–80*, 39 Strand; *1780*, 159 Fleet Street

30. **Dawe, George** (1781–1829), printmaker, painter, *b*. London, son of Philip Dawe, engraver: *1796*, 103 Tottenham Court Road; *1801–18*, 40 and 44 Wells Street; *1815–17*, 22 Newman Street (RA student 1794–, ARA 1809, RA 1814)

31. **Dawe, Philip** (*c*. 1750– ?), mezzotinter and printmaker, father of George Dawe, *b*. London: *1772*, Woodstock Street; *1773– 82*, 4 Goodge Street, Tottenham Court Road

32. **De Loutherbourg, Philippe-Jacques** (1740–1812), landscape and scenery painter, *b*. Strasbourg, father miniaturist and engraver, to London 1771: *1782*, Lisle Street, opens the 'Eidophusikon' (ARA 1780, RA 1781)

33. **De Wilde, Samuel** (1751–1832), portrait painter, *b*. London, father Dutch physician: *?*–, Leicester Fields; *1804–9*, Tavistock Row

34. **Devis, Arthur** (1712–1787), portrait painter, *b*. Lancashire, father carpenter, to London 1740s: *1747*, Great Queen Street; *1783*, Brighton

35. **Dickinson, William** (1746/7?–1823), engraver, printseller, *b*. London (?): *1768–71*, St Martin's Lane (with Robert Edge Pine); *1774*, 180 Strand; *1774*, Mr Sledge's, Henrietta Street, Covent Garden; *1778–91*, New and Old Bond Street; *1797*, bankrupt, goes to Paris. Engraved for Reynolds, Kauffman, Peters

36. **Dighton, Robert** (1751–1814), publisher, printer, draughtsman, opera singer, *b*. London, father printseller: *1769–73*, 65 Fetter Lane; *1774–5*, at Mr Glanville's, opposite St Clement's Church; *1785*, 266 Henrietta

Street, Covent Garden; *1794–9*, 12 and 6 Charing Cross; *1810–14*, 4 Spring Gardens, Charing Cross

37. **Du Bosc, Claude** (1682–*c.* 1746), engraver, printseller, *b.* France, to London by 1713: Charles Street, Covent Garden

38. **Edwards, Edward** (1738–1806), painter, *b.* London, father chairmaker: *1738–*, Castle Street, Leicester Fields; ?–, St Martin's Lane; *1760–*, Compton Street, Soho (RA student 1769, ARA 1773)

39. **Ellys, John** (1701–1757), portrait painter, *b.* Covent Garden; 'most of life', Piazza, Covent Garden

40. **Faber, John** (*c.* 1695–1756), engraver, mezzotinter, painter, *b.* Amsterdam, father engraver, to London *c.* 1698: *1707–*, opp. Essex Street; at Blue Ball, Catherine Street; at Two Golden Balls, Savoy; *c. 1721–5*, Fountain Court, Strand; *late 1720s*, Green Door, Piazza, Covent Garden; *c. 1731–4*, Craven Buildings, Drury Lane; *c. 1734–*, Golden Head, Bloomsbury Square

41. **Fisher, Edward** (1722–1781/2), mezzotinter (studio of McArdell; engraved Reynolds portraits), *b.* Dublin, father feltmaker, to London 1758: *1758–*, in McArdell's studio; ?–1761, Leicester Fields (co-lodger with murderer Gardelle); *1779*, 11 Ludgate Street

42. **Flaxman, John** (1755–1826), sculptor, designer, illustrator, *b.* York, father plaster-cast maker, to London 1756: *1756–*, Strand; ?–, Buckingham Street, off Strand

43. **Fuseli, Henry** (*formerly* Johann Heinrich Füssli) (1741–1825), painter, writer, *b.* Switzerland, to London 1764: *1764–*, Cranbourne Alley, Leicester Fields; *1779–*, 1 Broad Street, corner of Portland Street; *1788–93*, 72 Queen Anne Street East (now Foley Street) (ARA 1788, RA 1790)

44. **Gainsborough, Thomas** (1727–1788), painter, printmaker, *b.* Suffolk, father publican, clothier, postmaster, to London *c.* 1740: *c. 1740–*, Covent Garden area (?); *1744–8*, Little Kirby Street, Hatton Garden; *1748–74*, Sudbury, Ipswich, and Bath; *1774–*, part of Schomberg House, Pall Mall (RA founder member)

45. **Gardelle, Théodore** (1722–1761), murderer, painter, miniaturist, *b.* Geneva, father goldsmith, to London 1759: *1759–61*, 36 Leicester Fields, where he murdered landlady; hanged in the Haymarket

46. **Gibbons, Grinling** (1648–1721), woodcarver, sculptor, *b.* Rotterdam (English parents), to England *c.* 1667: *1672*, La Belle Sauvage inn, Ludgate Hill; *1678–*, Bow Street, Covent Garden

47. **Gillray, James** (1756–1815), caricaturist, *b.* London, father soldier: *c. 1780–84*, 'portrait painter', 7 Little Newport Street, Leicester Fields;

1788, Temple Bar, Strand; *1790*, King's Road, Chelsea; *1793*–, 18 Old Bond Street, with Hannah Humphrey, printseller; *1798*–, 27 St James's Street, with the same

48. **Gilpin, Sawrey** (1733–1807), animal painter, *b*. Cumberland, father landscape painter, brother William Gilpin, to London 1749: *1749–58*, 4 Tavistock Row; *1747–58*, 2 Henrietta St (as apprentice to Samuel Scott); *1786–1807*, Knightsbridge, and Brompton (ARA 1795, RA 1797)

49. **Girtin, Thomas** (1775–1802), watercolourist, engraver, *b*. London, father brushmaker, Huguenot descent: *1794–6*, 2 St Martin's le Grand, City; *1797*, 35 Drury Lane; *1798*, 25 Henrietta Street; *1799*, 6 Long Acre; *1800*, 50 Drury Lane; *1800*, Scott's Place, Islington; *1801*, St George's Row, Hyde Park; *1802*, Strand

50. **Goupy, Louis** (Lewis) (*c*. 1674–1747), painter, miniaturist, *b*. France, to London 1710: *1710–33*, King Street, Covent Garden

51. **Gravelot, Hubert-François** (1699–1773), book illustrator, engraver, *b*. Paris, father master tailor, to London 1733: *1733–45*, Southampton Street, King Street and James Street, Covent Garden; *1745*, return to Paris

52. **Green, Valentine** (1739–1813), engraver, publisher, *b*. Warwickshire, father dancing-master: *1770–77*, Salisbury Street, Strand; *1778–9*, 52 Strand (Rowlandson lodges there 1792); *1779–90*, 29 Newman Street; *1790–97*, 13 Berners Street, Oxford Street; *1800*, 2 New Road, Fitzroy Square; *1803–7*, 51 Upper Titchfield Street (RA 'associated engraver' 1775)

53. **Grignion, Charles** (1753–1804), history and portrait painter, *b*. London, Huguenot descent: Great Russell Street, Covent Garden; *1763*, James St, Covent Garden; *1770s*, Russell Street; also 104 St Martin's Lane

54. **Grimm, Samuel Hieronymus** (1733–1794), watercolourist, *b*. Switzerland, father notary, to London 1768: lived 'most of his life' at Mrs Susanna Sledge's, printseller, 1 Henrietta Street; *d*. Tavistock Street, Covent Garden

55. **Hamilton, Gawen** (1697?–1737), painter, *b*. Lanarkshire, to London mid-1720s: *1720s*, 'off the Strand'; *d*. 'near St Paul's, Covent Garden'

56. **Hayman, Francis** (1707/8–1776), painter, engraver, book illustrator, *b*. Devon, to London 1718: *c*. *1743–53*, 8 Craven Buildings, Drury Lane; *1753–63*, 104 St Martin's Lane (following Reynolds); *1763–76*, 42–43 Dean Street, Soho (RA founder member)

57. **Hearne, Thomas** (1744–1817), watercolourist, topographical draughts-

man, *b*. Gloucestershire, to London 1750s: *1750s*, apprenticed to pastrycook uncle, Maiden Lane; *1780s?–1817*, 5 Macclesfield Street, Soho

58. **Heath, James** (1757–1834), engraver, *b*. London, father bookbinder: *1768*, Long Acre; *1785*, 13 Lisle Street, Leicester Square; *1795*, Newman Street; *1802–4*, Russell Place, Fitzroy Square; *d*. Great Coram Street. (ARA)

59. **Highmore, Joseph** (1692–1780), painter, *b*. London, father City coalmerchant: *1724*, Lincoln's Inn Fields; *1761*, to Canterbury

60. **Hogarth, William** (1697–1764), painter and engraver, *b*. Smithfield, London, father schoolmaster: *1714–20*, silver engraver for Ellis Gamble, Cranbourne Street, Leicester Fields; *1720–*, Long Lane, Smithfield (mother's house); *1724*, at Golden Ball, corner Cranbourne Alley and Little Newport Street; *1730*, 'Little Piazza', Covent Garden; *1731–3*, married, lodges with father-in-law James Thornhill, 12 Great Piazza; *1733–64*, 30 Leicester Fields

61. **Holland, William** (1757–1815), print publisher, birthplace unknown: *1782–6*, 66 Drury Lane; *1786–1802*, 50 Oxford Street; *1802–15*, 11 Cockspur Street

62. **Hone, Nathaniel** (1718–1784), painter, *b*. Dublin, to London *c*. 1743; *1740s*, St James's Place; *1754*, Frith Street, Soho; *1774*, Pall Mall; *1775*, 70 St Martin's Lane (one-man exhibition); *1780*, 44 Rathbone Place (RA founder member)

63. **Howitt, Samuel** (1756/7–1823), printmaker, painter, brother-in-law of Thomas Rowlandson, *b*. Nottinghamshire (?): *1791*, 2 New Road, Marylebone; *1801*, 15 Queen Street, Soho; *1801–2*, Panton Street, Haymarket; *1805*, 73 Wardour Street, Soho

64. **Hudson, Thomas** (1701–1779), portrait painter, *b*. Devon, father victualler, to London *c*. 1725: *c*. *1740*, Newman's Row, Lincoln's Inn Fields; *1754–6*, Rusell Street, Covent Garden; *1763*, Great Queen Street

65. **Humphrey, George** (1739–1826), publisher, printseller, *b*. London: *1783–8*, 48 Long Acre

66. **Humphrey, William** (?1742 –?1814), engraver, printseller, *b*. London, brother of Hannah Humphrey printseller: *1765*, near New Street, Street Martin's Lane; *1771–4*, opposite Cecil Court, St Martin's Lane; *1774–8*, Gerrard Street, Soho; *1776–88*, 227 Strand (with 18 New Bond Street); *1777–8*, 70 St Martin's Lane; *1780–85*, near Temple Bar (occasional); *1780–85*, 227 Strand; *1786*, Lancaster Court; *1801*, 4 Rupert Street

67. **Humphry, Ozias** (1742–1810), miniature and portrait painter, *b.* Devon, father peruke-maker, mercer, to London 1757: *1768–73*, 21 King Street, Covent Garden; *1793–7*, Old Bond St; *1799–1805*, 13 High Row, Knightsbridge; *d.* 39 Thornhaugh Street, Bedford Square (ARA 1779, RA 1791)

68. **Hysing, Hans** (1678–1752/3), portrait painter, *b.* Stockholm, father goldsmith, to London 1700, as pupil of Dahl then of Keller and Charon: *1733*, Leicester Fields

69. **Ireland, John** (*c.* 1742–1808), print dealer, watchmaker, biographer, *b.* Shropshire: *1769*, Maiden Lane, Covent Garden as watchmaker, then picture-dealer; friend of Gainsborough and J. H. Mortimer, biographer of Hogarth

70. **Kauffman, Angelica** (1741–1807), history and portrait painter, *b.* Switzerland, father painter, to London 1766: *1766–*, Suffolk Street, Charing Cross; Golden Square, Soho; *1782–1807*, Rome (RA founder member)

71. **Kirkall, Elisha** (1681/2–1742), engraver, *b.* Sheffield, father locksmith; to London *c.* 1702: Great Queen Street Academy; *1724–*, Wine-Office Court, Dogwell Court, Whitefriars, Fleet Street

72. **Kneller, Sir Godfrey** (1646–1723), history and portrait painter, *b.* Lubeck, Germany, to London 1676: *1676*, Durham Yard; *1682–1703*, Covent Garden Piazza; *1703–*, Great Queen Street, Lincoln's Inn Fields

73. **Laguerre, Louis** (1663–1721), painter, *b.* Versailles, father keeper of royal menagerie, to England 1684: children baptized at and himself buried at St Martin-in-the-Fields

74. **Lambert, George** (1699/1700–1765), landscape and scene painter, birthplace unknown: 'most of his life', Covent Garden Piazza

75. **Laroon, Marcellus II** (the Elder) (1648/1649–1702), *b.* The Hague, to London after 1660, drapery painter, assistant to Kneller: *1679–1702*, 4 Bow Street; *1709–*, 'Covent Garden'

76. **Laroon, Marcellus III** (the Younger) (1679–1772), portrait and scene painter, *b.* Chiswick: *1679–*, ?4 Bow Street; *c. 1712*, Kneller's assistant, Great Queen Street; 'Covent Garden'; *d.* Oxford

77. **Lawrence, Sir Thomas** (1769–1830), painter, draughtsman, *b.* Bristol, father exciseman, publican, to London 1787: *1787*, 4 Leicester Square; *1787–*, 41 Jermyn Street, 24 Old Bond Street; *1799–1804*, Greek Street, Soho: *1813* until death, 65 Russell Square (RA)

78. **Lely, Sir Peter** (1618–1680), portrait and court painter, *b.* Westphalia, father infantry captain, to London *c.* 1643: *1650–80*, Covent Garden Piazza

79. **Lens, Bernard II** (1659–1725), printmaker, mezzotinter, *b.* London,

father 'Dutch preacher': *1690*, 'between Bridewell Bridge and Fleet Bridge in Blackfriars'; *1703*, at the Three Crowns and Dial, Fleet Street; *1705–10*, at the Golden Head in Wine Office Court, Fleet Street; *1725*, St John's Street (father of **Bernard Lens III** (1682–1740), miniaturist, address unknown; *d.* Hyde Park Corner

80. **Lowe, Mauritius** (1746–1793), painter, illegitimate son of Baron Southwell, friend of Johnson, teacher of Turner: *1782–*, 3 Hedge Lane (later Whitcombe Street)

81. **Major, Thomas** (1720–1799), publisher, printmaker: *c. 1745–7*, Rue St Jacques, Paris; *1749–52*, West Street, St Martin's Lane; *1755–6*, Chandos Street; *1756–*, 'on the paved stones', St Martin's Lane

82. **Malton, Thomas (the Younger)** (1751/2–1804), architectural draughtsman, *b.* London, father draughtsman: *1768*, near Exeter Exchange, Strand; *1774–77*, 3 Poland Street, Soho; *1779*, 56 Poland Street, Soho; *1780*, Bath; *1781–96*, 8 Carlisle Street, Soho – and *1783–9*, 6 Conduit Street, Hanover Square; *1791–6*, 81 Great Titchfield Street; *1796–1804*, 103 Long Acre

83. **Marlow, William** (1740/41–1813), landscape and view painter (Samuel Scott's apprentice), *b.* London: *1754–61*, 2 Henrietta St; *1763*, Great Newport Street; *d.* Twickenham

84. **Martin, Elias** (1739–1818), landscape and portrait painter, *b.* Stockholm, father master joiner, to London 1768–80, 1788–91 (thereafter Sweden): *1773*, Dean Street, Soho; *1778–*, 8 Leicester Street, Leicester Fields RA (student 1769, ARA 1770)

85. **McArdell, James** (1727/8–1765), mezzotint engraver, *b.* Dublin, to London 1746: *c. 1746–*, Golden Head, Henrietta Street

86. **Mercier, Philip** (1691–1760), painter, etcher, *b.* Berlin, father Huguenot tapestry weaver, to London 1715 or 1716: *1720–27*, Leicester Fields; *1735–9*, Great Piazza, Covent Garden; *1739–51*, York; *1762–8*, second wife Dorothy printseller in Little Windmill Street, Soho

87. **Morland, George** (1763–1804), landscape and genre painter, *b.* Haymarket, father painter (below): *1784–?5*, Martlett's Court, Bow Street; Kensal Green; *1786*, Marylebone High Street; Camden Town; *1787–9*, Warren Place, Camden Town; *thereafter nomadic*: Leicester Street, Leicester Fields; Tavistock Row, Covent Garden; St Martin's Lane; *1790*, 'White Lion', Paddington (drovers' tavern); *1792*, Charlotte Street, Fitzroy Square; *c. 1793*, 121 Pall Mall, above Mrs Lay's printshop; Chelsea; Lambeth; East Sheen; Queen Anne Street East, etc., etc.; *1799–1802*, 'rules' of King's Bench prison; *1803*, Garrick's Head, Bow Street

88. **Morland, Henry Robert** (1716/19–1797), painter, engraver, *b*. London: ?– *1760*, 47 Leicester Fields; *1763*, Haymarket; *1784*–, Haymarket; Chapel Street, Wardour Street; *d*. Stephen Street, Rathbone Place

89. **Mortimer, John Hamilton** (1740–1779), painter, etcher, *b*. Sussex, father mill-owner, customs officer, to London 1756–7: Church Court, Covent Garden; *d*. 33 Norfolk Street, Strand (ARA 1778)

90. **Moser, George Michael** (1706–1783), chaser, enameller, *b*. Switzerland, father coppersmith, to London 1726: *1726–30*, Soho; *1730–37*, Salisbury Court, Fleet Street; *1730–32*, James Street, Covent Garden; *1737–70s*, Craven Buildings, Drury Lane (RA founder member, Keeper 1768–83).

91. **Mosley, Charles** (*d*. 1756), engraver, printseller: Old Round Court, Strand; *1750*–, Maiden Lane, Covent Garden

92. **Newton, Richard** (1777–1798), satirical engraver, *b*. ?London: *1797*, 13 Bridges Street, Covent Garden

93. **Opie, John** (1761–1807), portrait and history painter, *b*. Cornwall, father mine carpenter, to London 1781: *1781–c. 1791*, Orange Court, Castle Street, Leicester Fields; *1783*, Great Queen Street (ARA 1786, RA 1787)

94. **Parmentier, James** (1658–1730), decorative painter, *b*. Paris, to London 1680, then Yorkshire 1700–1721; buried St Paul's Covent Garden

95. **Pars, William** (1742–1787), artist, *b*. London, father engraver: *1763*, 'the Twisted Pillars', Strand (RA student 1769–, ARA 1770)

96. **Peters, Rev. (Matthew) William** (1742–1814), painter, *b*. Isle of Wight, father agricultural writer, to London (after Italy and Dublin) 1765: *1766*, Tavistock Row, Covent Garden; *1767–9*, Bond Street, Suffolk Street, Welbeck Street; *1776–7*, Great Newport Street (RA 1771)

97. **Peeters, John** (1666/7?–1727?), painter, *b*. Antwerp, to London 1685: addresses unknown, but *c. 1685–1712*, drapery painter for Kneller (–*1703*, Covent Garden Piazza; *1703*–, Great Queen Street); buried St Martin-in-the-Fields

98. **Pine, Robert Edge** (1730–1788), portrait painter, *b*. London, father engraver: *1765–72*, St Martin's Lane; *1772*–, Bath; *1784*–, Philadelphia

99. **Pond, Arthur** (1701–1758), artist, printseller, *b*. London, father surgeon: *1727–35*, Piazza, Covent Garden; *1735* until death, Great Queen Street

100. **Ramsay, Allan** (1713–1784), portrait painter, *b*. Edinburgh, father bookseller, to London 1732: *1738(–54?)*, Piazza, Covent Garden; *1757*, 31 Soho Square; *1764*, 67 Harley Street

101. **Ravenet, Simon François** (1721–1774), engraver, *b*. Paris, to London

1743 (to engrave *Marriage A-la-Mode*): ?–, St Martin's Lane (?); *1763*, 10 Poland Street, Soho; *d.* Kentish Town

102. **Reisen, Charles Christian** (1679–1725), gem engraver, *b.* London, father Danish; directs Kneller's academy, Great Queen Street; buried St Paul's, Covent Garden

103. **Reynolds, Joshua** (1723–1792), portrait and history painter, *b.* Devon, father schoolmaster, to London 1740: *1752–3*, 104 St Martin's Lane; *1753–60*, 5 Great Newport St; *1760–92*, 47 Leicester Fields (RA founder member, President RA 1768–92)

104. **Richards, John Inigo** (1730/31?–1810), scene-painter at Covent Garden, *b.* London, father scene-painter, Hogarth his godfather, studied with George Lambert: *1788–*, Somerset House (RA founder member, secretary 1788)

105. **Richardson, Jonathan** (the Elder) (1667–1745), portrait painter, *b.* London, father silk-weaver, citizen of London: *1703–24*, Holborn Row, Lincoln's Inn Fields; *1725–45*, Queen Square, Bloomsbury

106. **Richardson, William** (*fl.* 1778–1812), print publisher: *1778–82*, 68 High Holborn; *1783–5*, 174 Strand; *1794–5*, 2 Castle Street, Leicester Fields; *1796–1811*, 31 Strand

107. **Roach, John** (*fl.* 1793–1795) and/or **Roach, James** (*fl.* 1786–1819), booksellers, publishers, *b.* London: *1793–5*, Woburn Street ('opposite the pitt door entrance New Drury Theatre Royal'); 5 Russell Court, Drury Lane; *1799*, 5 Vinegar Yard, Drury Lane; *1804–17*, Woburn Court, Drury Lane

108. **Romney, George** (1734–1802), painter, *b.* Lancashire, father smallholder, to London 1762: *1765–75*, Great Newport Street; *1775–98*, Cavendish Square; *1798–9*, Hampstead

109. **Rooker, Edward** (1724–1774), engraver, actor, father of Michael Rooker, *b.* London: *c. 1740*, High Holborn; *1755–63*, Queens Court, between Holborn and Lincoln's Inn Fields; *1767–9*, Great Queen Street; *d.* Great Russell Street, Bloomsbury

110. **Rooker, Michael Angelo** (1746–1801), topographical watercolourist, theatre designer, son of Edward Rooker, *b.* London: *1763–7*, Great Queen Street; *1768*, Long Acre; *1769–73*, Queens Court, between Holborn and Lincoln's Inn Fields; *1774–86*, Great Russell Street; *1789–92*, Long Acre; *d.* 23 Dean St, Soho (RA student 1769–, ARA 1770)

111. **Roubiliac, Louis François** (1702–1762), sculptor, *b.* Lyons, father merchant, to London by *1731*: Peters Court, St Martin's Lane; *d.* St Martin's Lane

112. **Rowlandson, Thomas** (1757–1827), artist, *b.* London, father bankrupt City wool and silk merchant: *early 1770s*, 4 Church (now Romilly)

Street, Soho; *c. 1775–86*, 103 Wardour Street, Soho; *1786–90*, 50 Poland Street, Soho; *1791–2*, 52 Strand (Valentine Green there 1778–92); *1792–3*, 121 Pall Mall, above Mrs Lay's printshop; *1792–5*, 2 Robert Street, Adelphi; *1807–27*, 1 James Street, Adelphi

113. **Ryland, William Wynne** (1733–1783), engraver, publisher, *b*. City of London, father engraver, copperplate printer: *1759–*, Lichfield Street; *1762*, Russell Street, Covent Garden; *1765–9*, Stafford Row, St James's; *c. 1765–72*, Cornhill, City; *1774–5*, 159 Strand; *1781*, Knightsbridge; executed at Tyburn for forgery

114. **Ryley, Charles Reuben** (*c.* 1752–1798), painter, *b*. London, father trooper in Horse Guards: *1780*, 12 Great Titchfield Street; *d*. New Road, Marylebone

115. **Sandby, Paul** (1725–1809), watercolourist, *b*. Nottingham, father propertied framework knitter, to London 1745: *1751–3*, 23 Great Pulteney Street, Soho; *c. 1761–3*, Dufours (De Ford's) Court, Broad Street, Soho; *1767–72*, 58 Poland Street, Soho; *1772–1809*, St George's Row, Oxford Street (RA founder member)

116. **Sandby, Thomas** (1721–1798), architect, topographical draughtsman, *b*. Nottingham, father propertied framework knitter, to London 1742: *1751–3*, 23 Great Pulteney Street, Soho; *1760–65*, 58 Marlborough Street, Soho; to Windsor; *1791*, St George's Row, Oxford Street (RA founder member)

117. **Scotin, Louis Gérard** the Younger (1690?–), engraver, *b*. Paris, to London 1733 (to engrave for Hogarth and others)

118. **Scott, Samuel** (1701/2–1772), marine and landscape painter, *b*. London, father barber-surgeon: *1718–47*, Little Piazza, Covent Garden; *c. 1736–47*, 4 Tavistock Row; *1747–58*, 2 Henrietta St; *thereafter* Twickenham, Ludlow, Bath

119. **Serres, Dominic** (1722–1793), mariner, marine painter, *b*. Auch, Gascony, to London *c.* 1752: *1750s –*, London Bridge; opposite Black Bear, Piccadilly; *1760s* (?), Warwick Street, Soho; *1780s*(?), St George's Row, Oxford Street (RA founder member)

120. **Shipley, William** (1715–1803), founder of Society for the Encouragement of Arts, Manufactures and Commerce, *b*. London, father citizen, stationer: *c.1734–41*, Great Queen Street (apprenticed to C. Phillips); *1754–61*, drawing school at Beaufort Buildings, Strand

121. **Simon, John** (1675–1751), mezzotinter, *b*. Normandy, to London as Huguenot exile: *c. 1705*, Cross Lane, Long Acre, Covent Garden; after *1720*, Seven Stars in King Street, Covent Garden; Golden Eagle in Villiers Street; New Street, Covent Garden

122. **Slaughter, Stephen** (1697–1765), portrait painter, *b.* Covent Garden, related to proprietor of Old Slaughter's coffee-house; Paris, Flanders, Dublin; *1734–*, Bloomsbury Square, and Rathbone Place; *–1763–*, Little Piazza, Covent Garden (with daughter Mary, portraitist in wax); *d.* Kensington

123. **Smith, John** (1652–1743), mezzotint engraver, *b.* Northampton; *1680s–1743*, Lion and Crown, Russell Street, Covent Garden

124. **Smith, John Raphael** (1751–1812), engraver, publisher, printmaker, *b.* Derby, father landscape painter and engraver, to London 1767: *1772–4*, 4 Exeter Court, Strand; *1775–80*, 10 Bateman's Buildings, Soho Square; *1781–6*, 83 Oxford Street; *1782–1806*, 31 King Street, Covent Garden; *1806–11*, 33 Newman Street

125. **Smith, John Thomas** (1766–1833), printmaker, draughtsman, *b.* London, father printseller, sculptor (Nathaniel Smith, assistant to Nollekens): *1787*, 18 Gerrard Street, Soho; *1788 and 1801–14*, 18 May's Buildings, St Martin's Lane; *1797–8*, 40 Frith Street, Soho; *1805–6*, 36 Newman Street, Oxford Street; *1814–15*, 4 Chandos Street; *1833*, 22 University Street, Tottenham Court Road

126. **Stothard, Thomas** (1755–1834), painter, book illustrator, *b.* London, father publican of Black Horse inn, Long Acre: *1755*, Black Horse inn, Long Acre; *1784–*, Henrietta Street, Covent Garden; *1793–1834*, 28 Newman Street (RA student 1777–, ARA 1791, RA 1794)

127. **Stuart, James** ('Athenian') (1713–1788), painter, architect, *b.* London, father Scottish mariner: *1742–59*, Italy; *1766–88*, 35 Leicester Fields

128. **Stubbs, George Townley** (1748–1815), printmaker, *b.* York, father artist George Stubbs: *1772*, Long Acre; *1774*, Edward Street, Cavendish Square; *1776*, Great Titchfield Street; *1782*, 18 New Bond Street; *1783*, *1786*, 30 Henrietta Street, Covent Garden; *1785*, Newport Street; *1786*, Peter's Court, St Martin's Lane; *1791*, 2 Compton Street, Soho; *1795*, *1798*, *1800*, High Street, Marylebone

129. **Sullivan, Luke** (*c.* 1725–1771), engraver, miniature painter, *b.* Ireland, father a groom of Duke of Beaufort: *1764*, near Norris Street, Haymarket; *later*, Golden Lion, St Alban's Street; *d.* White Bear, Piccadilly

130. **Thornhill, Sir James** (1675/6–1734), decorative painter, *b.* Dorset, father lord of manor of Thornhill, to London 1680s: *1716–34*, 12 The Piazza

131. **Tillemans, Peter** (*c.* 1684–1734), painter, draughtsman, *b.* Antwerp, brother-in-law of Pieter Casteels, to London 1708: *1725*, Golden Head, Holles Street, off Oxford Street

132. **Turner, Joseph Mallord William** (1775–1851), landscape and history painter, *b*. London, father barber, wig-maker of Maiden Lane: *1775*–, 21 Maiden Lane; *1790–99*, 26 Maiden Lane; *1799–1808*, 64 Harley Street, with mistress, Sarah Danby, nearby; *1805*, Sion Ferry House, Isleworth; *1806–11*, Hammersmith; *1808–51*, 47 (now 22 and 23) Queen Anne Street; *1846–51*, 6 Davis Place, Cremorne New Road, Chelsea (RA student 1789–, ARA 1799, RA 1802)

133. **Van Aken, Joseph** (*c*. 1699–1749), drapery painter, painter of genre and conversation pieces, *b*. Antwerp (?), to London *c*. 1720: address unknown but worked in Covent Garden for Thomas Hudson and Allan Ramsay, etc.; joined Hogarth, Hudson, Francis Hayman and the sculptor Henry Cheere on a trip to Paris in 1748; *d*. London

134. **Vanderbank, John** (1694–1739), painter, draughtsman, *b*. London, father tapestry manufacturer: *1694–1724*, Great Queen Street and St Martin's Lane; *1729*–, Holles Street, Cavendish Square

135. **Van der Vaart, Jan** (1647–1727), painter, engraver, dealer, *b*. Haarlem, to England *c*.1674; *1711–26*, Tavistock Row, Covent Garden

136. **Vanloo, Jean-Baptiste** (1684–1745), portrait painter, *b*. Aix-en-Provence, France, to London 1737: *1737–42*, Henrietta Street, Covent Garden (then to Paris)

137. **Vertue, George** (1684–1756), engraver, *b*. St Martin-in-the-Fields, London, father tailor, mother servant in Duke of York's household: *1713–15*, Belton Street, Drury Lane; *1717–56*, Brownlow Street, Drury Lane

138. **Vivares, Francis** (1709–1780), publisher, printmaker, landscape engraver, *b*. France, to London 1727: key teacher of the British school of line-engraving; *1749*, Porter Street, Leicester Fields; *1755–71*, Great Newport Street, Leicester Fields

139. **Wale, Samuel** (1721?–1786), painter, book illustrator, *b*. Norfolk: *1748*, Palladio's Head, Long Acre; *1763–86*, Castle Street, Leicester Fields (RA founder member)

140. **West, Benjamin** (1738–1820), history painter, *b*. Pennsylvania, father innkeeper, to London 1763: Covent Garden; 14 Newman Street (RA founder member, President 1792–1820)

141. **Wheatley, Francis**(1747–1801), portrait and landscape painter, *b*. Wild Court, Covent Garden, father tailor: *1778–83*, flees to Dublin with another's wife; *d*. Marylebone (RA 1792)

142. **Wilson, Benjamin** (1721–1788), portrait painter, scientist, *b*. Leeds, father wealthy clothier: *1750*, Great Queen Street, Lincoln's Inn Fields (Kneller's former residence); *d*. 56 Great Russell Street, Bloomsbury

143. **Wilson, Richard** (1712/13–1782), landscape painter, *b*. Montgomery-shire, father rector, to London 1729: *1747–50*, Tavistock Row; *1757*, Little Piazza, Covent Garden; *1770s*, Tottenham Street, Rathbone Place (RA founder member)

144. **Worlidge, Thomas** (1700–1766), printmaker, painter, *b*. Peterborough, father lawyer: Little Piazza, Covent Garden; Great Piazza, Covent Garden; *1763*, Great Queen Street; *d*. Hammersmith

145. **Zincke, Christian Frederick** (1684?–1767), enamel painter, *b*. Dresden, to London 1704 or 1708: *1704 (or 1708)–1746*, Tavistock Row, Covent Garden; *1746–*, Lambeth

146. **Zoffany, Johan Joseph** (1733–1810), portrait painter, *b*. Germany, father court cabinet-maker, to London 1760: *c. 1763–71*, Covent Garden Piazza; *1780–1810*, Strand-on-the-Green, Kew Bridge (RA 1769)

Others referred to in text with no known address around Covent Garden:

Cosway [*née* Hadfield], **Maria** (1760–1838), history painter, *b*. Florence, to London 1779; *1781*, married Richard Cosway, see next

Cosway, Richard (1742–1821), artist, *b*. Devon, father schoolmaster, to London 1754: *1754–*, Beaufort Buildings, Strand; *1768–84*, 4 Berkeley Street; *1784–91*, Schomberg House, Pall Mall; *1791–1821*, Stratford Place, Oxford Street; *1821*, 31 Edgware Road (RA student 1769–, ARA 1770, RA 1771)

Cotes, Francis (1726–1770), portrait painter, *b*. London: *1750s*, Cork Street, Mayfair, *1765*, Cavendish Square (RA 1768)

Farington, Joseph (1747–1821), landscape painter, diarist, *b*. Lancashire, to London 1763: Upper Charlotte Street, Fitzroy Square (ARA 1783, RA 1785)

Nollekens, Joseph (1737–1823), sculptor, *b*. Soho: *1771–1823*, 9 Mortimer Street, Marylebone (ARA 1771, RA 1772)

Northcote, James (1746–1831), artist, author, *b*. Plymouth, to London 1771: *1771*, Strand; *1780*, Old Bond Street; *1780s*, Clifford Street; *1789–1822*, 39 Argyll Street; *1822–31*, 8 Argyll Place (RA student 1771–, ARA 1786, RA 1787)

Rysbrack, (John) Michael (1694–1770), sculptor, *b*. Antwerp, to London 1720: *1725* until death, Vere Street, Oxford Road (Street)

Ward, James (1769–1859), printmaker, painter: *1790*, Warren Place, Kentish Town; *1792–4*, 20 Winchester Row; *1795–9*, Paddington; *1800–1843*, 6 Newman Street; *1831–55*, Cheshunt (ARA 1807, RA 1811)

Ward, William (1766–1826), printmaker: *1785*, 10 Well Street, Oxford Street; *1787*, *1793*, Warren Place, Hampstead Road; *1795–6*, Paddington; *1791*, *1794*, *1797–99*, Camden Town; *1804–15*, 24 Buckingham Place, Fitzroy Square; *1819*, 57 Warren Street, Fitzroy Square; *1820–24*, 24 Winchester Row, Paddington; *1825–6*, 12 Mornington Crescent (RA 'associate engraver')

List of Illustrations

I thank the following for permissions to reproduce pictures in their care:

© Trustees of the Museum of the Bank of England: plate 1

© Private Collection / The Bridgeman Art Library: plate 4

© Trustees of the British Museum: plates 3, 5, 7, 15, 16, 20, 23, 25–7, 29; figs., 2, 3, 5, 6, 8, 9, 11–15, 18, 19, 21–9, 31–6, 38–50, 52, 53, 59–62, 64, 68–72, 75–7, 79, 81, 82, 84–6, 90, 93–9, 102, 104, 105, 107–13 116–21, 123–4, 127, 128, 130–34, 136–8, 140–43, 145, 146, 149, 150, 154, 159–64, 167, 170, 173

© Coram in the care of the Foundling Museum, London / The Bridgeman Art Library: fig. 101

© The Samuel Courtauld Trust, Courtauld Gallery: fig. 56

© Trustees of the Dulwich Picture Gallery: fig. 106

© Trustees of the Fitzwilliam Museum, Cambridge: plates 12, 21, 22

© Trustees of the Guildhall Art Gallery: plate 28

© Hermitage Museum, St Petersburg: fig. 73

© Huntington Art Collections, San Marino, California: plate 24

© Mount Vernon Ladies' Association: fig. 92

© Museum of London: plates 2, 6; figs. 1, 126

© National Gallery: plate 17

© Norfolk Museums & Archaeology Service (Norwich Castle Museum & Art Gallery): fig. 115

© Nottingham City Museums and Galleries: plate 8

© Her Majesty Queen Elizabeth II: plate 13

© National Portrait Gallery: fig. 78

© Royal Academy: fig. 166

© Sotheby's, London: figs. 55, 139

© Tate Britain: figs. 59, 100, 168, 169, 171, 172

© Frances Lehman Loeb Art Center, Vassar College, New York: fig. 37

© Victoria and Albert Museum: plate 18; figs. 87, 91, 144

© Yale Center for British Art, New Haven, Connecticut: plates 9–11, 14, 19; figs. 4, 7 10, 20, 30, 52, 57, 58, 63, 65–7, 74, 83, 88, 89, 103, 125, 147, 148, 152, 153, 155–8, 165

PLATES

1. Paul and Thomas Sandby, *The Piazza, Covent Garden* (1768–9), pen, grey ink, wash, 520 x 675 mm
2. Canaletto (Giovanni Antonio Canal), *Northumberland House* (1752), oil on canvas, 840 x 1370 mm
3. Jan Griffier I (the Elder), *Covent Garden* (1704–18?), oil on canvas, 1040 x 1140 mm
4. Samuel Scott, *Covent Garden Piazza and Market* (1749–58), oil on canvas, 1100 x 1667 mm
5. George Scharf, *Church Lane looking West* (1828), watercolour over graphite, 256 x 173 mm
6. Robert Dighton, *The Westminster Election, 1788* (1788), pen, ink and watercolour, 410 x 506 mm
7. Thomas Rowlandson, *A Bawd on her Last Legs* (1792, Fores), etching, 250 x 319 mm
8. George Morland, *The Artist in his Studio and his Man Gibbs* (1802), oil on canvas, 635 x 762 mm
9. Joseph Highmore (attrib.), *Figures in a Tavern or Coffee-House* (c. 1725 or after 1750), oil on panel, 197 x 464 mm
10. William Hogarth, *A Midnight Modern Conversation* (c. 1729–32), oil on canvas, 762 x 1638 mm
11. Hogarth, *Self-Portrait* (c. 1735), oil on canvas, 546 x 508 mm
12. Rowlandson, *French Valet and English Lackey* (n.d.), ink and watercolour, grey wash, 259 x 284 mm
13. Johann Zoffany, *John Cuff and his Assistant* (1772), oil on canvas, 898 x 700 mm
14. Rowlandson, *Connoisseurs* (c. 1790), watercolour, pen and ink over graphite, 229 x 305 mm
15. Rowlandson, *An Aristocrat* (n.d.), pen, grey ink, watercolour, 288 x 215 mm
16. Hogarth, *The Shrimp Girl* (c. 1740–45), 635 x 525 mm
17. James Gillray, *Titianus Redivivus; – or – The Seven Wise Men consulting the new Venetian Oracle, . . . a Scene in yᵉ Academic Grove* (1797), etching and aquatint, 541 x 408 mm

FIGURES

Introduction

1. A Sense of Place

2. A Low and Turbulent People

3. Harlots

4. The First Bohemians

5. The Men's World

6. Real Life

7. Hogarth and Low Life

8. Rowlandson's London

9. The Gordon Riots: An Ending

10. Turner, Ruskin and Covent Garden: An Aftermath

Notes

ABBREVIATIONS

Angelo, *Reminiscences*	Henry Angelo, *Reminiscences of Henry Angelo* (2 vols., 1828)
BM	British Museum (online)
Farington, *Diary*	K. Cave, K. Garlick, A. Macintyre and E. Newby (eds.), *The Diary of Joseph Farington, 1793–1821* (17 vols., 1978–98)
Gatrell, *City of Laughter*	Vic Gatrell, *City of Laughter: Sex and Satire in Eighteenth-Century London* (2006)
Hogarth *Notes*	Hogarth's 'Autobiographical Notes', *c.* 1763–4 (British Library, Add. MS. 27991), in Joseph Burke (ed.), *Hogarth's Analysis of Beauty* (Oxford, 1955)
Leslie and Taylor, *Reynolds*	Charles Robert Leslie and Tom Taylor, *Life and Times of Sir Joshua Reynolds* (2 vols., 1865)
Nichols, Hogarth *Anecdotes*	John Nichols, *Biographical Anecdotes of William Hogarth* (3rd edn, 1785)
OBSP	*Old Bailey Sessions Papers 1674–1913* (online)
ODNB	*Oxford Dictionary of National Biography* (online)
Paulson, *Hogarth's Works*	Ronald Paulson, *Hogarth's Graphic Works* (3rd rev. edn, 1969)

Smith, *Nollekens*

John Thomas Smith, *Nollekens and his Times* (2 vols., 1828)

Strype (1720)

John Strype, *A Survey of the Cities of London and Westminster* (1720) (online)

Survey of London:

vol. 5: *Survey of London: St Giles-in-the-Fields*, pt II (ed. W. Edward Riley and L. Gomme, 1914) (online)

vol. 20: *Survey of London: St Martin-in-the-Fields*, pt III: Trafalgar Square and Neighbourhood (ed. G. H. Gater and F. R. Hiorns, 1940) (online)

vols. 33–34: *Survey of London: St Anne, Soho* (ed. F. H. W. Sheppard, 1966) (online)

vol. 36: *Survey of London: Covent Garden* (ed. F. H. W. Sheppard, 1970) (online)

Vertue, *Note-books*

'The Note-books of George Vertue' (6 vols., The Walpole Society, Oxford), xviii (1929–30), xx (1931–2), xxii (1933–4), xxiv (1935–6), xxvi (1937–8), xxx (1948–50)

Walpole, *Anecdotes*

Horace Walpole, *Anecdotes of Painting in England: with Some Account of the Principal Artists* (4 vols., 2nd edn, 1782)

Walpole, *Correspondence*

The Yale Edition of Horace Walpole's Correspondence (48 vols.) (online)

YCBA

Yale Center for British Art (online)

Unless otherwise specified, place of publication is London.

INTRODUCTION

1. Smith, *Nollekens*, vol. i, p. 186; Walter Thornbury, *Old and New London* (6 vols., 1878), vol. iii, p. 256.

2. Vertue, *Note-books*, vol. xviii, p. 54.

3. Pierre Jean Grosley, *A Tour to London; or, New Observations on England, and its Inhabitants* (2 vols., 1772), vol. i, p. 24. Walpole, *Correspondence*, vol. xi, p. 212, 5 Mar. 1791.

4. L. D. Schwarz, *London in the Age of Industrialisation: Entrepreneurs, Labour Force and Living Conditions, 1700–1850* (Cambridge, 1992), p. 51; George Rudé, *Hanoverian London 1714–1808* (1971), pp. 57–8.

5. James Boswell, *Life of Johnson* (Oxford, 1980), p. 107.

6. César Graña and Marigay Graña (eds.), *On Bohemia: The Code of the Self-Exiled* (1990), p. xv.

7. H. Fielding, *Tumble-Down Dick: or, Phaeton in the Suds* (1736); Daniel Defoe, *A Review of the Affairs of France*, VIII (no. 75), Sept. 1711; G. F. A. Wendeborn, *A View of England towards the Close of the Eighteenth Century* (2 vols., 1791), vol. i, p. 292.

8. Cited in Graña and Graña (eds.), *On Bohemia*, p. 50.

9. *Survey of London*: vol. 36, pp. 82–4; Rictor Norton, *Homosexuality in Eighteenth-Century England: A Sourcebook* (http://rictornorton.co.uk/eighteen/mother.htm).

10. Sir John Hawkins, *The Life of Samuel Johnson, Ll. D* (1787), p. 335; Leigh Hunt, *The Town: Its Memorable Characters and Events* (2 vols., 1848), vol. ii, p. 122. The assault on Dryden in 1679 is still commemorated by a plaque in Rose Alley; it was 'an organized revenge . . . almost certainly prompted by the manuscript circulation of *An Essay upon Satire*, in which . . . the king, his mistresses, Rochester, and Dorset were crudely vilified': P. Hammond, 'Dryden, John (1631–1700)', *ODNB*.

11. Farington, *Diary*, 10 Dec. 1793.

12. Michael North, 'Production and Reception of Art through European Company Channels in Asia', in Michael North (ed.), *Artistic and Cultural Exchanges between Europe and Asia, 1400–1900* (2010), pp. 90–91; Michael North, *Art and Commerce in the Dutch Golden Age* (1997).

13. Richard Lachmann, *Capitalists in Spite of Themselves: Elite Conflict and Economic Transitions* (Oxford, 2002), Table 3.3, p. 52.

14. J. H. Plumb, *The First Four Georges* (1956), pp. 13–14.

15. John Ireland (ed.), *Anecdotes of William Hogarth, Written by Himself*

(1833), p. 9. Ireland here paraphrased the autobiographical notes that Hogarth wrote in his last years. Hogarth's original reads: 'occular demo[n]stration will convince and [word illegible] man sooner than ten thousand Vols.': Hogarth *Notes*, p. 215. On the *Notes*, see n. 56, chapter 5.

1. A SENSE OF PLACE

1. Smith, *Nollekens*, vol. i, p. 92.
2. [W. H. Pyne], *Wine and Walnuts; or, After Dinner Chit-Chat* (2 vols., 1823), vol. i, p. 125.
3. F. A. Pottle (ed.), *Boswell's London Journal, 1762–1763* (1950), pp. 43–4. B. Jerrold, *The Life of George Cruikshank* (1898), pp. 39–40.
4. John Forster, *The Life of Charles Dickens* (3 vols., 1875), vol. i, pp. 39, 53.
5. *Survey of London*: vol. 36, 82–4.
6. *Leigh Hunt's London Journal* (2 vols. in 1, 1834), vol. i, p. lxviii.
7. G. M. Trevelyan, *An Autobiography and Other Essays* (1949), p. 13.
8. Robert Latham and William Matthews (eds.), *The Diary of Samuel Pepys: A New and Complete Transcription* (11 vols., 1970–83), vol. iv, Glossary, p. 454; G. Hodder, *Sketches of Life and Character, Taken at the Police Court, Bow Street* (1847), p. 82.
9. Arthur Wilson, *The History of Great Britain, Being the Life and Reign of King James I* (1653), p. 146.
10. *Survey of London*: vol. 36; A. J. Downs, Jr, 'Inigo Jones's Covent Garden: The First Seventy-Five Years', *Journal of the Society of Architectural Historians*, 26, 1 (Mar. 1967), pp. 8–33.
11. *Survey of London*: vol. 36, pp. 80–82, 230–39, 322. The balconies are most visible in Hollar's stiff and modest engraving of the Piazza in the 1640s.
12. Strype (1720), vol. vi, pp. 6, 87.
13. John Forster (ed.), *The Diary and Correspondence of John Evelyn* (2 vols., 1857), vol. i, p. 49.
14. Strype (1720), vol. vi, pp. 6, 87–93; Daniel Defoe, *The Compleat English Tradesman* (1726–7), vol. ii, pp. 104, 163.
15. One version of Nebots, work is in Tate Britain, the other in the Guildhall Art Gallery. Van Aken's is in the Museum of London.
16. Smith, *Nollekens*. vol. ii, p. 274. *ODNB* gives Scott's addresses as 4 Tavistock Row and 2 Henrietta Street; Anne Lyles and Robin Hamlyn, *British Watercolours from the Oppé Collection* (Tate, 1997), cat. no.

9, locate his studio in the Piazza's eastern range. The landscape painter Richard Wilson was using this in 1757.

17. One went into the Bedfords' collection at Woburn.

18. Smith, *Nollekens*, vol. i, pp. 210–11.

19. See prints of *The Solemn Mock Procession of the Pope, Cardinalls, Jesuits, Fryers, Nuns exactly Taken as they Marcht through the Citty of London November the 17th, 1680*; and George Vertue's *The View of the Charity-Children in the Strand, upon the VII of July, MDCCX-III* (both in BM).

20. Benoist's double print was republished thirty-five years later by Francis Vivares. For the procession see Angelo, *Reminiscences*, vol. i, pp. 407–9; *Evening Post*, 19 Mar. 1741; A. G. Mackey and H. L. Haywood, *Encyclopedia of Freemasonry* (2 vols., 1909), vol. ii, p. 907. *OED* defines the word 'scald' (archaic) as 'affected with the "scall"; scabby', or '"Scurvy", mean, paltry, contemptible': 'scald miserable' was 'a burlesque designation app. first used in 1742 in connection with a procession of ragamuffins intended to ridicule the Freemasons'.

21. Strype (1720), bk iv, p. 119.

22. Ibid., bk vi, pp. 5, 68–9.

23. Sheridan, prologue to *A Trip to Scarborough* (1777).

24. Pierre Jean Grosley, *A Tour to London: or, New Observations on England, and its Inhabitants* (2 vols., 1772), vol. i, pp. 37–8, 44–5; G. F. A. Wendeborn, *A View of England towards the Close of the Eighteenth Century* (2 vols., 1791), vol. i, pp. 187–8.

25. *The Works . . . of William Shenstone, Esq.* (3 vols., 1769), vol. iii, p. 162.

26. Daniel Defoe, *A Tour thro' the Whole Island of Great Britain* (3 vols., 1724–5), vol. ii, pp. 177.

27. Close if mediocre copies were made both by Scott's studio (Bonham's auction, 18 Jan. 2012) and by William James (YCBA); Joseph Nickolls adapted the original to a painting from a slightly different angle (YCBA). Thomas Bowles III had the original engraved and published in 1753. C. Beddington (ed.), *Canaletto in England: A Venetian Artist Abroad, 1746–1755* (2006), p. 79.

28. Place Papers, vol. iv, fos. 7–9 (BM Add. MSS 27828); Gatrell, *City of Laughter*, pp. 28–9.

29. *Survey of London*: vol. 20, pp. 125–7.

30. D. Masson, *Memories of London in the Forties* (1908), cited by P. Jackson, *George Scharf's London: Sketches and Watercolours of a Changing City, 1820–1850* (1987), p. 75.

31. Joseph Addison, *Spectator*, 251, 18 Dec. 1711.

32. Paulson, *Hogarth's Works*, pp. 110–11.

33. Farington, *Diary*, 17 Feb. 1809; J. W. Warter (ed.), *Selections from the Letters of Robert Southey* (4 vols., 1856), vol. ii, p. 81 (valy 1808).

34. F. M. L. Thompson, 'Nineteenth-Century Horse Sense', *Economic History Review*, 2nd ser., xxix (1), pp. 65, 77.

35. Giacomo Casanova, *History of My Life* (12 vols. in 6, Baltimore, 1997), vols. 9–10, pp. 251–2.

2. A LOW AND TURBULENT PEOPLE

1. E. A. Wrigley, 'A Simple Model of London's Importance in Changing English Society and Economy, 1650–1750', *Past and Present*, 37, 1967; George Rudé, *Hanoverian London, 1714–1808* (1971), p. 7.

2. *Tatler*, 263, 14 Dec. 1710.

3. D. A. Kent, 'Ubiquitous but Invisible: Female Domestic Servants in Mid-Eighteenth-Century London', *History Workshop Journal* (1989), vol. 28 (1), pp. 111–28; C. Harvey, E. M. Green and P. J. Corfield, 'Continuity, Change, and Specialization within Metropolitan London: The Economy of Westminster, 1750–1820', *Economic History Review* (Aug. 1999), New Ser., vol. 52, no. 3, p. 477.

4. On pauper mortality in St Martin's parish, see Leonard Schwarz and Jeremy Boulton, *Pauper Lives Project*: http://research.ncl.ac.uk./pauperlives/ and 'The Pre-industrial Urban Environment and the Pattern of Disease in Eighteenth-Century Westminster' (Economic History Society conference 2008): http://www.ehs.org.uk/ehs/pressbriefings2008/assets/schwarz-boulton-death.doc

5. *Survey of London*: vol. 20, pp. 112–14 and vol. 36, pp. 53–63.

6. C. Masterman, *From the Abyss* (1902), p. 24.

7. Alan Mayne and Tim Murray (eds.), *The Archaeology of Urban Landscapes: Explorations in Slumland* (Cambridge, 2001), p. 2: Alan Mayne, *The Imagined Slum: Newspaper Representation in Three Cities, 1870–1914* (Leicester, 1993); Mayne and Murray (eds.), *Explorations in Slumland*, p. 4; and Seth Koven, *Slumming: Sexual and Social Politics in Victorian London* (Princeton, 2004), pp. 16, 146.

8. Philip Davies, *Lost London 1870–1945* (2009), pp. 121, 124.

9. P. Quennell (ed.), *The Memoirs of William Hickey* (1976 edn), p. 23.

10. Francis Grose, *A Classical Dictionary of the Vulgar Tongue* (1796); Walter Thornbury, *Old and New London* (6 vols., 1878), vol. iii, pp. 149–60.

11. Its width was extended to sixteen and a half feet in 1813 when William Faden bought the plates and added eight sheets to accommodate Regent's Park, Chelsea and the docklands. Horwood charged five guineas for the finished work, aiming it at nobility, lawyers, bankers, merchants and parish officials, and offering to represent the 'back parts' of houses and gardens in detail if owners paid extra: *The Times*, 12 Feb. 1800. The engraving was done by a man so obscure that he is known only as 'Ash' (possibly D. Ash of Fetter Lane: trade card in BM Prints and Drawings Dept, Heal 99.7). See P. Laxton, 'Introduction', *The A to Z of Regency London* (1985), pp. vii–viii; and on Rocque, R. Hyde, 'Introduction', *The A to Z of Georgian London* (1982), pp. v–vii.

12. *Survey of London*: vol. 5, pp. 112–14; 'A German Gentleman', *A View of London and Westminster: or, The Town Spy* (2nd edn, 1725), p. 12.

13. Report of 1876 to the Metropolitan Board of Works, which cleared the area east of Bedfordbury four years later and widened it and Chandos Street. In 1881 the Peabody trust erected dwellings for 720 people. Part of Chandos Street survives in the modern Chandos Place; the rest was obliterated by William IV Street (*Survey of London*: vol. 36, pp. 266–70).

14. George Augustus Sala, *Twice Around the Clock* (1859), pp. 164–5.

15. For a selection, see Malcolm Smuts, University of Massachusetts: www.london.umb.edu/index.php/doc–repository/prostitution. The citation is dated 1638.

16. *Tatler*, 46, 26 July 1709.

17. *Daily Courant*, 19 June 1730; *Postman*, 24 Jan. 1701–2, cited in Peter Cunningham, *A Handbook for London: Past and Present* (2 vols., 1849), vol. i, p. 67.

18. *Annual Register* for 1772, p. 136.

19. Mary Thale (ed.), *The Autobiography of Francis Place* (Cambridge, 1972), p. 107.

20. *Morning Chronicle*, 9 Feb. 1778; Edwin Chadwick, the sanitary reformer, cited by H. Jephson, *The Sanitary Evolution of London* (1907), p. 36.

21. 'A German Gentleman', *A View of London and Westminster*, p. 13. Cf. Tony Henderson, *Disorderly Women in Eighteenth-Century London: Prostitution and Control in the Metropolis, 1730–1830* (1999); Sophie Carter, *Purchasing Power: Representing Prostitution in Eighteenth-Century English Popular Print Culture* (2004), ch. 1.

22. Purportedly written from Newgate's condemned cell, its author was an anonymous hack: published in *The Daily Journal*, 16 Nov. 1724, after

Sheppard's execution: see Vic Gatrell, *The Hanging Tree: Execution and the English People, 1770–1868* (Oxford, 1994), p. 139. For Sheppard in Drury Lane, see P. Linebaugh, *The London Hanged: Crime and Civil Society in the Eighteenth Century* (2nd edn, 2006), p. 37.

23. Saunders Welch, *A Proposal to Render Effectual a Plan, to Remove the Nuisance of Common Prostitutes from the Streets of this Metropolis* (1758), p. 13 n.

24. Thale (ed.), *Autobiography of Francis Place*, pp. 77, 81.

25. Henry Fielding, *The Covent-Garden Journal*, 1 (35), p. 138 (13 Aug. 1752). But Mary Robinson, the Prince of Wales's actress-mistress, lived in Tavistock Row in 1796–8 (*Survey of London*: vol. 36, pp. 222–3).

26. F. A. Pottle (ed.), *Boswell's London Journal, 1762–1763* (1950), p. 84.

27. Thale (ed.), *Autobiography of Francis Place*, p. 51 n.

28. On Roach's prosecution see National Archives KB28/370/5; on Holland's pornography, D. Alexander, *Richard Newton and English Caricature in the 1790s* (1998), p. 18 and n. 40. On Morland's, below, chapter 4. On flagellation see J. Chandos, *Boys Together: English Public Schools 1800–1864* (Oxford, 1984), pp. 230–37; Ian Gibson, *The English Vice: Beating, Sex and Shame in Victorian England and After* (1979), pp. 18, 52, 99, 183.

29. Smith, *Nollekens*, vol. i, pp. 210–11.

30. 'A German Gentleman', *A View of London and Westminster*, cited in *Survey of London*: vol. 33, pp. 1–19.

31. Gatrell, *City of Laughter*, pp. 597–604.

32. Jacob Simon, 'Thomas Gainsborough and Picture Framing', in 'The Art of the Picture Frame', National Portrait Gallery research website.

33. 'John Middleton *c.* 1774–1809, J. Middleton & Son 1809–1818': 'British Artists' Suppliers, 1650–1950', National Portrait Gallery research website. *John Middleton with his Family in his Drawing Room* is in the Museum of London, ID no. 93, 28.

34. *Nollekens*, vol. ii, pp. 162–3; 'British Artists' Suppliers, 1650–1950'.

35. BM, Trade cards: Heal 32.24.

36. *Morning Chronicle and London Advertiser*, 28 May 1773. A memory of as well as a professional interest in such shops doubtless informed Turner's oil sketch of an *Artists' Colourman's Workshop* (*c.* 1807, in Tate Britain). In a workshop painted in Teniers's style, a blindfolded mule turns a wheel to grind pigments coarsely, while the finer grinding into oil on a marble slab is finished by a man in the centre: it took half a day to grind a sellable quantity.

37. Blake used a marble slab and 'carpenter's glass' (fish glue) as a binder, claiming that Jesus's earthly father, Joseph, had given him this secret in a vision. Alexander Gilchrist, *The Life of William Blake, 'Pictor Ignotus'* (2 vols., 1863), vol. i, pp. 69–70.

38. Joseph Addison, *Tatler*, 454, 11 Aug. 1712. *Leigh Hunt's London Journal* (2 vols. in 1, 1834), pp. lxv–lxvii.

39. J. T. Smith, *The Cries of London: Exhibiting Several of the Itinerant Traders of Antient and Modern Times* (1839).

40. T. B. Macaulay, *The History of England from the Accession of James II* (5 vols., 1848), vol. i, pp. 121–2.

41. *Survey of London*: vol. 36, pp. 129–50.

42. *Evening Post*, 23–26 June, 1739.

43. Smith, *Nollekens*, vol. ii, pp. 234–5.

44. *The Tyburn Chronicle: Or, The Villainy Display'd in All Its Branches: Containing an Authentic Account of The Lives, Adventures, Tryals, Executions, and Last Dying Speeches of the Most Notorious Malefactors . . .* (4 vols. 1768), vol. iii, pp. 146–51; Walpole, *Correspondence*, vol. xvii, pp. 503–4, 21 July 1742; *Gentleman's Magazine* (1742), vol. xii, p. 386, (1744), vol. xiv, p. 226; Tim Hitchcock, '"You bitches . . . die and be damned": Gender, Authority and the Mob in St Martin's Round-house Disaster of 1742', in T. Hitchcock and H. Shore (eds.), *The Streets of London: From the Great Fire to the Great Stink* (2003), pp. 69–81.

45. Robert Latham and William Matthews (eds.), *The Diary of Samuel Pepys: A New and Complete Transcription* (11 vols., 1970–83), vol. iv, for 1 July 1663.

46. *Survey of London*: vol. 36, pp. 199–204; Thornbury, *Old and New London*, vol. iii, pp. 269–86; V. Stater, 'Vere, Aubrey de, twentieth Earl of Oxford (1627–1703)', *ODNB*.

47. *A Compleat Collection of Remarkable Tryals . . . in the Old Baily* (4 vols., 1718–21), vol. iii, pp. 105–7; *London Society: An Illustrated Magazine* (74 vols., 1862–98), vol. xiv (1868), pp. 540–41.

48. C. Winton, *John Gay and the London Theatre* (Kentucky, 1993), pp. 19–25, 170–73; Daniel Statt, 'The Case of the Mohocks: Rake Violence in Augustan London', *Social History*, 20 (1995), pp. 79–99; Neil Guthrie, '"No Truth or Very Little in the Whole Story"? A Reassessment of the Mohock Scare of 1712', *Eighteenth-Century Life*, 20 (2), May 1996, pp. 33–56.

49. Walter Scott (ed.), *The Works of Jonathan Swift* (10 vols.), vol. iii, p. 62 (*Journal to Stella*, letter 43, 8 March 1711/12); Thomas Shadwell,

The Scowrers (1691); Steele, 'Account of the Mohawk Club', *Spectator*, 324, 27 Mar. 1711–12; Charles Lillie, *Original and Genuine Letters sent to the Tatler and Spectator* (2 vol. 1725), vol. i, p. 349.

50. George Dawe, *The Life of George Morland: With Remarks on his Works* (1807; ed. J. J. Foster, 1904), p. 60.

51. The eighteenth-century Westminster electoral pollbooks are online at the UK Data Archive, University of Essex: see C. E. Harvey, E. M. Green and P. J. Corfield, *The Westminster Historical Database, 1749–1820: Voters, Social Structure and Electoral Behaviour* (Bristol, 1998). They and the Westminster ratebooks are accessible through the *London Lives* project (www.Londonlives.org).

52. For bones and cleavers at mock elections, see Anon., *A Description of the Mock Election at Garrat* [Surrey] ... *Wherein is given Some Historical Account of its first Rise* ... (1768), p. 23.

53. Cf. *The Funeral Procession of the Celebrated Mr Ionathan Wild* (1725). Samuel Pepys, *Diary*, 11 Feb. 1659–60: http://www.pepysdiary.com/diary/1660/02/ (the Maypole stood at the foot of Drury Lane until 1718; the church of St Mary-le-Strand was built on the site a few years later); *Spectator*, 617, 8 Nov. 1714; Thomas Wright, *England under the House of Hanover: Its History and Condition* (2 vols., 1848), vol. i, p. 45.

54. Walpole, *Correspondence*, vol. xvii, p. 196 and vol. xviii, p. 96. For marrow-bones and cleavers in a Wolverhampton procession in the 1770s, see John Bicknell, *Musical Travels through England* (1776), p. 60. Later, Shelley had a 'CHORUS OF PRIESTS accompanied by the Court Porkman on marrow bones and cleavers' in his *Oedipus Tyrannus, or Swellfoot the Tyrant* (1820–21). Dickens has marrow-bones and cleavers at marriages in *Dombey and Son*, *A Christmas Carol* and *The Chimes*.

55. Henry Wheatley and Peter Cunningham, *London Past and Present: Its History, Associations, and Traditions* (1891), p. 218. The Kingsway-Aldwych improvement scheme obliterated Clare Market in 1905.

56. [J. Hartley]. *History of the Westminster Election ... from its Commecement* [sic] *on the First of April, to the Final Close of the Poll, on the 17th of May* (1784), pp. 296, 359, etc. The Satires are: Gillray, *The Butchers of Freedom*; Brown, *Arms & Trophies, of the Westminster Candidates*; Anon., *Opposition Music or Freedom of Election*.

57. [Hartley]. *History of the Westminster Election*, p. 359. Wilmot's Bethnal Green house and his office in Worship Street, Shoreditch, had been destroyed by the Gordon rioters in June 1780. He had been active in suppressing the riots of Spitalfields weavers some years

before, and had been fined £100 in February 1780 by Lord Justice
Mansfield for abusing his office by arbitrarily imprisoning a respecta-
bly employed man when he resisted impressment: *London Chronicle*,
22–24 Feb. 1780; James Oldham, *English Common Law in the Age of
Mansfield* (North Carolina, 2004), p. 36; *Narrative of the Proceedings
of Lord Geo. Gordon, and . . . the Protestant Association* (1780), p.
31. Cf. the anonymous satire on Wilmot's zeal for impressment (as
'Just-Ass of the Peace'), *Bethnal-Green Company of Irish Impresst
Volunteers* (BM Reg. No. 2000, 0521.33).

58. *OBSP*, June 1784: t17840601-1.

3. HARLOTS

1. Gordon Williams, *Dictionary of Sexual Language and Imagery in
 Shakespearean and Stuart Literature* (1994), pp. 323, 421. E. J. Bur-
 ford, *Wits, Wenchers and Wantons: London's Low Life: Covent
 Garden in the Eighteenth Century* (1986) is the best guide to Covent
 Garden's past sex life, though it lacks references. Dan Cruickshank's
 attempt to prove that the local economy was controlled by the sex
 trade is tunnel-visioned, television-driven and under-researched: *The
 Secret History of Georgian London: How the Wages of Sin Shaped the
 Capital* (2009).

2. F. A. Pottle (ed.), *Boswell's London Journal, 1762–1763* (1950), pp.
 272–3, 263–4.

3. *Harris's List* was published between 1757 and 1795. Its later editions
 were sold from 'No. 9, Little Bridges-street, near Drury-Lane Playhouse,
 and at No. 55, Fleet-street'. The former address was John Roach's shop
 in Vinegar Yard: *The Times*, 2 Feb. 1785 and 14 Apr. 1790.

4. P. Thompson, 'Quin, James (1693–1766)', *ODNB*.

5. Roger Thompson, *Women in Stuart England and America: A Com-
 parative Study* (1974), p. 241.

6. Anon., *Progress of a Rake: or, the Templar's Exit. In Ten Cantos, in
 Hudibrastick Verse* (1732). This predated Hogarth's *A Rake's Pro-
 gress*, but was composed after *A Harlot's Progress*.

7. Rev. James Barber, *Tom K's: or the Paphian Grove, with the Humours
 of Covent Garden* (1738).

8. W. B. Ober, 'Boswell's Gonorrhea', *Bulletin of the New York Academy
 of Medicine*, June 1969, 45(6), p. 610 n.; [Francis Grose], *Guide to
 Health, Beauty, Riches, and Honour* (1783), p. 12.

9. [Grose], *Guide to Health, Beauty, Riches, and Honour*, pp. 11–12.

10. *Spectator*, 266, 4 Jan. 1712.

11. James Boswell, *Life of Johnson* (Oxford, 1980), 30 July 1763; James Prior, *Life of Edward Malone* (1860), p. 161.

12. Sir John Hawkins, *The Life of Samuel Johnson, Ll. D.* (1787), pp. 320–21.

13. Hawkins, *The Life of Samuel Johnson*, pp. 321–2.

14. John Fielding, *An Account of the Origin and Effects of a Police . . . To which is added, A* PLAN *for preserving those deserted Girls in this Town, who become Prostitutes from Necessity* (1758), p. 45.

15. Henry Fielding, 'An Inquiry into the Causes of the Late Increase of Robbers &c' (1751), in T. Roscoe (ed.), *The Works of Henry Fielding* (1851), p. 780.

16. *The Works . . . of William Shenstone, Esq.* (3 vols., 176, vol. iii. p. 73.

17. Giacomo Casanova, *History of My Life* (12 vols. in 6, Baltimore, 1997), vols. 9–10, p. 174.

18. Newton's Court led from Vine Street to Old Round Court: J. Lockie, *Topography of London* (1810).

19. *OBSP*: t17991030–49.

20. Westminster Justices' documents, Sept. 1794; Home Office Prison Registers; *OBSP*: t17961130–8 (*London Lives* website).

21. Edward [Ned] Ward, *Secret History of Clubs* (1709), p. 303.

22. D. M. George, *London Life in the Eighteenth Century* (1966), p. 54; George Rudé, *Hanoverian London 1714–1808* (1971), p. 5.

23. *OBSP*, Greenaway and Rush, highway robbery: t17450530–20; Ordinary's *Account*: OA17450709450709016.

24. Pierre Jean Grosley, *A Tour to London: or, New Observations on England* (2 vols., 1772), vol. i, pp. 59–60. London has also 'many substantial wholesale dealers, who keep warehouses, in which are to be found compleat parcels': he was referring to bagnios and their whores.

25. *The Times*, 17 Oct. 1787; *Survey of London*: vol. 36, pp. 225–6.

26. *Johnson's British Gazette*, 3 July 1803.

27. Gatrell, *City of Laughter*, p. 101; P. Quennell (ed.), *The Memoirs of William Hickey* (1976), pp. 48–50.

28. *Public Advertiser*, 11 April 1764; *Morning Post and Daily Advertiser*, 26 Jan. 1775; *OBSP*: t17821016–8; *Johnson's British Gazette*, 3 July 1803.

29. *Memoirs of the Celebrated Miss Fanny Murray. Interspersed with the Intrigues and Amours of Several Eminent Personages. Founded on Real Facts* (2 vols., Dublin, 1759), vol. i, pp. 50–52.

30. B. White, 'Murray, Frances [Fanny] (1729–1778)': *ODNB*.

31. Edward [Ned] Ward, *The London Spy Compleat, in Eighteen Parts* (4th edn, 2 vols., 1709), vol. ii, pp. 27–32.

32. Over 2,000 coffee-houses can be listed between 1650 and 1850: see B. Lillywhite, *London Coffee-houses: A Reference Book* (1963). For discussion of the overused notion of the 'public sphere', see C. Philo and E. Laurier, '"A parcel of muddling muckworms": Habermas and the Early Modern English Coffee-Houses' (2005), http://web.geog.gla.ac.uk/-elaurier/cafesite/texts/muckworms.pdf

33. Thomas Brown, *Amusements Serious and Comical, Calculated for the Meridian of London* (2nd edn, 1702), p. 130; and ibid., in *Works* (3 vols., 1708), vol. iii, p. 24. For further citations see Williams, *Dictionary of Sexual Language*, p. 445.

34. *Pepys Ballads*, V. 405: English Broadside Ballad Archive, University of California, http://ebba.english.ucsb.edu/page/cataloguing.

35. BM Reg. No. 1902, 1011.7990.

36. *Notes and Queries*, 18 (Mar. 1850), p. 286; BM Coins and Medals, Reg. No. M7576m. The King's bagnio was built *c.* 1676 and rebuilt and enlarged in 1694, and stood on the south side of Long Acre between Conduit Court and Leg Alley (Strype (1720)). The King's might simply have been the Duke's bagnio renamed in the new reign.

37. Anon., *The Life and Character of Moll King* (*c.* 1747), pp. 19–20.

38. Martin C. Battestin and Ruthe R. Battestin, *Henry Fielding: A Life* (1993), p. 347.

39. John Cleland, *Memoirs of a Woman of Pleasure* (1749), part vi, second letter.

40. *Lettres de Monsieur ** à un de ses amis à Paris, Pour lui expliquer les Estampes de Monsieur Hogarth* (1746), pp. 38–9.

41. From *Progress of a Rake* and *Midnight Spy*, cited in Williams, *Dictionary of Sexual Language*, p. 59 ('bagnio').

42. Cited by Hugh Philips, *Mid-Georgian London: A Topographical Survey* (1964), p. 143.

43. C. Ryskamp (ed.), *Boswell: the Ominous Years 1774–1776* (1963), p. 306; Boswell, *Life of Johnson*, 12 May 1778; Quennell (ed.), *Memoirs of William Hickey*, pp. xi, 13, 58, 48–9, 42.

44. Henry Fielding, *Amelia* (1751), bk 1, ch. 7.

45. *The Covent Garden Jester* (1785), recycled from *Joe Miller's Jests* of 1739 (many subsequent editions).

46. *Scots Magazine*, 14 (1752), p. 213.

47. Anon., *Covent Garden in Mourning: A Mock Heroick Poem. Containing*

some Memoirs of the Late Celebrated Moll King, and Anecdotes of some of her Sisters, particularly Mrs D-gl-s, Mrs L-w-s, Mrs C-mpb-ll, Mrs C-r-y, Mrs P-ge, &c, (1747), pp. 4–5.

48. Identifications pencilled at the bottom of the BM's impression were probably Frederick Crace's, from whose son the BM bought it in 1880. Their source was Smith, *Nollekens*, vol. ii, pp. 272–3, reporting the magistrate Sanders Welch's information that Henry Fielding at Bow Street regarded Montagu, Laroon and Little Cazey as 'the three most troublesome and difficult to manage of all my Bow Street visitors'. But Smith wrote unreliably in the 1820s. In *Covent Garden in Mourning*, pp. 4–5, the men in the print were identified merely as 'rakes'. In 1779 they were said to be 'Captain Overton, a well-known Blood, at that time, about the [Covent] Garden; and the Lady within, the celebrated Poll M-nt-g-e, who then lived in Spring Gardens': *Nocturnal Revels: or, the History of King's-Place, and other Modern Nunneries* (2 vols., 1779), vol. ii, pp. 9–10.

49. Again, perhaps Smith's wishful thinking. Smith, *Nollekens*, vol. i, pp. 93–4, vol. ii, p. 255.

50. Anon., *Covent Garden in Mourning*, p. 4.

51. Tom King's name is in the Eton register for 1713, and against it is noted that 'he afterwards kept that Coffee-house in Covent Garden which was called by his own name': Thomas Harwood, *Alumni Eton-enses: or, A Catalogue of the Provosts & Fellows of Eton College & King's College, Cambridge* (1797), p. 293.

52. Their sign was an effigy of an American Indian, possibly in memory of the aristocratic Mohocks who once plagued the Piazza: Barber, *Tom K—'s*.

53. Anon., *Life and Character of Moll King*, p. 8.

54. J. T. Smith heard this a century later in 1812 from the aged proprietor of the Bedford coffee-shop: J. T. Smith, *The Streets of London* (posthumously published 1846), pp. 157–8.

55. *OBSP*, Ordinary's Account, 8 Nov. 1738: OA17381108.

56. *The Rake's Progress; or, The Humours of Drury-Lane. A Poem. In Eight Canto's. In Hudibrastick Verse . . . a Compleat Key to the Eight Prints . . . by the celebrated Mr Hogart* (1735). The excuses of works like these were moralized but transparent: 'my sole design [is] to expose a Place that has flourish'd for some years either to the shame of our Laws, or the Scandal of our Magistrates'.

57. *Common Sense or the Englishman's Journal*, 9 June 1739.

58. It featured in satires through to the 1820s: Gatrell, *City of Laughter*,

p. 298 and n. Apparently of Irish provenance, it was published in *The London Miscellany: Being a Collection of Several Scarce and Valuable Pieces* (1730), p. 12, as 'A new song, to the tune of Black-Joak the words by the R—d Mr S—th, chaplain to a man-of-war'. The earliest datable copy is in Charles Coffey's *The Beggar's Wedding* (4th edn 1729). For words, music, and historical notes see http://sniff.numachi.com/-rickheit/dtrad/

59. Paulson, *Hogarth's Works*, pp. 89–91.

60. T. Clayton, 'George Bickham the Younger (*c.* 1704–1771)', *ODNB*; T. Clayton, *The English Print, 1688–1802* (1997).

61. *Westminster Journal or New Weekly Miscellany*, 23 Feb. 1745.

62. F. G. Stephens (and Edward Hawkins), *Catalogue of Prints and Drawings in the British Museum* (1877), vol. iii (i) (1734–*c.* 1750), pp. 138–40.

4. THE FIRST BOHEMIANS

1. *Grub Street Journal*, 2 May 1734.

2. Charles Dickens, 'Literary Outcasts', *All the Year Round*, 10 Oct. 1863, p. 153.

3. Ibid.

4. Samuel Johnson, *An Account of the Life of Mr Richard Savage, son of the Earl Rivers* (1744), pp. 75, 126–7, 129.

5. T. B. Macaulay's review of Croker's edition of Boswell's *Johnson* (*Edinburgh Review*, vol. liv (107), Sep. 1831, pp. 23–4).

6. *The Idler*, 64 (1759), in W. J. Bate, J. M. Bullitt and L. F. Powell (eds.), *The Yale Edition of the Works of Samuel Johnson* (23 vols., New Haven, 1963–), vol. ii, p. 199.

7. John Forster, *The Life and Adventures of Oliver Goldsmith* (1848), pp. 99, 148, 153.

8. Several similar comments on the relationship between the indifferent *Bookseller* and the supplicant *Author* recur into the 1790s: *The Brain-Sucker, or the Miseries of Authorship* (self-published, 1787, Lewis Walpole Library); (YCBA); *An Author and Bookseller* (drawing, Boston Museum Fine Arts, etched 1797, LWL); *The Tax Collector and the Poor Poet* (drawing, Boston Museum Fine Arts).

9. F. A. Pottle (ed.), *Boswell's London Journal, 1762–1763* (Edinburgh, 1991), 3 Feb. 1763.

10. Leslie and Taylor, *Reynolds*, vol. i, p. 167.

11. Oliver Goldsmith, 'The Present State of Polite Learning' (1754), and

'An Essay on the Theatre; or, a Comparison between Laughing and Sentimental Comedy' (1773), in A. Friedman (ed.), *The Collected Works of Oliver Goldsmith* (5 vols., Oxford, 1966), vol. i, pp. 320–22 and vol. iii, pp. 209–13. For this discussion: Gatrell, *City of Laughter*, pp. 63–4.

12. Fiona MacCarthy, *Byron: Life and Legend* (2002), pp. 256–7.

13. Samuel Pepys, *Diary*, 26 Oct. 1667.

14. Vertue, *Note-books*, vol. xviii, p. 97. Lely's portrait of Gwynn was sold to a private buyer at Sotheby's on 6 July 2011. The erudite catalogue notes insist that the voluptuous lady is indeed Gwynn, and not the Duchess of Cleveland as some have suggested.

15. Pepys, *Diary*, 2 Jan. 1667.

16. On identification: Elizabeth Einberg and Judy Egerton. *The Age of Hogarth: British Painters born 1675–1709* (1988), entry no. 1161.

17. A. Oddey, 'Abington, Frances (1737–1815)', *ODNB*.

18. Frances [Fanny] Burney, *Memoirs of Doctor Burney* (3 vols., 1832), vol. ii, p. 94.

19. Simon McVeigh, *Concert Life in London from Mozart to Haydn* (Cambridge, 2006).

20. Jeremy Barlow, *The Enraged Musician: Hogarth's Musical Imagery* (2005), p. 5.

21. John Ginger (ed.), *Handel's Trumpeter: The Diary of John Grano* (1988), pp. 154 and passim.

22. M. Kitson (ed.), 'Hogarth's "Apology for Painters"', *Walpole Society*, xli (1966–8), pp. 100–101, cited by S. Sloman, 'Aken, Joseph van (*c.* 1699–1749)', *ODNB*; M. Postle, 'Toms, Peter (bap. 1726, d. 1777)', *ODNB*.

23. *ODNB*, individual entries.

24. Kitson, 'Hogarth's "Apology for Painters"', p. 79.

25. Luke Herrmann, *Paul and Thomas Sandby* (1986), p. 61, citing Farington, *Diary*, 13 Jan. 1807.

26. T. Clayton, 'Ryland, William Wynne (1733–1783)', *ODNB*.

27. M. Postle, 'Reynolds, Sir Joshua (1723–1792)', *ODNB*, citing James Northcote; A. Saunders, 'Thomas Malton the Younger (1751/2–1804)', *ODNB*, citing Farington, *Diary*.

28. W. M. Thackeray, 'The Artists', in *Heads of the People Drawn by Kenny Meadows; with Original Essays by Distinguished Writers* (1841–2), republished in W. M. Thackeray, *The Book of Snobs: and Sketches and Travels in London* (1869), pp. 242–3. On the shift from the 'artisan' to the 'professional' painter: Iain Pears, *The Discovery of*

Painting: The Growth of Interest in the Arts in England 1680–1768 (1988), pp. 107–32.

29. L. Worms and A. Baynton Williams, *British Map Engravers: A Dictionary of Engravers, Lithographers and their Principal Employers to 1850* (2011), p. 327.

30. Vertue, *Note-books*, vol. xxii, pp. 97–8.

31. Smith, *Nollekens*, vol. ii, pp. 346–52; William Hazlitt, *Table Talk* (2 vols., 1825), vol. ii, pp. 66–7.

32. Charles Lamb, 'Recollection of a late Royal Academician' (1831) in *Correspondence and Works of Charles Lamb* (4 vol., 1870), vol. iii, p. 406.

33. Walpole, *Anecdotes*, vol. iv, pp. 124–5.

34. BL, Add. MS 27337, fol. 88.

35. S. Lloyd, 'Richard Cosway (1742–1821)', *ODNB*; Leslie and Taylor, *Reynolds*, vol., i, p. 403.

36. Kim Sloane, 'Cozens, Alexander (1717–1786)', *ODBN*.

37. Jenny Uglow, *Hogarth: A Life and a World* (1997), pp. 185–9.

38. The group migrated to Slaughter's from the Rainbow coffee-house, Lancaster Court: E. Grist, 'Rainbow Coffee House group (act. 1702–1730)', *ODNB*.

39. D. W. Davies, 'Williams, David (1738–1816)', *ODNB*.

40. Alexander Gilchrist, *The Life of William Blake, 'Pictor Ignotus'* (2 vols., 1863), vol. i, pp. 6, 13–20, 305.

41. Letter to J. Heath, 1 March 1804, BL Add. MS 29300, fol. 26; John Riely, *Rowlandson Drawings from the Paul Mellon Collection* (1977), pp. xiii–xiv.

42. The original drawing (1810) was bought by the Regent: John Hayes, *Rowlandson's Watercolours and Drawings* (1972), plate 133.

43. Some time after *Artist's Studio* was drawn (Mellon Collection: thus entitled), Rowlandson copied it and gave it a new title: *Manufacturers of Old Masters at Work* (sold at Sotheby's, 9 March 1989). The pipe-smoking artist – 'smoking' the picture as well as the hams in the rafters above his head – recalls the forging of what Hogarth had called 'the Dark Masters': see his *Time Smoking a Picture* (1761).

44. Rudolf and Margot Wittkower, *Born under Saturn: The Character and Conduct of Artists* (1963), p. 294.

45. Both citations in W. L. Pressly, 'Barry, James (1741–1806)', *ODNB*.

46. Edward Edwards, *Anecdotes of Painters, who have Resided or been Born in England* (1808), pp. 220–23. On Lowe and Turner, see below, ch. 10.

47. Charlotte Barrett (ed.), *The Diary and Letters of Madame d'Arblay* (4 vols., 1891), vol. i, pp. 351–2.

48. S. O'Connell, 'Sullivan, Luke (*c.* 1725–1771)', *ODNB*, citing Smith, *Nollekens*, vol. ii, p. 212.

49. L. Peltz, 'Chatelain, John-Baptist Claude (1710–1758)', *ODNB*; J. Strutt, *A Biographical Dictionary ... of all the Engravers ... to the Present Time* (2 vols., 1785–6), vol. i, p. 192.

50. J. Hayes (ed.), *The Letters of Thomas Gainsborough* (2001), pp. 22, 44; Farington, *Diary*, 28 June 1808.

51. G. E. Bentley (ed.), *William Blake's Writings* (2 vols., Oxford, 1978), vol. ii, p. 1463.

52. Smith, *Nollekens*, vol. ii, p. 351.

53. Edward Dayes, *Works of the late Edward Dayes* (1805), p. 340.

54. B. Jerrold, *The Life of George Cruikshank* (1898), pp. 47, 240; R. L. Patten, *George Cruikshank's Life, Times, and Art*, vol. i, 1792–1835 (1992), p. 91.

55. Angelo, *Reminiscences*, vol. i, p. 432.

56. Smith, *Nollekens*, vol. i, p. 139; D. H. Solkin, 'Wilson, Richard (1712/13–1782)', *ODNB*; Walpole, *Anecdotes*, vol. iv, pp. 46, 125–6; Leslie and Taylor, *Reynolds*, vol. ii, p. 168.

57. Smith, *Nollekens*, vol. ii, p. 337; James Gillray, *Connoisseurs Examining a Collection of George Morland's* (1807).

58. W. Gilbey and E. D. Cuming, *George Morland: His Life and Works* (1907), pp. 215–16.

59. William Collins, *Memoirs of a Painter: being a Genuine Biographical Sketch of the late Mr George Morland* (1805), p. 133.

60. George Dawe. *The Life of George Morland: With Remarks on his Works* (1807; ed. J. J. Foster, 1904), pp. xv, 64, 77; Collins, *Memoirs of a Painter*, p. 144.

61. *The Eccentric Mirror*, vol. iv (33), (1807), p. 8.

62. Collins, *Memoirs of a Painter*, pp. 59, 205; Dawe, *Morland*, pp. 40, 76, 88.

63. BM Reg. No. S.2.66.

64. Dawe, *Morland*, pp. 17–18; Gatrell, *City of Laughter*, p. 87.

65. The night-bonnets and faces of Fanny and Phoebe in their lesbian scene are replicated in a non-erotic mezzotint depicting two girls innocently reading a story in bed together (*The Delightful Story*), which Ward took from Morland and published *c.* 1787. H. S. Ashbee listed more of Morland's erotic prints from this date than the BM holds; he suggested that some might have been engraved by J. R. Smith, though he listed Smith's

own erotica separately: H. S. Ashbee, *Catena Librorum Tacendorum* (1885), pp. 83–5, 408, 410–13.

66. Angelo, *Reminiscences*, vol. ii, p. 222; E. G. D'Oench, *Copper into Gold: Prints by John Raphael Smith, 1751–1812* (1999); E. G. D'Oench, 'Smith, John Raphael 1752–1812,' *ODNB*.

67. Ashbee, *Catena Librorum Tacendorum*, pp. 408–10.

68. Angelo, *Reminiscences*, vol. ii, pp. 222, 170. J. R. Smith engraved Peters's *Hebe*, his *Sylvia* and his *Love in her Eye sits Playing*. On *Lydia*, see Tate Gallery, *Illustrated Catalogue of Acquisitions 1986–88, London* (1996).

69. Cf. *The School of Venus: The Postures of Love Described in Two Instructive and Confidential Dialogues between a Wife and a Virgin*: published by the bookseller Lewis McDonald of 'St Martin's Fields', and prosecuted for obscene libel in 1788: Nat. Archives KB28/347/5. A. D. Harvey, *Sex in Georgian England: Attitudes and Prejudices from the 1720s to the 1820s* (1994), pp. 21–9.

70. M. Rosenthal, *The Art of Thomas Gainsborough* (1999), p. 273; Angelo, *Reminiscences*, vol. i, p. 262; A. Meyer, 'Parnassus from the Foothills: The Royal Academy viewed by Thomas Rowlandson and John Wolcot (Peter Pindar)', *British Art Journal*, 3 (2), (2002), pp. 32–43.

71. *Sir Joshua Reynolds' Notes and Observations on Pictures: . . . also, The Rev. W. Mason's Observations on Sir Joshua's Method of Colouring* (1859, publ. J. R. Smith), pp. 49–63, cited in Leslie and Taylor, *Reynolds*, vol. i, pp. 173–5.

72. William Hazlitt, *Conversations of James Northcote* (1830), p. 126.

73. Smith, *Nollekens*, vol. i, pp. 356–7. On St Giles's as a (later) source of nude models: L. Robinson, *William Etty: The Life and Art* (2007), pp. 346–7.

5. THE MEN'S WORLD

1. Strype (1720), bk iv, ch. 4, p. 75; Béat Louis de Muralt, *Letters Describing the Character and Customs of the English and French Nations* (1725, transl. 1726), p. 36.

2. A scatological satire on George III and Pitt, *A British Minister Worshipping the Meridian Sun* (1786), 'engraved after the Original painted by Maria Closestool', the 'original' being Cosway's painting, *A Persian going to Adore the Sun*.

3. Leslie and Taylor, *Reynolds*, vol. ii, p. 125.

4. *Samuel Butler's Notebooks* (1912, edn 1951), p. 298.

5. Artists attending it included Bindon, Bockman, Casteels, Chéron, Closterman, Dandridge, Du Guernier, Ellys, Gibbs, Goupy, Hysing, Seymour, Sheppard, Slaughter, Smibert, Vanderbank, Vertue, Winstanley.

6. Leslie and Taylor, *Reynolds*, vol. i, pp. 136–7.

7. Jean André Rouquet, *The State of the Arts in England* (1755), pp. 23–4.

8. *St James's Evening Post*, 7 June 1737.

9. Nichols, *Hogarth Anecdotes*. On Ireland, see below, note 56.

10. They were Hayman, Highmore, Hudson, Ramsay, Lambert, Scott, Wilson, Wale, Moser; the others were Wills, Haytley, Carter, Monamy, Taylor, Pyne: J. Brownlow, *Memoranda; or, Chronicles of the Foundling Hospital* (1847), pp. 10–11; Matthew Hargraves, '*Candidates for Fame': The Society of Artists of Great Britain, 1760–1791* (Yale, 2005), p. 12.

11. *The Idler*, 79 and 82 (Oct. and Nov. 1759), in Joshua Reynolds, Edmond Malone and Thomas Gray, *The Works of Sir Joshua Reynolds* (3 vols., 1798), vol. ii, pp. 229–31, 242–3.

12. William Sandby, *The History of the Royal Academy of Art* (2 vols., 1862), vol. i, pp. 125, 140, 154; Holger Hoock, *The King's Artists: The Royal Academy of Arts and the Politics of British Culture 1760–1840* (Oxford, 2005), pp. 52–62; H. Hoock, 'Founders of the Royal Academy of Arts', *ODNB*.

13. *The Connoisseur*, I (1754), in Walter Thornbury, *Old and New London* (6 vols., 1878), vol. iii, pp. 238–55.

14. T. B. Macaulay, *The History of England from the Accession of James II* (5 vols., 1848), vol. i, pp. 124–5.

15. 'Hints towards an Essay on Conversation', in *The Works of Jonathan Swift: Miscellaneous Essays* (edn 1814), pp. 380–81.

16. Edward [Ned] Ward], *Vulgus Britannicus: or, The British Hudibras in Fifteen Cantos* (3rd edn, 1711), facing p. 45.

17. Paulson, *Hogarth's Works*, p. 85; Jenny Uglow, *Hogarth: A Life and a World* (1997), pp. 229–31.

18. Closterman, Dahl, Thornhill, Grinling Gibbons, Zincke, Baron, Hysing, Wootton, Vertue, Rysbrack the sculptor, and the architects Kent and Gibbs. Vertue, *Note-books*, vol. xxii, p. 120; M. Myrone, 'Society of the Virtuosi of St Luke (act *c.* 1689–1743)', *ODNB*; D. H. Solkin, *Painting for Money: The Visual Arts and the Public Sphere in Eighteenth-Century England* (1992), pp. 98–9.

19. Walpole, *Correspondence*, vol. xviii, p. 211, 14 Apr. 1743.

20. Paulson, *Hogarth's Works*, p. 112. The Latin reads 'What was once white is now the opposite': cf. *Jonathan Wild*, I, ch. 9.

21. Walter Arnold, *The Life and Death of the Sublime Society of Beef Steaks* (1871), pp. xi–xii; 'The Sublime Society of Beefsteaks', *Chambers' Journal*, 284 (5 June 1869), pp. 353–6.

22. This riposte is now widely misattributed. Confirmation that it was Wilkes's was given by Henry Brougham, who had it from the Duke of Norfolk who was present at the time: H. Brougham, *Historical Sketches of Statesmen who Flourished in the Time of George III* (Paris, 2 vols., 1844), vol. ii, pp. 105–6.

23. Vertue, *Note-books*, vol. xxx, pp. 31–7. Hog Lane was renamed Crown Street in 1762 'from the Rose and Crown, an inn of some celebrity and standing': Peter Cunningham, *Handbook for London: Past and Present* (2 vols., 1850 edn), vol. i, pp. 229. The street is now absorbed in Charing Cross Road.

24. The sketch is reproduced in Vertue, *Note-books*, vol. xxx, pp. 31–2.

25. Vertue, *Note-books*, vol. xviii. p. 122; vol. x, pp. 31–2.

26. William Whitely, *Artists and their Friends in England, 1700–1799* (1928), vol. i, p. 70.

27. Baron, Casteels, Chéron, Ellys, Gibbs, Goupy, Hysing, Kirkall, Laroon the Younger, Lens III, Peeters, Reisen, Sheppard, Smibert, Vanderbank and Vertue.

28. Angellis, Baron, Bockman, Casteels, Chéron, Du Bosc, Laguerre, Laroon III (the Younger), Bernard Lens III, Parmentiere, Rysbrack, Scheemakers, Scotin, Tillemans, Van Loo, Vanderbank, Peeters and Zincke; one might add Moser from Switzerland and Hysing from Stockholm.

29. Christine Riding, 'Foreign Artists and Craftsmen and the Introduction of the Rococo Style in England', in Randolph Vigne and Charles Littleton (eds.), *From Strangers to Citizens: The Integration of Immigrant Communities in Britain, Ireland, and Colonial America, 1550–1750* (Sussex, 2001), pp. 133–43.

30. Cf. Mercier's *The Schutz Family and their Friends on a Terrace* (1725), Tate Britain.

31. Ronald Paulson, *Hogarth*, vol. ii: *High Art and Low, 1732–1750* (1992), p. 65, citing Rouquet, *State of the Arts*.

32. Amal Asfour and Paul Williamson, *Gainsborough's Vision* (Liverpool, 1999), pp. 56, 73.

33. César de Saussure, *A Foreign View of England in the Reigns of George I and George II* (edn 1902), p. 112.

34. Edward Edwards, *Anecdotes of Painters, who have Resided or been Born in England* (1808), pp. 214–16; [W. H. Pyne], *Wine and Walnuts; or, After Dinner Chit-Chat* (2 vols., 1823), vol. ii, p. 82; W. C. Monkhouse, rev. David Cordingly, 'Serres, Dominic (1722–1793)', *ODNB*.

35. *Survey of London*: vols. 33–34, pp. 1–19.

36. Farington, *Diary*, vol. i, p. 24 (Dec. 1803).

37. Listed in Paulson, *Hogarth's Works*, pp. 14–16. Cf. Robert Cowley, *Marriage A-la-Mode: A Review of Hogarth's Narrative Art* (Manchester, 1983), pp. 10–11.

38. The figures exclude foreign-born sculptors and painters who lived nearer the West End – e.g. Rysbrack, Casteels, Tillemans and the art dealer Vandergucht, all Antwerp-born.

39. *A Complete Collection of Old and New English and Scotch Songs* (4 vols., 1736), vol. iv, p. 27.

40. Alexander Gilchrist, *The Life of William Blake* 'Pictor Ignotus' (2 vols., 1863), vol. ii, p. 152; Smith, *Nollekens*, vol. i, p. 54 n.

41. Macaulay, *History of England*, vol. i, p. 124.

42. M. Postle, 'Northcote, James (1746–1831)', *ODNB*.

43. M. Postle, 'Cotes, Francis (1726–1770)', *ODNB*.

44. Smith, *Nollekens*, vol. ii, p. 92.

45. John Forster, *The Life and Adventures of Oliver Goldsmith*, (1848), pp. 268–9.

46. Strype (1720), bk vi, ch. 5, p. 68.

47. Leslie and Taylor, *Reynolds*, vol. ii, p. 7.

48. Roger Thompson, *Women in Stuart England and America: A Comparative Study* (1974), p. 243; Smith, *Nollekens* vol., i, pp. 122–3; Uglow, *Hogarth*, p. 237.

49. Each had to be three storeys high with cellars below and 'cocklofts' above; windows were to be uniform in style and height, and the houses at least 18 feet wide and 36 to 48 feet deep, with gardens behind. Sewers were required, and a three-foot footway had to be laid out in front of each house 'with french paveing such as is before Whitehall gate' (*Survey of London*: vols. 33–34, pp. 416–40).

50. Apart from Hogarth and Reynolds, at one or another point across the century artist residents included Baron, the Cozenses (father and son), Dahl, De Wilde, Edwards, Fuseli, Gardelle, Hysing, Thomas Lawrence, Martin, Mercier, Henry Morland, Opie, 'Athenian' Stuart, Vivares and Wale.

51. Westminster ratebooks and pollbooks: C. E. Harvey, E. M. Green and P. J. Corfield, *The Westminster Historical Database, 1749–1820: Voters,*

Social Structure and Electoral Behaviour (Bristol, 1998); cf. *Survey of London*: vols. 33-34, pp. 416-40.

52. Paulson, *Hogarth*, vol. ii: *High Art and Low*, p. 45.

53. Uglow, *Hogarth*, pp. 279, 395.

54. Ronald Paulson, *Hogarth*, vol. iii: *Art and Politics, 1750-1764* (1992-4), p. 49.

55. Ibid., pp. 220, 411.

56. The original notes are in British Library, Add. MS. 27991, and are transcribed in Joseph Burke (ed.), *The Analysis of Beauty* (Oxford, 1955), pp. 201-36. John Ireland (*c.* 1742-1808), a watchmaker in Maiden Lane and intimate with Gainsborough and J. H. Mortimer, received many of Hogarth's disordered manuscripts from Hogarth's wife's executor. He published *Hogarth Illustrated* (2 vols., 1791; 2nd edn, corrected, 1793) and then a biography based on the autobiographical notes, entitled *A Supplement to Hogarth Illustrated* (1798; 2nd edn, 1804). This was republished in J. B. Nichols, *Anecdotes of William Hogarth, Written by Himself* (1833). When he undertook to make sense of the notes in 1798, Ireland described them as 'written in a careless hand, generally on loose pieces of paper, and not paged, [so] my first endeavour was to find the connection, separate the subjects, and place each in its proper class'. His gloss didn't misrepresent Hogarth's opinions, though it gave them a false coherence. There was no connection between John Ireland and Samuel Ireland, author of *Graphic Illustrations of Hogarth*.

57. M. Postle, 'Sir Joshua Reynolds (1723-1792)', *ODNB*.

58. W. Mason, 'Observations on Sir Joshua's Method of Colouring', in *Sir Joshua Reynolds's Notes and Observations on Pictures* (J. R. Smith, 1859), p. 50.

59. Leslie and Taylor, *Reynolds*, vol. i, pp. 182-4, 186-9; Paulson, *Hogarth: Art and Politics*, pp. 192, 255.

60. Leslie and Taylor, *Reynolds*, vol. i, pp. 194-7.

61. Ibid. vol. ii, p. 184.

62. Richard Wendorf, *Sir Joshua Reynolds: The Painter in Society* (1998), p. 85.

63. *Middlesex Journal* cited in *Joshua Reynolds: The Creation of Celebrity* (catalogue, Tate Britain exhibition, 2005).

64. Leslie and Taylor, *Reynolds*, vol. ii, pp. 638, 642.

65. William Hazlitt, 'On Farington's *Life of Sir Joshua Reynolds*', *Edinburgh Review*, 1820.

6. REAL LIFE

1. Desmond Shawe-Taylor, *The Conversation Piece: Scenes of Fashionable Life* (2009), p. 137; Oliver Millar, *The Later Georgian Pictures in the Collection of Her Majesty the Queen* (2 vols., 1969), vol. i, p. 152; M. Postle (ed.), *Johan Zoffany, RA: Society Observed* (2012). For the optician's identity, see C. A. Hanson. 'How to Portray a Trade? Identity and Interpretation in Johan Zoffany's *An Optician with His Attendant*', *Eighteenth-Century Fiction*, vol. 23 (2), (2010–11), pp. 409–24.

2. W. L. Pressly, 'Barry, James (1741–1806)', *ODNB*.

3. A. P. Oppé (ed.), 'Memoirs of Thomas Jones, Penkerrig, Radnorshire', *Walpole Society*, 32 (1946–8), cited in J. Egerton, 'Jones, Thomas (1742–1803)', *ODNB*.

4. Walpole, *Anecdotes*, vol. iv, pp. 140–41.

5. John Ruskin, *Modern Painters*, vol. iii, part iv, ch. xviii, §3, 'On the Teachers of Turner', pp. 308–9.

6. Leslie and Taylor, *Reynolds*, vol. ii, p. 125.

7. J. H. Plumb, *The First Four Georges* (1956), pp. 13–14.

8. Charles Dickens, 'Literary Outcasts', *All the Year Round*, 10 Oct. 1863, p. 153.

9. D. E. Williams, *The Life and Correspondence of Sir Thomas Lawrence* (2 vols., 1831), vol. i, p. 221; Judy Egerton, *Wright of Derby* (1990), p. 12; J. Hayes (ed.) *The Letters of Thomas Gainsborough* (2001), p. 42

10. Leslie and Taylor, *Reynolds*, vol. ii, p. 601.

11. In *Pug the Painter*, *c.* 1754: BM Sat. 3277. This attacked Hogarth's history painting, but the reference to Reynolds was clear.

12. Hayes (ed.), *Letters of Thomas Gainsborough*, p. 90.

13. Leslie and Taylor, *Reynolds*, vol. ii, p. 448.

14. Edward Buliver-Lytton (ed.), *Literary Remains of William Hazlitt* (2 vols., 1836), vol. ii, p. 167.

15. Timothy Hilton, *The Pre-Raphaelites* (Oxford, 1977), p. 46.

16. Brian Sewell, *Evening Standard*, 20 May 2005.

17. *Cupid in the Character of a Link Boy* is in the Albright-Knox Art Gallery, Buffalo, NY. Its companion is the equally odd *Mercury as Cutpurse* (Faringdon Collection): Mercury was slang for pimp, and the boy carries a bag resembling a scrotum. Nicholas Penny (ed.), *Reynolds* (1986), pp. 264–5; Leslie and Taylor, *Reynolds*, vol. ii, p. 175.

18. William Hazlitt, 'On the Old Age of Artists,' *Table Talk* (2 vols., 1825), vol. ii, pp. 66–7; W. M. Thackeray, 'The Artists' (1841–2), in *The Book of Snobs: and Sketches and Travels in London* (1869).

19. Gatrell, *City of Laughter*, pp. 284–5.

20. Leslie and Taylor, *Reynolds*, vol. i, p. 259; J. Newman, 'Reynolds and Hone: The Conjuror Unmasked', in Penny (ed.), *Reynolds*; B. Rooney, 'Hone, Nathaniel (1718–1784)', *ODNB*.

21. Edward Edwards, *Anecdotes of Painters, who have Resided or been Born in England* (1808), p. 117; Smith, *Nollekens*, vol. i, p. 2; Charles Dickens, 'Gone Astray', *Household Words* (1853).

22. Karen O'Brien, *The Times Literary Supplement*, 11 Jane 2013, p. 9.

23. Martin C. and Ruthe R. Battestin, *Henry Fielding: A Life* (1993), p. 328.

24. J. H. Burton, *The Life and Correspondence of David Hume* (2 vols., Edinburgh, 1846), vol. ii, p. 134.

25. Sir John Hawkins, *The Works of Samuel Johnson, LL.D. together with his Life* (11 vols., 1787), vol. xi, p. 208. Hawkins included this famous though unreliable comment among Johnson's 'Apopthegms, Sentiments, and Occasional Reflections', mostly based on hearsay: J. Lynch and A. McDermott, *Anniversary Essays on Johnson's Dictionary* (Cambridge, 2005), p. 11.

26. Hester Piozzi, *Anecdotes of the late Samuel Johnson, LL.D* (1786), p. 99; Sir John Hawkins, *The Life of Samuel Johnson, LL.D* (1787), p. 319.

27. Samuel Johnson, 'Preface to the Plays of Shakespeare' (1765), in P. Martin (ed.), *Selected Writings: Samuel Johnson* (Boston, MA, 2009), p. 357; James Boswell, *Life of Johnson* (1980), p. 480.

28. Ronald Paulson (ed.), *William Hogarth: The Analysis of Beauty* (1997), p. 59.

29. A private collector bequeathed Hals's *Gypsy Girl* to the Louvre under the title *La Bohémienne* in 1869; no copy of its engraving before Hogarth's death is recorded in BM. Original paintings by Hals were rare in London in Hogarth's lifetime. Marcellus Laroon was said to have owned a Hals portrait (R. Raines, *Marcellus Laroon* (1967), p. 56). For other examples, S. Slive, *Frans Hals*, vol. iii: *Catalogue* (1970), p. 13.

30. Ronald Paulson, *Hogarth*, vol. ii: *High Art and Low, 1732–1750* (1992), p. 116.

31. Jenny Uglow, *Hogarth: A Life and a World* (1997), pp. 408–9.

32. Collet was variously engraved and published by Thomas Bradford, Robert Sayer, John Smith, Sayer and Bennett, and Carington Bowles. Bowles's catalogue in 1784 advertised '34 new and elegant humorous Prints . . . finely executed from the capital Paintings of that eminent Artist the late John Collet, Esq.' , and announced that 'When framed and glazed they make a handsome Appearance and Fashionable Furniture, and are always kept ready finished. Price 2s. plain, or finely

coloured from the paintings, 3s. each.' Patricia Crown. 'Sporting with Clothes: John Collet's Prints in the 1770s', and David Alexander, 'Prints after John Collet: Their Publishing History and a Chronological Checklist' – both in *Eighteenth-Century Life*, vol. 26, no. 1 (Winter 2002), pp. 119–35, 136–46.

33. *Gazetteer and New Daily Advertiser*, 7 Oct. 1767.

34. He disagreed with Hogarth's hostility to the establishment of a hierarchical Academy; he and his brother were among the RA's founder members. The prints were published in 1753, and another in 1762. At issue, too, was Sandby's loyalty to the Duke of Cumberland, for whom he had worked in Scotland and who was probably his brother's current patron at Windsor. Hogarth had offended the duke with his *The March to Finchley*. See Luke Herrmann, *Paul and Thomas Sandby* (1986), p. 19, and L. Herrmann, 'Sandby, Paul (1731–1809)', *ODNB*; J. Bonehill and S. Daniels (eds.), *Paul Sandby: Picturing Britain* (2009).

35. For the Northumberland provenance, see BL Reg. No. 2010,7081.344. The title comes from a Drury Lane farce by James Townley (1759).

36. Walpole, *Anecdotes*, vol. iv, p. 149.

37. John Barrow, *Dictionarium Polygraphicum: or, The Whole Body of Arts Regularly Digested* (2 vols., 1735), vol. i, unpaginated.

38. Ronald Paulson, *Hogarth*, vol. i: *The 'Modern Moral Subject', 1697–1732* (1992), p. 25.

39. T. Clayton, 'Vandergucht, Gerard (1696/7–1776)', *ODNB*.

40. Vertue, *Note-books*, vol. xviii, p. 147.

41. *Daily Advertiser*, 9 Mar. 1775.

42. Antony Griffiths, *The Print in Stuart Britain, 1603–1689* (1998), p. 19.

43. Walpole, *Anecdotes*, vol. iv, pp. 1–2.

44. T. B. Macaulay, *The History of England from the Accession of James II* (5 vols., 1848), vol. i, p. 137.

45. Vertue, *Note-books*, vol. xxx, p. 201, and vol. xxii, pp. 12–13.

46. Jean Bernard (l'Abbé) Le Blanc, *Letters on the English and French Nations* (2 vols., 1747), vol. i, pp. 160–62. Hogarth's friend Jean André Rouquet excused the English on the grounds that as a commercial people they were interested only in portraiture: Jean André Rouquet, *The State of the Arts in England* (1755).

47. Cited in A. Yarrington, *Reflections of Revolution: Images of Romanticism* (1993), p. 145.

48. Brian Allen, 'The London Art World in the mid-Eighteenth Century', in C. Beddington (ed.), *Canaletto in England: A Venetian Artist*

Abroad, 1746–1755 (2006), p. 30. The Italians included Verrio in the 1670s, Amigoni and Soldi in the 1730s, Casali from 1741 and Bartolozzi from 1746, Zuccarelli in the 1760s and Rigaud in 1771.

49. Jane Martineau and Andrew Robison, *The Glory of Venice: Art in the Eighteenth Century* (1994), p. 223.

50. M. J. H. Liversidge, 'Marlow, William (1740/41–1813)', *ODNB*.

51. Reynolds's sixth *Discourse* to the Royal Academy: H. W. Beechey (ed.), *The Literary Works of Sir Joshua Reynolds* (2 vols. 1835), vol. i, p. 401.

52. Joshua Reynolds, 'Third Discourse, 14 Dec. 1770', *Discourses on the Fine Arts Delivered to the Students of the Royal Academy* (1853 edn), p. 12.

53. John Knowles (ed.), *The Life and Writings of Henry Fuseli* (3 vols., 1831), vol. ii, p. 156.

54. James Northcote, *The Life of Sir Joshua Reynolds* (1819), p. 138.

55. James Barry, *An Account of a Series of Pictures in the Great Room of the Society of Arts* (1783), pp. 162–5.

56. G. E. Bentley (ed.), *William Blake's Writings* (2 vols., Oxford, 1978), vol. ii, pp. 1450, 1459–61, 1467, 1470, 1535, 1582.

7. HOGARTH AND LOW LIFE

1. Hester Piozzi, *Anecdotes of the late Samuel Johnson, LP.D* (1786), pp. 104–5.

2. Cf. the merchant's low-life wall paintings in the sixth picture of *Marriage A-la-Mode*, and 'the true Dutch taste' of his self-parodic print, *Paul before Felix*.

3. See Robin Simon, *Hogarth, France, and British Art* (2007).

4. *The Harlot's Progress, or, The Humours of Drury Lane, Daily Post*, 31 Mar. 1733.

5. *Gentleman's Magazine*, 53 (1), p. 171.

6. Martin C. Battestin, *A Henry Fielding Companion* (2000), p. 82; Paulson, *Hogarth's Works*, pp. 112–13.

7. Jenny Uglow, *Hogarth* (1997), pp. 603–4.

8. The paintings of 1731 were never engraved. The later *Before* and *After*, set in a bedroom, Hogarth engraved for wider sale in 1736. On his alleged regret about the bedroom pairing of *Before* and *After*, Nichols, Hogarth Anecdotes, p. 233.

9. M. Kitson (ed.), 'Hogarth's "Apology for Painters"', *Walpole Society*, xli (1966–8), p. 106.

10. Hogarth *Notes*, p. 202.

11. Smith, *Nollekens*, vol. ii, p. 346; Nichols, Hogarth *Anecdotes*, pp. 6, 13, 101–2; Ronald Paulson, *Hogarth*, vol. iii: *Art and Politics, 1750–1764* (1993), p. 77; Jack Lindsay, *Hogarth: His Art and his World* (1977), pp. 20, 157. YCBA hold fifteen caricatures sketched on two-inch scraps of paper. YCBA attributes them to Hogarth, but the BM holds several too, and says they are 'after Hogarth' from his prints. Samuel Ireland etched four sketches in 1786 (BM) from alleged originals drawn in Button's coffee-house *c.* 1730, but it is unlikely that they were Hogarth's.

12. *OBSP*, Ann Barton, Theft, 3rd September 1740: t17400903–12. The bagnio is identified as the Turk's Head in Bow Street in Anon., *Marriage A-la-Mode: An Humorous Tale ...; Being an Explanation of the Six Prints Lately Published by the Ingenious Mr Hogarth* (1746), p. 45. Robert Cowley (*Marriage A-la-Mode: A Review of Hogarth's Narrative Art* (Manchester, 1983), p. 12) and Paulson (*Hogarth's Works*, p. 114) refer to the Bow Street Turk's Head as 'Mrs Earle's'. In fact, when Hogarth painted the series in early 1743 it was owned by William Jones and was thus referred to in the trial just cited. Mrs Earle joined the business in Dec. 1743 (*Daily Advertiser*: the bagnio 'is now kept by LUCY EARLE, from Lemon Street, Goodman's Fields; where Cupping and Bathing are perform'd after the best Manner, the House being newly fitted up, and adorn'd with the best of Furniture, with proper Attendance. Note, Commodious Lodgings at reasonable Rates'). But she was still in partnership with Jones. On 12 Dec. 1744, the *Daily Advertiser* announced that the Turk's Head was to be let with or without furniture ('Enquire at Mrs Keebles, a Pastry-Cook, in Russel-Street'). A month later, 24 Jan. 1745, it advertised that the partnership between William Jones and Lucy Earle had expired at Christmas and that Earle ran the bagnio by herself (and that feather-beds were now provided). In the same issue Jones advertised that he had moved to the New Bagnio in Charles Street (late Mrs Hayward's), and there would 'continue to cup in the most approv'd manner'.

13. William Hazlitt, 'On the Works of Hogarth', in *Lectures on the English Comic Writers* (1819, 1845 edn), p. 165; William Hazlitt, 'On Farington's *Life of Sir Joshua Reynolds*', *Edinburgh Review* (1820); Charles Lamb, 'On the Genius and Character of Hogarth' (1811), in *The Works of Charles Lamb* (4 vols., 1860), vol. iv, pp. 148–9.

14. Leigh Hunt, *The Town: Its Memorable Characters and Events* (2 vols., 1848), vol. ii, p. 179.

15. Leslie and Taylor, *Reynolds*, vol. i, p. 231.

16. 'The Parish: Inhabitants', *The Records of St Bartholomew's Priory* [and] *St Bartholomew the Great, West Smithfield* (2 vols., 1921), vol. ii, pp. 248–91; Ronald Paulson, *Hogarth*, vol. i: *The 'Modern Moral Subject', 1697–1732* (1992), pp. 5–6.

17. They were photographed again in 1909 before their demolition: reproduced in Philip Davies, *Lost London 1870–1945* (2009), pp. 46–9. In these photographs, the gables on the houses around the churchyard suggest seventeenth-century or earlier origins; otherwise the timbered buildings in Bartholomew Close seem to have been rebuilt in brick in the eighteenth century.

18. Hogarth *Notes*, p. 204.

19. Strype (1720), vol. iii, ch. 12, p. 281.

20. *Hogarth's Frolic: The Five Days' Peregrination around the Isle of Sheppey of William Hogarth and his fellow Pilgrims, Scott, Tothall, Thornhill, and Forrest* (1872), p. v.

21. Hogarth *Notes*, p. 227.

22. Nichols, Hogarth *Anecdotes*, p. 49.

23. David Garrick, *The Private Correspondence of David Garrick* (2 vols., 1832), vol. ii, p. 339.

24. Nichols, Hogarth *Anecdotes*, p. 97; Ronald Paulson, *Hogarth*, vol. ii: *High Art and Low, 1732–1750* (1992), p. 212.

25. Vertue, *Note-books*, vol. xxii, pp. 156, 123.

26. Hunt, *The Town*, p. 129.

27. Dickens to Napier, 28 July 1845, in Kathleen Tillotson (ed.), *The Letters of Charles Dickens 1844–6* (Pilgrim edn, Oxford, 1977), p. 340.

28. John Forster, *The Life of Charles Dickens* (3 vols., 1875), vol. i, p. 29.

29. William Hazlitt, *Lectures on the English Comic Writers* (3rd edn, 1841), p. 292.

30. *OBSP*: OA 16860602.

31. Béat Louis de Muralt, *Letters Describing the Character and Customs of the English and French Nations* (1725, transl. 1726), p. 72. In 1728 people thronging to *The Beggar's Opera* in Lincoln's Inn Fields might read that Mary Fox and Mary Lewin, alias Archer, were caught in the playhouse passageway picking a pocket of a 'Guinea, a Piece of Foreign Gold, value 12 s., and a Silk Purse'. Truth could always match fiction in Covent Garden. Mary Lewin was saved from the noose when the court valued her theft at ten pence; she was transported instead. *OBSP*: t17280501–41.

32. *OBSP*: t17310115-74.

33. A. P. Herbert (preface), *John Gay's The Beggar's Opera* (1937), pp. ix–x. Rictor Norton provides an excellent account of the Black Boy Alley gang (and much else) at http://rictornorton.co.uk/guo5.htm.

34. *Recollections of the Table-Talk of Samuel Rogers* (1856), p. 2; Walter Thornburg, *Old and New London* (6 vols., 1878), vol. i, p. 29.

35. Cf. James Gillray's *The Hopes of the Party, prior to July 14th* (1791).

36. Daniel Defoe, *A Tour thro' the Whole Island of Great Britain* (3 vols., 1724–5), vol. ii, pp. 154–6; Vic Gatrell, *The Hanging Tree: Execution and the English People, 1770–1868* (Oxford, 1994), pp. 112–13; P. Rogers, *Grub Street: Studies in a Subculture* (1972), pp. 150, 292–5.

37. BM. Reg. No. 1883, 0714.103: q.v. for curatorial comment on Hamilton's identity.

38. Gatrell, *Hanging Tree*, ch. 4.

39. 'Preface', *Middlesex County Records: Calendar of Sessions Books 1689–1709* (1905), pp. iii–xxvi.

40. Gatrell, *Hanging Tree*, pp. 69–70; *The Tyburn Chronicle or, The Villainy Display'd in All Its Branches: Containing an Authentic Account of Th Lives, Adventures, Tryals, Executions, and Last Dying Speeches of the Most Notorious Malefactors . . .* (4 vols., 1768), vol. iv, p. 100.

41. Vertue, *Note-books*, vol. xii, p. 58.

42. Edward [Ned] Ward, *The London Spy Compleat, in Eighteen Parts* (1700), cited in Gordon Williams, *A Dictionary of Sexual Language and Imagery in Shakespearean and Stuart Literature* (1994), p. 603.

43. Sophie Carter, *Purchasing Power: Representing Prostitution in Eighteenth-Century English Popular Print Culture* (2004), pp. 45–6, citing Mark Hallett to the same effect in his *The Spectacle of Difference: Graphic Satire in the Age of Hogarth* (1999).

44. *Grub Street Journal*, 6 Aug. 1730; *Evening Post*, 24 April 1731; *Daily Advertiser*, 1 and 5 May 1731; *The Ordinary of Newgate his Account . . . of the Malefactors, who were Executed at Tyburn, on Friday the 17th, of this Instant, April, 1730*. The gambler, rake and convicted serial rapist Colonel Francis Charteris had been condemned to swing alongside Francis Hackabout and five others, but he was pardoned because he was wealthy and connected with Robert Walpole. In plate 1 of *A Harlot's Progress*, the innocent Moll Hackabout's downwards spiral is initiated when Needham meets her off the country coach: Charteris waits for her to be handed over to his care, one hand jiggling in his pocket.

45. William Hazlitt, 'On Originality', in *Criticisms on Art* (1844), pp. 92–3.

46. Nichols, Hogarth *Anecdotes*, pp. 150–53.

47. Ibid., p. 173 (deleted from subsequent editions).

48. Gatrell, *Hanging Tree*, pp. 178, 182.

49. Hogarth *Notes*, pp. 226–7.

50. According to Nichols, Hogarth *Anecdotes*, p. 286, in the Blood Bowl 'scenes of blood ... were there almost daily exhibited, and ... there seldom passed a month without the commission of a murder'. But there is no newspaper record of a murder in the Blood Bowl.

51. *OBSP*, Ordinary's Account, 15 Mar. 1745: OA17450315.

52. *OBSP*, James Stansbury, Mary Stansbury, Violent Theft and robbery, 7 September 1743: t17430907–52. For newspaper reports on the Blood Bowl's owners and habitués see *Universal Morning Advertiser*, 9–12 Sep. 1743; *Daily Gazetteer*. 11 Mar. 1745; *Penny London Post or Morning Advertiser*, 15–18 Mar. and 17–19 July 1745.

53. *Gentleman's Magazine*, 31 (Apr. 1761), p. 172; *Tyburn Chronicle*, vol. iv, p. 203; Anon., *The Life of Theodore Gardelle ...* (2nd edn, 1761); *OBSP*; *Annual Register*, vol. iv; A. Spencer (ed.), *Memoirs of William Hickey* (1922), vol. i, p. 19 [omitted from Quennell edn].

54. *Weekly Chronicle*, 7 May 1837, cited Gatrell, *Hanging Tree*. p. 69.

55. Leslie and Taylor, *Reynolds*. vol. i, pp. 199–201; Gatrell, *Hanging Tree*, pp. 261–2.

56. Engraved by Samuel Ireland for *Graphic Illustrations of Hogarth* (2 vols., 1794), vol. i, p. 172.

57. *Nocturnal Revels: or, the History of King's-Place, and other Modern Nunneries ... by a Monk of the Order of St Francis* (2 vols., 1779), vol. i, pp. 12–13. Paulson (*Hogarth's Works*, p. 177) and nearly every other writer locates Careless and Douglas's premises in the Piazza's north-eastern wing. But the ratebooks show that it was the respectable widow of a Dr Douglas who lived there; Careless and Douglas's establishment was in Tavistock Row, next door to John Rigg's bagnio: Hugh Phillips, *Mid-Georgian London: A Topographical and Social Survey of Central and Western London about 1750* (1964), pp. 138, 143.

58. Charles Johnstone, *Chrysal: the Adventures of a Guinea* (1760 and many editions thereafter).

59. Battestin, *Fielding Companion*, p. 59; E. J. Burford, *Wits, Wenchers and Wantons: London's Low Life: Covent Garden in the Eighteenth Century* (1986), p. 132; Jerry White, *London in the Eighteenth Century: A Great and Monstrous Thing* (2012), pp. 366–7.

60. *Evening Post*, 9–11 June 1761.

61. Burford, *Wits, Wenchers and Wantons*, p. 134, speculates that a real

Mother Cole was the original of Foote's in *The Minor*, but he gives no sources. References to 'Mother Cole' come from much later dates: cf. Williams, *Dictionary of Sexual Language and Imagery*, p. 257.

62. John Gillies, *Memoirs of the Rev. George Whitefield* (New Haven, 1812), pp. 139–41, 149.

63. John Trusler, *Hogarth Moralized . . . With an Explanation, Pointing out the many Beauties . . . and . . . their Moral Tendency . . . With the Approbation of Jane Hogarth, Widow of the late Mr Hogarth* (1768). Trusler noted only 'an old procuress' in *March to Finchley*, and 'an old bawd' in plate 11 of *Industry and Idleness*: pp. 94, 173. The first identification of Mother Douglas (as Mother Cole) in *March to Finchley* appears to be by Nichols; but Nichols did not identify her as a figure in plate 11 of *Industry and Idleness* (1747): Nichols, Hogarth *Anecdotes*, pp. 64, 56–8 of Appendix. Her identity is there affirmed much later, unreliably one assumes, by Thomas Cook in *Hogarth Restored: The Whole Works of the Celebrated William Hogarth* (1808), p. 238. Nor is there evidence that Douglas had as yet (by 1750) converted to Methodism or that she kept a brothel in Tottenham Court Road. Nor had Whitefield as yet moved there.

64. The title recalled his friend Hubert-François Gravelot's satire on Whitefield and his female acolytes: *Enthusiasm display'd or the Moor-Fields Congregation* (1739).

65. In John Ireland, *Hogarth Illustrated* (2nd edn, 3 vols., 1793), vol. iii, pp. 233, 236.

8. ROWLANDSON'S LONDON

1. France lost some 1,783,000 military dead from battlefield wounds and disease in the long 'hundred years war' that ended in 1815. Britain was spared the worst battlefield massacres because most of its fighting was against French seapower and colonies. Even so, Britain's population was two-fifths the size of France's. The bloodiest war of the eighteenth century was the Seven Years War of 1756–63: French, Prussian and Austrian military deaths were between 550,000 and 868,000. But the Napoleonic Wars cost more lives in battle than any other conflict before 1914, and brought to battle 'the largest armies seen in the West since ancient times (and probably including ancient times)'. Michael Clodfelter, *Warfare and Armed Conflicts: A Statistical Reference to Casualty and Other Figures, 1500–2000* (2nd edn, 2002), pp. 5, 90, 147, 159, 191.

2. Alexander Pope, *Epistle to Dr Arbuthnot* (1734).

3. *A Letter from Mr Cibber to Mr Pope* (1742), pp. 47–9. Other bawdy prints on the subject are George Bickham's (?) unsigned *An Essay on Woman, by the Author of the Essay on Man: Being Homer Preserv'd, or the Twickenham Squire Caught by the Heels*, and Gravelot's *And has not Sawney too his Lord and Whore?* (BM).

4. Deane Swift (ed.), *Letters Written by the Late Jonathan Swift . . . and friends* (4 vols., 1768), vol. iv, p. 22.

5. Charles Baudelaire, 'Some Foreign Caricaturists' (1857), in P. E. Charvet (ed.), *Baudelaire: Selected Writings on Art and Literature* (1992).

6. See Sandby's *Horse Fair on Bruntsfield Links, Edinburgh* (1750), in J. Bonehill and S. Daniels (eds.), *Paul Sandby: Picturing Britain* (2009), pp. 121, 128.

7. F. A. Pottle (ed.), *Boswell's London Journal, 1762–1763* (2004 edn), p. 44 (19 Nov. 1762); James Boswell, *Life of Johnson* (Oxford, 1980), pp. 176, 405, 859.

8. For the following: Lamb to Wordsworth, 30 Jan. 1801, and Lamb to Manning, *c.* same date, in E. W. Marrs (ed.), *The Letters of Charles and Mary Ann Lamb* (3 vols., 1975), vol. i, pp. 267, 248, vol. iii, p. 27, n 1; Charles Lamb, 'The Londoner', *Morning Post*, 1 Feb. 1802, in P. Fitzgerald (ed.), *The Life, Letters, and Writings of Charles Lamb* (6 vols., 1903), vol. iv, p. 323.

9. In 1826 he noticed 'a print of Rowlandson's, or somebody's' on wild dogs: Fitzgerald (ed.), *Life, Letters, and Writings*, vol. ii, p. 368.

10. Louvre, inventory nos.: RF 10182 (Delacroix, *Nine Caricature Heads*) and 83.2.1 and 87.7.1 (Boilly, *L'effet du mélodrame* and *Une loge, un jour de spectacle gratuit*).

11. D. Roberts (ed.), *Lord Chesterfield's Letters* (Oxford, 1992), 9 March 1748.

12. *Carington Bowles's New and Enlarged Catalogue of Useful and Accurate Maps, Charts, and Plans: Curious and Entertaining Engraved and Mezzotinto Prints* (1784).

13. Much of the following is adapted from Vic Gatrell, 'Rowlandson's London', in Patricia Phagan, Vic Gatrell and Amelia Rauser, *Thomas Rowlandson: Pleasures and Pursuits in Georgian England* (Vassar College and Northwestern University, Chicago, catalogue, 2011); for permission I thank Vassar's Francis Lehman Loeb Library.

14. Angelo, *Reminiscences*, vol. i, pp. 233–4.

15. Robert R. Wark, *Drawings by Thomas Rowlandson in the Huntington Collection* (San Marino, 1975), p. 1.

16. 'Introduction', *BM Catalogue of . . . Satires*, vol. viii (1947), pp. xxx-vii–xxxviii; *Catalog of Books Illustrated by Thomas Rowlandson Exhibited at the Grolier Club* (New York, 1916).

17. Ronald Paulson, *Rowlandson: A New Interpretation* (1972), pp. 17–18, 29.

18. John. Hayes, *Rowlandson: Watercolours and Drawings* (1972), pp. 46, pp. 52–60. Hayes's critical snobberies are embarrassing. He adds that Rowlandson could not create 'real' characters except 'through the urgency of the line' (!), that his view of the world was limited to the 'comfortable middle classes', and that his representations of the 'seamy side of life' were weaker than Hogarth's. Elsewhere, as oddly, he states that Rowlandson's output revealed 'the whole panorama of contemporary life' but concludes that he was 'in many ways a limited and superficial artist' and that 'his world is the ordinary world and the ordinary man's response to it'.

19. Wark, *Drawings*, p. 26.

20. Gatrell, *City of Laughter*, chs. 6 and 11.

21. 'Thomas Rowlandson, Artist', *Notes and Queries*, 2 Oct. 1869, p. 278.

22. W. M. Thackeray, 'On Some Illustrated Children's Books', *Fraser's Magazine*, 33 (Apr. 1846), p. 496; Charles Dickens in *The Examiner*, 30 Dec. 1848; *North British Review*, vol. xlii (1865), p. 110.

23. A. P. Oppé, *Thomas Rowlandson: His Drawings and Water Colours* (1923). Of the erotica, the fullest collection of (fifty) reproductions from the BM and Victoria and Albert Museum is in G. Schiff, *The Amorous Illustrations of Thomas Rowlandson* (1969). Hayes is dismissive of his erotica (*Rowlandson*, p. 26); Paulson, *Rowlandson*, allows it one page (p. 77). For fuller discussion, see Gatrell, *City of Laughter*, pp. 388–405, and Bradford K. Mudge, 'Romanticism, Materialism, and the Origins of Modern Pornography,' *Romanticism on the Net*, 23 (August 2001).

24. *Survey of London*: vols. 33–34, pp. 60–63. Rowlandson's life is now covered in M. T. W. and J. E. Payne, *Regarding Thomas Rowlandson, 1757–1827: His Life, Work and Acquaintance* (2010).

25. For Bewick's library: www.bewicksociety.org/ The elder Dr Monro's drawings auctioned at his death included Rowlandson drawings alongside drawings by Andrea del Sarto, Sandby, A. Kauffman, Turner, etc.: *World*, 6 Dec. 1793. Rowlandson drawings were auctioned in Monro's son's collection in 1833, with works by Turner, Girtin, Gainsborough, Cozens, Cotman, De Wint, P. Sandby, Morland, etc.: *The Times*, 27 June 1833 (advertisements in British Library database, 'British Newspapers

1600-1900'). Sir Thomas Lawrence's collection, auctioned by Christie in 1830, included Rowlandsons alongside works by Gainsborough, Cosway and Blake: *Morning Chronicle*, 25 Mar. 1830.

26. Cf. his self-portrait alongside fashionable and admiring young women, *Rowlandson and his Fair Sitters* (c. 1783-4). His illustrations for his *Tour in a Post-Chaise* (to the New Forest and Isle of Wight in 1784) show him flirting with young women, chucking a servant-girl under the chin, etc.: Wark, *Drawings*, cat. nos. 83, 44 and 48.

27. *Gentleman's Magazine*, 97/1 (1827), pp. 564-5. He produced dozens of brilliant depictions of gambling life in these years. One of them implies that he was familiar with the Duchess of Devonshire's table: *A Gaming Table at Devonshire House* (1791), Metropolitan Museum of Art.

28. John Adolphus, *Memoirs of John Bannister, Comedian* (2 vols., 1839), vol. i, pp. 289-90.

29. Cf. the Fitzwilliam Museum's drawing of holiday gambols on One Tree Hill, and a rare print of *One-Tree-Hill, Greenwich Park* (1811) in the National Maritime Museum.

30. [W. H. Pyne], 'Reminiscences of Artists', in Pyne's *Somerset House Gazette and Literary Museum*, 26 (1824), pp. 409-12.

31. M. Hardie, *English Coloured Books* (1906), citing J. Grego, *Rowlandson the Caricaturist: A Selection from his Works, with a Sketch of his Life* (2 vols., 1880), vol. i, p. 31.

32. Cf. his illustrations for James Beresford's *Miseries of Human Life* (1806-7), or his *Breaking-up of the Blue Stocking Club* (1815): Gatrell, *City of Laughter*, pp. 45, 60.

33. *A Catalogue of the Valuable Collection of Prints, Drawings & Pictures of the Late Distinguished Artist Thomas Rowlandson . . . which will be Sold by Auction by Mr Sotheby . . . on Monday, 23rd June 1828 and three following days* (London, 1828); Payne and Payne, *Thomas Rowlandson*, pp. 350-54.

34. *The Times*, 10 Oct. 1950.

35. One awesome print, *Chaos is Come Again* (1791), imagines the collapse of the Drury Lane Theatre auditorium and the crushing of terrified men and women in the audience by falling masonry. It was a satire on the forthcoming demolition of Drury Lane Theatre for rebuilding, but that hardly explains its wilful violence: Gatrell, *City of Laughter*, pp. 395-6.

36. Angelo, *Reminiscences*, vol. ii, p. 293.

37. Payne and Payne, *Thomas Rowlandson*, p. 355.

38. Gatrell, *Hanging Tree*, p. 182.

39. Some authorities assume that Rowlandson's erotic prints were collected by the Prince of Wales (Tate Britain website; and Mudge, 'Romanticism, Materialism, and the Origins of Modern Pornography'). The evidence is thin. In 1880, Grego 'understood' from an unnamed 'authority' (possibly H. S. Ashbee, who catalogued Rowlandson's erotica in his *Catena Librorum Tacendorum* (1885), that Rowlandson produced a 'series of drawings, notoriously of a free tendency as regards subject ... for the delectation of George IV'. The 'same authority' asserted that a collection of Rowlandson erotica was 'destroyed by a nobleman well known for his princely liberality, on the death of the patron who had selected the subjects': Grego, *Rowlandson the Caricaturist*, vol. i, p. 11. But aristocratic if not princely patronage of Rowlandson's rude pictures is suggested by the Victoria and Albert Museum's copies of *Twelve Plates of Amorous Scenes* and of thirty-seven *Erotiques*. They are bound in expensive vellum and morocco leather.

40. Payne and Payne, *Thomas Rowlandson*, p. 247.

41. Robert Hughes, reviewing a Rowlandson exhibition, New York: *Time*, 19 Feb 1990.

42. Many of his satires express Pittite views. His relationship with the anti-Pittite Prince of Wales was complex, however. The Prince was included in early attacks: *Money Lenders* (1784, W. Humphrey), and an undated drawing, *Mrs Fitzherbert and the Prince of Wales*, that depicts a corpulent man gazing adoringly at a society lady (Boston Museum of Fine Arts): the given titles may be guesswork, however. But relations with the prince improved after 1784. In 1790 Rowlandson and Henry Wigstead dedicated their *Excursion to Brighthelmstone* to him. For Wigstead's role as intermediary between the prince and Rowlandson, see M. J. W. and J. E. Payne, 'Henry Wigstead, Rowlandson's Fellow-Traveller,' *British Art Journal*, 3 (2003), pp. 27–8. Rowlandson's satires on French Revolutionary and Napoleonic bloodthirstiness reveal his instinctive loyalism and Toryism. So does the fact that he paid seven shillings in 1796 to attend the Westminster election dinner for the Pittite candidate: Farington, *Diary*, vol. ii, pp. 523–4.

43. For example: *Tithe Pig* (1790, Fores); *A Brace of Public Guardians* (1796, 1800 Ackermann reissue); *St James's Courtship / St Giles's Courtship* (1799); *Recovery of a Dormant Title, or A Breeches Maker become a Lord* (1805, self-published); *A Select Vestry* (1806, self-published, in Lewis Walpole Library); *The Hopes of the Fammily* [sic] *or Miss Marrowfat Home from the Holidays* (1809, Tegg); *Pray Remember the Poor Sweeper* (n.d., British Library); *Distressed Sailors* (n.d., John Johnson

Collection, Bodleian Library); *Fast Day* (1812, self-published, probably first in 1793); and undated drawings such as *The Tax Collector* and the *Poor Poet* (Boston Museum of Fine Art); *The Lord of the Manor Receiving his Rents* and *The Press Gang* (YCBA).

44. Wark, *Drawings*, pp. 6, 10.

45. Osbert Sitwell, *Sing High! Sing Low!* (1944), p. 132; Wark, *Drawings*, p. 26.

46. Apart from *The Chamber of Genius* (1812), fig. 64 above, see, too, the cluster of four self-published prints of 1799 (their subtexts in identical format): *Connoisseurs* (the BM's impression (fig. 95 above) was published by Fores of Piccadilly with a different typeface; the Metropolitan Museum's impression was published by Rowlandson on his own account); *The Sculptor*, in which the ugly Joseph Nollekens carves a statue from a nude female model; *Lady H******* [Hamilton's] Attitudes*, in which the nude Emma Hamilton adopts one of her 'attitudes' before her older husband and a young artist; and *Pygmalion*: set in the Academy's cast-room, it has the naked female statue into whom Pygmalion's desire has breathed life crouching over the sculptor to guide his substantial penis into herself – on which, see Gatrell, *City of Laughter*, p. 398.

47. Nichols, *Hogarth Anecdotes*, p. 12.

48. Wark, *Drawings*, p. 10.

49. Gatrell, *City of Laughter*, pp. 378, 446.

50. John Forster, *The Life of Charles Dickens* (3 vols., 1875), vol. i, p. 39.

9. THE GORDON RIOTS: AN ENDING

1. Frederick Reynolds, *The Life and Times of Frederick Reynolds* (2 vols., 1826), vol. i, p. 81.

2. Walpole, *Correspondence*, vol. xxxiii, pp. 175–6.

3. W. Hayley and T. S. Grimshawe, *The Works of William Cowper: his Life and Letters* (8 vols., 1835), vol. i, p. 169.

4. *Memoirs of Thomas Hardy . . . written by Himself* (1832), pp. 13–14; *Survey of London*: vol. 36, pp. 225–6.

5. In the same tavern the government's *agent provocateur* George Edwards tried to woo an innocent man into the conspiracy by complaining of the government, 'What a pity it is, Pickard, that we can't destroy these bloody vermin', and by then trying to foist onto him a grenade and a pike. See Mary Thale (ed.), *Selections from the Papers of the London Corresponding Society, 1792–1799* (Cambridge, 1983),

p. 27; *Cobbett's Complete Collection of State Trials* . . . , vol. xxxiii (1826), cols. 1076, 1171, 1302, 1552; *Parliamentary Debates* (1820), 'House of Commons Proceedings', 9 May 1820, cols. 242, 244, 246.

6. *Survey of London*: vols. 33–34, pp. 1–19.

7. J. Summerson, *The Life and Work of John Nash, Architect* (1980), pp. 71, 75–81 and ch. 10; H. J. Dyos, 'The Objects of Street Improvement in Regency and early Victorian London', in D. Cannadine and D. Reeder (eds.), *Exploring the Urban Past: Essays in Urban History by H. J. Dyos* (Cambridge, 1982), pp. 82–3; D. Arnold, *Re-presenting the Metropolis: Architecture, Urban Experience and Social Life in London, 1800–1840* (2000).

8. Martin Myrone, 'Fuseli to Frankenstein: the Visual Arts in the Context of the Gothic', in Martin Myrone (ed.), *Gothic Nightmares: Fuseli, Blake, and the Romantic Imagination* (catalogue, 2006), pp. 31–9.

9. Frederick Reynolds, *Life and Times*, vol. i, p. 81; George Crabbe, *The Life of the Rev. George Crabbe, LI.B* (1834), pp. 77–8.

10. Walpole, *Correspondence*, vol. xxxiii, pp. 193, 186; William Cowper, *Table Talk and Other Poems* (1817), p. 12.

11. Roy Porter, *English Society in the Eighteenth Century* (1982), p. 116.

12. Thomas Holcroft's *A Plain and Succinct Narrative of the Late Riots and Disturbances* (1780) still provides the clearest narrative.

13. J. P. de Castro, *Gordon Riots* (1926), pp. 110, 136–7.

14. Susan Burney Letters Project, University of Nottingham: www.nottingham.ac.uk/hrc/projects/burney/rationale.php

15. Jeremy D. Popkin (ed.), *Panorama of Paris: Selections from 'Le Tableau de Paris' [by] Louis-Sébastien Mercier* (Pennsylvania, 1999), pp. 111–12.

16. *OBSP*: t17800628-112; Alexander Gilchrist, *The Life of William Blake, 'Pictor Ignotus'* (2 vols., 1863), vol. i, p. 35.

17. *OBSP*: t17800628-82.

18. Number 3 Bow Street was added to the office in number 4 in 1813; the two houses remained the magistrates' court until it was moved to the east side of the street in 1880: *Survey of London*: vol. 36, pp. 185–92.

19. Martin C. and Ruthe R. Battestin, *Henry Fielding: A Life* (1993), p. 475; *Evening Post*, 16–18 Aug. 1737, cited by Paulson, *Hogarth's Works*, p. 107.

20. *OBSP*: t17490906-4.

21. *OBSP*: t17800628-1.

22. Walpole, *Correspondence*, vol. xxix, pp. 58–9 (9 June); F. R. Pryor (ed.), *Memoirs of Samuel Hoare by his Daughter Sarah and his Widow*

Hannah (1911), p. 57; *A Complete Collection of State Trials and Proceedings for High Treason* (1816), xxi, col. 539; *OBSP*: t17800628–43.

23. Nathaniel Wraxall, *Historical Memoirs of my own Time, Part I* (1818), p. 348; Christopher Hibbert, *King Mob: The Story of Lord George Gordon and the London Riots of 1780* (1956), p. 131.

24. George Rudé, 'The Gordon Riots: A Study of the Rioters and their Victims', *Transactions of the Royal Historical Society*, 5th series, 6 (1956), p. 99; George Rudé, *The Crowd in History: A Study of Popular Disturbances in France and England, 1730–1848* (1964), pp. 13–15 and ch. 3.

25. Walpole, *Correspondence*, vol. xxxiii, p. 194, 10 June; vol. xxv, pp. 74–5, 24 July.

26. A. Dyce (ed.), *Recollections of the Table-Talk of Samuel Rogers* (2nd edn, 1856), pp. 183–4.

27. E. Burke, *Works and Correspondence* (8 vols., 1852), vol. v, pp. 580–81.

28. Cited by E. P. Thompson, *The Making of the English Working Class* (1963), p. 73.

29. Charlotte Barrett (ed.), *Diary and Letters of Madame D'Arblay* (4 vols., 1891), vol. i, p. 298.

30. E. Kimber and R. Johnson, *The Baronetage of England* (2 vols., 1771), vol. ii, p. 49, cited by Leslie and Taylor, *Reynolds*, vols. ii, p. 303; Wraxall, *Historical Memoirs*, p. 338.

31. James Boswell, *Life of Johnson* (Oxford, 1980), pp. 1054–7.

32. P. Quennell (ed.), *The Memoirs of William Hickey* (1976 edn), p. 279.

33. Walpole, *Correspondence*, vol. xxxiii, p. 189.

34. Leslie and Taylor, *Reynolds*, vol. ii, p. 303.

35. Cited in J. Bonehill and S. Daniels (eds.), *Paul Sandby: Picturing Britain* (exhibition catalogue, 2010), p. 144.

36. Crabbe, *Life of Crabbe*, p. 80.

37. Frederick Reynolds, *Life and Times*, vol. i, p. 82.

38. Hibbert, *King Mob*, p. 80.

39. Myrone, 'Fuseli to Frankenstein', p. 32; Ian Haywood, '"A Metropolis in Flames and a Nation in Ruins": The Gordon Riots as Sublime Spectacle', in Ian Haywood and John Seed (eds.), *The Gordon Riots: Politics, Culture and Insurrection in Late Eighteenth-Century Britain* (Cambridge, 2012).

40. Brooking, *Ship on Fire at Night, c. 1756* (YCBA); Scott, *French Fireships Attacking the English Fleet off Quebec, 28 June 1759* (National Maritime Museum).

41. Two paintings in the Philadelphia and the Cleveland Museums of Art; watercolour sketches in Tate Britain.

42. Mortimer's sketch of *c.* 1775 and the etching of 1784 are in BM.

43. West's 1796 version is in Detroit, and his 1817 version in Pennsylvania. The composition influenced de Loutherbourg and Blake and foreshadowed Delacroix. Gillray parodied the theme in *Presages of the Millennium* (1796) and Rowlandson in *Downfall of Monopoly* (1800) and *More Incantations* (1815).

44. Ronald Paulson, *Representations of Revolution (1789–1820)* (New Haven, 1983), pp. 182–3.

45. Gatrell, *City of Laughter*, pp. 279–80; Myrone, 'Fuseli to Frankenstein', p. 34.

10. TURNER, RUSKIN AND COVENT GARDEN: AN AFTERMATH

1. *Blackwood's Magazine*, Oct. 1836; *Literary Gazette*, 14 May 1842; *Athenaeum*, 14 May 1842.

2. F. Anderson et al. (eds.), *Mark Twain's Notebooks and Journals* (3 vols., Berkeley, 1975–9), vol. ii, pp. 139–40.

3. W. Hazlitt, *The Round Table: A Collection of Essays on Literature, Men, and Manners* (2 vols., Edinburgh, 1817), vol. ii, pp. 19–20.

4. Roberta Smith, *The New York Times*, 4 July 2008.

5. Frank Harris, *My Life and Loves* (4 vols. in 1, 1922–7; ed. J. F. Gallagher, 1991), p. 400.

6. It is now agreed that such gaps as there are in their pages have innocent explanations. This account draws on Ian Warrell, 'Exploring the "Dark Side": Ruskin and the Problem of Turner's Erotica', *British Art Journal*, IV (1), Spring 2003, pp. 5–14; and Andrew Leng, 'Recontextualizing "The Two Boyhoods": Ruskin, Thornbury and the Double Lives of Turner', *Prose Studies*, 28 (1), April 2006, pp. 54–73. For reproductions and further comment, see Ian Warrell, 'Checklist of Erotic Sketches in the Turner Bequest', *British Art Journal*, IV (1), Spring 2003, pp. 15–46; and Ian Warrell, *Turner's Secret Sketches* (2012).

7. Walter Thornbury, *The Life of J. M. W. Turner, R.A.: Founded on Letters and Papers furnished by his Friends and Fellow-Academicians* (2 vols., 1862), vol. ii, pp. 167–8.

8. *The New Canting Dictionary* (1725), in J. S. Farmer, *Musa Pedestris: Three Centuries of Canting Songs and Slang Rhymes (1536–1896)* (privately printed, 1896), pp. 42, 55. For 'wap' as 'copulate': Francis Grose, *Classical Dictionary of the Vulgar Tongue* (1785) (no pagination), and Gordon Williams, *A Dictionary of Sexual Language and*

Imagery in Shakespearean and Stuart Literature (1994), pp. 499, 948 and passim.

9. Antony Bailey, *Standing in the Sun: A Life of J. M. W. Turner* (1997), pp. 240–41.

10. Thornbury, *Turner*, vol. i, p. 117. 'Mr Lascelles as well as Lady Sutherland are disposed to set up Girtin against Turner, – who they say effects his purpose by industry – the former more genius – Turner finishes too much' (Farington, *Diary*, 9 Feb. 1799).

11. John Ruskin, 'On the Teachers of Turner', in *Modern Painters*, vol. iii (1856), part iv, ch. xviii, pp. 308–9.

12. D. H. Solkin, *Turner and the Masters* (Tate Britain catalogue, 2009).

13. Ruskin, 'The Two Boyhoods', in *Modern Painters*, vol. v (1860), part ix, ch. ix, pp. 301–13. The other 'boyhood' was the Venetian painter Giorgione's.

14. Thornbury, *Turner*, vol. i, p. 29.

15. Cf. *A Family Seen from Behind* (1796), *Studies near Brighton Sketchbook* [Finberg XXX], Tate Britain.

16. H. Miles, 'Wilkie, Sir David (1785–1841)', *ODNB*.

17. *Survey of London*: vol. 36, pp. 239–52; A. J. Finberg, *The Life of J. M. W. Turner, R. A.* (2nd edn, Oxford, 1961), pp. 1–65.

18. Thornbury, *Turner*, vol. i, p. 2.

19. James Hamilton, *Turner: A Life* (1997), p. 10, lists the seven as Burgess, Butler, Hearne, William James, Jouret, James Nixon, Pouncy.

20. All but two of the male householders who voted in 1784 were of the same kinds. They divided their votes almost equally between Fox, the Tory partnership of Hood and Wray, and the combined candidacy of Hood and Fox. For Westminster ratebooks see the *London Lives* Project (www.Londonlives.org).

21. *The Times*, 6 June 1806, *Trewman's Exeter Flying Post*, 12 June 1806.

22. Rowlandson's 1798 drawing of *The Brilliants* is reproduced in John Hayes, *Rowlandson: Watercolours* (1972), plate 108. The drawing was etched and published by Ackermann in 1801, and this is reproduced and discussed in Gatrell, *City of Laughter*, p. 89. For the Brilliants' history: John Badcock, *Slang: A Dictionary of the Turf, the Ring, the Chase, the Pit* (1823), pp. 16–17; [C. Westmacott], *The English Spy: An Original Work, Characteristic, Satirical, and Humorous* (1825), vol. i, p. 398; John Timbs, *Curiosities of London* (1868), p. 248.

23. Ruskin, *Modern Painters*, vol. iii (1856), part iv, ch. xviii, p. 32 and n 103.

24. Hamilton, *Turner*, p. 13.

25. For Carlyle's campaign, *The Carlyle Letters online* (2007): http://carlyleletters.org (keyword 'Lowe'). Finberg's standard *Life of Turner* doesn't mention Lowe; Hamilton's *Turner* gives him a sentence (p. 18).

26. James Boswell, *Life of Johnson* (Oxford, 1980), 28 April 1778.

27. *Gentleman's Magazine*, 159 (1835), pp. 582–3.

28. In BM: *A Sudden Squall in Hyde Park*; *A Field Day in Hyde Park*; and *Damp Sheets*. In Lewis Walpole Library: *Inn on Fire*. All for Fores, 1791.

29. Farington, *Diary*, 12 Nov. 1798, cited by Luke Herrmann. 'Turner, Joseph Mallord William (1775–1851)', *ODNB*. Monro was a mad-doctor in fashionable practice, and Cozens was his patient. Monro orchestrated conversations about art among his protégés, encouraging several of them (not Turner) to form a 'brotherhood' which came to be known as 'Girtin's Sketching Club' in acknowledgement of Girtin's supremacy before Girtin died prematurely in 1802, his twenty-seventh year.

30. Rowlandson had satirized Monro's father, Dr John Monro, in his print *The Incurable* (1784); and both father and son collected Rowlandson's drawings.

31. Gilbert White of Selborne describing the technique of the watercolourist Samuel Hieronymus Grimm, BM website citation at BM 1984, 0512,4.

32. Curator's comment, BM website at BM 1958, 0712,402.

33. 'Names and Residences, of the principal Artists residing or practising in the Metropolis', in James Elmes (ed.), *Annals of the Fine Arts for 1817* (1817), pp. 421–36. The list includes miniaturists. Sculptors, engravers and architects were listed separately and are not counted here.

34. *The Times*, 10 Nov. 1856; Thornbury, *Turner*, vol. ii, pp. 178–81.

Index

Illustrations are indicated either by page references in *italics* or by plate numbers in **bold**. References to endnotes are indicated by *n* and the note number (e.g. 453*n*25) and references to footnotes are indicated by an asterisk (345*).